FEMINISM AT THE MOVIE

Feminis ... *a* examines the
way th ... book offers a
compre ... ith analyses of
over tw ... hick flicks, teen
pics, h ... lawyer films.
Contrib ... on the interface
of popu ... e the gendered
politica ... ist fatherhood,
consum ... ality, gendered
violenc

The v ... nks, Heather
Brook, ... nt, Hannah
Hamac ... Lane (with
Nicole ... ary Radner,
Rob S ... r Stapleton,
Rebe

Hilar ... Otago, New
Zeala ... ity: *Shopping*
Arou ... *Neo-Feminist*
Cinem ... Her recent
co-ed ... State Press,
2009)

Rebe ... Otago, New
Zeala ... on and how
these ... appeared in
journ ... *rnal of Drug*
Policy ... nonograph,
Knou

FEMINISM AT THE MOVIES

Understanding Gender in Contemporary Popular Cinema

Edited by
Hilary Radner and Rebecca Stringer

Routledge
Taylor & Francis Group

NEW YORK AND LONDON

First published 2011
by Routledge
711 Third Avenue, New York, NY 10017

Simultaneously published in the UK
by Routledge
2 Park Square, Milton Park, Abingdon, Oxon OX14 4RN

Routledge is an imprint of the Taylor & Francis Group, an informa business

Library of Congress Cataloging in Publication Data
Feminism at the movies : understanding gender in contemporary popular
cinema / Hilary Radner, Rebecca Stringer [editors].
 p. cm.
Includes bibliographical references.
1. Feminism and motion pictures. 2. Feminist films–History and
criticism. 3. Women in motion pictures. 4. Masculinity in motion
pictures. 5. Sex role in motion pictures. 6. Motion pictures for
women–United States.
PN1995.9.W6F453 2011
791.43082–dc22 2011013486

ISBN: 978-0-415-89587-3 (hbk)
ISBN: 978-0-415-89588-0 (pbk)
ISBN: 978-0-203-15241-6 (ebk)

Typeset in Bembo
by Glyph International Ltd.
Printed and bound in the United States of America on acid-free paper by
Edwards Brothers, Inc.

CONTENTS

FIGURES

ACKNOWLEDGMENTS

As is the case with many edited volumes, this book would not have emerged without the sustained encouragement and assistance of a number of people. In particular, we wish to acknowledge the generous assistance that we received from the Department of Anthropology, Gender and Sociology and the Division of Humanities at the University of Otago in progressing this project. Ellen Pullar, Elspeth Knewstubb and Peter Stapleton provided editorial assistance in the long process of preparing the manuscript, and Lisa Marr undertook the index with great diligence, while Hugh Campbell, Barry Keith Grant, Jacqui Leckie, Janet Wilson, and Janet Staiger provided crucial support at various stages in the project's evolution. We would like to take this occasion to express our gratitude to Matt Brynie, Erica Wetter, Gail Newton, Paula Clarke, and Carolann Madden at Routledge, New York, who made everything possible, and to our partners Alistair Fox and Brian Roper who generously shared their expertise with us and supported us through the project's long incubation, development and completion. But most of all we would like to thank the contributors, the authors whose insight, scholarship and enthusiasm provided the *sine qua non* of the volume.

INTRODUCTION

"Re-Vision"?: Feminist Film Criticism in the Twenty-first Century

Hilary Radner and Rebecca Stringer

A primary preoccupation that marks contemporary culture is the question of gender: who are we, and to what extent do biological divisions of male and female continue to inform our sense of identity? The questions routinely raised by feminist scholars within the academy during the last 20 years of the twentieth century have become the stuff of popular narrative in the twenty-first century—with contemporary movies continuing to provide a collective locus for the expression of cultural concerns within the largely comforting and reassuring framework of established genres in hybridized form. This volume does not attempt to offer a comprehensive survey of gender and film; rather, its mandate is to air issues surrounding the cinematic representation of gender that continue to be the object of both popular and scholarly attention.

The volume pursues the task of feminist film criticism as initially defined in works such as *Re-Vision: Essays in Feminist Film Criticism*, originally published in 1984; we propose to continue, within the landscape of popular movies of the twenty-first century, the project set forth by the editors of that volume, whose goal was "re-vision," with the purpose of

> seeing difference differently, re-vising the old apprehension of sexual difference and making it possible to multiply differences, to move away from homogeneity.[1]

Maintaining a focus on the woman's film, a productive topic of analysis for feminist film theory over the past 30 years, the essays gathered together provide an entrée into current debates on gender as they inform movies that address the female audience. Each chapter offers analyses of specific films *familiar* to today's students, films that each author re-views, that is, subjects to the process of

re-vision in the full sense of the word as intended by the authors quoted above—films such as *The Secret Life of Bees* (Gina Prince-Bythewood, 2008) and *Juno* (Jason Reitman, 2007), but also *Michael Clayton* (Tony Gilroy, 2007) and *A Single Man* (Tom Ford, 2009)—in other words, films that have sparked debate in a number of different quarters while remaining accessible to mass audiences. By covering a wide range of films (we include 21 chapters; *Re-Vision* only eight), the volume moves beyond the traditional delineation of women's cinema. Indeed, as Rob Schaap observes in "No Country for Old Women," unlike male viewers, who are reluctant to choose films that fall under the rubric routinely referred to as "femme fare," women watch a wide variety of films, and, if fans of the woman's film, they rarely confine themselves to that genre. While industry figures on gay audiences are difficult to find, responses to films like *Sex and the City: The Movie* (Michael Patrick King, 2008) suggest that their viewing habits are closer to that of the "female demo" than to those of the male viewer; this glaring absence of information supports Schaap's further contention that global Hollywood's division of audiences into four quadrants disadvantages groups that do not neatly correspond to its preferred category of males under 25, in spite of the fact that many of these so-called "minority" groups may be regular film-goers.[2]

The selection of films here reflects, then, the eclectic tastes of the expanded femme fare audience: Janet Staiger opens the volume, in her chapter "The First Bond Who Bleeds," with a discussion of older women's investments in films typically thought to target a young male audience, which she re-dubs "'Pretty Boy' Action Movies," emphasizing their appeal to viewers who want to look at men. This chapter is followed by Michael DeAngelis on *A Single Man*, a narrative that revolves around a gay male protagonist and his lost love, echoing the classical romantic melodrama as a genre that typically spoke to "femmes." Although viewers' experiences may be dominated by global Hollywood, certain genres, such as horror, even when produced nationally, attract an international "niche" audience. Independent films such as *The Secret Life of Bees* that are produced and promoted by a celebrity, such as Queen Latifah, also offer alternative discourses to another type of niche audience, remaining nonetheless within the popular. It is this range and complexity, we argue, that define the circulation of discourses about gender in cinema today. Examining a broad compendium of films, not only "chick flicks," such as *Miss Congeniality* (Donald Petrie, 2000), but also spy films, *Casino Royale* (Martin Campbell, 2006), or even horror, *Haute Tension* [*High Tension/Switchblade Romance*] (Alexandre Aja, 2003), as a group, the analyses included here offer a "thick" and diverse articulation of the figuration of gender within contemporary cinema as a plurality of positions that are inherently contradictory.

Through the scope of films considered and its engagement with popular cinema as a form of ideological interrogation, *Feminism at the Movies* suggests a break with feminist film scholarship of the 1980s and 1990s. In particular, the need to define a feminist counter-cinema, an authentic woman's cinema,

a representation of "woman as woman,"[3] or a woman's voice or "look," no longer serve as primary impetuses behind these current assessments of popular cinema. Movies are accepted as important and complex social documents in their own right, serving a variety of functions, not all of which are in the interests of a hegemonic status quo. Notwithstanding, the volume also testifies to the continuing legacy and influence of *Re-Vision* as a landmark publication: notably, Linda Williams's "When the Woman Looks"[4] provides the foundation for Barry Keith Grant's current contribution, "'When the Woman Looks': *Haute Tension* (2003) and the Horrors of Heteronormativity." The larger list of topics and authors comprising the volume's table of contents testifies, however, to the shifting terrain of research in feminist film criticism, marked by the increased participation of male scholars; by the heightened visibility of lesbian, gay, and queer analyses and questions surrounding masculinity; by the focus on contemporary history, particularly as it informs "raced" and postcolonial subjects; by a more pronounced interrogation of the links between violence and gender; by the assumption that popular films, popular culture, and consumer culture are complex and ambivalent social forces in the production of gender.

Structures of heteronormativity and of inclusion and exclusion remain a substantive concern, as do maternity and kinship, now inflected by changes in the politics and technologies of reproduction. Though psychoanalysis (as it did for scholars in *Re-Vision*) provides the vocabulary with which a number of contributors describe the symbolic fields through which gender is generated as such, psychoanalysis does not dominate thinking about feminist film scholarship as was the case in 1984. Contributors today call upon a range of different paradigms, such as reception theory, neoliberalism, and postfeminism, within which to situate their analysis, demonstrating the ways in which cinema has become a fruitful object through which to examine and discuss feminist issues relating to fields beyond cinema studies itself, such as sociology, legal studies, political studies, and philosophy, echoing the home disciplines of the authors themselves.

Following the recent flourishing of feminist research on contemporary feminine culture, such as Angela McRobbie's *The Aftermath of Feminism* and Diane Negra's *What a Girl Wants: Fantasizing the Reclamation of Self in Postfeminism*, many of these chapters return to some of the topics that marked second wave feminist writing such as that of Molly Haskell and Marjorie Rosen, which attempted to evaluate the types of images offered by film, often described as "the 'image of' tradition of feminist film criticism."[5] While popular feminism has never abandoned these issues, feminist film scholarship, under the influence of ciné-psychoanalysis, sought to move beyond this framework in order to interrogate the role and specificity of cinema as medium and institution in generating the structures and circulation of fantasy and desire.[6] On the one hand, there are very few chapters that do not bear the mark of this research; on the other, chapters such as those by Taunya Lovell Banks on the representation of

women lawyers, or Yael D Sherman on the presentation of new patterns of femininity, suggest that the "images of women" mode of analysis remains both pertinent and necessary. To fail to question the models of femininity that cinema produces and circulates would be to subscribe to a postfeminism that posits the second wave modalities as outmoded and unnecessary. Indeed, as legal scholar Taunya Lovell Banks explains, the battle for representation in a literal sense has yet to be won, as shown by films such as *Michael Clayton* (2007), which perpetuates the stereotyping that historically characterizes "women lawyer" movies. Similarly, Kelly Kessler demonstrates how popular cinema fails to adequately represent lesbian sexuality as something other than a transitory experiment and a deviation from the heterosexual norm. The relative homogeneity exhibited by the protagonists (most are "white," young, thin, and middle-class) of the films considered by this volume (with a number of notable exceptions, such as *The Secret Life of Bees*) demonstrates that cinema continues to rely upon established stereotypes in generating popular narratives.

Though still at times caught in some of the conundrums that excited the ire of second wave feminists, current cinema itself has become much more self-conscious in its treatment of gender. While in general the direct political references to feminism associated with films like *Nine to Five* (Collin Higgins, 1980) or *Thelma and Louise* (Ridley Scott, 1991) are rare, movies in the twenty-first century are aware of their role in the social production of gender, and commonly represent, and deliberately reflect upon, the dilemmas that face the contemporary subject. While as popular films their conclusions generally serve to reassure viewers that singles, parents, and kids "are alright," they also raise questions about gender that undermine our understanding of it as being biologically ordained, or a "natural" category. JaneMaree Maher points to the ways that new reproductive alternatives give rise to new family structures in *Baby Mama* (Michael McCullers, 2008); Heather Brook suggests that bridal culture may be about new, and enduring, forms of female friendship that may sit alongside heterosexuality, but also question its centrality; and Gary Needham argues that what he calls the "transgender figure" destabilizes normative and essentialist definitions of gender.

The topics with which these chapters engage are varied but uniformly center on the dilemmas of gender, particularly femininity, including: the undoing of masculinity in the face of evolving gender roles; the emergence of gay and queer sexualities and identities; postfeminism and consumer culture; the neoliberal feminine subject; feminine adolescent sexuality; the continued cultural ambivalence surrounding the professional woman; the vexed permutations of gender, race, and ethnicity with regard to the postcolonial subject; a new feminine narcissism; the hegemony of gender-oriented consumer culture in conglomerate Hollywood; the female event film and its soundtrack; the politics of feminine independence; the re-articulation of intimacy, affective relations, and kinship; the containment of lesbian sexuality; female friendship and consumer culture; postfeminist

fatherhood; history, race, and violence; rape narratives; and the pathologizing of violent masculinity. The book includes five broad sections that define the central issues addressed: Masculinity in Question; New Feminine Subjects; Consuming Culture(s); Relationships, Identity, and Family; and Gender and Violence. The chapters exhibit a strong consistency in themes; the examination of consumerism is prevalent across all sections, for example, with those grouped in the section "Consuming Culture(s)" focusing more specifically on consumer culture as a central concern of the analysis. In many cases, chapters might easily fall into one section or another—this is because these larger *topoi*, such as family relations or consumerism, cut across contemporary cinema in a systematic fashion as central and recurring concerns.

Masculinity in Question

Contemporary deliberations about femininity throw into relief the ways in which masculinity as its analytic other is itself an unstable and contested category. Janet Staiger, in her analysis of *Casino Royale*, considers the evolution of the action film in terms of an increasingly marked tendency towards melodrama and "tears," and its implication for both female and male spectators. In so doing, she suggests the need to revise received views about gender and its impact on a viewer's relations to the screen image and narrative. In "Queer Memories and Universal Emotions," Michael DeAngelis examines how *A Single Man* presents a "paradoxical" version of "queerness—as both gay specific and universally accessible." While *A Single Man* offers a gay romantic hero, the heterosexual male, as David Hansen-Miller and Rosalind Gill argue in "'Lad Flicks': Discursive Reconstructions of Masculinity in Popular Film," is presented as a figure of fun in a recent cycle of comedies that center on a man, no longer young, as in *The 40-Year-Old Virgin* (Judd Apatow, 2005), who struggles with "immaturity, neurosis, lack of success or social power." For Hansen-Miller and Gill, the comic mode suggests how masculinity constitutes "a troubled cultural category" in contemporary culture. In a similar vein, Gary Needham claims in *Transamerica* (Duncan Tucker, 2005) that the main character Bee (Felicity Huffman), as a "transgender figure," highlights "the cultural construction of gender, but also assumptions about sexualities and bodies." According to Needham, the transgender figure then calls both masculinity and femininity into question as modes of being that can be undone and re-done—or re-viewed—in which the "queering of the road movie" becomes "a model for thinking about the gendered body and identity as a journey, or in theoretical terms the process of becoming rather than being." These chapters are united, then, in the way that they demonstrate how contemporary cinema has called into question notions of a stable masculine identity, and by extension femininity—in which masculinity is understood in terms of what Hansen-Miller and Gill call "its difficulties," and in which social hierarchies, including those involved in regimes of looking, are not monolithic.

New Feminine Subjects: A Space for Women?

While Part I offers a view of masculinity as troubled and fragile, Part II posits an equally fraught and vexed position for the feminine subject. Yvonne Tasker in her analysis of *Enchanted* (Kevin Lima, 2007) concludes that as a postfeminist film it seems to advocate empowerment for women while actually encouraging them to adopt roles that will leave them with little economic or political clout, a form of what Diane Negra has called "retreatism."[7] Foreshadowing the subsequent section on consuming culture, Tasker also observes that the film emphasizes consumerism as the privileged and legitimate form of self-fashioning available to women—that again repositions them in terms of conventional femininity. Yael D Sherman on *Miss Congeniality* links what she calls neoliberal femininity to consumption and a concern with appearance. In "Neoliberal Femininity in *Miss Congeniality* (2000)," she argues that the film demonstrates how neoliberalism has generated a new model of femininity that attempts unsuccessfully to reconcile feminism and femininity, leaving the feminine subject in an untenable position, echoing Yvonne Tasker's analysis of *Enchanted*. Sarah Projansky examines the franchise that grows out of the novel *The Sisterhood of the Traveling Pants*, which includes further novels and two films. While Projansky sees the franchise as offering possibilities for a feminist reading by looking across the various texts and examining their contradictions, she also sees its stories as "missed opportunities." In the final instance, these texts fail to empower young women to understand and engage with their own sexuality, and fall back on ethnic and gender stereotypes. Taunya Lovell Banks argues that *Michael Clayton* (2007), as a recent example in a long line of "commercial films that treated women lawyers harshly," "tells viewers that the powerful twenty-first century corporate/legal world remains a decidedly male environment ill-suited for women." Mridula Nath Chakraborty offers a similarly pessimistic view of *Bend It Like Beckham* (Gurinder Chadha, 2002), which she understands as replicating "the primacy accorded to marriage and family in feminist subcontinental films that have explored the theme of same-sex love," while promoting an ethos of assimilation. In her discussion of *13 Going On 30* (Gary Winick, 2004), Hilary Radner explores how the film represents a new feminine pathology in which narcissism, grounded in consumer culture, takes the place of hysteria. Contemporary cinema's new subjectivities are neither, perhaps, as new or as radical as second wave feminism might have hoped, with consumer culture taking an increasingly dominant role in the definition of femininity.

Consuming Culture(s)

Part III continues the volume's exploration of consumer culture as fundamental to feminine identity, echoing earlier chapters by Tasker and Radner. While most chapters see films for women as advocating participation in consumer culture in

the form of acquiring fashionable garments, etc., the authors are not unified in their view, with some arguing that so-called independent, low-budget and mid-budget films may allow female directors to critique the tyranny of feminine consumer culture and the validity of the assumption that it is intrinsic to feminine identity, thereby generating alternative positions. This section also highlights how film as an object that is consumed inevitably positions it and its viewers in relation to larger economic structures. Thus, Rob Schaap describes how the institutional and economic structure of conglomerate Hollywood discourages the production of films targeting a female audience, especially those over 25. Peter Stapleton examines the soundtrack of *Sex and the City: The Movie*, illustrating how the demands of Conglomerate Hollywood in terms of synergies and product tie-ins constrain the kinds of music employed, with significant ideological implications that result in the promotion of "old fashioned values" and heteronormativity. Michele Schreiber posits that films like *Friends With Money* (Nicole Holofcener, 2006), which she describes as produced outside the Hollywood system, offer the possibility of questioning and even de-legitimating the consumeristic discourses of films like *Sex and the City*. Similarly, Christina Lane and Nicole Richter see Sofia Coppola, in films such as *Marie Antoinette* (2006), interrogating the position of woman as both looking and being looked at, while self-consciously exploiting her own situation as a "name brand" director, in which she must circulate her image as a marketing device. For Lane and Richter, Coppola's Marie Antoinette uses consumption to create herself as a spectacle, her primary form of self-expression, paralleling Coppola's own aesthetic as an auteur filmmaker.

Relationships, Identity, and Family

In spite of a focus on consumerism and self-fulfillment at the individual level in many contemporary films, issues surrounding family and motherhood remain central to contemporary cinema for women, while female friendship film continues as a significant genre. JaneMaree Maher's analysis of *Juno* (Jason Reitman, 2007) and *Baby Mama* (Michael McCullers, 2008) raises questions about the relationship between economic status and motherhood, with motherhood, particularly in *Juno*, seemingly reserved for the economically privileged; however, Maher also demonstrates how the films also move their characters towards new relations and articulations of family that are outside traditional patriarchal structures. Kelly Kessler expresses her disappointment in *Kissing Jessica Stein* (Charles Herman-Wurmfeld, 2001), which ultimately posits the lesbian relationship as de-sexualized, a form of female friendship that asserts the ascendancy of heterosexuality. She posits the film as a cinematic inversion of a "hetero bait-and-switch," in which the film promises a lesbian union, but ultimately concludes with a heterosexual couple. In contrast, Heather Brook finds that in *Bride Wars* (Gary Winick, 2009), female friendship may provide stability, when

heterosexuality cannot, generating an anxious, if gentle, critique of bride culture. If motherhood remains a privileged topic for the woman's film, fatherhood has more recently become the focus of a number of action films, emphasizing the increasingly prominent melodramatic dimensions of films directed at the male audience, perhaps with a view to recognizing the female audience that inevitably comes along as well. Hannah Hamad explores what she calls "postfeminist fatherhood" in Steven Spielberg's *War of the Worlds* (2005) as typical of a current spate of films in which a man must prove himself as a father in an environment in which the family is under threat and in which the role of the mother is de-emphasized, to the benefit of the redeemed patriarch.

Gender and Violence

The final section, Gender and Violence, picks up on many themes that characterize films about family; however, the fact of violence is a general structuring device among the group of films that fall under this rubric. The three final chapters speak to a longstanding feminist concern about violence in relations of gender and power; the films addressed enable a complex engagement with these relations, extending discussion of sexist violence to its entwinement with racist violence, to the ethics of counter-violence, and to figurations of the violent woman. For Ewa Plonowska Ziarek, *The Secret Life of Bees*, set in the 1960s in rural South Carolina, raises questions about kinship, citizenship, and interracial ties by following the lives of two fugitives bonded as victims of male violence, one, a young "white" girl, escaping an abusive father, the other, a young African-American woman, beaten as she attempts to vote. Rebecca Stringer pursues the theme of male violence and female victimhood by examining two films that depict female vigilantes, *The Brave One* (Neil Jordan, 2007), and *Hard Candy* (David Slade, 2005). Finally, the volume concludes with Barry Keith Grant's reading of *Haute Tension*, a cult horror film that emerged out of the movement known as the New French Extremity, or New French Extremism, and which, in Grant's perspective, hinges upon revealing the unmitigated violence associated with masculinity itself. In reading the film as an indictment of masculinity, Grant rejoins Hansen-Miller and Gill, and Hamad in positing masculinity as troubled—here both threatening and threatened, for only through its complete eradication can a resolution be achieved—highlighting how films such as *Haute Tension*, often achieving cult standing, throw into relief the manner in which gender and its ramifications continue to provide one of the major preoccupations of contemporary cinema.

 The diversity and strength of these analyses point to the sustained relevance of the project initiated by *Re-Vision* as an outgrowth of second wave feminism. Indeed, if the role of feminist scholarship is to interrogate the social and cultural role of gender, "making it possible to multiply differences, to move away from homogeneity," our volume documents the continuing vitality of feminist film

scholarship, of this approach to cinema as a means of understanding ourselves and our culture as we move forward into the second decade of the twenty-first century.

Notes

1 Mary Ann Doane, Patricia Mellencamp, and Linda Williams, "Feminist Film Criticism: An Introduction," in *Re-Vision: Essays in Feminist Film Criticism*, ed. Mary Ann Doane, Patricia Mellencamp, and Linda Williams (Los Angeles, CA/Frederick, MD: The American Film Institute/University Publications of America, 1984), 14–15.

2 Hilary Radner, *Neo-Feminist Cinema: Girly Films, Chick Flicks and Consumer Culture* (New York: Routledge, 2010), 156–7.

3 Christine Gledhill, "Developments in Feminist Film Criticism," in *Re-Vision: Essays in Feminist Film Criticism*, ed. Mary Ann Doane, Patricia Mellencamp, and Linda Williams (Los Angeles, CA/Frederick, MD: The American Film Institute/University Publications of America, 1984), 18.

4 Linda Williams, "When the Woman Looks," in *Re-Vision: Essays in Feminist Film Criticism*, ed. Mary Ann Doane, Patricia Mellencamp, and Linda Williams (Los Angeles, CA/Frederick, MD: The American Film Institute/University Publications of America, 1984), 83–99.

5 Angela McRobbie, *The Aftermath of Feminism* (London: Sage, 2009); Diane Negra, *What a Girl Wants?: Fantasizing the Reclamation of Self in Postfeminism* (London and New York: Routledge, 2009); Doane, Mellencamp, and Williams, "Feminist Film Criticism: An Introduction," 6.

6 For a succinct description of the evolution of feminist film scholarship, see E. Ann Kaplan, "Feminism," in *Schirmer Encyclopedia of Film*, vol. 2, ed. Barry Keith Grant (Farmington, MI: Thomson Gale, 2007), 201–7.

7 Negra, "Postfeminism, Family Values and the Social Fantasy of the Home Town," in *What a Girl Wants?*, 15–46.

PART I
Masculinity in Question

1

"THE FIRST BOND WHO BLEEDS, LITERALLY AND METAPHORICALLY"

Gendered Spectatorship for "Pretty Boy" Action Movies

Janet Staiger

My fascination with "pretty boy"[1] movies began around 2003 when a group of friends went to see *Pirates of the Caribbean* (Gore Verbinski, 2003). Afterwards, two other women of about my age and I enjoyed drinks, sharing our pleasures in watching Johnny Depp, I attracted in particular to his rather bold choices in starring roles and his unique and memorable interpretations of the characters, but my friends also delighted in him for their own reasons. Soon the three of us began regularly seeing all films in which he starred and named ourselves the Deppettes. I might also reveal here that this is the only "fandom" in which I participate.

Luckily, Depp is recruited for many roles, but occasionally when we want to see a film, we are Depp-rived.[2] While we have favorite genres as an alternative to a Depp movie, one of our first options is to see movies with "pretty men." We have standard tastes here; however, I was the one to think that Daniel Craig justified going to see *Casino Royale* (Martin Campbell, 2006). Although I shall be using myself as a source of response, an auto-ethnographical move, some of the public reception of the film surprised me.[3] In particular, in a fan chat room, one person confessed to crying, and others replied that they had as well. I certainly had no such reaction although I found the film an exciting reboot of the franchise. While in retrospect I believe that I can account for some of the critical and fan reception of *Casino Royale*, the case may be illustrious of some contemporary male spectatorship of male action-adventure films, one of the most powerful and successful genres today. In particular for this chapter, I shall be focusing on reports by males of crying and their related attributions of realism for the film. I shall also discuss what I believe to be a related, inverted formula and its success with female audiences. While somewhat theoretical, this chapter remains a historical materialist reception studies account since I am

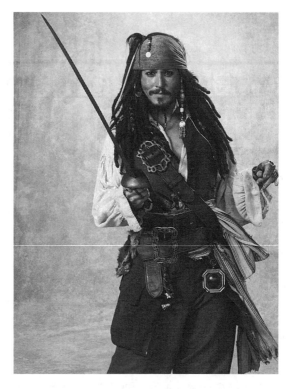

FIGURE 1.1 "Pretty boy" Johnny Depp in *Pirates of the Caribbean: At the World's End* (2007). Courtesy of Sony Pictures/Photofest.

contextualizing the space of reception and noting current trends of filmmaking that affect viewers' horizons of expectation.

The 2006 *Casino Royale* begins with James Bond earning his double-0 with his first two kills. He tracks down Le Chiffre (Mads Mikkelsen) who is financing terrorists. With the help of an MI6 accountant, Vesper Lynd (Eva Green), and despite his egotism (about which both M and Vesper caution him), Bond wins Le Chiffre's money at Monte Carlo. Afterwards, Le Chiffre tortures Bond for the password to the bank account where the money is stored, but at the last moment he and Vesper are saved. Vesper and Bond enjoy an idyllic moment, and Bond says he is going to turn in his resignation papers so they can be together; however, when they are to transfer the funds to MI6, it appears that Vesper has conned him. That turns out not to be true: Le Chiffre was holding her former boyfriend in exchange for the funds, and she arranges for Bond to re-secure the money and kill Le Chiffre, but she dies, in a suicidal act, and "Bond, James Bond" is "born."[4]

The Male Weepies[5]

Let me begin my analysis with the reports of crying. In an Internet Movie Database (IMDb) thread, "Who cried? *Spoilers*,"[6] emzy64 starts with the statement,

> Okay it might be just me, but I found the ending reallyyy sad. I was literally bawling my eyes out; mainly because of the fact that the love story was so developed and you could tell they really loved each other … then suddenly, its all over and she dies.
>
> When he's trying to revive her on the rooftop, oh, that was so sad! Maybe it's just because over the course of the movie I grew to love Vesper's character so much and so, her death affected me deeply.
>
> Everytime I watch it now, I think "noo please don't die" but then I guess if she didn't, we wouldn't have a series of James Bond novels. I don't know which one I'd prefer though.

While I do not know the sex of emzy64, the three people who reply use login names or replies that imply they are male, and comments in the responses reinforce this. Donald_Hai writes,

> I agree it was very sad, but I think Vesper had to die in order for James Bond to forever become numb … Tragic Bond ☹.

JustAMessageBoardPoster2 says:

> I am a guy and I am not ashamed to admit I am a sucker for that stuff. I cried.
>
> I chalk it up to Green. Her subtly nuanced and layered performance as well as her absolutely unearthly beauty just had my heart breaking right along with Bond when Vesper dies.

Royale Green contributes:

> I am in complete agreement … I got very choked up at the end and especially … especially when he tried reviving her. [He used CPR.] …
>
> Such a sad ending, but it's a necessity for the franchise.

Of course, not all males cried, or probably more than a few.[7] The space for these confessions needs to be considered. I was in the Internet Movie Database, which is certainly friendly to male participants. Moreover, Henry Jenkins notes the typicality of these sorts of exchanges. He writes, "Entries [in net groups] often began with 'Did anyone else see …' or 'Am I the only one who thought …,'

indicating a felt need to confirm one's own produced meanings through conversations with a large community of readers."[8] Still the response and the writers' rationale for the narrative events are worth some attention.

Casino Royale is in the mode of the melodramatic. Using the arguments of Linda Williams and Rick Altman,[9] scholars recognize that it is analytically fruitful to see melodramatic characteristics of narrative and narration as pervasive across numerous genres.[10] Laura Mulvey and Tom Schatz have discussed melodrama within westerns and 1950s family stories with male protagonists; John Mercer and Martin Shingler, amongst others, note that action movies are ripe for melodrama.[11] In extending this work, I have argued that a parallel to the "fallen woman" story exists in the "fallen man" formula, which is used in many film noirs and superhero movies.[12] In the fallen man formula,

> plot devices lure a man into wayward paths because of his lack of control. These lures may be drink or gambling or even blind ambition; they are often sex, perhaps motivated as derived from a femme fatale tricking, seducing, or forcing the man into his wayward path ... the male protagonist may be able to redeem himself.[13]

A really good example of the fallen man formula is *Casablanca* (Michael Curtiz, 1942), which very much resembles *Casino Royale*, with the hero detoured from his proper path in fighting the enemy by a woman he loves and whom he mistakenly believes betrays him, but who turns out to have loved him very much. She, however, must be sacrificed so that he can head off and "wed" his country. The cult of *Casablanca* lays bare the emotional appeal to men (and to women, of course) of this formula. Williams emphasizes that a large number of action films with male victim-heroes "pivot upon melodramatic moments of masculine pathos. ... And when the victim-hero doesn't win, the pathos of his suffering seems perfectly capable of engendering what Thomas Schatz ... has termed a good 'guy cry.'"[14]

An important part of the fallen-man plot is the pathos of suffering that in recent years has laid itself upon the beautifully sculpted naked body of the male victim-hero/star. Since I am just beginning this research I can only discuss *Casino Royale*, but from my random film viewing I am guessing that it is fairly typical. As a reviewer of the film panted, "the numerous shots of [Craig's] torso and piercing blue eyes will, I suspect, make many in the female audience extremely happy."[15] Some males as well, I would add: Netflix reviewer FrankenPC writes, "I had to question my sexuality after watching this movie. Daniel Craig is hot. Steaming hot!"[16]

Casino Royale exploits Craig, with the first naked chest shot a lovely leisurely reveal: Bond slowly rises out of the sea, standing momentarily against the blue water. What follows is the beginning of a seduction sequence with a beautiful

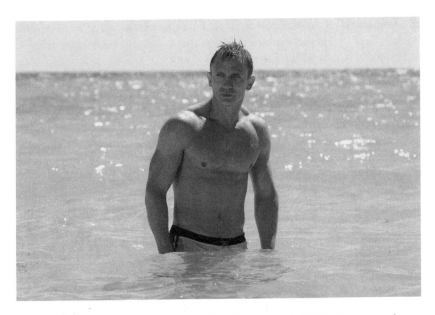

FIGURE 1.2 Daniel Craig as "James Bond" in *Casino Royale* (2006). Courtesy of Artina Films/Photofest.

black-haired woman in a green bikini riding bareback on a magnificent white horse. Ah, the opportunities for identification and desire!

The Male Body and the Male Heart

Since melodrama is never complicated—John Cawelti notes it employs "an arsenal of techniques of simplification and intensification"[17]—it is upon the body that pain is inflicted. The value of the routine of body torture of male protagonists in fallen-men stories is transparent: Mel Gibson in the *Lethal Weapon* (Richard Donner, 1987; 1989; 1992; 1998) series, Bruce Willis in *Die Hard* (John McTiernan, 1988) (think of the walk across broken glass). Neal King comments: "The outrageous beating fantasies and sexual/violent penetrations of male bodies present peculiar visions of political order of 'mourning in America,' to say the least."[18] King and Fred Pfeil attribute this body torture to cultural crises in masculinity, with Pfeil noting (in line with Steven Neale and others) that the punishment for these fallen men involves "simultaneous feminization and spectacularization."[19]

Miriam Hansen, however, explores further this melodramatic technique, considering what is at stake for the case of Valentino—another bare-chested victim-hero who is often whipped in his films. Arguing for case-by-case analysis, she claims that the Valentino appeal "sets into play fetishistic and voyeuristic mechanisms"[20] and reveals "the fascination with and suppression of ethnic and

racial otherness," a "cult of consumption and [a] manifestation of an alternative public sphere."[21] Hansen explains the pleasures of the torture scenes by referring to Freud's "A Child is Being Beaten" story.[22]

Although displays of cultural crises and sado-masochistic fantasies might explain part of the enjoyment of watching the body of Bond in *Casino Royale*—one Netflix writer comments, "This Bond is battered, bruised and shaken and the rest of us are stirred"[23]—that explanation does not do much to account for the crying, and those explanations were not meant to, especially since the IMDb writers specifically attribute their sadness to the loss of the girl, another mechanism for making the male suffer. In fact, the IMDb males tolerate body pain, but not heart pain.

Mercer and Shingler note that Neale explains tears at happy endings as "due to the fulfillment of our own infantile fantasy (crying being a demand for satisfaction and our tears sustaining that fantasy)," but for unhappy endings, tears are "a product of powerlessness."[24] Williams disagrees with that theory for sad endings. She argues, "[W]e cry when something is lost and it cannot be regained." Thus, "because tears are an acknowledgement of hope that desire will be fulfilled, they are also a source of future power. ... Mute pathos entitles action."[25]

Williams's thesis seems to me a bit optimistic in terms of what a spectator might be projecting. Williams refers to an essay by Franco Moretti on crying over literature. Moretti writes, "Tears are always the product of *powerlessness*" against reality, but tears simultaneously shield us from viewing such a "resignation," instead creating anger about the reality and creating a "communal weeping" amongst the survivors.[26] "Crying enables us *not to see*" as well as provoking "definitive sadness, because the loss is definitive; and at the same time relief, because, if nothing else, all inner conflict has ceased."[27] So Moretti's view is a bit more cautionary than the conclusion that Williams draws.

Still, I would prefer to backtrack just a bit. Although Hansen does not reference Elizabeth Cowie's earlier work on Freud's story of "A Child is Being Beaten," Cowie's discussion of fantasy provides great assistance in understanding what is going on in these fallen-men melodramas. Cowie argues that a fantasy is a structure, a "mise-en-scène of desire."[28] The fantasy she analyzes allows for multiple points of identification and positions of desire in the scenarios of seduction and masochism. But Cowie also notes, "defences [sic] are inseparably bound up with the work of fantasy." She recounts a case discussed by Freud in which the female client describes a story of desire, but as the story unfolds she is punished and ends up crying. Cowie asks, "But why has she produced a story to make herself cry, and may not the tears be a response not to the pathos of the story but to its satisfactions? The crying thus acting as a defence, brings the fantasy to the end in the same way Freud speaks of waking oneself up from the dream."[29] The woman's fantasy had begun as a seduction, but closes with her having borne an illegitimate child and experiencing desertion by the lover. Cowie concludes,

"the man's desertion is *not* the punishment, but part of the wish, ie [sic] for the eviction of the [lover as her] father, so that the child has the mother to herself, and it is *this* wish which provokes the final censorship of tears."[30]

I really like this idea of tears as a defense mechanism, something to which Moretti alludes as well within his essay. Applying the idea to *Casino Royale*, I would postulate that the unconscious wish is *not* for the success of the love affair, but for Vesper's death, which allows the availability of Bond as an action-hero who will endure more tortures and more sexual liaisons. Recall the viewers' responses acknowledging the narrative necessity as well as *payoff* for Vesper's death. Her removal from the story offers up Bond as the redeemed protagonist to continue the story.[31] It is significant that, in this era of filmmaking, creating franchises and serializing protagonists are part of what viewers expect.

This removal of Vesper has another psychological advantage: it returns Bond to M who, in exchange, restores Vesper's integrity to Bond by pointing out to him that Vesper must have saved him during the rescue at the torture scene. The film seems over-determined in its Oedipal fantasies between Bond and M. Much narrative focus is made of Bond's intrusion into M's home, his pilfering of her password, and his unauthorized uncovering of her real name. He calls her "Mum" at the conclusion of that chastisement. M is also masculine and in charge, something Bond notes about Vesper. So M's gendering is complex (perhaps the phallic mother), but her position in the psychoanalytical dynamics of the narrative seems painfully obvious.

The fallen-man formula has an inverted relation to another melodramatic formula, the one-true-love fantasy. The one-true-love fantasy is succinctly apparent in the 1970 hit novel and the 1970 film *Love Story* (Arthur Hiller). The novel famously begins with the male narrator declaring, "What can you say about a twenty-five-year-old girl who died?"[32] Thus, from the start of the story, the reader/spectator knows that the female's death is certain, but, unless we have a very unreliable narrator, the male storyteller has survived. A more recent, highly successful example is *Moulin Rouge!* (Baz Luhrmann, 2001), both arguably formula remakes of the opera *La Bohème* (1896).[33]

This formula has also appeared in recent films with *female* narrators who recount the story of their true love as a flashback: see *Dirty Dancing* (Emile Ardolino, 1987), *Edward Scissorhands* (Tim Burton, 1990), and the remarkably successful *Titanic* (James Cameron, 1997).[34] In an important way, the true-love plot also appears in *The Curious Case of Benjamin Button* (David Fincher, 2008) since from the start of the film we know that Benjamin and his girl are doomed to be at the right age for their true love only for a short while. In this case Benjamin narrates the story from near the end of his life, listened to by his true love at the end of hers.

In thinking about the appeal of the one-true-love plot, I believe that the narrative desire is a liberation fantasy. One has the exhilaration of the "perfect"

love, and then one is set free to explore the world, untethered by the mundane life of "after the marriage." Similarly, Rick in *Casablanca*, Bond in *Casino Royale*, and the women of *Dirty Dancing*, *Edward Scissorhands*, and *Titanic* walk away from the strictures of commitment to another person to enjoy exciting lives. The tears at the reality of the lover's death are excellent defenses in the dynamics of fictional fantasy not, here, to a confrontation with reality, but rather to the implications of the mise-en-scène of desire. It may be that instead of positing a single dynamic for crying we need to consider the specific narrative engagement and how crying functions as defense mechanism for either the recognition of the reality of loss or the fantasy of continuing desire.

The Claim of Realism

Aiding and abetting the fantasy for *Casino Royale* is the shift in tone for this reboot. As I noted for the title of this chapter, one reviewer writes, "he's the first Bond who bleeds, literally and metaphorically."[35] Roger Ebert rather feebly writes, "if you prick him, he bleeds" since Bond is "able to be hurt in body and soul," and Ebert praises the film for making him care about Bond and Vesper.[36] Indeed, while I certainly would not have survived the jumps and falls, at least this time after a battle, Bond emerges with scratches across his face—although these heal surprisingly quickly. Twice Bond is shown cleaning up flowing blood from his chest and face. And I must say that Craig's acting when Le Chiffre hits his testicles with a large knotted rope was exceptionally strong. Reviewers see this physical humanizing of Bond as providing "new depth": "he seems like a real person, susceptible to fear and love as well as anger."[37]

Despite the casual critical opposition between melodrama and realism, scholars have tempered the notion that these are strict binary terms. They have accomplished this by qualifying what is meant by "realism." Cawelti points out that one strand of melodrama is the social melodrama, a style that he writes is "defined by the combination of melodramatic structure and character with something that passes for a 'realistic' social or historical setting."[38] Referring to the representational style of the late 1800s, Williams includes the characteristic of "realism" within her list of five central features of the melodramatic mode. Like Cawelti, Schatz emphasizes that the family melodrama of the 1950s focuses on a contemporary social issue: the "nuclear, middle-class family," which is in transition at the time.[39]

I would be hard pressed to argue that *Casino Royale* is particularly realistic in the way that Cawelti, Williams, or Schatz mean: a social or historical setting and issue or a writing style. It is the case that *Casino Royale* provides the requisite *historical setting* in its European tourism spectacle, but that is not what is provoking the critical and fan response that the film seems real. Lots of action film protagonists *fall in love* and lose their girls—which I hope I have explained above—and that does not produce claims of realism. I might point to the bleeding, which is

rather innovative for action films, so as a *writing style Casino Royale* is somewhat novel, but this seems insufficient as a cause.

No, I think what is producing this claim is a classic intertextual contrast with the prior Bond movies. *Casino Royale* seems real *in opposition* to where the franchise has gone from its opening in *Dr. No* (Terence Young, 1962), which seemed over the top even then. The tactic of reducing the exaggeration and comedy of the other Bond films accelerates the ability to invest in the fantasy. After all, who would imagine reports of crying over any of the prior Bond movies? Thus, in a slightly different way than she means it, I do agree with *New York Times* critic Manohla Dargis who opines, "Every generation gets the Bond it deserves if not necessarily desires, and with his creased face and uneasy smile, Mr. Craig fits these grim times well."[40] This pretty boy offers another exemplary fallen-man story to cry over.

In conclusion, I might note that none of the Deppettes cried over *Casino Royale* although we certainly enjoyed the adventure and the spectacle. In terms of narrative investment, I personally was much more drawn into the analogous one-true-love fantasy offered by *The Curious Case of Benjamin Button*. I do not know if my involvement is due to Brad Pitt or to a "doomed" but liberating story structure, but it is certainly something to research. In any event, returning to Cowie's discussion of crying as a defense mechanism in the creation and enjoyment of "sad" endings requires further exploration, although I would also argue that different explanations of crying may be necessary to explain various sorts of story triggers for this emotional response. As the field of feminist studies explores affective responses to narratives in understanding the current dynamics of gendered spectatorship, accounting for these and other affects through psychoanalytical explorations and other theories is valuable to analyzing the power of media.

Notes

Special thanks go to Ashley Carter who helped with the research and listened to my initial ramblings about this. As well I thank the audiences for the 2009 *Screen* (Glasgow) and the 2010 Society for Cinema and Media Studies (Los Angeles) conferences. These colleagues provided excellent queries, points of disagreement, places for further research, and essays. So did the UT Film Faculty who are always the best friends in scholarship. And extra special thanks to the Deppettes: Anna Madrona and Honoria Starbuck.

1 This chapter will not try to define what a "pretty boy" is and how that might figure into the responses. I would note that the range of what might constitute this figure is likely very large and subjective.
2 Thanks to Krin Gabbard for that pun. I had originally written "Depp-less," but Krin's term is so much better.
3 My research is by no means any kind of appropriate sampling of the critical or fan response; I am pulling out some of the more intriguing reactions for purposes of analysis. I make no claims about the typicality of these responses. In fact, many fans reported disliking the film or being bored with it.

4 Although Vesper dies by suicide in the original story, she has been a double agent for some time. Bond ends the story considering all of the security gaps she has created. Vesper is not "rescued" by "M" or the circumstances of her betrayal as she is in this film.

5 Thanks to Ben Singer for helping me with sources for the label "male weepies." While the notion of women crying at the movies is well known, Hollywood and film critics recognized that men cried too. According to Singer's research, it appears in a published film script for *Come Fill the Cup* (Gordon Douglas, 1951). Raymond Durgnat discusses John Ford's *She Wore a Yellow Ribbon* (1949), Vittorio DeSica's *Umberto D.* (1952), and Pietro Germi's *Man of Iron* (1955) as these in *Films and Feelings* (Cambridge, MA: The M.I.T. Press, 1967), 154–5. Andrew Sarris notes Durgnat's use of the term in *The American Cinema: Directors and Directions, 1929–1968* (New York: E. P. Dutton, 1968), 110, as does Molly Haskell in *From Reverence to Rape: The Treatment of Women in the Movies*, 2nd ed. (Chicago, IL: University of Chicago Press, 1987), 155–6. Thomas Schatz subtitles part of his chapter on melodrama as "Nicholas Ray, Vincente Minnelli and the Male Weepie," applying the term instead to male-protagonist family melodramas although the resemblance amongst these uses is close. See *Hollywood Genres: Formulas, Filmmaking and the Studio System* (New York: Random House, 1981), 239. Julian Hanich also describes instances of males crying; he starts his essay with Franz Kafka noting in his diary in 1908 that he had wept at the movies. "A Weep in the Dark: Tears and the Cinematic Experience," in *Passionate Politics: The Cultural Work of American Melodrama from the Early Republic to the Present*, ed. Ralph J. Pool and Ilka Saal (Newcastle, GB: Cambridge Scholars Publishing, 2008), 27–45.

6 Emzy64, "Who cried? *Spoilers*," IMDb.com, 1 December 2008, accessed 6 January 2009. First ellipses mine; second punctuation in the original.

7 In the 1950 British Mass-Observation study, a query to the respondents about crying "reported that most of its mainly middle-class group of respondents admitted to weeping, and that even among men, only one in two argued that he never cried." Sue Harper and Vincent Porter, "Weeping in the Cinema in 1950: A Reassessment of Mass-Observation Material," "Mass Observation Archive Occasional Paper, No. 3" (Sussex, GB: Mass-Observation Archive, University of Sussex, 1996), 1. The cautions of interpreting the data are amply described in Sue Harper and Vincent Porter, "Moved to Tears: Weeping in the Cinema in Postwar Britain," *Screen* 37, no. 2 (Summer 1996): 152–73. Harper and Porter note the lack of embarrassment amongst the women and the defensiveness of the male respondents, something the men in this small sample also evince. As a comparative set of data, the mass-observation information could be very useful to current scholars. The data also indicate quite different responses by men and women. Harper and Porter consider sex, class, and age differences, but they do not attempt to provide a theoretical explanation for the differences they perceive. They also have a very good meditation on the variable meanings of "crying" (154) as does Hanich, "Weep in the Dark," 29–30.

8 Henry Jenkins, *Textual Poachers: Television Fans & Participatory Culture* (New York: Routledge, 1992), 79.

9 Linda Williams, "Melodrama Revisited," in *Refiguring American Film Genres: History and Theory*, ed. Nick Browne (Berkeley, CA: University of California Press, 1998), 42–88; Rick Altman, *Film/Genre* (London: BFI Publishing, 1999).

10 John Mercer and Martin Shingler, *Melodrama: Genre, Style, Sensibility* (London: Wallflower, 2004), 94–5.

11 Ibid., 98.

12 Janet Staiger, "Film Noir as Male Melodrama: The Politics of Film Genre Labeling," in *The Shifting Definitions of Genre: Essays on Labeling Films, Television Shows and Media*, ed. Lincoln Geraghty and Mark Jancovich (Jefferson, NC: McFarland & Company, 2008), 71–91.

13 Ibid., 73. Linda Williams notes that, overall, men have much more causal power than women in these fallen-person narratives, which is certainly the case; however, as the climax nears, both men and women need to make decisions that will determine (or not) their redemption—at least by normative social and ideological standards. Linda Williams, Society for Cinema and Media Studies, conference paper discussion, 19 March 2010.

14 Williams, "Melodrama," 83–4.

15 Chris Tookey, "We're stirred, Mr. Bond," *Mail Online*, 4 November 2006.

16 FrankenPC, "Casino Royale," *Netflix Reviews*.

17 John G. Cawelti, *Adventure, Mystery, and Romance* (Chicago, IL: University of Chicago Press, 1976), 264.

18 Neal King, *Heroes in Hard Times: Cop Action Movies in the U.S.* (Philadelphia, PA: Temple University Press, 1999), 10.

19 Fred Pfeil, *White Guys: Studies in Postmodern Domination & Difference* (London: Verso, 1995), 29.

20 Miriam Hansen, *Babel and Babylon: Spectatorship in American Silent Film* (Cambridge, MA: Harvard University Press, 1991), 252. For a reading of what might be at stake for masochistic fantasies in male protagonist melodramas for gay men, see Brett Farmer, *Spectacular Passions: Cinema, Fantasy, Gay Male Spectatorship* (Durham, NC: Duke University Press, 2000), 240–7. I am pursuing a psychoanalytical approach here but other theories of crying exist. See Hanich, "A Weep in the Dark," who uses phenomenology, and also see evolutionary biology studies. A source recently drawn to my attention that looks at the matter aesthetically is James Elkins, *Pictures & Tears: A History of People Who Have Cried in Front of Paintings* (New York: Routledge, 2001).

21 Hansen, *Babel and Babylon*, 253.

22 Ibid., 285–7.

23 RolftheRuf, "Casino Royale," *Netflix Reviews*.

24 Mercer and Shingler, *Melodrama*, 92. This essay is pursuing explanations of crying at unhappy endings. I am not sure whether the dynamics are the same for happy endings but Neale's explanation there may be the best one available.

25 Williams, "Melodrama," 71.

26 Franco Moretti, "Kindergarten," in *Signs Taken for Wonders: Essays in the Sociology of Literary Forms*, trans. Susan Fischer, David Forgacs, and David Miller (London: Verso, 1983), 162 and 173.

27 Ibid., 179.

28 Elizabeth Cowie, "Fantasia," *M/F* 9 (1984), 71.

29 Ibid., 82.

30 Ibid., 82.

31 For the value of that, see Peter Brooks, *Reading for the Plot: Design and Intention in Narrative* (New York: Vintage Books, 1984).

32 Erich Segal, *Love Story* (New York: Harper & Row, 1970), 1.

33 The famous feminist criticism of the plot is Sally Potter's *Thriller* (1979).

34 Although the lover does not die in *Dirty Dancing*, he is effectively out of the picture. The box office numbers for these films indicate their success: *Casino Royale* ($167,445,960); *Moulin Rouge!* ($57,386,607); *Dirty Dancing* ($63,446,382); *Edward Scissorhands* ($56,446,382); *Titanic* ($600,788,188); and *The Curious Case of Benjamin Button* ($127,509,326). Data from Box Office Mojo, boxofficemojo.com.

35 Nick Curtis, "Bond Back to his Most Menacing and Erotic Best," *Evening Standard* (London), 6 November 2006.

36 I suppose since the usual punning is missing with this Bond movie, Ebert had to joke instead. Roger Ebert, "Casino Royale," rogerebert.com.

37 Pete Vonder Haar, "Casino Royale," filmthreat.com, 18 November 2006.

38 Cawelti, *Adventure*, 261. Cawelti notes that this historicizing of detail may account for the rapid aging of these stories. Williams also notes that Christine Gledhill emphasizes this; Williams, "Melodrama," 53.

39 Williams, "Melodrama," 67; Schatz, *Hollywood Genres*, 221–60.

40 Manohla Dargis, "Renewing a License to Kill and a Huge Movie Franchise," *New York Times*, 17 November 2006.

2

QUEER MEMORIES AND UNIVERSAL EMOTIONS

A Single Man (2009)

Michael DeAngelis

Many of the most notable and celebrated works of the contemporary queer American cinema share a concern with recalling and representing a repressive historical past. Ang Lee's *Brokeback Mountain* (2005) recreates a rural American West of the late 1950s that has yet to find a place for two cowboys in love, while Gus Van Sant's *Milk* (2008) focuses upon a 1970s San Francisco where the increasing visibility of gay culture prompts both subtle and overt demonstrations of homophobia. The films of Todd Haynes reach back from the glam rock period of the 1970s (*Velvet Goldmine*, 1998) to a much more remote 1950s (*Far From Heaven*, 2002) where gay male sexuality is confined to dark theaters and concealed bars with unmarked entrances. The period specificity of these films is emphasized by the fact that all of them reference antecedents, varying widely from the historical (the extensively documented life of Harvey Milk), to the literary (Annie Proulx's source novel *Brokeback Mountain*), to the cinematic (*Citizen Kane* for *Velvet Goldmine*, *All That Heaven Allows* for *Far From Heaven*).

As an adaptation of Christopher Isherwood's 1964 novel, and with its time frame confined to a single day in post-Cuban-missile-crisis 1962 Los Angeles, Tom Ford's *A Single Man* (2009) continues in the historical tradition of these recent cinematic works. At the same time, however, the circumstances of its production, marketing, and critical reception serve to distinguish this film in its handling of relationships between "then" and "now" in ways that have brought into question the film's "authenticity"—regarding not only how faithful it has remained to the plot of the source novel, but also how "queer" it is as a work of cinema. These issues of adaptation arise from a set of temporal conditions that set *A Single Man* apart from the other queer films of its era. The strong correlation between plot and story elements in novel and film ensured the perceived

integrity of Ang Lee's adaptation of *Brokeback Mountain*, bolstered by Annie Proulx's status as a contemporary author without strong roots in the historical canon of gay American fiction. Whatever liberties it may take with the representation of events within its timeline, the narrative of *Milk* strives for accuracy in its references to gay American history and biography. And Haynes's intertextual referencing has triggered no debate about whether his use of prior cinematic works remains accurate or faithful; indeed, a central narrative strategy in his version of queer cinema involves the de-authentication of the past, rendering it strange rather than recognizably familiar.[1] The temporal-historical connection between film version and antecedent in *A Single Man* is more contentious and politically charged, with the novel often identified as a key work of gay fiction in the immediate pre-Stonewall period, and a director whose prior experience in the culture industries is limited to fashion design. Ford's insistence that "quite honestly, I just don't think about my sexuality,"[2] and his assertion that *A Single Man* is less a gay film than a work "about learning to live in the present,"[3] have fueled suspicions regarding his suitability for the project.

As the following chapter will demonstrate, these issues of authenticity in the representation of the historical past dovetail with key thematic concerns of *A Single Man*, a work which in both its novel and film versions focuses upon the psychological and political dimensions of remembering and re-imagining. The central protagonist, the solitary English professor George (Colin Firth), serves as an agent of memory, one whose life in the present remains subordinated to his recollections of a past time of joy and fulfillment with his lover Jim (Matthew Goode), who was killed in a car accident only months before the day upon which the plot of the narrative focuses. The film relates this role of the protagonist to a correlative process of envisioning the past that the cinematic narrative seeks to enable for its audiences. These acts of remembering set the terms for a critical debate regarding what comprises a "queer" film—a debate that places gay affective responses in the context of universal and sex-unspecific emotions, that dichotomizes authentic and inauthentic uses of film style, and that ultimately re-assesses the cinematic representation of human intimacy.

The version of George presented in the film harbors a preoccupation with the meaningless routines that have come to comprise a life in the present that he can no longer share with his partner. "Just get through the goddamned day,"[4] George asserts to his mirror image on the morning of the single-day film narrative, enduring more than embracing the formalized daily ritual of laying out a set of accoutrements and preparing his bodily exterior. In a major deviation from the novel, the mechanical and routinized organization of present time is extended to a preparation for self-inflicted death, planned as the final, logical act that might render the experience of the day cohesive. Insurance policies, packets of money, keys, and notes to loved ones all orderly arranged on his bureau, George attempts unsuccessfully to blow off his head, unable to get the angle of fire right while either lounging awkwardly in a sleeping bag on his bed, or posing

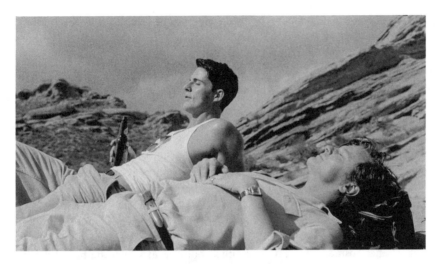

FIGURE 2.1 Colin Firth as "George" and Matthew Goode as "Jim" in *A Single Man* (2009). Courtesy of Artina Films/Photofest.

uncomfortably in his shower. The film posits these elements of ritual as a deliberate, failed attempt to forestall the surfacing of memories that mark an irretrievable past as uncannily present. In Isherwood's novel, the unprompted recollections extend from personal memories of his life with Jim to more general reflections upon the changes to familiar places that the passage of time has brought—from the progressive wearing that has weathered the face and feel of The Starboard Side (the bar where he met Jim), to the alienation that he feels as he looks out from his once favorite vantage points onto a Los Angeles now overpopulated to the point of unrecognizability.

Yet if for George everything seems unfamiliar and unreal in the present, the goal of Isherwood's narrative and Ford's adaptation is not to generate nostalgia for a lost time, but instead to suggest the involuntary process of yearning in all of its complexity and contradiction, emphasizing at once the pleasure it promises through the recreation of fixed and stable scenes of the past, and the pain it delivers through its insistent reminders of a now irretrievable reality. In both novel and film, George's death by heart attack is preceded by an epiphany through which he ultimately expresses a resolution—or at least a compromise—to the past/present conflict. Isherwood constructs this revelation as the protagonist's realization that keeping the memory of his dead lover alive is preventing him from moving forward, that Jim is "in the past now" and that he will need to find "another Jim."[5] Reflecting upon the predisposition to remembering that has plagued him throughout the story, the narrator observes that "George makes himself remember. He is afraid of forgetting. Jim is life, he says. But he will have to forget, if he wants to go on living. Jim is death."[6] In both versions of the

narrative, the revelation follows his final encounter with Kenny (Nicholas Hoult), the student whose pursuit of the professor ultimately leads them back to George's house, where George passes out drunk before any sexual encounter might take place. While some critics have argued that the film version promotes a *carpe diem* theme that ultimately undermines the novel's preoccupation with death and decay,[7] in Ford's version of this epiphany George actually remains more conflicted than he does in Isherwood's version. Treasuring the "moments of absolute clarity" that he now experiences, and burning his suicide notes, in the film George comments that "I've lived my life on these moments. They pull me back to the present. And I realize that everything is exactly the way it's meant to be."

While both the novel and film versions of *A Single Man* situate George in a struggle to balance a lucid and highly visualized past with a more tenuously imagined present-day reality, the audience of Ford's film is conspicuously placed in a parallel position of temporal conflict, but one in which the past that is to be imagined and ultimately contextualized is the specifically "gay" past of pre-Stonewall America, in which the Isherwood novel has been identified as a seminal work. While this imagining of a gay past from the position of a seemingly less repressive present did not figure into the experience of the literary work for readers in 1964, under the conditions of a cinematic adaptation in 2010 the gay past carries much more weight for audiences and critics of the film. Inevitably, audiences' experience of any film adaptation is steered by the formal and stylistic choices of its writer and director—what they have chosen to retain or exclude, and how they have reified literary descriptions into visual images. And it is not unusual for a writer or a director to be drawn to an adaptation project through a perceived alliance with the literary author or his protagonist, or for this alliance to be promoted to the public as a means of generating audience interest in the project.

The publicity discourse surrounding the case of Tom Ford is distinctive, however, in that it seeks not only to explain the circumstances that brought a director to consider adapting a novel, but also to justify the reasons why an openly gay man with no experience in the film industry would elect to deviate from a prior successful career because of this specific project. In an interview for the *Advocate*, Ford effects this justification through another version of the "then/now" narrative—one in which his career as a fashion designer for Gucci and Yves Saint Laurent becomes an aspect of a past in desperate need of abandoning, at least temporarily. As Ford explains, arguing that he was undergoing a midlife crisis prompted by both his feeling "forced out" of Gucci and Yves Saint Laurent and simultaneously languishing in the excessive materialism and unhealthy lifestyle that his overwhelming success at the design studios had afforded, "The underlying theme is letting go of the past and being able to live in the present— which is what I was struggling to do at that point in my life."[8] Emphasizing that his rediscovery of Isherwood's novel helped him to recover a sense of his

spiritual self, Ford's affective investment in both the film project and the source narrative serve to align his experience with that of George, thereby rendering his professional motives authentic. The interviewer's suggestion that Ford was initiating "the healing process of a kind of rarefied grief of his own—the loss of himself" strengthens the alliance between the biographical narrative of the new director and the personal history of Isherwood's protagonist.[9] Ford's clarification in another interview that Isherwood's rendering of the narrative of *A Single Man* was at least partially biographical extends this network of authenticity by forging a connection between original author and adapting director.[10] Paradoxically, this strategy of authentication extends to Ford's explanation for some of his signature changes to the plot and details of the literary narrative—not only the addition of the suicide plot as a vehicle for George's ultimate acceptance of living the present, but also the decision to give George the surname "Falconer," which was also the name of Ford's first love.[11]

On the basis of the critical responses to the reworking of the source novel, these strategies for validating and authenticating the creative decisions of the filmmaker through an alignment of narratives of the past are revealed to be much less seamless than Ford and the *Advocate* interviewer would have them be. The critical "objections" to Ford's decisions center less upon the plot changes than on his use of "style"—a term that extends beyond choices of mise-en-scène and cinematography to the larger matter of any of a number of devices that are imposed upon the narrative text, or that, on the basis of their distinctiveness, might be said to subvert the integrity of an imagined original vision on the part of the novelist. These objections rarely feature direct reference to Ford's roots in fashion design, but the criticism frequently posits clear distinctions between the type of "art" involved in designing clothes and the creative component of filmmaking. According to the *New York Times* reviewer Manohla Dargis,

> [Ford] hasn't fully learned to work inside the image plane, a space in which people and objects must be dynamically arranged rather than prettily arranged, as they occasionally are here. And at times his taste seems too impeccable, art-directed for maximum sale, as in a black-and-white flashback that brings to mind a perfume advertisement.[12]

The constructed contrast between "dynamic" and "pretty" arrangements, along with the description of stylistic choices as matters of "taste," polarizes the durable and complex dimensionality of cinema and an aesthetic that is deemed inherently flatter—perhaps more *au courant*, but consequently less timeless, and therefore far better suited to an industry that thrives upon the appeal of the "look." At the same time, Ford's aesthetic becomes static to the point of fussiness, its effectiveness assessable only within the staged, shallow realm of the commercially motivated advertising business. Such reminders about Ford's novice directorial

status generally assess his creative choices in terms of his "other" profession in the fashion industry, paradoxically suggesting that he is imposing his signature style upon an established work of art, and that he also has no developed or specific style to impose. For many critics, referencing the derivative status of his work in cinema becomes a means of emphasizing Ford's inauthenticity. For example, after identifying Wong Kar-Wai, Pedro Almodovar, and Sofia Coppola as Ford's stylistic influences, the *Sight and Sound* review of the film suggests that "the most sympathetic viewer is eventually mentally admonishing Ford to stop *fiddling* with this film." The reviewer explains, "In fashion terms, it's as if he had a classic basic ensemble in the pared-down story and fine lead actor, and then smothered the effect with incessant accessorizing."[13]

Although it is never explicitly articulated as such, the critical commentary regarding the director's inauthenticity constructs two conflicting and competing notions of queerness. Ford's version is one deemed too contemporary, too immersed in the realm of the high-gloss, fleeting, and fashionable present moment, despite his stylistic attempt to capture the ambience and feel of another era. Associated with an idealized past, Isherwood's "other" version of queerness becomes the authentic version, specifically because, in both critical discourse and cultural memory, its status as literary rather than a visual realization renders it capable of becoming more idealized from the perspective of those who actually remember the early 1960s, and those who must resort to imagining it. In this context, it is not surprising that critics and other commentators note connections between Ford's project and another visual representation of the era offered by *Mad Men*, and that *A Single Man* is deemed the inferior period recreation. According to *Daily Variety*, for example, the television series "gets the occasional ugliness of the period's design better."[14] Ford's fashion background also makes him more susceptible to accusations of "mistakes" in the period design, and an online respondent to the Manohla Dargis article explains that "the setting is California in the 1960s, but the color and tone are all about the 1940s. Even the ties are wrong. And all those underwater scenes are pastiches of Bill Viola videos, without content."[15] Consistently, then, Ford is accused of transforming an idealized literary and historical queer "then" into his own private "now." Rather than successfully evoking another time, his style is said to impose one form of remembering upon all other possible forms that critics and viewers might generate. In this context, style becomes a system that creates intimacy in its construction of visual meaning, even while it violates this same intimacy by presenting an "exclusive" vision that inevitably fails to accommodate alternative responses to Isherwood's literary art.

The matter of attempting to locate an intimate and authentic queerness in *A Single Man* extends to the realm of the visual world that George Falconer perceives within the diegesis of Ford's film—a world that critical and publicity discourses have either found less problematic or neglected entirely, but that also directly involves the use of style to represent and accentuate intimacy. The most

striking such stylistic device in this category is the subjective use of color saturation to signal the intensity of the protagonist's emotional state at various points in the narrative. "Tom wanted the color to go according to the characters' feelings," notes the film's cinematographer Edward Grau.[16] In the case of the intense encounter between George and a male hustler outside of a liquor store, with the accompanying rhythm of a heartbeat that also recurs at other intimate moments in the narrative, the color scheme changes to a deep red reflected not only in the hue of a Coke machine, a phone booth, and the hustler's lips, but also in the crepuscular light saturating the characters' skin. The red color scheme returns later in an encounter between George and Kenny at The Starboard Side, and as George dies in the final moments of the film, the color scheme responds with desaturation.

An equally conspicuous stylistic device is the extreme close-up, used strategically in the film to subjectively signal the preoccupations of desire to which George almost unknowingly succumbs throughout the day. Walking through campus with one of his colleagues who is describing his newly constructed bomb shelter, George suddenly redirects his attention to two shirtless male tennis players, the intimacy captured by crosscutting between close-ups of his captivated eyes and shots of the athletes' smooth, taut, sweat-glistened torsos captured in slow motion. The pattern is later repeated in the scene with the hustler, the camera cutting to close-ups of George's eyes and the hustler's ruby-red lips as his cigarette smoke gently glides past them. The device is also used to signal a deep yet painful connection to George's past. During the dream sequence that begins the film, a close-up is used to capture George as he kisses his dead lover's lips at the accident site; an inverse image recurs at the end of the film, with Jim returning to kiss the now dying George. Perhaps the most striking use of the slow-motion/close-up device to convey intimacy occurs in a parking lot where George encounters a dog of the same breed as his own, who was killed in the car accident along with Jim. "Smells like buttered toast," he utters, treating himself to a long, deep inhale of the creature's scent, with man and dog bathed in a soft, orange light.

If Ford uses such stylistic devices to accentuate moments of intimacy so intense that they filter out any auxiliary aspects of reality in the central protagonist's experience, the devices also foreground queer desire in a way that remains uncommon for a Hollywood-produced film. Through the use of color scheme changes and extreme close-ups as subjective devices suggesting psychological states and the intensity of desire, the film extends this intimacy from the diegesis to the cinematic experience of the viewer, in an act of inclusivity that runs counter to the claims of stylistic exclusivity expressed by many of the film's critics. That most of these instances of intimacy in the film occur between men (the sole exception is the scene with the dog) renders them accessible to gay male viewers as queer moments, yet the emotional states generated here are not in themselves sex or gender specific. Accordingly, rather than serving to alienate

non-gay-male viewers, the intimacy engulfs a range sufficiently wide to accommodate the affective investment of other audience sectors.

Still, the seemingly paradoxical nature of this version of "queerness"—as both gay-specific and universally accessible—is brought to the foreground in another set of critical discourses surrounding the film, and in this case centering upon whether the film is queer *enough*. What has been omitted from the plot of the novel is not at issue, perhaps because the film actually foregrounds and intensifies Isherwood's homosexual focus by eliminating any references to Doris, an ailing character with whom Jim was involved, and by de-emphasizing Kenny's sexual involvement with his friend Lois so that he appears to be more actively pursuing George as an object of desire. Instead, the question regarding the film's "gayness" is largely confined to its publicity discourse, and specifically both the producers' and the director's reworking of the film's sexual context and focus. The Weinstein Company revised Ford's original trailer once the film was sold to the production company, and as IndieWire explains, the newer version foregrounds George's relationship with Charley (Julianne Moore), diminishes the George/Kenny connection, and entirely edits out references to the male hustler.[17] An *Advocate* article appropriately entitled "Is *A Single Man* Too Straight?" interrogates the marketing strategy of the Weinstein Company's one-sheet for the film, which features an overhead shot of Colin Firth and Julianne reclining on adjacent pillows,[18] thereby accentuating that "the core of the film is [their] relationship."[19] Both critics decry these strategies, this perspective reinforced by Colin Firth himself, who argues that such publicity is "deceptive": "It's a beautiful love story between two men and I see no point in hiding that. People should see it for what it is."[20] At the same time, some critical accounts acknowledge the necessity of such deception as a condition for facilitating the film's wide release. Indeed, months before the *A Single Man*'s commercial run, *Daily Variety* warned that "Sterling perfs from a tony cast rep a selling point for the Weinstein Co. pickup, but its ripely homoerotic flavor will make finding lovers in the sticks more difficult."[21] "A poster featuring the mutually pillowed heads of Colin Firth and Julianne Moore was always likely to play better outside the multiplexes of the Midwest than one proclaiming the hero's actual orientation," argues *Film Blog*. "In America, trailers as well as posters have provoked 'de-gaying' protests but hey, tickets have to be sold."[22]

While such accounts suggest that the masking of queerness as heterosexuality is necessary in order to prevent straight viewers from becoming alienated from the film, another set of publicity discourses constructs a world in which the ultimate goal is to erase *distinctions* between straight and gay on the basis of the emotional appeal of a story that is, after all, "universal." A "then/now" conflict ensues here as well, but in this case the temporal contrast accentuates fundamental differences between authorized expressions of homosexuality in the present and past. "Time and again Tom Ford has told interviewers: 'This is not a gay film,'" explains one commentator,[23] and in the iTunes featurette on *A Single Man*,

FIGURE 2.2 Colin Firth and Julianne Moore in a misleading publicity shot for *A Single Man* (2009). Courtesy of Artina Films/Photofest.

Ford asserts that he was especially attracted to the "matter-of-fact" presentation of gayness in Isherwood's text, which made the story seem contemporary to him.[24] Ford also reiterates the universal nature of the film's themes, arguing that it elucidates both the isolation and need for connection that everyone feels. In fact, every actor interviewed in the mini-feature describes the film as a love story, and not a "gay" love story, and Nicholas Hoult (who plays Kenny) even argues that it would not have mattered if his character were female. Yet Colin Firth's response to an *Advocate* interviewer's observation that "some members of the gay community" are disappointed by Ford's de-emphasis upon gayness is especially revealing:

> But as militant as you can get on this issue is to actually say that it's incredibly important that we get to a place where we don't care one way or another. The world is full of battles where a minority is struggling for its rights, so of course I certainly get that you need a militant front. I'm not saying that all gays should be depicted in a way where it doesn't make an issue of it, but it should be considered a triumph when you finally have a character whose sexuality is secondary to the plot. It's just about human feeling, and I think that's wonderful.[25]

By differentiating a past that once necessitated the visibility of a disenfranchised group, from an ideal "breakthrough" present in which the reliance upon such visibility is something that has been overcome—where minorities are no longer "minoritized"—such perspectives point to a version of queerness that strives to be progressive in the present by using the past as a field of counterpoint and contrast, as essential to memory only because it reminds us of what we have overcome.

Remarkably, the publicity discourse of *A Single Man* works to sustain this progressive aspect of the film even as the film narrative itself references the lack of progress that has been made on so many fronts regarding queerness and homosexuality over the past 45 years. The "then" of the past may be something that contemporary American culture is moving beyond, but the film simultaneously situates this "then" in a place that continues to be relevant—not only as a referential counterpoint, but also as a reminder of what past and present have in common, of what has *not* yet been overcome. Rather than disavowing what was painful about being a gay man or expressing queer desire in 1964 America, the film validates the historical past while actively inviting its audiences to question just how "progressive" American culture has actually become in the present day. The two most prominent examples of this interrogation involve the reworking of plot elements from the novel. In Isherwood's narrative, George has indeed been invited to Jim's funeral, but he declines the invitation; in the film version, however, George is prepared to attend the funeral but is informed that it is for "family only." "With these two words, and without the slightest grandstanding," *Variety* argues, "Ford dramatizes the essential inhumanity of any policy, whether legal or cultural, that would conspire to keep loved ones apart during times of greatest need."[26] Here, the painfulness of injustice retains its connections to the past while also referencing equal rights policies that continue to be debated, and that have become even more prominent in the current political agenda. The second example is the addition of an argument between George and Charley, who bemoans the lost possibility of their having "a real relationship," and invalidates his 16-year relationship with Jim by asking, "Wasn't it really just a substitute for something else?" According to *Sight and Sound*, "George's answering fury invokes the cultural war still raging in the U.S. over gay marriage, nearly 50 years later,"[27] and indeed, such references almost self-consciously direct the audience's attention to the contemporary political agenda.

Despite these contradictions in the organization of temporal dichotomies at play in *A Single Man*, the film ultimately strives to reinforce the connections between "then" and "now," arguing for the specificity of queer desire even as it lures its sex-undifferentiated audiences with the promise of such universal and readily accessible emotions as yearning, longing, and grief. The film is respectful of the historical past even as it transforms an important work of pre-Stonewall gay fiction into a cinematic narrative relevant to the social and political concerns of contemporary audiences. While the publicity discourse surrounding Tom Ford's role in this transformation demonstrates that many critics and viewers are resentful of attempts to regulate their own memories and imaginings of the gay historical past, the style that this director has "imposed" upon Isherwood's work is ultimately one that opens up both the past and the present for critical scrutiny. By widening the audience base, such permutations of queer specificity and emotional universality may become the distinctive features of a version of queer

cinema that can continue to find a place on a screen of the multiplex in the second decade of our century.

Notes

1 For a discussion of these strategies, see Michael DeAngelis, "The Characteristics of New Queer Filmmaking: Case Study—Todd Haynes," in *New Queer Cinema: A Critical Reader*, ed. Michele Aaron (Edinburgh: Edinburgh University Press Ltd., 2004), 41–52.
2 Kevin Sessums, "Tom Ford: The Visionary," *Advocate*, December–January 2010, 64.
3 Peter Bowen, "The Mourning After," *Filmmaker—The Magazine of Independent Film* 18, no. 2 (2010): 67.
4 For all quotations from this film, see *A Single Man*, directed by Tom Ford (2009; Culver City, CA: Sony Pictures, 2010).
5 Christopher Isherwood, *A Single Man* (Minneapolis, MN: University of Minnesota Press, 2001), 182.
6 Ibid.
7 Michael Bronski, review of *A Single Man*, *Cineaste* 35, no. 2 (2010): 65.
8 Sessums, "Tom Ford: The Visionary," 66.
9 Ibid., 64.
10 Bowen, "The Mourning After," 68.
11 Sessums, "Tom Ford: The Visionary," 65.
12 Manohla Dargis, review of *A Single Man*, *The New York Times*, 11 December 2009.
13 Kate Stables, review of *A Single Man*, *Sight and Sound*, March 2010, 79.
14 Leslie Felperin, "A Single Man," *Daily Variety*, 16 September 2009.
15 Ambroisine Ratzkywatzky, "What a Muddle," online commentary on Manohla Dargis's review of *A Single Man*, movies.nytimes.com, 2 February 2010.
16 Peter Caranicas, "27 Year-Old D.P. Behind 'A Single Man,'" *Variety*, variety.com, 29 December 2009.
17 Peter Knegt, "A Tale of Two Cities: The De-Gaying of 'A Single Man,'" *IndieWire*, 9 November 2009.
18 There are a variety of publicity shots showing the actor and actress together, including one in which they share a pillow. See Figure 2.2. [Editors' note.]
19 "Is *A Single Man* Too Straight?" *Advocate.com*, 6 November 2009.
20 Greg Hernandez, "Colin Firth talks to *The Advocate* about 'A Single Man' and About Kissing his Male Co-star Matthew Goode," greginhollywood.com, 10 December 2009.
21 Felperin, "A Single Man," 16.
22 David Cox, "Why Can't A Single Man Be Glad to Be Gay?" *Guardian*, guardian.co.uk, 15 February 2010.
23 Hernandez, "Colin Firth."
24 iTunes Movie Trailers, *A Single Man* featurette, trailers.apple.com/trailers/weinstein/asingleman/.
25 Hernandez, "Colin Firth."
26 Andrew Barker, "A Single Man," *Variety*, 14 January 2010.
27 Stables, review of *A Single Man*, 78.

3

"LAD FLICKS"

Discursive Reconstructions of Masculinity in Popular Film

David Hansen-Miller and Rosalind Gill

Introduction

The aim of this chapter is to discuss an emerging genre of films that we call "lad flicks" or "lad movies." Lad flicks can be thought of as a hybrid of "buddy movies," romantic comedies, and "chick flicks" that center on the trials and tribulations of a young man or men as they grow up and make their way in the world (usually in North America or the United Kingdom). What distinguishes this popular and expanding genre from other coming–of–age movies, or movies featuring traditional male comic leads, is that *masculinity itself* is the central object. The source of dramatic tension and humor is the protagonists' struggle with competing definitions of what it means to be a man and their own ability to live up to that category. In what strikes us as a significant shift in popular discourses concerning masculinity, these films are increasingly confident in treating masculinity as an object of humor.

Lad flicks came to prominence in the late 1990s against the backdrop of anxieties about a "crisis in masculinity," and the proliferation of a number of other "lad productions" in different sites across popular culture: for example, radio, television, and "lad magazines." Unlike other popular forms, however, lad movies have gone relatively unnoticed as a culturally significant genre of films and have received little scholarly attention.[1]

In this chapter, we will set out to analyze dominant features of the genre and focus our discussion on two prominent examples: *The 40-Year-Old Virgin* (Judd Apatow, 2005), and *Role Models* (David Wain, 2008). Lad flicks are compelling texts for film theorists as they signal movement away from the subjective pleasures of masculine identification and towards examination of objectified masculinity as a troubled cultural category. While the films deploy classical

techniques of scopic pleasure and identification they also fall within more recent trends in popular films and rely heavily on a knowing gaze and irony. As discourse analysts, our interest is to explore "lad flicks" as historical and culturally specific gendered, racialized, and classed texts, which enunciate distinctive constructions of contemporary masculinity. We are primarily interested in analyzing these cultural texts in an effort to illuminate contemporary changes in, and understandings of, gender relations in the early twenty-first century.

The chapter is divided into four sections. We start by contextualizing lad flicks within wider social and cultural transformations and the emergence of the figure of the "new lad." We then chart the growth of lad flicks and explore some of their generic features. In the following section we consider the films in more detail, focusing on some distinctive features: their constructions of unheroic, fallible masculinities, their structural dependence upon a dynamic of homosociality and homophobia, and (connected to this) the representations of women within the movies. In the final, concluding section of the chapter we critically interrogate the narrative resolutions offered by the films in which growing up or coming of age is framed in terms of individuated, heterosexual monogamy.

The Rise of Laddism

The figure of the "new lad" has been a feature of popular culture in the United Kingdom, United States, and elsewhere since the early 1990s. He materialized as a new and distinctive articulation of masculinity, across a variety of cultural sites including "zoo" radio, quiz shows, sitcoms, "ladvertising," and popular fiction. Primarily, the new lad gained visibility in a new generation of magazines launched (or relaunched) in the mid-1990s. The so-called "lad mags" moved away from depictions of the egalitarian "new man," born of feminist demands for equality in the home and workplace, and towards a more "assertive articulation of the post-permissive masculine heterosexual script."[2] The new lad was a cultural figure organized around homosocial bonding and predatory and objectifying attitudes towards women. Lad mags offered a hedonistic, apparently shameless celebration of masculinity, constructed around men's assumed obsessions with drinking, football, and (heterosexual) sex.

There have been a variety of attempts to understand the cultural ascendance of the figure of the "new lad." Most relate it to ongoing social and economic transformations in post-industrial societies, including the decline of manufacturing and traditionally valued "male" laboring jobs, the "downsizing" of management roles through the mergers and acquisitions of the 1980s and 1990s, the technological displacement of well-paid administrative positions, the rise of "feminized" service sector work, as well as broader associated changes in the position of women.[3] However, these more recent changes constituting the "new lad" also fall into the line of older discourses concerning perceived threats to men and masculinity.

Michel Foucault has explained the manner in which repressive forms of social control were historically displaced by the modern profusion of regulatory, "bio-political" discourses and their demand for increasing self-discipline.[4] This meant that "private" spaces such as the family home and the intimate processes of rearing children increasingly became the object of state intervention. Through such processes women were increasingly invested with forms of social responsibility and authority that were historically reserved for men. As such powers became manifest so did cultural anxieties about the condition of men and masculinity. Signs of such insecurity were apparent as early as the late nineteenth century when men sought to imaginatively and practically disassociate themselves from the arenas of women's authority—what the historian John Tosh refers to as "the flight from domesticity."[5] The Victorian era saw a rapid growth in social and sporting clubs where men could escape into all-male environs, while the early twentieth century saw rising popularity in rugged all-male sports such as hunting and fishing.[6]

The "crisis" in masculinity consistently re-emerged over the twentieth century. Barbara Ehrenreich explores the unexpected success of *Playboy Magazine* in 1954, and the masculine bachelor lifestyle it advocated, by contextualizing it within the demanding conformity of the postwar American corporate world.[7] Men of the era faced considerable pressure towards marriage and family life such that those who resisted could find their sexuality under suspicion. *Playboy* turned the tables by mocking and deriding marriage as an arrangement where parasitic women sapped men's virility. From its start, *Playboy* combined the unapologetic enjoyment of urban consumer culture (fine clothing, the arts, expensive cars) with an unabashedly heterosexual hedonism. As the pages of *Playboy* dripped with sexuality they served to re-signify historically suspect pursuits as prime evidence of manly virility.

The late 1990s saw a proliferation of discourses about boys' poor educational performance relative to girls', young men's increasing "body anxieties" and associated disorders, as well as general concerns—amplified by small but vocal men's rights organizations—that men were becoming the new victims as they lost out to women in divorce courts, workplaces, and elsewhere. By the start of the twenty-first century, the word "masculinity" was rarely heard unless quickly followed by "crisis." As Beynon put it: "'masculinity' and 'crisis' have become so closely associated in some sectors of the media that they are in danger of becoming synonymous."[8] While scholars remain skeptical about the notion of masculinity being in crisis there is no doubt about the significance of "crisis talk" in opening up a discursive space in which the figure of the "new lad" could flourish.[9]

What marks laddism out as distinct from the "traditional" or "unreconstructed" versions of masculinity associated with a pre-feminist era is its self-consciously *postfeminist* style.[10] "New laddism" is not ignorant but entirely aware about how it offends against contemporary norms of probity, good taste,

and "reasonable" attitudes towards women. This is captured in *Loaded* magazine's strapline: "For men who should know better." The implication is that they do indeed know better, but take pleasure in not caring. Defiance is melded with a general ethos of "not taking things too seriously." More broadly, the affective tone of lad texts is anti-aspirational, smart, detached, ironic, and "deeply shallow."[11] Imelda Whelehan has argued that the new lad is "a nostalgic revival of old patriarchy; a direct challenge to feminism's call for social transformation, by reaffirming—albeit ironically—the unchanging nature of gender relations and sexual roles."[12] For others, he is better regarded as a response to the figure of the "new man," a more caring, sharing, and egalitarian version of masculinity which achieved a certain media prominence in the 1980s. Ben Crewe claims that lad culture emerged out of contempt for the "miserable liberal guilt" of the new man and his "hesitant and questioning stands on sexual relations."[13] The new man was condemned as unappealing, narcissistic, and above all inauthentic. Against this, lad culture is depicted as libidinous and refreshingly honest.

Lad Culture Goes to the Movies

The "lad flick" emerges and resides within this history as well as collectively indicating ongoing transformations in popular understandings of laddishness and contemporary masculinity. The films do not simply depict laddishness but meditate upon it. Where the "chick flick" historically targeted and commercially constituted female audiences through a focus on women and contemporary interpersonal relationships, any parallel cinematic focus on men and interpersonal relationships was traditionally subsumed under the banner of humanistic universality and therefore assumed to hold general relevance, not linked to one gender. For instance, while westerns and war movies drew predominantly male audiences this was not accomplished through an explicit attempt to engage with masculinity as such. A more direct engagement with masculinity did emerge in the 1980s with the popular American "buddy movie." Such films often paired black and white men, and therefore marked masculine differences, together for comedic and dramatic effect, as well as a more general cultural renegotiation of racial difference.[14] The contemporary "lad flick" combines different genre elements to focus specifically on the interpersonal difficulties facing contemporary masculinity. As we will detail, a predominantly white, entirely heterosexual, and generally lower-middle-class masculinity emerges as the significant point of crisis within these films.

While early films within the genre wedded humor with elements of melodrama, like the looming threat of Fiona's suicide in *About A Boy* (Chris Weitz, 2002), and so appeared to be sincere about the difficulties of a masculine adulthood, the genre has evolved to suggest that laddishness, new or old, is problematic and unsustainable. Increasingly, the humor of these films derives from what they depict as the juvenile nature of culturally identifiable masculine

> *Fever Pitch* (1997); *Big Daddy* (1999); *High Fidelity* (2000); *About a Boy*
> (2002); *Old School* (2003); *School of Rock* (2003); *Shaun of the Dead*
> (2004); *Without a Paddle* (2004); *Anchorman:The Legend of Ron Burgundy*
> (2004); *The Perfect Catch* (2005); *Wedding Crashers* (2005); *Hitch* (2005);
> *The 40-Year-Old Virgin* (2005); *You, Me, and Dupree* (2006); *Failure To*
> *Launch* (2006); *Talledega Nights* (2006); *Superbad* (2007); *Knocked Up*
> (2007); *Walk Hard: The Dewey Cox Story* (2007); *Forgetting Sarah*
> *Marshall* (2008); *Drillbit Taylor* (2008); *Zack and Miri Make A Porno*
> (2008); *Made of Honor* (2008);*Role Models* (2008); *Sex Drive* (2008);
> *Semi-Pro* (2008); *Step Brothers* (2008); *I Love You, Man* (2009); *Ghosts of*
> *Girlfriends Past* (2009)

FIGURE 3.1 Some "lad flicks."

values and ideals. Further, lad flicks construct those masculine values and ideals as the product of a pathological and anxiety–ridden pursuit of collective male approval. The comedic tension rests in the individual male's attempt to live up to or maintain the unrealistic version of masculinity that has been produced by their male peer group. The "lad" must eventually grow up, overcome their subordination to homosocial values and become a proper adult; however, "older" more traditional versions of masculinity, such as the stable breadwinner, appear to be foreclosed, while historically valued roles marked by fame or heroism are often mocked. Masculinity emerges as a difficult biographical project, as well as a masquerade.

The genre, relatively emergent as it is, is remarkably uniform with a small amount of narrative variation. The writer, director, and producer Judd Apatow, along with a circle of associated writers and actors such as Seth Rogan, Paul Rudd, and Jane Lynch, has come to dominate much of the output. The films generally follow a young (if aging) white heterosexual male who finds himself in a situation where he is reluctantly compelled to examine his present lifestyle. Apatow's *The 40-Year-Old Virgin* is an extreme but representative example in which Andy Stitzer (Steve Carell) is confronted with the possibility that if he doesn't change he may be a virgin for the rest of his life. Andy is innocently boyish in a number of ways, including his apartment, which is filled with a collection of boy's toys still in their original packaging. David Wain's later film *Role Models* offers a more grounded version of the narrative, where Danny (Paul Rudd), now in his mid–thirties, is still working in the same dead-end job that he got fresh out of college. He tours schools promoting "Minotaur" energy drink with his best friend Wheeler (Sean William Scott) who dresses up as the product mascot. Dumped by his girlfriend, who is tired of his increasingly negative attitude, Danny must change to get her back. Andy and Danny proceed to struggle with the conflicts between the security of their immaturity and the demand to grow up. Notably, it is generally the female love interest who voices the

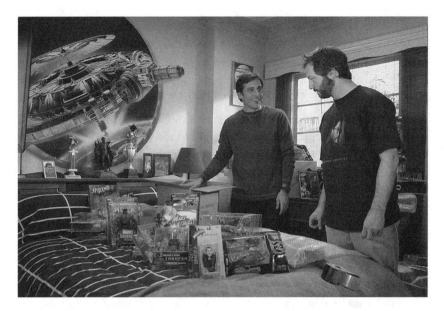

FIGURE 3.2 Steve Carell as "Andy" and "Andy's" toy collection with director Judd Apatow. Courtesy of Universal Pictures/Photofest.

demand for change while the protagonist's male friendship group represents the inclination to resist. Inevitably, the narratives positively resolve themselves when the lead lets go of his self-interest, rejects his foolishness or the foolishness of his male counterparts, and engages adult responsibilities—which are framed almost exclusively in terms of heterosexual domesticity—thus realizing a different level of personal integrity, happiness, and fulfillment.

While *The 40-Year-Old Virgin* (hereafter referred to as *Virgin*) and *Role Models* are representative of the genre's dominant tropes, there are a range of formulaic variations—some of which are beginning to crystallize as sub-genres. In what we might call "the Player" variation—*Ghosts of Girlfriends Past* (Mark Waters, 2009), *Made of Honor* (Paul Weiland, 2008), *Shallow Hal* (Bobby Farrelly, Peter Farrelly, 2001), *Wedding Crashers* (David Dobkin, 2005)—a similarly young but aging, often affluent man who has refused and renounced monogamy is compelled to re-examine his perspective on the matter. In "the Alpha Male" variation—*Anchorman* (Adam Mackay, 2004), *Semi-Pro* (Ken Alterman, 2008), *Walk Hard* (Jake Kasdan, 2007)—where the lead is almost exclusively played by Will Ferrell, a celebrity figure who selfishly dominates the men and women in his life must confront his behavior as circumstances change, threatening his happiness and livelihood. Again, in both examples the narcissism is resolved through renewed priorities of heterosexual commitment or parenting. Other examples could be categorized as the "boys gone wild" variation—*Without A Paddle*

(Steven Brill, 2004), *Old School* (Todd Phillips, 2003)—where men who have already assumed domestic responsibility get a chance to regress into boyish excess only to rediscover the value of their prior commitments.

Reading Lad Flicks: Unheroic Masculinities

Where the figure of the new lad seen in lad magazines and zoo radio arguably offered a defiantly homosocial masculinity as resistance to perceived threats, the lad flick foregrounds the confusion and instability of masculinity as a category. Lad flick male leads are not heroes, but nor are they anti-heroes. Instead they offer up a depiction of masculinity as fallible, damaged, and distinctly unheroic. In career terms many of the men are floundering, or doing jobs that are tedious and poorly paid. The majority of men within lad flicks are on the bottom edges of a middle-class existence, and this classed location of the protagonists is key to understanding the movies' depictions of unheroic masculinities. The lack of glamor in lower-middle- or working-class lives is emphasized through the aesthetic banality of a more everyday existence than we have come to expect from Hollywood representation. Many of the Apatow films are set in suburban Los Angeles and eschew enviable vistas (for example, the Hollywood Hills, Malibu) in favor of shopping mall parking lots and familiar chain stores.

In *Virgin*, Andy works in an electronics store (at first without any discernible rank) and lives in a small flat next door to an elderly couple that appear to be his only friends. In *Shaun of the Dead* (Edgar Wright, 2004), Shaun works in a similar store and is verbally humiliated by his teenage colleagues. A few of the films feature characters in danger of falling into lumpen desperation, which is the impetus to reflection and action. In *Zack and Miri Make a Porno* (Kevin Smith, 2008), the eponymous leads struggle to pay the rent in a run-down apartment in rustbelt Monroeville, Pennsylvania. Meanwhile, in *School of Rock* (Richard Linklater, 2003), Dewey (Jack Black) sponges off his friend who works as a supply teacher. Significantly, it is his friend's girlfriend (Sarah Silverman) who forces Dewey to find work by threatening to kick him out of their shared flat if he doesn't pay the rent. This gendered dynamic is typical of the genre, in which women are generally represented as attractive, "together," and relatively successful in contrast to the men. In *Role Models*, for example, Danny's ex-girlfriend Beth (Elizabeth Banks) is a beautiful and successful attorney—a postfeminist heroine combining "beauty and brains" as Wheeler puts it; in *Virgin*, Trish (Catherine Keener), Andy's love interest, is a single parent (and grandparent) who runs her own business.

However, women's working lives are not straightforwardly idealized: Trish struggles with her eBay store, and other lad flicks show female characters being subject to humiliation or workplace bullying. In *Knocked Up* (Judd Apatow, 2007), Alison's glamorous yet poisonous work environment functions to under-cut within the narrative any presumptive value in career ambitions suggesting

that Ben's (Seth Rogan) hedonistic life may not be entirely unreasonable. Female authority figures in *Virgin* and *Role Models* are also ambivalent: Paula (Jane Lynch), the electrical appliance store manager, is depicted as powerful but unstable—an instability the narrative suggests derives from sexual frustration, made evident in her "inappropriate" attempts to make Andy her "fuck-buddy." Meanwhile Sweeney (Jane Lynch), the leader of the "Sturdy Wings" mentoring program in which Danny and Wheeler are engaged (to escape prison), is portrayed as a damaged, capricious evangelist, whose zeal for helping children is an only partially successful displacement of her former addiction to cocaine, funded by her work as a prostitute. These are clearly unflattering depictions of the female boss but unlike the corporate "ice queens" of an earlier cinematic era—for example, *Network* (Sidney Lumet, 1976), *Working Girl* (Mike Nichols, 1988), *Disclosure* (Barry Levinson, 1994)—these comically unhinged examples of femininity function to underline the male lead's general social subordination rather than to emasculate them, and might be argued to be sympathetic characters.

Masculinity, Comedy, and Trauma

The comic absurdity of a particular version of masculinity is produced by discursively undercutting beliefs, behavior, and embodiment traditionally valued as masculine. A common trope of "masculinity training"—*Virgin, Hitch* (Andy Tennant, 2005), *Wedding Crashers* (David Dobkin, 2005), *Ghosts of Girlfriends Past* (Mark Waters, 2009), etc.—offers an explicit example of such strategies. Certain stock scenes are often present: the man will be taught how to flirt and chat up a woman, he will be instructed by his straight friends in the ways of becoming attractive to a woman (something that will often include chest waxing), he will be exhorted by his friends to watch porn, a prostitute will be hired for him for the evening—all of these events will go horribly and humiliatingly wrong, and turn out not to have been what he wanted or what the woman he desired wanted. His "ordinary," "nice," unwaxed (read "authentic") masculinity will be affirmed and in the process his friends (coaches) will also learn similar lessons about themselves. By the end of *Virgin*, Andy's male workmates have accepted, in different ways, that their attachments to homosocial definitions of masculinity are making them unhappy. Andy, initially positioned as a figure of derision, ironically becomes a model for the others to follow towards heterosexual monogamy and parenthood.

Such transformations necessarily invite reinterpretations of the hedonistic, pleasurable lifestyles that were supposedly enjoyed by the men. Jay, an African-American character, is depicted as Andy's lead "coach," embodying an effortless masculinity that makes him highly successful with women, while he cheats on his girlfriend. Andy looks to him for advice on how to be "cool" and how to get laid, and compares himself unfavorably with Jay's assumed-superior black masculinity. Through Jay, the film deploys stereotypes of black hyper-masculinity and

so produces both a greater comic effect and a more potent challenge to such values when he is also revealed as an unhappy fraud. As Andy comes closer to finally losing his virginity, so the other characters largely repudiate their lifestyles, which are attributed to some other frailty that they have not until that point acknowledged. When Jay's girlfriend dumps him he fights back the tears as he tells Andy what happened. When Andy asks him why he cheated on her in the first place, Jay bursts out, "Because I'm insecure. You can't tell?!" A more subtle example of this racial deployment is to be found in *Hitch*, in which black urban sophisticate Will Smith plays life and relationship coach to a hapless Albert (Kevin James)—yet in which the tables turn in favor of Albert's own authentic individuality by the end of the film.[15]

"The Player" variation offers a different example of traditionally valued masculine behavior being undercut by the imperative of individual authenticity. Within this sub-genre masculinity is less a humiliation as it is trauma that one bears. Often confidant, often rich, and living a seemingly enviable life of parties and casual sex with beautiful women, the traditional playboy protagonist's life is generally revealed to be the result of a psychic wound. In *Ghosts of Girlfriends Past*, Connor Mead (Matthew McConaughey) comes to understand that the lifestyle he thought he was happy with all roots from witnessing his childhood best friend and first love, the girl who helped him through the period of his parents' death, share her first kiss with someone else. Connor's refusal of monogamy and success in the realm of sexual conquest is actually a highly practiced defense against this difficult memory. So practised, in fact, that he has forgotten the original event. In *Shallow Hal*, Hal's (Jack Black) sexual pursuit of idealized beauty in women, regardless of their personality, roots back to the trauma of witnessing his religious father's delirious deathbed rambling where he insists that Hal understand that life is really all about "hot young tail." In the mode of Freud's early analysis of hysterical young women, Hal, comically, has no memory of the traumatic scene that is the cause of his obsession, which is also marked by elements of delusion about his own attractiveness. In both cases the value of sexual virility is externally imposed upon an emotionally vulnerable boy and the imposition causes each of them significant problems. In both cases the manifest voices of masculine knowledge and authority are patently unreliable as the characters are, to the audience, clearly unhappy or simply delirious.

The Queer Limits of Lad Flick Masculinity

One of the striking features of lad flicks is their dependence upon dynamics of intense heterosexual male bonding, paired with explicit homophobic humor. This connection between homosociality and homophobia is not incidental or innocent but constitutes a structuring feature of the films. Homophobic humor serves consistently to disavow and deflect the homoerotic potential among the characters or between male audiences and those on screen. The use of humor for

this purpose in cinema is well documented,[16] alongside other standard "devices" such as the presence of an attractive woman to "reassure" viewers of the protagonists' heterosexuality. However, instances of homophobic humor in the films invite further analysis as they become remarkable for their intensity—which gives the films an almost hysterical feel—*and* their heavily ironized status.

Early scenes in *Virgin* are indicative of the slippages and confusion within such narratives. From the beginning Andy's unrealized and unmatured heterosexual masculinity parallels historical stereotypes of gay men as fastidious or sissies. Before discovering the secret of Andy's virginity his workmates first speculate that he may be gay. That is "cool," Jay states, as he even "has friends who fuck guys … in jail." The notion of being "cool with gays" taps into a general comedic trend, used, for example, by writers on the popular U.S. TV series *Seinfeld* and *Friends*, which played with anxieties about *both* homosexuality *and* homophobia, as well as intertextually/ironically referencing a long tradition of homophobic stand-up. Each of these shows featured episodes in which a disavowal of homosexuality was immediately (and repeatedly) followed by a disavowal of homophobia: "I'm not gay … not that there's anything wrong with that." This might be seen as evidence of more liberal or progressive views on sexuality, or, contrastingly, as a modernized, more knowing, and pernicious form of heterosexism, a new way of "doing homophobia" that parallels shifts in the ways in which racism and sexism are practiced.

It is later in *Virgin*, in an exchange between David and Cal, as they debate the virtues of celibacy, that we see the clearest example of what we argue is the simultaneous enactment and mocking of homophobia. Over a duration of several minutes the pair trade barbs using the formulation "you know how I know you're gay" (because: "you like Coldplay," "you like the movie *Maid in Manhattan*," "you macraméd yourself a pair of jean shorts," etc.), intercut with shots of the videogame they play, in which two muscled, half-naked men do battle. In this prolonged sequence, homophobic insults are both traded and ironized, while the filming also seems to be drawing mocking attention to the cinematic conventions discussed above. The "irony" derives from the manner in which such jokes are seemingly less direct attacks upon an existent sexual minority than they are self-deprecating jokes about the homosexual potentials of heterosexual men. In this way, lad flicks acknowledge the idea that men who are homophobic harbor unconscious fears about being gay, while nonetheless leaving the denigrated status of homosexuality completely intact.

The homophobic construction of male homosociality is somewhat more apparent in *Role Models*. While there is no significant intimation that Augie (Christopher Mintz-Plasse)—Danny's "little" within "Sturdy Wings"—may be gay, Augie's degradation at the hands of his uncaring parents is underlined by his willing submission to the mincing, gay, adult "King Argotron" (Ken Jeon) within his male-dominated fantasy role-play subculture.[17] Further, Augie's

relative lack of sexual development is counter-posed to the younger and sexually precocious Ronnie (another deployment of stereotyped black hyper-masculinity), who is Wheeler's "little." King Argotron seems incapable of distinguishing fantasy from reality while scheming and cheating in an effort to maintain his juvenile and fictional authority. The abject figure of the king explicitly unites immaturity and homosexuality as potential psychic danger that can be defeated with the help of positive heterosexual role models—which is to say, men who take up their parental responsibilities. Through Danny's influence and help, Augie defeats Argotron and gains the confidence to talk to the girl that he has admired from a distance. Rather plainly, just as Danny must overcome his own juvenile attachments to realize his relationship with Beth, so must Augie overcome his juvenile attachments to realize his emerging hetero-sexual identity.

Conclusion: Having It All Ways? Masculinity, Ambivalence, and Melancholia

How, then, might we read lad flicks as contemporary filmic articulations of masculinity? We want to suggest that they are *multiply ambivalent texts*. They are at once self-evidently sexist, racist, and homophobic, yet they also constitute reflections on gender, race, and homosocial relations. Moreover, they seem to problematize the aggressive laddism of other productions. In one regard, lad flicks might be read as a positive development in the discursive evolution of masculin-ity in that they move away from the homosocial defiance found in earlier forms of laddism. If the new lad reactively resisted the perceived rise of feminine author-ity, then these films may suggest such anxieties are in the process of being assuaged. The implicit resolution of many of these movies seems to be that masculine hedonism and self-interest and feminine self-sacrifice and responsibility temper each other, in turn producing a modern mode of potentially egalitarian adulthood. There may be a temporal dimension to consider here too: if the new lad magazines that were so popular in the 1990s were targeted at men in their twenties, these films, which often represent men in their thirties, indicate the same generation's need to rethink earlier forms of social and cultural defensiveness.

Yet alongside this optimistic reading it is important to highlight the profound conservatism of lad flicks' resolutions in which "coming-of-age" is figured exclusively in heteronormative terms, to the extent, indeed, that adulthood itself is presented as synonymous with heterosexual monogamy (and sometimes parenthood). In an almost fairytale-like manner, the "patriarchal dividend" that Connell argues benefits all men appears magically to accrue to some protagonists when they renounce their laddish ways and take up their "proper" place in the heteronormative order.[18] In *Virgin*, for example, when Andy starts dating Trish he is suddenly promoted at work—a narrative development that seems to bear no

relationship to his strengths as an employee. Further, when Andy and Trish get married, he is rewarded with his own business.

In a sense, then, lad flicks offer a compelling "invitation" to men to "put aside childish things" and join the adult heterosexual world. But the films are, it seems to us, ambivalent about this. While the narrative resolutions might suggest one kind of reading (as above), this would appear reductive given the gleeful celebration of laddish pursuits depicted throughout the films. These activities include a whole array of "juvenile" behaviors, but center primarily on the enjoyment/use of women for sexual pleasure. The depictions of men's pursuits are clearly central to the pleasures offered by lad flicks, a fact that is underscored by reviews, and by the quotes prominently displayed in promotion of the movies which emphasize the enjoyable hilariousness of male bad behavior. *Role Models'* U.K. advertising poster, for example, featured the tag line "Bad behavior. Bad attitude. Bad example," followed by a single quote: "Laugh-out loud." To highlight this is to acknowledge the fact that the pleasures of hedonistic laddism are not entirely resignified through the narrative closure of the individualized heterosexual monogamy resolution. It returns us to the ambivalence discussed earlier in relation to the films' homophobia; like this, we suggest, it requires a reading that can see *both the celebration and the repudiation of laddism* within these films.

Such a reading is supported furthermore by the fact that not all lad flicks protagonists do "grow up" and settle down in the prescribed manner. In *Role Models*, for example, while Danny takes this path, Wheeler happily continues his promiscuous lifestyle. Indeed, it might even be argued that Wheeler succeeded where others had failed in mentoring Ronnie because he was able to bond with Ronnie—in classic homosocial fashion—through shared interests in "boobies" and "pussy." Moreover, Wheeler was partly motivated by the fact that Ronnie's mother was "hot." Wheeler, in other words, might be said to remain—unapologetically, if not defiantly—a "lad."

The ambivalent nature of the resolutions is also evidence in the sense of melancholy and loss that accompanies them. The derided forms of masculinity may be synonymous with irresponsibility, but they are also narratively coded as boyish *playfulness*. To become a modern man one has to abnegate attachments to play or subordinate them to the play of children. In *Virgin*, Andy's unopened toys not only suggest an unrealized manhood, they also suggest a thwarted boyhood. With the help of his new girlfriend he decides to sell them on eBay and there is a funny but poignant scene where he struggles to let go, saying goodbye to the different action figures as he packs them up for shipping. Similarly, while Danny is clearly miserable in the job that once gave him pleasure, he does still drive around in a toy truck and remains friends with Wheeler. Danny's resistance to the demands of his girlfriend and his bitterness about life in general arguably start to crystallize as disappointment about declining opportunities for satisfying play. This becomes explicit as Danny contends with Augie through his forced participation in the program for disadvantaged children. Danny's realizes the fulfillment

offered by adult responsibility in selflessly playing with Augie and embracing his embarrassing role-play subculture.

Judith Butler's understanding of the relationship between melancholia and heterosexual gender is instructive and can tell us more about the narrative of sacrifice and loss.[19] For Butler, a strictly heteronormative society demands that heterosexual people must renounce their passionate attachments to the same gender. For instance, while a boy's love for his mother is meant to be transferred and resolved in his eventual mature sexual attachment to a girlfriend, his similar love for his father cannot safely be transferred to other men. For Butler, gay men and lesbians cannot help but be aware of this process as a homophobic culture demands heterosexual attachments from all adults. While gays and lesbians mourn opposite-sex attachments through the coming-out process, heterosexuals are not allowed to mourn the loss of their same-sex attachments and the failure to mourn results in melancholia. Lad flicks demonstrate confused longing for the homo-social culture that mature heterosexual men must apparently leave behind. We could interpret this as melancholia concerning the passionate male friendships that, once confronted with the heterosexual imperatives of adulthood, can no longer be sustained without suspicion. *Role Models* can be understood in terms of the conflict Danny experiences between his love for Wheeler and his love for Beth. He struggles with and ultimately succeeds in transferring his boyish attachment to Wheeler to a more acceptable mentoring (which is to say "parental") relationship with Augie. Similarly, as Wheeler loses Danny to Beth he transfers his own affections to the more acceptable mentoring of Ronnie. Notably, *Role Models* concludes with a humorously sentimental scene where Danny, surrounded by the costumed role-play characters, sings a sentimental Broadway-style solo to Beth, while the narrative conclusions of *Virgin* are followed with a camp rendition of "Aquarius" from the counter-cultural, sixties-era musical *Hair*. Such endings seem to confess to the lack of satisfaction implicit in the conclusion at the same time that they curiously restore the specter of gay cultural sensibilities, or perhaps lament the optimism and aspirations for social change associated with "the sixties."

Rather than a positive resolution of the conflicts that accrue to contemporary masculinity, it is perhaps more appropriate to see lad flicks as a particular and socially located negotiation of conservative values. Where an earlier generation of working-class and middle-class men may have been able to rely on their wives to take up "the second shift" of domestic responsibilities and so continue to enjoy the all-male environs of after-work socialization,[20] economic and social changes appear to demand that the lad choose between the two. The movement from the defiant codes of "new laddism" to the lad flick's reluctant acceptance of domestication marks a significant shift, but one that ultimately leaves the fundamental problem intact. For the lad, some version of traditional masculine power and authority is necessary and alternative sources of personal validation are generally foreclosed. Further, no forms of political engagement with the problem are

anywhere to be found, much less taken seriously. While the lad lets go of his need to live up to traditional and homosocial standards of masculinity, he seems to only re-emerge within the not so clearly pleasurable confines of the nuclear family.

Notes

1 Some of these films have been discussed by film scholars as romantic comedies. See Tamar Jeffers McDonald, *Romantic Comedy: Boy Meets Girl Meets Genre* (London: Wallflower Press, 2007) and "Homme-com: Engendering Change in Contemporary Romantic Comedy," in *Falling in Love Again: Romantic Comedy in Contemporary Cinema*, ed. Stacy Abbot and Deborah Jermyn (London: I.B. Tauris, 2008), 146–59. See also Diane Negra, "Where the Boys Are: Postfeminism and the New Single Man," *Flow*, 14 April 2006; see also Celestino Deleyto, "The New Road to Sexual Ecstasy: Virginity and Genre in *The 40-Year-Old Virgin*", in *Virgin Territory Representing Sexual Inexperience in Film*, ed. Tamar Jeffers McDonald (Detroit, MI: Wayne State University Press, 2010), 255–68, which was published after this article was submitted.

2 Sean Nixon, "Re-signifying Masculinity: From 'New Man' to 'New Lad,'" in *British Cultural Studies*, ed. David Morley and Kevin Robins (Oxford: Oxford University Press, 2001), 373–86.

3 See Rosalind Gill, "Power and the Production of Subjects: A Genealogy of the New Man and the New Lad," *Masculinity and Men's Lifestyle Magazines*, ed. Bethan Benwell (Oxford: Blackwell, 2003), 33–56.

4 Michel Foucault, *Discipline and Punish: The Birth of the Prison*, trans. Alan Sheridan (New York: Vintage Books, 1977), and *The History of Sexuality, Vol. 1: An Introduction*, trans. Robert Hurley (New York: Vintage Books, 1978).

5 John Tosh, *A Man's Place: Masculinity in the Middle-Class Home in Victorian England* (London: Yale University Press, 1999), 170–94.

6 Gail Bederman, *Manliness and Civilization: A Cultural History of Gender and Race in the United States, 1880–1917* (Chicago, IL: The University of Chicago Press, 1995).

7 Barbara Ehrenreich, *The Hearts of Men: American Dreams and the Flight from Commitment* (New York: Anchor Books, 1987).

8 John Beynon, *Masculinities and Culture* (Buckingham, UK, and Philadelphia, PA: Open University Press, 2002), 77.

9 See generally ibid.

10 Benwell, *Masculinity and Men's Lifestyle Magazines*, 149–68.

11 Michael Kimmel, *Guyland* (New York: HarperCollins, 2008).

12 Imelda Whelehan, *Overloaded: Popular Culture and the Future of Feminism* (London: The Women's Press, 2000), 5.

13 Ben Crewe, "Masculinity and Editorial Identity in the Reformation of the UK Men's Press," in Benwell, ed., *Masculinity and Men's Lifestyle Magazines*, 91–111.

14 Robyn Wiegman, "Bonds of (In)difference," in *American Anatomies: Theorizing Race and Gender* (Durham, NC: Duke University Press, 1995), 115–46.

15 Race is central to lad flicks in a way that we have not been able to discuss as fully as we would like. *Virgin*, for example, offers up a range of racial stereotypes for humorous effect, centered on the fraught relationship between Mooj, Haziz and Jay, the three black characters who work at the store.

16 Richard Dyer, "Don't Look Now: The Male Pin-up," *Screen* 23, nos 3–4 (1982): 61–73; Steve Neale, "Masculinity as Spectacle," in *Screening the Male*, ed. Steven Cohan and Ina Rae Hark (London and New York: Routledge, 1993), 9–22.

17 It is hard to ignore that the character of Argotron, an Asian-American male, may also rely upon historical racial stereotypes in which Asian men are figured as less masculine than black or white men.

18 R.W. (aka Raewynn) Connell, *Masculinities* (Cambridge: Polity Press, 1996).
19 Judith Butler, "Melancholy Gender/Refused Identification," in *The Psychic Life of Power: Theories in Subjection* (Stanford, CA: Stanford University Press, 1997), 132–50.
20 Arlie Russell Hochschild, *The Second Shift* (New York: Avon Books, 1990).

4

TRANSAMERICA (2005)

The Road to the Multiplex after New Queer Cinema

Gary Needham

It would appear that the 78th Academy Awards in 2006 was further indication of progress in the mainstreaming of queerly themed films. Three queer films were in the nominations that year, *Brokeback Mountain* (Ang Lee, 2005), *Capote* (Bennett Miller, 2005), and *Transamerica* (Duncan Tucker, 2005), and each won one or more Oscars on the night. The protagonists of these films were clearly queer and non-normative characters: a postoperative transsexual woman in *Transamerica*, two closeted cowboys in *Brokeback Mountain*, and a well-known gay author in *Capote*. The image of these queers adorned posters and marketing and were highly visible in the usual public spaces of film advertising such as shopping malls and bus stops. Importantly, those were lives depicted onscreen and seen by many, not in the relative safety of the liberal art-house cinema but right at the center of multiplex film-going.

The theatrical poster for *Transamerica* depicts the central character Bree (Felicity Huffman) standing between the doors of a male and female toilet with the tagline "Life is more than the sum of its parts." Like *Transamerica*'s poster, these recent queer films are not shy in articulating their politics and implant in public perception a politics of gender and sexuality drawn from ideas common to queer theory. In advance of viewing the film, *Transamerica*'s poster already presents the audience with the arbitrary nature of the "male" and "female" symbols on the entrance to public toilets, and the design includes blue doors against a pink painted concrete wall.

Although these recent films are not the same as the independent gay and lesbian films of the 1980s and 1990s, the sort associated with the term New Queer Cinema, they are independent features nonetheless and, despite their varying affiliations with Hollywood, they do attempt to narrativize sexual and gender nonconformity. The reference to them as queer in this context is to take

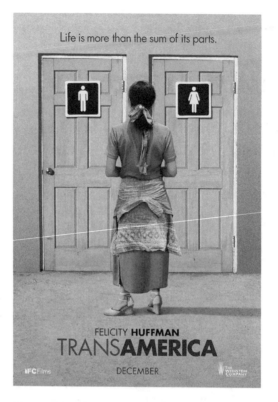

FIGURE 4.1 "Bree" (Felicity Huffman) standing between two doors. Courtesy of The Weinstein Company/Photofest.

the term at its most elastic, since these are films which are also problematic and contradictory in their queer politics too—a critical impasse that Eve Sedgwick refers to as "kinda subversive, kinda hegemonic."[1] The films, however, that I have mentioned do attempt to rearticulate popular film and genre conventions through a queer lens and, to quote Sedgwick once more, are concerned with the "lapses of meaning when the constituent elements of anyone's gender, of anyone's sexuality aren't made (or *can't be* made) to signify monolithically."[2]

The success of this recent "queer mainstream," in particular that of *Brokeback Mountain*, has not ushered in an era of multiplex-friendly gay and lesbian cinema, and one should be cautious in assuming that increased visibility or popularity translates readily into political progress. Despite the appeal of a queer cinema to a wider cinema-going public, and one should also include television here, the homophobic climate surrounding the civil rights of queer people in the United States and beyond has certainly persisted. The "queer mainstream" represents an

historical juncture where a queer presence in the space of the multiplex and in discourses of popular culture is both tense and troubled. Films like *Transamerica* and even more recently *A Single Man* (Tom Ford, 2009), on the one hand, enjoy wide popularity, are grounded in recognizable conventions of genre, and are driven by star appeal. On the other hand, they also positively gesture towards queer theory and associated concepts of queering and queerness. *Brokeback Mountain*, for example, queers both the melodrama and the western genre;[3] *Capote* does the same for the biopic, while *Transamerica* queers the road movie. Furthermore, the characters in these films—the closeted cowboys, the swishy author, the preoperative transsexual—solicit identification in ways that engage the multiplex audience with a queer gaze and levels of dissonant gender identification. These films expose the cultural construction of gender and assumptions about sexualities, desires, and bodies in popular cinema.

Furthermore, it is important not to forget that these films are equally identified by the slippery terms "mainstream" and "indie" through their widely accepted critical praise, unprecedented awards and nominations, modest box-office takings, and locations of exhibition. As Harry Benshoff has already stated in his reception study of *The Talented Mr Ripley* (Anthony Minghella, 1999), these are films that need to "be understood as a by-product of New Queer Cinema's success," in addition to an exertion of "influence upon mainstream film practice."[4]

Queer theory has been an important critical as well as political discourse that came to fruition in the early 1990s and offered a paradigmatic shift in ways of thinking about gender, sex, and sexuality as well as in terms of reclaiming, appropriating, and subverting official histories, cultures, and ideas that have strategically excluded queers. Prior to queer theory a general assumption was that feminism was concerned with gender, and gay and lesbian studies was concerned with sexuality. In this sense, the newness of queer theory was to bring both gender and sexuality into a productive dialogue with one another in order to reap new insights about both. Queer theory's theoretical and political history then is indebted to both feminism and gay and lesbian studies. It does not replace them; rather, it works alongside them as an anti-essentialist endeavor that presents new and unorthodox challenges.

Queer theory did not develop in an academic bubble either, since it belongs to a moment of intense political activism in the wake of an apathy to AIDS when the term queer was reclaimed by groups such as Queer Nation from being a homophobic insult. In this context of political action and theory, queer artists also emerged to produce art, video, and film. The latter outcome was subsequently dubbed "New Queer Cinema" in the early 1990s by critic B. Ruby Rich.[5] Besides taking inspiration from artists, filmmakers, and activists, queer theory's interrogation of homophobia, gender oppression, hetero- and homo- normativity, and liberal-left and right-wing politics calls for an unfixing of identity from common-sense assumptions and binary systems of categorization

that normatively align gender and sex. Within this context the figure of the transsexual and the transgender person has a certain currency (whether complicit or not) in that s/he gestures most obviously to the instability of gender and its relationship to sex.

Transamerica is a queer text because it destabilizes what is understood in the broadest sense to be normative through its transsexual main character. *Transamerica* exposes normative assumptions about gender and unveils other formations of the natural and the hegemonic in ways that draw attention to gender as a problem, reminiscent of Judith Butler's dictum that "'being a man" and "being a woman" are internally unstable affairs.[6] *Transamerica* is explicit in asking the audience to consider how gender can be constituted in different ways and made meaningful by common-sense cultural assumptions, family relations, prejudices, and stigmas, as well as medical and psychiatric discourses. *Transamerica* is important because it prompts an audience, otherwise alien to an affective identification with a transsexual woman, to empathize with and acknowledge the complexities of her gender. In this respect, it is no less than a triumph that a film can mobilize such politics in a multiplex context. Is this radical politics, however, being displaced through queer cinema's new-found mainstreaming? Before discussing this question in detail a brief summary of *Transamerica*'s plot is necessary.

In the week leading up to her sexual reassignment surgery, Bree receives a phone call from delinquent teenager Toby (Kevin Zegers) who, it turns out, is Bree's biological son, the outcome of a sexual encounter when Bree was Stanley. Bree's therapist puts the consent for surgery on hold until Bree deals with her past and confronts the fact that she has a son. Bree travels to New York where she meets Toby but pretends to be a Christian do-gooder who intends to return him to his stepparents. They embark on a cross-country road trip from New York to California where they develop a bond that is eventually undone, first, by Bree's deceit (not outing herself as transsexual) and second, by her lies (not telling Toby that she is his father). During their journey they encounter Toby's sexually abusive stepfather, a vegan robber (who steals their car and Bree's hormone tablets), a transsexual community in the heartlands, a kindly Native American with romantic inclinations, and Bree's bossy and transphobic mother. When Toby eventually finds out that Bree is his father he runs away and the two become estranged once more. At the film's conclusion Bree gets her sexual reassignment surgery and several months later Toby finds her apartment and they make another go at a relationship.

As a queer film *Transamerica* is also popular and conventional in that it engages with star performance and genre; it is comical and tragic, political and, at times, solipsistic in its appeal to melodramatic affect. The film is positioned within a contradictory and tense situation that is both queer through its interrogation of the normative but also complicit in making a spectacle of and deriving humor from transsexual difference. As a queer film at the multiplex *Transamerica* belongs to a legacy of political filmmaking associated with New Queer Cinema.

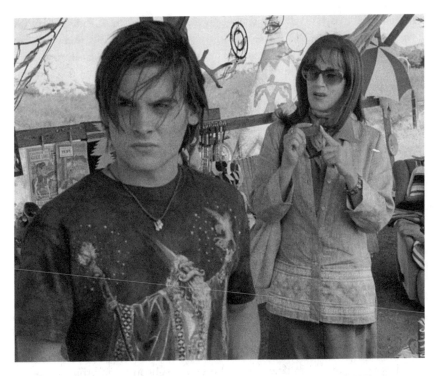

FIGURE 4.2 "Bree" and son "Toby" (Kevin Zegers) in *Transamerica* (2005). Courtesy of The Weinstein Company/Photofest.

However, it also seems at home in the multiplex, alongside films that it implicitly critiques in their strategies of othering difference. Although *Transamerica* does expose the assumptions, phobias, and norms around gender and transsexuality, the film's comfortable position in the multiplex would appear to call this into question. Judith Butler leveled a similar concern at the drag ball documentary *Paris is Burning* (Jennie Livingston, 1990) when she questioned "whether parodying the dominant norms is enough to displace them."[7]

In order to answer some of these questions I will limit my examination to issues around voice and film sound and to two of popular cinema's fascinations—the road movie and the spectacle of difference. First, theories of film sound can be usefully brought into dialogue with queer thought in relation to how bodies, voices, and gender align or dis-align with one another, how they might, or might not, signify monolithically. The queer or trans voice in *Transamerica* refuses to confer a normative alignment between gender, sex, and voice. Second, *Transamerica*'s queering of the road movie utilizes the tried-and-tested generic tropes of the genre as a ruse to see bodily transformation and identity as another type of journey. Last, *Transamerica* also solicits a fascination with seeing the

transgendered body as well as how expertly Felicity Huffman, already famous for *Desperate Housewives* (ABC, 2004–), "performs" this particular role. A key scene in this respect is when Bree's son glimpses her penis in a rear-view car mirror. Such a "look" functions as a kind of proof or shock of difference and begs the question of how we are positioned to see at this moment of revelation, which is fundamental for thinking about the central conflict that makes this film both "after New Queer Cinema" and multiplex-friendly. This conflict or tension is between *Transamerica*'s well-intended queer politics (its New Queer Cinema legacy) and the potency of popular cinema's classical forms to produce surprise, comedy, and spectacle around forms of difference. This, I would argue, is what makes *Transamerica* an important film for thinking about the complex and contradictory intersections between feminism, queer theory, and the multiplex.

Transamerica's Queer Voice

Transamerica makes a point of Felicity Huffman's vocal performance, which is a touch lower than her "real" voice and the one we probably associate with her character in *Desperate Housewives*. Throughout the film it is Bree's voice rather than her appearance that threatens to reveal the traces of Stanley and it often changes at moments when she is stressed. Bree's voice in *Transamerica* is also part of the film's sound and therefore a textual element. I would like to consider how sound as voice, in this instance, may also be brought into the orbit of a queer examination.

In general, film sound, and the cinematic technologies that produce it and mask its production, work to integrate seamlessly sound and image so that we experience them not as separate elements but as whole and credible. *Transamerica* frequently draws our attention to film sound throughout, whether it is the well-chosen music that accompanies the road movie tropes or Huffman's vocal performance. It is important to consider voice, not just because the film begins with a voice that performs gender but also because queer voices draw attention to the regulatory practices that define voices as normatively gendered.

In the first shot of the film we see and hear a voice tutorial on a television screen. We see a woman with an open mouth making an "aaahh" sound for several seconds as her voice begins on a high note that slowly descends into a deep, rasping, guttural tone. She holds a mirror up to examine the transformation of the vaginal-looking epiglottis at the back of the throat. The woman on the screen then speaks with accompanying text that reads, "This is the voice I want to use."[8] Following this, the film establishes the character of Bree through a montage intercut with the main credits on a black background as she is preparing herself for the day. She slides on some form-fitting spandex to hide the bulge of her penis and give her shapely hips, pads her bra out a little, and applies thick pan-stick foundation. We catch a glimpse of her *Glamour* magazine as she attends to her pastel pink ensemble, a skirt and blouse, which is prim and conservative and

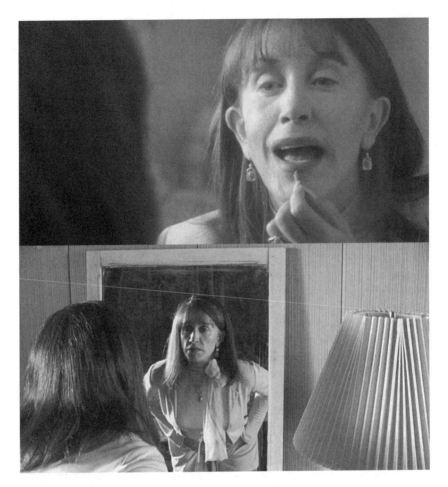

FIGURES 4.3 AND 4.4 "Bree" prepares herself for the day.

in keeping with her immaculately pink nails. We then see Bree's face reflected in the mirror and it looks odd; although recognizably feminine, it is not the ideal represented by her "aspirational" *Glamour* magazine. There is some sense of fascination on the part of the audience to recognize Felicity Huffman as not looking herself, by which I mean her usual self from television. Confident that she is ready to face the world, Bree leaves the house. As she struts along the street, a performance that is exaggerated in its connotations of feminine deportment, we hear an off-screen interview in which she recounts to a psychiatrist the medical procedures that she has undergone: electrolysis, three years of hormone therapy, facial feminization surgery, brow lift, forehead reduction, jaw re-contouring, and a tracheal shave. In these short introductory minutes *Transamerica* reveals just how

much "work" goes into the construction of femininity. Importantly, it reveals femininity as a cultural rather than natural construct, something that is imitative and can be molded by performance and shaped by surgery. It is not just about looking like or passing as a woman but also sounding like a woman and making people believe you are a woman.

However, this cultural and conceptual womanliness is according to norms and ideals of what common sense assumes to be an appropriately gendered heterosexual femininity. Bree has not achieved her goal of becoming a complete woman since she still has her penis and it literally gets in the way and causes anxiety and psychological discomfort. In the psychiatric meeting Bree is hoping to secure the consent for the vaginoplasty that will "cure" her of clinically defined gender dysphoria. During the psychiatric evaluation the male doctor mentions that gender dysphoria is a serious mental disorder and in doing so enacts a momentary shift in our attention away from the cultural construction of femininity towards the medical and legal definition of Bree's body. We may ask at this point who is in control of this body and who defines it—psychiatry, culture, the state, Bree—and who decides when and if sexual reassignment surgery will go ahead.

For such a short introduction to the protagonist the film packs in a good deal of information in relation to Bree's experience as a transsexual woman. The film's textbook approach presents us with, at one end, the cultural work involved in being a gender and, at the other end, the medical definition through which gender is determined biologically and anatomically in relation to sex. Furthermore, for Bree to become a woman requires her to appease the American Psychiatry Association as well as her therapist by conforming to a version of femininity that is both normative and ideal in that it ticks the boxes of what is considered physiologically and psychologically normal—with the opposite being pathological and queer! It appears that it takes a lot to make a lady, and if we return to the beginning of this establishing sequence and the instructional video one could also add to the equation technological practices. Later on in the film there is a telling scene when a disappointed Bree presses her finger down on the vinyl of an opera recording that slows down the soprano's voice into a distorted, incomprehensible, and warped sound.

Learning to sound like a woman, to erase the masculine voice that perhaps betrays the feminine appearance, requires a tutorial and a repetitive mimicry until the correct appropriately gendered voice can be achieved. The voice is thus cast as a locus for regulating normative ideas of gender and, importantly, cinema, which also plays its part in this normalizing process. What a person sounds like, especially onscreen, is one process through which gender comes to be normalized in cinema. The scene with the television tutorial and the record player draw our attention to how technology can transform and alter the voice.

There have been very few cinematic voices that contradict the gender of the person onscreen. One could argue that there would seem to be a preference in

promoting ideal alignments between how a star looks and how they sound. The exception here is the horror film that frequently presents us with threatening off-screen voices that are often ambiguously gendered and thus perverse. It should be noted that horror films also favor the sounds of women screaming as a nod to the genre's trade in the eroticization of women's fear. There is the occasional unusual voice in cinema, perhaps a non-native English speaker like Garbo or Dietrich, the huskiness of Kathleen Turner or the shrill of Jennifer Tilly, but popular cinema rarely transgresses from its cozy match of voice, body, and star.

Transamerica's foregrounding of the problem of voice brings to mind *The Dueling Cavalier*, the fictitious film-within-a-film that appears in *Singing in the Rain* (Stanley Donen and Gene Kelly, 1952). *The Dueling Cavalier* is meant to be a primitive talkie and its function is to make us aware of the Hollywood magic and the perfecting of sound and image synchronization so obvious in *Singing in the Rain*. *Singing in the Rain* attempts to confirm through the film-within-the-film the apparent failure of early cinema's actors to make the transition to sound cinema because they just didn't sound the way audiences imagined. In *The Dueling Cavalier* Lina Lamont's (Jean Hagen) voice is a high-pitched shrill. The microphone doesn't reproduce film space with sonic fidelity, and the synchronization between sound and image eventually breaks down. The ultimate synchronization error occurs when in a shot-reverse-shot structure male voices appear when the female actor speaks onscreen and vice versa. It is a funny moment that reveals the technical progress of Classical Hollywood in perfecting the synchronization of sound but in doing so it also points towards how technology and cultural assumptions normalize the relationship between sound and gender. First, Lina Lamont just does not sound right; her voice is squeaky and excessive, and, arguably, perversely high-pitched. Second, men who sound like women and women who sound like men, as the film's diegetic audience tells us, are hilarious and queer; queer in the old-fashioned sense of the word as something odd and strange. In *Singing in the Rain* sound and image out of sync becomes a joke of mismatched genders and is in definite need of fixing, quite simply because it does not work, especially when the actors' voices reinforce this problem with the slowed-down utterances of "no, no, no."

In a roundabout way *Transamerica* is making a similar point with its emphasis on voice as film sound and notions of synchronization, both textual and transsexual. This is a clear indication that we can characterize the film as doing something queer with conventions. *Transamerica* stresses the importance of voice in relation to gender and as a film text it nudges at the imagined unity of sound and image in the cinema which, like the illusion of gender's apparent naturalness, is the result of being constructed to appear as if no such construction had ever taken place.

In film history the drive to synchronization in the late 1920s is often related to issues in the development of cinema's narrative realism. Mary Ann Doane has

argued that sound contributes to "concealing the work" of the film text, which means that the material difference between the image and the soundtrack is erased.[9] As an audience we have no awareness that image and sound come from the different technological apparatuses of projector and speaker. In magically working as a unified experience, sound does not just support the image but produces the unifying effect. In this sense, one may argue that the gender-appropriate voice seeks similarly to confer some kind of unity and thus speak the truth of the body's sex. Furthermore, Doane speaks about textual unity as if it were a kind of body, a phantasmatic film body, when she writes that "the addition of sound to the cinema introduces the possibility of re-presenting a fuller (and organically unified) body."[10] Unifying practices seek to render both the text and the body as unproblematic and unconstructed. If we extend the metaphor of the material difference between image and sound, it is perhaps no stretch to make an analogy with "passing," what Bree refers to in the film as "living stealth," where transsexual people appear or aspire to be whole and unified in their sex/gender alignment.

Transamerica's foregrounding of sound through transgenderism could be considered a queer undoing of film sound. The use of sound at various moments works to disarticulate the voice and the body from one another showing us the possibilities of adopting another gendered voice with the help of surgery and training. Furthermore, it questions the assumptions we make about how image and sound are, like gender, unified in order that we do not recognize their material difference.

The Road to Trans-Formation

The film's title is smart in its overlap of meaning between a cross-country journey and the cross-gender of its American protagonist. It is also a title that "marries" the road movie with queer cinema as *Transamerica* is a film about literal and figurative journeys. The road movie provides an appealing generic framework that readily narrativizes the story of crossing gender. As a genre the road movie has been a quintessential feature of American cinema and is often associated with a desire to escape "that sets the liberation of the road against the oppression of hegemonic norms."[11] As a genre, however, the road movie is commonly associated with men, cars, motorbikes, and male buddies with *Easy Rider* (Dennis Hopper, 1969) being the road movie *par excellence*. Yet, some notable queer and feminist features such as *The Living End* (Gregg Araki, 1992), *My Own Private Idaho* (Gus Van Sant, 1991), *Thelma and Louise* (Ridley Scott, 1991), *Boys on the Side* (Herbert Ross, 1995) as well as rereadings of *The Wizard of Oz* (Victor Fleming, 1939) have suggested that the road is equally significant in providing alternative routes for women and queers to explore new possibilities and ultimately escape the prejudice and oppression in their off-the-road life. Despite the "increasing hospitality of the road to the marginalized and alienated," being

on the road is not always better since it frequently introduces new confrontations and ways to experience bigotry and hatred.[12] Furthermore, road movies that include central characters who are women or queer do not always translate into films that are free from problematic and prejudicial politics. *Thelma and Louise* has been the subject of considerable feminist debate for and against its gender politics and similarly Pamela Robertson's reading of *The Adventures of Priscilla, Queen of the Desert* (Stephan Elliot, 1994) reveals how the film is racist and misogynist.[13] The point of the queer and feminist road movie is to make bigoted and oppressive positions illogical and unjustified.

Transamerica does conform to the thematic and visual preoccupation of the road: traveling to a carefully chosen soundtrack, makeshift campsites, and time spent inside cars with the characters in conversation. As a road movie there are several encounters with people both good and bad that in *Transamerica* allows for a range of positions through which different attitudes and misunderstandings towards transsexuality can be explored. These encounters are engineered in a way that helps the audience understand the transsexual experience. In one road stop café encounter an 8-year-old child "reads" traces of ambiguity in Bree's gender that sends her into a panic and straight on the phone to her "sexual wellbeing" therapist. In another encounter Bree and Toby are robbed by what at first seems to be a well-intentioned hitchhiker only for them to have their car stolen and with it Bree's hormone medicine. The point of this encounter is to provide us with inside knowledge relating to the hormone therapy dependency. One of the most positive encounters is when Bree meets a kind Native American man called Calvin Many Goats (Graham Greene) who helps them out after being robbed. A sparkle of a relationship is hinted at as a future possibility for Bree and Calvin, the latter aware of Bree's unspoken difference, but as a queer film and an independent film, and in many ways counter to the multiplex ethos, *Transamerica* does not ascribe to a stereotypical romantic closure.

Transamerica is a queer road movie because the genre's defining characteristic of the transformative journey becomes analogous for trans identity and experience. As Cohan and Hark suggest, "the road has always functioned in movies as an alternative space where isolation from the mainstream permits various transformative experiences."[14] The road movie gestures towards an endpoint in the journey, and equally the transsexual journey desires its own need for conclusion. The appropriation of the road movie genre for the purposes of exploring one person's transsexual experience is what defines *Transamerica* as a queering of the road movie. The journey and the encounters and experiences on the road become ways of understanding the personal experience of not being the gender of one's anatomical sex: the difficult experiences with families (there are references to suicide and institutionalization), the disempowering effect of cultural-medical-legal definitions of trans identities and bodies, and, importantly, revealing gender as culturally defined and not always neatly aligned with one's sex, are all issues explored in depth in the field.

Spectacle, Melodrama, and Difference

I have so far been discussing the film's progressive elements. *Transamerica*, however, is not without problems in its representations of queerness and alterity, for it is a film that seems to be obsessed with Bree's penis. It is the proof that Bree is not yet the complete woman whom she aspires to be, and it points to her queerness, the fact that her gender and her sex are not normatively aligned. Although not at first obvious, the narrative trajectory is driven by the reassignment surgery—or should that be realignment surgery—which also provides the film with a sense of closure. The delay of the surgery also becomes a complicating action in the narrative. When her penis is eventually seen it is coded as a surprise, a shock, and a spectacle of otherness. During a pit stop Bree needs to go to the toilet and urinates behind the car. When she stands up Toby catches a glimpse in the rear-view mirror.

The moment of visibility signals a shift in register as our usual identification with Bree is jettisoned in favor of momentarily representing her figuratively through Toby's point of view as a freakish "chick with a dick." The offense of this expression says it all and it is a scene coded for shock that does not appear to be in keeping with the film's queer credentials. In this moment, *Transamerica* closely resembles *The Crying Game* (Neil Jordan, 1992), a film that presents a similar strategy of exposure when the trans character's penis is revealed as a shocking denouement. Peter Lehman refers to the shock of discovery in *The Crying Game* as melodramatic, a mode of representing the penis for maximum affect.[15] For Lehman, it is a strategy that "maximizes the shock value of the moment by making it a perceptual experience for the spectator."[16] In her analysis of *Boys Don't Cry* (Kimberly Peirce, 1999), Judith Halberstam also discusses

FIGURE 4.5 "Bree" as a freakish "chick with a dick."

The Crying Game and remarks that both films rely on a "successful solicitation of affect—whether it be revulsion, sympathy, or empathy" and that such appeal for affect "allows mainstream viewers access to the transgender gaze."[17]

Transamerica is also melodramatic in its narrative organization because Bree is unaware of Toby's knowledge about her transsexual status and it allows for a constellation of deceit and duplicity to be organized around the character and a particular part of her body that signifies her gender/sex difference. It is typically melodramatic because it produces a discrepancy between knowledge and point of view[18] that empowers Toby to know more than Bree while at the same time reminding us that she is not telling the truth and that she is, to use her own term, an "ersatz woman." In a later scene, one that reverses the structure of power through narrative knowledge, Toby comes on to Bree as a potential lover. He exposes his penis (off-screen) unaware of the fact that Bree is his father, which of course the spectator has known from the start. This is the moment when Bree is compelled to "out" herself as Toby's father. Both scenes are about Bree's relationship to secrecy and disclosure, more familiar as a dynamic of the closet,[19] and are structured through tried-and-tested melodramatic conventions that stand in opposition to the aesthetics of New Queer Cinema. It is the spectacle of difference signified by the shocking exposure of Bree's penis and the conventional melodramatic devices that work against *Transamerica*'s status as a queer film. Instead, the film is drawn, momentarily, towards the appeasement of a multiplex-friendly staging of otherness.

This chapter has demonstrated the politics of a film that is nestled between queer cinema and mainstream cinema. *Transamerica* represents a particular historical moment in cinema that allows multiplex audiences to access the tenets of queer theory through generic and textual conventions such as the road movie and film sound; however, despite a touching story in which the audience identifies with a transsexual woman, the film is also contradictory. *Transamerica* contradicts its queer politics through the way it represents the transsexual body as source of spectacle that we are positioned to view melodramatically as other. In its fusion of "queer" and "multiplex," *Transamerica* present a cinematic journey far from traveled and destination as yet unknown.

Notes

1 Eve Kosofsky Sedgwick, *Tendencies* (London and New York: Routledge, 1993), 15.
2 Ibid., 8.
3 Gary Needham, *Brokeback Mountain* (Edinburgh: Edinburgh University Press, 2010).
4 Harry Benshoff, "Reception of a Queer Mainstream Film," in *New Queer Cinema: A Critical Reader*, ed. Michele Aaron (Edinburgh: Edinburgh University Press, 2004), 172–86.
5 B. Ruby Rich, "New Queer Cinema," in *New Queer Cinema: A Critical Reader*, ed. Michele Aaron (Edinburgh: Edinburgh University Press, 2004), 15–22.
6 Judith Butler, *Bodies That Matter: On The Discursive Limits of Sex* (London and New York: Routledge, 1993), 126.

7 Ibid., 125.
8 For all quotations from this film, see *Transamerica,* directed by Duncan Tucker (2005; New York: Weinstein Company, 2006).
9 Mary Ann Doane, "The Voice in Cinema: The Articulation of Body and Space," in *Movies and Methods Volume 2,* ed. Bill Nichols (Berkeley, CA: University of California Press, 1985), 565–77.
10 Ibid., 568.
11 Steve Cohan and Ina Rae Hark, "Introduction," in *The Road Movie Book,* ed. Steve Cohan and Ina Rae Hark (London and New York: Routledge, 1997), 1.
12 Ibid., 12.
13 Harvey R. Greenberg, Carol J. Clover, Albert Johnson, Peter N. Chumo II, Brian Henderson, Linda Williams, Marsha Kinder, and Leo Braudy, "The Many Faces of Thelma and Louise," in *Film Quarterly* 45, no. 2 (1991–92): 20–31; Pamela Robertson, "Home and Away: Friends of Dorothy on the Road to Oz," in *The Road Movie Book,* ed. Steve Cohan and Ina Rae Hark (London and New York: Routledge, 1997), 271–86.
14 Steve Cohan and Ina Rae Hark, "Introduction," in *The Road Movie Book,* 5.
15 Peter Lehman, "Crying Over the Melodramatic Penis: Melodrama and Male Nudity in Films of the 90s," in *Masculinity: Bodies, Movies, Culture,* ed. Peter Lehman (London and New York: Routledge, 2001), 25–41.
16 Ibid., 29.
17 Judith Halberstam, *In a Queer Time and Place: Transgender Bodies, Subcultural Lives* (London and New York: New York University Press. 2005), 77.
18 Mary Ann Doane, *The Desire to Desire: The Woman's Film of the 1940s* (Bloomington, IN: Indiana University Press, 1987).
19 Eve Kosofsky Sedgwick, *The Epistemology of the Closet* (New York: Penguin, 1990).

PART II

New Feminine Subjects: A Space for Women?

5

ENCHANTED (2007) BY POSTFEMINISM

Gender, Irony, and the New Romantic Comedy

Yvonne Tasker

This chapter approaches questions of postfeminism in contemporary popular cinema through a discussion of the 2007 Disney production *Enchanted* (Kevin Lima), a film that combines animation and live action, exploiting and reflecting on the long history of the Disney brand. *Enchanted* plays out an ironic, tongue-in-cheek scenario in which the youthful and naïve princess-to-be Giselle (Amy Adams) is propelled by evil Queen Narissa (Susan Sarandon) from the magical animated Andalasia into real-world Manhattan. Such fictional, yet somehow plausibly named magical kingdoms are a common feature of Hollywood's princess preoccupation (Genovia in Disney's *Princess Diaries* films, for instance [Garry Marshall, 2001; 2004]). And, as I'll argue, magic forms are as significant a feature of the contemporary romantic comedy as fate; if a defining feature of realist drama is the refusal of the fantastic *deus ex machina* of melodrama, then the genre's embrace of magical resolutions and fairytale tropes is telling of a retreat from contemporary gendered realities. New York (a site invested with its own magical or fantasy status in numerous fictions) is the scene for most of the narrative action in *Enchanted*. Here, Giselle's fairytale ideas about true love are tested while she waits for Prince Edward (James Marsden) to rescue her, in the process developing romantic feelings for divorce attorney Robert (Patrick Dempsey). Robert, whose wife, we learn, left him to raise their 6-year-old daughter Morgan (Rachel Covey) alone, seeks to conduct his relationship with partner Nancy (Idina Menzel) along rational rather than emotional lines. Giselle's romanticism and Robert's bruised cynicism position them as the typical romantic comedy couple—opposed in almost every way, and yet clearly destined to be together. The narrative obstacles, which romantic comedy uses to defer the formation of the "right" couple till the closing scenes, have here to do with a clash of animated and "real" worlds, of fairytale endings and emotional complexity. The climax stages fairytale tropes in

the real world, with a pitched battle between Giselle and Queen Narissa that allows the naïve heroine to defeat a monstrous foe and rescue her lover.[1] That the film's representative professional woman, Nancy, departs to Andalasia with Prince Edward suggests a fundamental dissatisfaction with contemporary gender norms, embracing instead a fantastical mode of fantasized femininity that can only be termed postfeminist.

Since postfeminism is a discourse—that is, a set of ideas about how the world is organized which are expressed in policy, practice, and culture—which is both highly *knowing* about sex and gender (both cognizant of sexism and knowing with respect to sexual innuendo) and deeply invested in conventional modes of femininity, it is perhaps unsurprising that postfeminist media culture is intensely ironic in tone. *Enchanted* revels in its referential, ironic character, making numerous nods to Disney and other movies as it plays out its central romance narrative. As I'll argue here, it is this contradictory play of ironic knowingness on one hand, and the seemingly sincere presentation of ideas of true love on the other, that make *Enchanted* such a quintessential expression of postfeminist ideology.

For students of the cinema, a discussion of postfeminism involves making sense of the contemporary filmic representation of gender identities and (dis)engagement with gender politics. Postfeminism is one of those concepts that has proven tricky to define in part because it is used in so many different ways.[2] Not only that, postfeminism tends to mean different things when used by academics and when used—as it frequently is—by journalists, cultural commentators, and in public discourse more broadly. Though it may be tempting as a result to set the term aside altogether, the very fact that it *is* so widely used makes it important to make sense of postfeminism as a concept.

First and foremost, postfeminism involves an historical relationship to feminism, a political movement and philosophy that points to the pervasive impact of gender hierarchies and argues for gender equality. Postfeminism is, by definition, connected to feminism in some way; indeed, much of the confusion around the term comes from pinning down the precise nature of that connection. Feminist scholars typically use postfeminism as a term to describe cultural trends to do with gender identity. Popular commentators use postfeminism either to suggest that feminism has been detrimental to women and to men or, more typically, to imply that feminist goals have been more or less achieved and that therefore feminism itself can be effectively relegated to the history books. While such perspectives set aside the manifest inequalities that persist with respect to levels of pay, employment, and participation in arenas from sports to public life, as well as issues such as domestic and sexual violence against women, they also underline the extent to which ideas about—or perhaps more accurately *images of*—female empowerment are centrally inscribed in western culture.

Setting aside lived inequalities, postfeminist culture operates in the realm of images, and here it is concerned above all to celebrate female empowerment and strength. Postfeminism emphasizes women's achievements—physical, educational,

professional—and places particular emphasis on individual choice. Contemporary women are imagined by postfeminist discourse to be free to choose; free of both old-fashioned, sexist ideas about women's limits and feminism's supposed imposition of an asexual, unfeminine appearance. The extraordinary *lack* of diversity in media images of girls and women belies that emphasis on choice. Moreover, the fact that postfeminist culture's critique of feminism has so much to do with lifestyle and appearance is telling. While postfeminism insists on female strength and the primacy of the self (for which choice stands as the marker), that strength can, it seems, only be celebrated when figured in appropriately feminine terms. And since conventional femininities are traditionally aligned not with strength but with passivity, malleability, and a broad willingness to sacrifice self for others, the postfeminist commitment to an imagery of strong, self-defined, sexually confident yet resolutely feminine women is potentially rife with contradiction. Indeed, what postfeminist culture deems to be signs of empowerment routinely emerges as an accommodation to, and acceptance of, a diminished role for women.

In the popular cinema, the contradictory character of postfeminism—its simultaneous commitment to female strength and feminine passivity—is expressed in a number of genres.[3] It is evident in the action cinema, for instance, in the highly accomplished yet girlish female fighters who are packaged for the screen in skin-tight costumes in films such as the *X Men* series (Bryan Singer, 2000, 2003; Brett Ratner, 2006; Gavin Hood, 2009). Perhaps, most of all, postfeminism registers its discursive presence in romantic comedy, a genre whose narrative structure is premised on an antagonistic relationship between a man and a woman who will ultimately form a couple. Traces of feminism as a cultural force are apparent in romantic comedy, frequently expressed as discontent with misogynist masculinities and a narrative insistence that men too must change. Contemporary romantic comedy must also acknowledge the (repeated) failure of romantic ideals and marriage as an institution, even while it values intimacy and true connection.

Regression and an attendant delight in childish pleasures is a staple of film comedy; the genre revels in the grotesque, inverting the social meanings of youth and age and experimenting with taboo topics.[4] Of course the comedy in romantic comedy has less to do with slapstick or the grotesque (as showcased in gross-out comedy) and more to do with absurd situations, verbal sparring, and improbable couplings. The genre is underpinned by ideas about heterosexual romance and frequently generates its humor from conventional gender roles as they are expressed in men's and women's mistaken expectations of each other. The narrative development of romantic comedy is, of course, geared towards adult norms of monogamous coupledom, rather than an immersion in adolescent desires or childish pleasures. Nonetheless, gross-out comedies such as *Dodgeball: A True Underdog Story* (Rawson Marshall Thurber, 2004), *Knocked Up* (Judd Apatow, 2007), and *Wedding Crashers* (David Dobkin, 2005) foreground the extended

adolescence of their male protagonists who are drawn kicking and screaming towards marriage and/or parenthood. David Denby dubs these movies "slacker-striver romances," reading their primary narrative as to do with the maturation of boys via a coupling with women who are already emotionally and professionally adult.[5]

Enchanted suggests that regression means something different for girls; the film prominently features a girl-woman whose presence comically disrupts the life of the protagonist via her uncanny innocence rather than sexual knowingness. Where successful comedies featuring male characters who have not grown up revel in bodily humor and sexual innuendo, the girl-woman is an innocent figure bound up in a narrative that values romance above all. If the gross-out movies mentioned above display a knowing, adult femininity requiring an appropriately mature partner, romantic comedy frequently features women whose lack of romantic stability suggests *their* failure to fully grow up: consider the character of Jane (Katherine Heigl) in *27 Dresses* (Anne Fletcher, 2008), for instance, a woman whose enthusiasm for organizing the weddings of others underlines her own single state. Jane's investment in the idea of the wedding is explicitly anchored in the film's opening scenes to the childhood loss of her mother. Thus, *27 Dresses* conforms to a tendency in contemporary romance to present female professionals as in various ways compensating for emotional fear and loss.

Enchanted exemplifies postfeminist cinema in a number of ways. It adopts a knowing tone—though its central character is defined by her innocence, her lack of knowledge about the modern world—and is characterized by irony. It plays with, and even mocks, the conventions of the Disney tradition of animated and musical films as well as the romantic comedy even as it fulfills those conventions. This doubleness is symptomatic of the contradictions identified above as centrally enshrined within postfeminist culture. Giselle's belief in the idea of "true love's kiss"[6] is first mocked—Prince Edward is something of a buffoon—and then ultimately endorsed through her romantic love for Robert who literally revives her with a kiss (she swoons after biting a poisoned apple). It offers gestures towards feminism while making full use of conservative gender stereotypes, such as the girl-woman, sexually pure princess, frustrated professional woman, and wicked stepmother. All of this is staged within a framing narrative that contrasts fairytale ideals about friendship, love, and marriage with the "real" world of New York City. What is particularly striking about genre films like *Enchanted*—and postfeminist cinema culture more broadly—is the extent to which playful strategies, both visual and narrative, enact a knowingness that ingeniously recommends conservative gender paths.[7] It is this suppressed paradox of a simultaneous celebration of female empowerment and more traditional norms of femininity that characterizes postfeminism. *Enchanted*'s hybridization of the romantic comedy with the conventions of the magical, fantasy worlds so familiar from Disney films past and present allows an effective and entertaining staging of the impossible knowing innocence of postfeminism.

Irony, Knowingness, and the Disney Princess

Enchanted exemplifies the self-reflexive or knowing quality which has become such a pronounced feature of contemporary Hollywood cinema. Indeed, there is a marked connection here with a postmodern aesthetic of recycled images and genres, one that, as Vera Dika so astutely notes, suppresses history in "the impulse to merge past and present."[8] Cinematic nostalgia, she observes, does not represent an uncomplicated desire to return to an imagined past. Rather she cites Jameson's comment that:

> The nostalgia film [is] a misnomer to the degree to which the term suggests that genuine nostalgia—the passionate longing of the exile in time, the alienation of the contemporary bereft of older historical plenitudes—is still available in postmodernity.[9]

Thus the (Disney) princess image is valued as a sign, but detached from context and effectively made the subject of irony. *Enchanted* features numerous references (some explicitly played for laughs, some made in passing) to Disney's most successful animated features including *Sleeping Beauty* (Clyde Geronimi, 1959), *Cinderella* (Clyde Geronimi, Wilfred Jackson, and Hamilton Luske, 1950), *Snow White and the Seven Dwarfs* (William Cottrell, David Hand, Wilfred Jackson, Larry Morey, Perce Pearce, and Ben Sharpsteen, 1937), *Lady and the Tramp* (Clyde Geronimi, Wilfred Jackson, and Hamilton Luske, 1955), as well as to other elements of Disney film and to musical theater.[10] In the troll featured in the film's opening animated scenes *Enchanted* also references a key Disney rival, *Shrek* (Andrew Adamson and Vicky Jenson, 2001; Andrew Adamson, Kelly Asbury, and Conrad Vernon, 2004; Chris Miller and Raman Hui, 2007), the DreamWorks series that spoofs fairytale conventions in general, and the idealization of the princess (and passive princess femininity) in particular, via its feisty troll Princess Fiona (voiced by Cameron Diaz).[11]

Enchanted suggests its revision of the Disney princess figure in two rather different ways. Firstly, the film stages her excessive femininity as a recurrent, even structuring joke, setting out her lack of compatibility with modern urban life and Robert as cynical exemplar of that life. Secondly, the film plays out a role-reversal scenario in which Giselle, having finally been revived by "true love's kiss," wields a sword to rescue Robert from Queen Narissa, now transformed into a dragon who scales the skyscraper with the hero in her claws. The extent to which the film plays this scenario as a modern inflection of gendered movie peril is made explicit by Narissa's sneering dialogue in which she refers to the "twist" of casting Robert as the "damsel in distress." In promotional interviews, director Kevin Lima presented this ending as a riposte to more traditional Disney princess narratives.[12] *Newsweek* cites him as follows: "Traditionally, the female character is very strong until the last minutes of the film, and then the prince comes in and she's saved.

I don't think that's a contemporarily responsible story. I had to give an alternative ending."[13] The sort of gesture towards feminism evident here registers both a discomfort with the reproduction of passive models of feminine acquiescence for audiences of girls, and a need to reconcile that discomfort with the requisite happy ending in which the couple are united. While *Enchanted* celebrates the princess as a marker of femininity, it takes care in the closing montage to signal that its protagonist has been able to turn this very identity into a source of employment with glimpses of Giselle as a businesswoman.

Ironic knowingness is a central feature of both postmodern culture and a postfeminist media in which both highly sexualized and traditionally feminine images of women are effectively cited, sold to affluent female consumers as lifestyle choices. Since such citations are never intended to be taken entirely seriously, critique frequently seems to be misplaced (if, I would argue, absolutely necessary). Critique suggests a failure to get the joke (and the supposed humorlessness of feminism plays a part here). As Angela McRobbie writes, in contemporary gender culture "objection is pre-empted with irony."[14] The spectacular comic sequence in which Giselle cleans up Robert and Morgan's messy apartment with the help of the city's vermin—rats, roaches, pigeons, etc.—generates both humor and disgust from the contrast with the cute animated animals that assist Giselle in Andalasia (and the sequence in Disney classic *Cinderella*, which is referenced here). The scene highlights both Giselle's innocence (expressed not only in song, but in her enthusiasm for domestic tasks) and the knowingness of this Disney film in contrast to numerous others, underlining in the process the less than ideal aspects of modern urban living.

If Giselle is insistently innocent, Nancy is knowing (discovering Giselle at Robert's apartment, she immediately assumes a sexual encounter has taken place). Significantly, while Nancy is a knowing contemporary woman, she longs for a world without irony. While here that means her desire for romance, the fairytale happy ever after, that longing acknowledges the dreariness of the real world and implicitly the ways in which irony is so often coupled to a retro-sexism that dismisses women. In this context the postfeminist enthusiasm for femininity might read as a retreat from the aggressive sexualization of women in contemporary media. Thus, Nancy responds delightedly to the flowers Giselle has sent in Robert's name (normally, he just sends digital flowers and email cards) and later reacts with amazement to Edward's declaration of love for Giselle: "so straightforward, not a hint of irony—it's very romantic." This comment prefigures her leap with Edward into Andalasia and a marriage ceremony in which her modernity (and knowingness) is suggested by the gesture of sweeping the animated Edward off his feet into an embrace. These images cleverly play out the knowing woman's choice of a traditional lifestyle and the insistence that she retains her sexual agency in making that choice. Such imagery chimes with Diane Negra's analysis of retreatism as a central trope of contemporary postfeminist culture. As she writes: "A variety of recent popular cultural narratives centralize/idealize a woman's apparently fully

knowledgeable choice to retreat from public sphere interactions in favor of domesticity."[15] However playful and funny, the scene of an animated Nancy casting aside her cell phone to embrace her animated prince effectively reprises the exuberant media presentation of affluent women's conscious choices to seek domesticity as detailed by Negra.

Giselle herself is never ironic and rarely knowing (in either the savvy or sexual sense of that term), but she is highly intuitive. Giselle's girlishness makes her the butt of the joke, for example, when she assumes that old people are to be trusted—both the homeless man who steals her tiara in New York and the hag disguise of Queen Narissa (herself a seductress and witch rather than an innocent cipher of magic) in Andalasia are testament to this naïveté. Yet she routinely engages with and even enchants strangers, giving money to an old woman in Central Park (and receiving information on Edward's whereabouts in return), reconciling one of Robert's clients with her estranged husband, and leading diverse groups of musicians, city workers, and citizens in song in the spectacular number set in Central Park and (ironically) titled "That's How You Know." Giselle's capacity to enchant Robert—and her difference from the values he claims to adhere to—is embodied in the pleasures of romance as signaled by music and dance. During the "That's How You Know" number, Robert insists that he doesn't sing and he doesn't dance. Later, at the ball, it is revealed that he can do both, but has chosen not to; Giselle's femininity brings music and dance into Robert's life once more. This magical transformation of the hero, his reclamation of romance, is prefigured in daughter Morgan's intent interest in Giselle as an apparition of the very princess identity her father seeks to rule out for her.

Fantasy and Femininity

As with comedy more broadly, recourse to irony can often indicate points of acute cultural uncertainty or difficulty: thus the knowingness of so many contemporary Hollywood movies when it comes to questions of violence, race, and social inequalities and, of course, gender. Irony has to do with doubleness, layers of meaning, which are even more pronounced in a recycled image culture. Double discourse is also central to postfeminism. Indeed, McRobbie explores postfeminism through what she terms a characteristic "double entanglement," that is, "the coexistence of neoconservative values in relation to gender, sexuality, and family life ... with processes of liberalization in regard to choice and diversity in domestic, sexual, and kinship relations."[16] Popular culture's capacity to maintain quite contradictory stances on gender politics is at issue here and is nowhere more problematic and pervasive than the trope, which is central to *Enchanted*, of empowerment through femininity. Through the course of the narrative, Giselle experiences both anger and desire for the first time (both are figured as empowering, adult emotions), while her femininity enchants and transforms the hero.

Postfeminism seeks to bind together an idea of female strength and power with a femininity characterized by passivity and dependence. *Enchanted* couples femininity with fantasy, embodied in the figure of Giselle, an out-of-this-world caricature. The film introduces Giselle as a Disney princess-in-waiting in the magical space of Andalasia; surrounded by animated woodland animals, Giselle proclaims through song her desire for true love's kiss. Prince Edward promptly appears, saving her from a troll and catching her when she falls from a tree; singing together, he pronounces that they will marry the next day (presumably Giselle concurs). This superficial happy-ever-after scenario is punctured by Queen Narissa, who refuses to cede power to her stepson Edward and has long schemed to keep him single. Disguised as an old woman, Narissa deceives Giselle and dispatches her to New York ("a place where there are no happily ever afters") where she emerges from a manhole into the busy streets at night, resplendent in a preposterous wedding gown that limits her ability to maneuver the crowded city. In this way the film sets up its central comic device of a fairytale character adrift in a contemporary urban setting, contrasting girlish innocence and an excessive femininity with, on the one hand, professional urban women, and, on the other, the evil older Queen clutching at power. When Narissa herself appears in New York later in the film she is dressed in clinging black, her costume and make-up explicitly echoing the evil queen of *Snow White* ("as if dressed for a fetish ball," quips critic Manohla Dargis[17]).

With respect to gender, this comic device of opposing fantastic femininity to real-world rationalism allows an effective unlearning of cultural common sense about what it is to be a contemporary woman. Femininity, we might note, is a mode of appearance and behavior that conservative cultural commentary frequently judges feminism to have denied women. Feminism, it is suggested, would have women behave and dress like men, donning business suits rather than sparkly frocks, a contrast illustrated in *Enchanted* primarily through Nancy and Giselle. Yet Nancy's tailored look is echoed by numerous women seen in the background; it is in many ways the city's norm. Urban professional status is thus visualized as a rather grim chore. Against this monochrome existence, Giselle stages a celebration of femininity for the benefit of the women she encounters in New York *and* for female audiences in the cinema. The film's structuring opposition between Andalasia and Manhattan, romance and cynicism, speaks directly to questions of gender then. A magical figure of otherworldly princess femininity, Giselle brings romance/fantasy for the audience as well as for Robert. Yet Giselle also needs to change, a transition signaled in the film (how else?) through costume. Thus the move from full-length gowns replete with bows and frills to, first, a mid-length floral dress and then, for the ball, a streamlined modern evening dress set off with straightened (that is, tamed) hair. These changes bespeak a process of maturation, a movement from the disordered girlishness of the princess fantasy that Giselle embodies in the film's early stages, to her emergence as a girlish, but nonetheless clearly adult woman who is desiring and available for romance.

In what Disney describes as a "family comedy," this makeover speaks in different ways to a girl audience for Disney princess movies and products (in a manner echoed in Disney's hugely successful *Princess Diaries* makeover movies) and an adult female viewer of contemporary romantic comedy.

Enchanted is, of course, immersed in the very princess culture its heroine grows out of. Ironically enough, as a father, Robert wants to protect Morgan from princess fantasies and romantic notions; he tells Giselle that he wants Morgan to be strong, to prepare her for a life that involves no clear route to happiness. Morgan is first seen wearing a karate suit, implying that she is being taught to physically assert herself. Robert gives Morgan a book, *Important Women of Our Time*, suggesting that prospective stepmother Nancy is a lot like the women therein. Rosa Parks and Marie Curie are the two women mentioned; though their actions and achievements may resonate, neither are really women "of our time" (they are historical figures) and neither appeals to Morgan. As Negra notes, the book is "set aside" when father and daughter meet Giselle, a strategy that allows the film to posit "the viability of princesshood as an alternative to the troubled terms of 'real world' female achievement."[18] As a divorce lawyer, Robert is steeped in cynicism with regard to marriage and romance and the world in which his daughter will become a woman.[19] These romantic/feminine and cynical/masculine world views collide when the father/daughter pair encounter Giselle attempting to scale the outside of the Palace Casino in the pouring rain. This composite imagery of the 6-year-old girl in karate suit, important women of history and a rain-sodden princess recalls what Rachel Moseley terms, in her discussion of popular culture's teenage witches, a "postfeminist concern with holding together conventional femininity and power."[20]

Postfeminism presents femininity as both youthful and energizing, qualities apparent in Giselle's child-woman persona (against this is set Narissa's older, destructive energies and misplaced power). In the film's brief coda we see that her magical femininity has brought a childish sense of play to Robert's and Morgan's life as the three of them cavort happily around the apartment. In a postfeminist gesture to female independence the film is also careful to show Giselle having capitalized her femininity into a company, Andalasia Fashion, which seems to be in the business of selling princess-style dresses to young girls. Robert and Morgan are enthusiastic participants—along with a few rats and pigeons—in this scene of magical, feminized work. These brief images offer, and answer, the problem of women's work in postfeminist culture. Here, work is not only reconciled with domesticity, but it speaks to the pleasure of consuming fantasy femininity and the money to be made from such fantasies.

Choice is a central term within postfeminist cinema, although there are clear and relatively conventional (that is, limited) choices to be made by female characters in contemporary Hollywood cinema. Giselle's choice to remain in New York and Nancy's choice to escape the city for animated Andalasia evoke models of femininity that elide the economic context in which women's lives

are lived. And as various academics and commentators have noted, in postfeminist culture, choice seems irretrievably linked to consumption: hence the ubiquity of the makeover as a trope and the shopping montage as a sequence that celebrates/ stages that trope. *Enchanted* features both: Giselle is subject to a transformation narrative signaled through costume and through a growing awareness of her love for Robert. Her life in New York allows her to experience new emotions—anger and sadness as well as of course love (and implicitly sexual desire)—which suggest a more fully human character, an emotional as well as literal fleshing out of the animated princess.

Giselle's disruptive femininity (she tidies Robert's apartment, but has a chaotic effect physically and emotionally) is out of place in Manhattan and needs to be contained and constrained. The wedding dress, which conspicuously impedes her movements, starts to come apart as she is pushed and pulled into Robert's apartment. From forging her own clothing out of the home's fabrics (a source of comedy but also suggestive of an outmoded form of feminine domesticity[21]), Giselle is ultimately inducted into shopping and grooming behaviors, acquiring a more understated dress and hairstyle. At the costume ball which provides the

FIGURE 5.1 "Giselle" (Amy Adams) in her wedding dress. Courtesy of Walt Disney Pictures/Photofest.

FIGURE 5.2 "Giselle" (Amy Adams) at the costume ball. Courtesy of Walt Disney Pictures/Photofest.

setting for *Enchanted*'s climax; Giselle is the most simply dressed and coiffed of all the women there. Giselle's education in consumption allows her to emerge as a modern woman who retains her girlish enthusiasms. The emphasis on consumption as a route to self-fashioning and appropriate feminine activity returns us to the doubleness of postfeminist culture, in which female strength may be celebrated, but only in the service of conventional femininity.

It is 6-year-old Morgan who facilitates Giselle's shopping trip, remarking that her father's gold card is "better than a fairy Godmother."[22] This scenario encapsulates the familiar construction of consumption as magical/therapeutic as staged in numerous Hollywood movies directed at women (best exemplified perhaps by the facile consumerism of *Sex and the City* [Michael Patrick King, 2008]). Giselle and Morgan's many purchases are spread out around them (in a display of their conspicuous consumption and, by extension, Robert's ability to provide material comforts) as they talk in the beauty shop about an experience that neither has had: shopping with their mothers. Consumerism thus provides the subject of, and setting for, female intimacy. Indeed, despite the fact that Giselle remains a girl-woman, this scene explicitly prefigures the relationship

between Giselle and Morgan as a model of the good stepmother/daughter rela-
tion (as against Narissa's destructive lust for power, on one hand, Nancy's awk-
wardness, on the other). They discover the world of consumption together,
a virtual mother/daughter approximating an experience of intimacy through
acquiring the accoutrements of femininity (clothes, hair, make-up). The film
comically reveals that Morgan's youthful knowingness about money is not
matched by sexual knowingness, as she reveals to Giselle that boys are only after
one thing, but that no one will tell her what it is.

Anyone who has parented a girl might empathize with Robert's desire to
distance his daughter from the fairytale fantasy that constitutes so much of mass
media presented to girls—not least the ubiquitous Disney princess franchise itself.
The Disney princess brand—reportedly worth $4 billion in 2007, the year of
Enchanted's release—markets numerous ancillary products derived from the
Disney back catalogue to young girls. While initial reports suggested that *Enchanted*
was intended to add a character to the franchise, the live action emphasis made
that implausible; moreover, the film's knowing tone seems quite at odds with the
core market of girls aged 6 and under. Whether or not *Enchanted* consciously
acknowledges parental uncertainty with princess products is debatable; the film's
insistence on the magical, transformative possibilities of this positioning suggests
otherwise. Certainly, *Enchanted* makes clear how entranced Morgan is by the
possibility of having met "a real princess"; Giselle's quasi-maternal connection
with the child reinforces the rightness of the film's central romantic couple. If
Giselle did not become a part of the Princess franchise, as of April 2008 women
could buy a wedding dress derived from the film, albeit one considerably more
understated than the dress that comically hampers Giselle's progress around
New York City. As with the costume ball that provides the setting for *Enchanted*'s
climax, such products speak to adult desires to dress up in period costume, to
enact the gender rituals of an earlier and implicitly more straightforward time.
Looking backwards and forwards simultaneously—with its sword-wielding
princess, fantastical evocations of Hollywood's past and yet absolute insistence on
true love—*Enchanted* effectively evokes the knowing sincerity of postfeminist
cinema.

Notes

Thanks to Diane Negra for her helpful comments on this chapter.

1 In the classical ballet *Giselle* the eponymous heroine is an innocent peasant girl seduced
 and betrayed by an aristocrat whom she loves and protects from beyond the grave.
2 Sarah Projansky gives an excellent overview of the complex and contradictory ways
 in which postfeminism appears in popular and academic discourse. Sarah Projansky,
 Watching Rape: Film and Television in Postfeminist Culture (New York: New York
 University Press, 2001), 66–89.
3 Outside the cinema the presentation of sexualized images of the self as a route
 to celebrity continues to proliferate. Linking this sexualization to princess imagery,

journalist Peggy Orenstein ponders "how 'Someday My Prince Will Come' morphs into 'Oops! I Did It Again.'" She writes: "It is no wonder that parents, faced with thongs for 8-year-olds and Bratz dolls' 'passion for fashion,' fill their daughters' closets with pink sateen; the innocence of Princess feels like a reprieve." Peggy Orenstein, "What's Wrong with Cinderella?", *New York Times*, 24 December 2006.

4 See Geoff King, *Film Comedy* (London: Wallflower, 2002), 77–92.

5 David Denby, "A Fine Romance: The New Comedy of the Sexes," *The New Yorker*, 23 July 2007.

6 For all quotations from this film, see *Enchanted*, directed by Kevin Lima (2007; Burbank, Los Angeles, CA: Walt Disney Video, 2008).

7 Playful intertextuality is evidenced additionally in the casting of Idina Menzel, strongly associated with the Broadway hit *Wicked*, and Patrick Dempsey whose persona is shaped by his role in TV series *Grey's Anatomy* in which his character pursues a complexly deferred romance.

8 Vera Dika, *Recycled Culture in Contemporary Art and Film: The Uses of Nostalgia* (Cambridge: Cambridge University Press, 2003), 124.

9 Ibid., 23.

10 My DVD copy includes director Kevin Lima promoting the Blu-ray version, which features the option to guess and/or have revealed all the Disney references featured in *Enchanted*. Presumably this quiz targets adult audiences familiar with those earlier Disney films as well as younger audiences familiar with the *Princess Diaries* franchise.

11 As of 2009 Dream Works has a long-term distribution deal with Disney.

12 Having said this, the independence, self-reliance, and maturity (or otherwise) of the Disney princess figure have been an issue for comment and debate since at least *The Little Mermaid* (Ron Clements and John Musker, 1989), which featured an active, at times almost rebellious mermaid princess figure.

13 Ramin Setoodeh and Jennie Yabroff, "Princess Power," *Newsweek*, 26 November 2007.

14 Angela McRobbie, "Post-feminism and Popular Culture: Bridget Jones and the New Gender Regime," in *Interrogating Postfeminism: Gender and the Politics of Popular Culture*, ed. Yvonne Tasker and Diane Negra (Durham, NC: Duke University Press, 2007), 33.

15 Diane Negra, "Quality Postfeminism? Sex and the Single Girl on HBO," *Genders Online Journal* 39, 2004.

16 McRobbie, "Post-feminism and Popular Culture," 28.

17 Manohla Dargis, "Someday My Prince Will … Uh, Make That a Manhattan Lawyer," *New York Times*, 21 November 2007.

18 Diane Negra, *What a Girl Wants?: Fantasizing the Reclamation of Self in Postfeminism* (New York: Routledge, 2009), 14.

19 As Linda Mizejewski writes, Hollywood romantic comedy "idealizes monogamy and long-term commitment, but not the qualities that actually sustain them—loyalty, endurance, patience, friendship." Linda Mizejewski, *It Happened One Night* (Malden, MA: Wiley-Blackwell, 2010), 21.

20 Rachel Moseley, "Glamorous Witchcraft: Gender and Magic in Teen Film and Television," *Screen* 43, no. 4 (2002): 409.

21 Making clothes from curtains also recalls the thrift of Maria (Julie Andrews) in *The Sound of Music* (Robert Wise, 1965).

22 The 2007 *Newsweek* feature cited above reports an Ariel credit card amidst other princess products aimed at adult women.

6

NEOLIBERAL FEMININITY IN *MISS CONGENIALITY* (2000)

Yael D Sherman

In her speech at the end of *Miss Congeniality* (Donald Petrie, 2000), Gracie Hart (Sandra Bullock), an undercover FBI agent, says, "[F]or me, this experience [participating in the Miss United States beauty pageant] has been one of the most rewarding and liberating of my life."[1] In her discussion of the film, Linda Mizejewski dismisses this statement with sarcasm: "[I]t's tough to figure out what these young women have been 'liberated' from, except feminism, intellectualism, and ugliness."[2] Mizejewski recreates the binary chain in which ugly, smart, and feminist are opposed to pretty, stupid, and antifeminist; however, Mizejewski ignores the fact that *Miss Congeniality* breaks these binary oppositions. Rather than simply dismissing Hart's claim on the face of it, we must ask: what is Hart liberated *from*? What does this new-found femininity offer her? And if this femininity is not simply a repudiation of feminism, how is it positioned with regard to feminism?

As a makeover movie, *Miss Congeniality* transforms its title protagonist, Gracie Hart, played by Sandra Bullock, from a benighted "before" to triumphant "after," exemplified by what I call neoliberal femininity.[3] Neoliberal femininity is a type of ambitious, middle-class femininity, oriented to success in both the public and private spheres.[4] While Gracie rejects femininity at the beginning of the film, she eventually changes her understanding of what femininity can mean and embraces it. As comedy, *Miss Congeniality* highlights the physical discomfort and labor of femininity: the makeover is not a pleasurable scene of pampering and shopping, but an industrial production of waxing, plucking, and dying.

Despite this ironic look at femininity, the film establishes that Gracie is, as her pageant mentor says, an "incomplete person" because she lacks femininity. Becoming feminine enables Gracie's success in the private sphere, paving the road to friendship and romance. Likewise, developing feminine attachments and

participating in the beauty pageant enables her success in the public sphere: she solves the FBI case and saves the "girls." In the end, Gracie discovers that pretty and smart are not mutually exclusive, that femininity is not limiting, but "liberating," and that she really does want world peace. Neoliberal femininity proves to be the only good choice for Gracie. The film offers an impossible solution to the conflict between feminism's ideal of solidarity and neoliberal femininity's ideal of hyper-competitive individualism: Gracie can have both! Feminism is endorsed, repudiated, and ultimately rendered fantastic in *Miss Congeniality*.

Femininity

Given the historic exclusion of "respectable" women from the public sphere,[5] femininity has typically been understood in two ways: first, as a way to increase one's value on the marriage market, and second, as a tool women use to manipulate men.[6] Though a middle-class woman competing for safety and security through marriage could not change her "breeding," wealth, or father's profession, she could potentially work on and improve her appearance. Sandra Bartky argues that "[k]nowing that she is to be subjected to the cold appraisal of the male connoisseur and that her life prospects may depend on how she is seen, a woman learns to appraise herself first."[7] By "life prospects," Bartky means marriage. Similarly, John Berger argues that "ultimately how she appears to men, is of crucial importance for what is normally thought of as the success of her life"[8]—again, marriage. Women learn to see themselves through men's eyes in order to make themselves more pleasing to men and, therefore, more desirable mates.

Secondly, femininity has been understood as a tool of the weak, in the Nietzschean sense: those with less power cunningly manipulate those with more power.[9] Joan Riviere argues that women put on a mask of femininity to hide their intelligence and to reassure men.[10] Similarly, Susan Brownmiller argues that women use femininity to disguise their ambition in the public sphere.[11] Both arguments rely on the notion that a feminine appearance signals a woman's attempt to appeal to and please men. Femininity effectively hides women's desires (even while it may secretly further them) because its performance turns one into a sex object to and for those with power—men.

In both cases, femininity is a response to conditions of structural inequality and dependency. Femininity is not passive; it is actively used to obtain the object of women's desires, whether marriage or manipulating men; however, these desires are themselves the product of structural and cultural limitations. For instance, if women were never allowed to practice medicine, then how could a woman imagine herself a doctor? This kind of femininity is best understood as a mode of agency available in a very constrained field; however, when women embrace this kind of femininity, they lend credence to the idea that women only want to please men, and have no desire or ambition themselves. If most women feel constrained to behave in this way, they make femininity seem inevitable for women, thus

naturalizing femininity. If the performance of femininity requires one to hide intelligence and intention, then beauty will be associated with frivolous, seemingly stupid women. Beauty and intelligence become opposed through social interaction under these structural and cultural constraints. In other words, as some theorists argue, enacting femininity can work to reinforce women's subordinate and dependent status.[12]

Now that women can find the "success of their life"—become business executives, artists, and scientists or whatever else—outside of marriage and the private sphere, why should they need to cultivate femininity? If culture were simply and purely a response to underlying structural conditions, one might expect femininity to vanish away as we approach equality (particularly for privileged women), if not liberation. But this is not the case. Instead, ideals of femininity shift, emerge, and compete for cultural dominance in response to both culture and social structure.

Under conditions of partial equality, feminism, and neoliberalism, a new form of femininity, what I call neoliberal femininity, has emerged.[13] Neoliberalism is both a social policy based on extending the logic of the market to every sphere and a corresponding norm for how individuals should behave and govern themselves. Neoliberal citizenship is based on the discriminating consumer. Under neoliberalism, individuals must care for themselves, take responsibility for themselves, and "enterprise" themselves. Underpinning this new (seemingly empowering) model is the reality of an attack against the welfare state. According to neoliberal thought, accepting the aid of the state makes one dependent and therefore ill. As a result, instead of supporting social safety nets, neoliberalism aims to "actively create the conditions within which entrepreneurial and competitive conduct is possible."[14] In other words, individuals must be "empowered" to "compete." Structural problems are to be solved by individuals working on themselves and making "better" choices. This hyper-individualizing logic ignores structural inequality and the reality of discrimination. Rather than being able to count on the state for assistance, the citizen-consumer must help herself.

While a number of scholars have remarked upon the convergence between the ideal neoliberal self and the ideal feminine self,[15] none of these theorists examine how femininity is *transformed* under neoliberalism. Traditional femininity only enables competition in the marriage market and is therefore marked as a means to dependence. Once ensconced in the family, the traditional feminine woman is, according to Wendy Brown, to be both self-sacrificing and self-less—a far cry from the enterprising self of neoliberalism.[16] While both traditional and neoliberal femininity require that women objectify themselves and work on their appearance, the connotations associated with a feminine appearance shift under neoliberal femininity. While traditional femininity connotes "sex object," neoliberal femininity connotes competent subject; while traditional femininity implies dependence, neoliberal femininity implies independence; and while traditional femininity is associated with the sin of vanity, neoliberal femininity implies that

one is actively self-responsible. Neoliberal femininity implies a calculating care of the self, a form of self-management highly valued under neoliberalism. Neoliberal femininity no longer suggests an attempt to flatter individual men, but rather announces the intention to compete in both the public and private spheres. Rather than opposing "pretty" and "smart," neoliberal femininity aligns them on the same side. While traditional middle-class femininity enabled "success" through marriage in the private sphere, neoliberal femininity renders femininity an asset in the public sphere as well as the private. Neoliberal femininity is a *new* form of femininity that takes up elements of feminism, neoliberalism, and traditional femininity.

Miss Congeniality

The first scene sets up the dilemma of *Miss Congeniality*, opening with a scene from Gracie's childhood. Gracie—clad in pants and a long-sleeved T-shirt, black rimmed glasses, and dark brown hair in braids—sits by herself reading a Nancy Drew mystery. When a large boy bullies a smaller boy, Gracie leaves her mystery novel to defend the small boy. The bully calls Gracie a girl—an insult to her. She calls him a girl in response, then beats him up. Gracie tells the smaller boy that he's smart and funny and she likes him. Whereupon he tells her that he doesn't like her—he was humiliated by her rescue. Gracie yells "wimp" and punches him in the face, ruining her rescue and her chances of love. This scene sets up the problems of the movie: Gracie doesn't fit into the categories of boy or girl, and, therefore, doesn't fit in anywhere. Though Gracie is presented as both caring and assertive, her rejection of traditional femininity costs her what she wants: a successful rescue and the admiration of the boy. When we first meet Adult Gracie, she looks almost exactly like her tomboy self: dark-rimmed glasses, braided dark brown hair, and boyish clothes. This mirrored appearance suggests that Gracie is paused in her development, stuck in a tomboy phase.

As an adult, Gracie has rejected femininity and embraced her love of solving mysteries. An FBI agent, Gracie's appearance is distinctly unkempt, in or out of disguise. Her hair is messily braided, her clothes are baggy, her shoes "masculine," and she appears to wear no make-up. Her lack of femininity extends beyond her appearance. Rather than cooking a meal for herself, Gracie heats up a frozen microwave dinner. Her apartment is a mess, covered with obstacles over which she inevitably trips. Gracie is not in fact graceful; her name is an ironic comment on her lack of stereotypically feminine qualities. Gracie has no typically feminine interests, characteristics, or occupations. She appears to have no connections at all in the private sphere—neither friends nor family. In her spare time, she works out and practices self-defense. As Gracie tells Victor, her pageant coach, she is "the job"—she defines herself entirely through her career. As the agent of Gracie's transformation, Victor speaks for the film, telling her, "You're also a person.

And an incomplete one at that. In place of friends and relationships you have sarcasm and a gun." In essence, the film invalidates Gracie's lone cowboy, hyper-masculine identity.

Initially, Gracie rejects femininity in order to claim intelligence and agency. Gracie and Eric's discussion over Gracie's participation as an undercover agent in the Miss United States beauty pageant reveals that Gracie opposes the qualities "smart" and "pretty" and identifies on the side of "smart." First, Gracie refuses, saying: "I'm not going to parade around in a swimsuit like some airhead bimbo who goes by the name of Gracie Lou Freebush and all she wants is world peace." For Gracie, embracing femininity and "parading" oneself—displaying one's body—implies that one is an "airhead bimbo." Gracie's "feminist" rejection of femininity is made explicit in Gracie's immediate reaction to the beauty pageant: "It's like feminism never even happened, you know. I think any woman who would do this is catering to some misogynist Neanderthal mentality." Gracie literally cannot understand why any woman would perform femininity except to please men who hate women, a self-defeating position. For Gracie, at best, feminine women suffer under false consciousness; at worst, they only want to flatter and please men. When Gracie finds out that Eric has in fact assigned the cover name of Gracie Lou Freebush, she quips, "Yeah well my IQ just dropped ten points." Gracie replicates traditional patriarchal ways of thinking about feminine women, imagining them as objects. Gracie claims a stereotypically masculine identity for herself by dis-identifying from feminine women and rejecting femininity.

Despite her appearance, which implies that she is undisciplined and sloppy, Gracie is a competent agent. She figures out that "The Citizen"—the well-known terrorist in the film—is targeting the Miss United States pageant. Though Eric is given the plum assignment of leading the effort against "The Citizen," Gracie comes up with the idea to contact pageant organizers, alert them, and ask for their help. She explains that the FBI has jurisdiction over the case because "The Citizen" has been theirs from the start; however, though competent, Gracie is not recognized as such at work: Eric is made team leader, not her, largely because Gracie disregarded orders to let a suspect choke to death.

Further, despite her attempt to be one of the boys at the FBI, Gracie is still perceived as a woman and, therefore, as subordinate. In an early scene, Gracie is given the key assignment of procuring various coffee drinks for dozens of people. Though this scene is given a comic air by Gracie's intensity, her use of the siren and her badge to park illegally and cut in front of the line at Starbucks, the irony of the "urgent" assignment is undercut by the fact that Gracie is performing a very familiar role—the historically secretarial and feminine responsibility of fetching coffee. This scene shows that, first, the FBI is terribly sexist and, second, trying to look and act like a man is *not* a winning strategy for Gracie in her professional career.

"The Citizen's" threat against the Miss United States Pageant gives Gracie her first professional break. Though the Chief initially assigns Gracie to desk work as a punishment for disobeying orders, Gracie is assigned to the case because she is literally the only female agent who can go undercover at the pageant as she is the only available female agent who possesses a slender, muscled body—the pageant's feminine ideal.[17] While Gracie resists being seen as a woman, the fact that she is a woman is what gives her a break at the FBI; however, while Gracie has the necessary body, she lacks all of the other attributes of femininity. Her lack requires a makeover.

While makeovers are portrayed as pleasurable scenes of pampering and shopping in movies like *Enchanted* (Kevin Lima, 2007), *The Devil Wears Prada* (David Frankel, 2006), or *Pretty Woman* (Garry Marshall, 1990), this makeover montage portrays the pain and the costs of femininity under the guise of comedy, much like *The Princess Diaries* (Garry Marshall, 2001). Men loom over Gracie and prescribe treatments for her "bad" teeth, hair, and skin. Simply combing out her tangled hair is played as a painful ordeal. Hair is ripped off her legs, arms, and bikini area—a treatment punctuated by Gracie's screams. Her sandwich is confiscated. Though the makeover is given a humorous spin, femininity is shown as work, not a self-indulgent form of pampering.

Simply changing Gracie's appearance is not enough to make her truly feminine. Gracie's resistance is revealed when she tells Eric, "I am in a dress. I have gel in my hair. I haven't slept all night. I'm starved and I'm armed. Don't. Mess. With. Me." Rather than making her more feminine, changing her appearance has made her more belligerent than ever. The humor in this scene results from the contrast between Gracie's feminine appearance and her masculine attitude. The humor is allowed in this scene because this makeover scene is *not* the true makeover in the movie; if it were, the movie would end after this scene. Changing Gracie's appearance is only the first step in her transformation; her true transformation takes place through trying on and finally embracing femininity in the pageant.

Indeed, it is only through play-acting at femininity that Gracie makes friends with other women for the first time. In order to try on femininity, Gracie first has to distance herself from her job and her identity as an FBI agent. When the FBI suspects that Cheryl is "The Citizen," Eric asks Gracie to talk "girl talk" with her. As she removes her earpiece, Gracie quips that "I can't talk girl talk with a guy in my head—I can't even do it with me in my head." Impelled by the job, however, Gracie manages to connect with Cheryl over drinks at a club. Gracie comes to know and care for the participants through eating together, drinking together, and sharing confidences.

Through her interactions with the pageant contestants and her own experience in the pageant, Gracie discovers that smart and feminist are not necessarily opposed to pretty and feminine. Speaking of her fellow contestants near the end of the movie, Gracie says, "I realized that these women are smart terrific people

who are just trying to make a difference in the world." Rather than dismissing them for their femininity, as she did before, she can now see that they are both smart *and* pretty. Gracie stresses the contestants' attempts to change the world, implicitly arguing that objectification does not necessitate or imply the obliteration of their agency. Gracie also discovers that donning femininity does not require her to hide her intelligence or change her personality. In fact, Gracie finds that even though she doesn't have room to hide a gun in her costume, she can still demonstrate self-defense as her "talent" in the pageant and use her wit to gently mock her reluctant helper, Eric. Embracing femininity does not require Gracie to give up her strongly held beliefs that women should be able to defend themselves from violence. She can be feminine and empower women at the same time; in fact, the pageant makes it possible for her to reach many women who might otherwise never have considered learning self-defense. The binary oppositions of smart and feminist versus pretty and feminine are broken down through the second half of the movie.

Gracie's performance of femininity in the pageant transforms her on the inside and "liberates" her from bodily shame. As Victor prepares Gracie for the swimsuit competition, Gracie clutches a towel around herself and tells him: "The last time I was this naked in public I was coming out of a uterus, ok? I don't have any breasts, my thighs—I should be wearing a mumu. I have been avoiding this experience my entire life." Gracie's disgust and shame over her body are markedly evident. Indeed, bodily shame is represented as a constraint, something holding her back: she has avoided showing off her body and feels obliged to cover it up.

In postfeminist culture, being able to proudly show off one's body is understood as a position of empowerment—provided that one's body is suitably close to the ideal.[18] Through her objectification in the pageant, Gracie learns to appreciate her body. After Victor pulls the towel off Gracie and shoves her onto the stage, she poses in her bikini in front of the wildly cheering audience. The camera cuts between Gracie laughing and snorting (in a restrained way), the cheering men in the audience, largely sailors, and Victor watching proudly. By the end of the pageant, Gracie no longer fears exposing her body or laughs at herself while she parades on stage. Instead, she flawlessly executes the choreography of the pageant with poise. At the end of the film, after Gracie has solved the mystery and is back in her old clothes, she tells Eric, "I know I'm going to miss the heels because they do something to my posture. And I'm suddenly very aware and proud of my breasts." Having received adulation for her body, Gracie is freed from bodily shame. Having been appreciated for her body, she can now appreciate her body herself. Gracie is "liberated" through objectification and self-objectification; freed from the constraints of shame, she becomes an "empowered" subject.

Embracing femininity not only "liberates" Gracie, it also leads to her success in both the public and private spheres. Through gossiping with her friends, Gracie

learns the key facts that enable her to crack the case. As they primp together in the bathroom, Mary Jo (Miss Texas) tells Gracie that Kathy Morningside was only a runner-up in the pageant—until the winner got food poisoning. In addition, Kathy Morningside was fired by the network—a fact she neglected to divulge to the FBI. Further, when Morningside found out, she threw a chair through a window. Gracie explains these facts to the Chief, but he neglects to take the pageant gossip seriously because the FBI had just apprehended "The Citizen." Gracie argues that this must be a copy-cat case—after all, they found female DNA on the envelope, which goes against "The Citizen's" modus operandi. The FBI chief dismisses this possible female villain as "The Citizen's" girlfriend. Gracie, however, knows that women can be agents, which means that they can also be villains. Though the FBI disagrees with her, Gracie's engagement in femininity— primping together in the bathroom, sharing and listening to gossip—helps her to do her job.

When the FBI leaves, Gracie first petitions to stay as a private citizen, then quits her job to stay. Given that her job was her "life," Gracie's turn away from the masculine institution of the FBI is highly significant. It represents not only the prioritization of female bodies above masculine orders, but also a commitment to relationships with people previously lacking in Gracie's life. Gracie's sense of responsibility and care for her new friends gives her the courage to leave the FBI to protect them. Gracie's decision to stay can also be understood as a feminist commitment to helping women. Participating in the pageant helps Gracie grow beyond "the job."

As the FBI is no longer fixing the pageant, Gracie must make it into the top ten and then the top five on her own merit. After Victor (as part of the FBI investigation) leaves, Gracie is left on her own to prepare herself for the pageant. Gracie has no idea how to do her own hair or make-up. When Cheryl realizes that Gracie is struggling with the feminine arts, she urges the other pageant con- testants to help Gracie with her hair and make-up. Where one might expect femininity to be most competitive—at a beauty pageant—sisterhood triumphs *through* femininity. The inherently competitive nature of working on oneself to get ahead and, in this case, to literally beat out other contestants, is effaced by the sisterly support of the contestants. With their help, Gracie places second. Her achievement of femininity enables her to literally save Cheryl's life: she is close enough to grab the booby-trapped crown and dispose of it before it blows up. Gracie's successful embodiment of femininity enables her to solve the case and save the contestants.

Embracing neoliberal femininity also enables Gracie's success in the private sphere. When Gracie rejected femininity, she could be neither a sexual object nor a sexual subject. Although it is clear to the spectator that Gracie and Eric like each other—they tease, spar, and wrestle each other—neither of them can see or, perhaps, admit this attraction. Eric likes to date sexy, feminine women and Gracie basically never dates. As Gracie is transformed, Eric begins to really see her.

He acknowledges her beauty after the first, most extreme physical transformation, but Gracie cannot respond, because she is so uncomfortable in her feminine guise. Later, after Eric compliments her appearance again, Gracie teases Eric, singing, "You think I'm gorgeous you want to kiss me you want to hug me." She mocks his desire because she is afraid to express her own desire. Eric leans in as though he would kiss her, then takes a bite out of a candy bar and tells her that the Chief is more feminine than her. Later, when Gracie worries about being able to do her job, Eric reassures her that while the Chief may have chosen her because she looked the part, he chose her to be the undercover agent because she's "smart, funny, and easy to talk to." This reassures the audience that Eric doesn't like her only for her appearance. In addition, Gracie's feminine transformation leads her to recognize her desire and lends her the confidence to act on it. In the second-to-last scene, Eric congratulates Gracie on her good work. They flirt and Gracie sings her mocking song again—"You think I'm gorgeous you want to date me love and marry me"—but this time, instead of waiting for Eric to act, Gracie grabs his coat, pulls him close, and kisses him. First he pulls away, surprised—then he returns for a long and sexy kiss. Now that Gracie can appreciate her body, she can see herself as a sexual subject and object. Gracie's new-found pride enables her sexual agency and, thus, her success in the private sphere—the traditional domain of femininity—as well as the public sphere.

In addition to romantic success in the private sphere, the film frames friendship as another form of success in the private sphere—and arguably as more important. Rather than ending with the kiss between the two romantic leads, the film ends with Gracie accepting the award of Miss Congeniality. Although she loses the crown of Miss United States to Cheryl, the women bring back an old award, that of Miss Congeniality, for Gracie. Gracie is recognized as the "nicest, sweetest, coolest girl at the pageant" in Cheryl's words. The pageant ends not with women competing over who is the most beautiful, but with the contestants' recognition of Gracie as a "true friend." Gracie is finally, fully transformed in this final scene: "I never thought anything like this would happen to me. I hoped it wouldn't but now that it has I just want to say that I'm very, uh, very honored and moved and truly touched and I really do want World Peace." Like the pageant winner that she earlier mocked, Gracie is overcome with emotion; she has become one of "them." The other pageant contestants reward Gracie for her friendship and for protecting them. Gracie wins public recognition as "Miss Congeniality," as a friend and protector of women. Weaving public and private success together, this final scene highlights Gracie's transformation into a neoliberal feminine icon.

Through neoliberal femininity, Gracie can become a "complete person." Gracie is "liberated" from her constraining life as "the job." The pageant enables Gracie to grow as a person and make friends, "liberating" her from her former "feminist" distrust of femininity and feminine women. Her experience of objec-tification in the pageant "liberates" her from bodily shame and enables her to

FIGURE 6.1 "Gracie" (Sandra Bullock) finds self-confidence, success, and happiness in beauty pageant culture. Courtesy of Warner Bros./Photofest.

become a sexual agent, object, and subject. In addition to "liberating" her from her preconceptions, bodily shame, and lack of confidence, becoming feminine also enables Gracie to find love and friendship—success in the private sphere—and to solve the case—success in the public sphere. Through adopting neoliberal femininity, Gracie finds self-confidence, success, and happiness.

The film's engagement with feminism is quite complex. Feminism shapes the ideals of the movie in terms of "liberation," sisterhood, and valuing women's success, but this feminist engagement is undercut both by the explicit repudiation of Gracie's "feminism" and the ideal of neoliberal femininity (see below). Gracie initially identifies as a feminist but this "feminism" consists of rejecting and condemning femininity and feminine women rather than critiquing the system that rewards women (only) for being beautiful. Gracie's experience of empowerment through objectification undermines the feminist critique of objectification—which is taken as all of feminism. When Kathy Morningside baits Gracie, asking her if she thinks that the pageant is outdated and antifeminist, Gracie responds, "I used to be one of them," implying that she used to be a feminist but has been "liberated" from this identity; however, when Gracie uses the language of liberation to discuss how the pageant has impacted her, she draws on the language and ideals of feminism. While the film upholds the values of sisterhood and liberation, Gracie's "feminism," rather than being useful for women, is shown to be actively harmful, perhaps more oppressive than patriarchy.

The film promotes two competing ideals: neoliberal femininity and sister-hood. Where the highest good under neoliberalism is to take care of yourself so that no one else has to care for you, the highest good under sisterhood is solidarity—to help your "sisters." Where neoliberalism is fundamentally selfish, sisterhood is about reaching beyond your individual self. Neoliberal femininity may seem vaguely feminist—what's wrong with promoting self-confidence, hap-piness, and success?—but it is, at heart, an antifeminist ideal, based on disregarding structural inequality and embracing competition as the solution to all problems. Neoliberal femininity promises that it will enable subjects to better compete in all spheres of life. Under this pervasive competition, no one can be "sisters"—other women are not potential allies, but "competition"—for jobs, "scholarships" (as in the pageant itself), or men.

There is a tension in *Miss Congeniality* between sisterhood and neoliberal femininity. On the one hand, Gracie stays to help the pageant contestants and they, still unaware that she is an undercover agent, rush to help her get ready for the pageant. While Gracie's actions are understandable under either neoliberal femininity *or* sisterhood, the contestants' actions are solely those of sisterhood, when one might imagine that competition would be foremost. This resolution in favor of sisterhood seems disingenuous. The film wants to have it both ways: Gracie does not have to give up sisterhood in order to compete, because none of the women in the film are really in competition with her. The only threat to Gracie's conquest of Eric, Beth, is dealt with early in the movie and, oddly, none of the contestants are interested in Eric. Gracie's FBI team is all men and she is the only one who stays to solve the case. The only woman with whom Gracie seriously competes is the villain of the piece, Kathy Morningside. Despite the film's seeming allegiance to the importance and power of sisterhood, Gracie manages to "win" all of her competitions through her newfound neoliberal femininity: she solves the case, saves the girl, wins accolades, gets the man, and is even rewarded with the "Miss Congeniality" title. The movie promises that one can have sisterhood and neoliberal femininity at the same time—an impos-sible solution. In doing so, *Miss Congeniality* performs one of film's traditional functions, providing a fantasy solution to one of the deepest contradictions of society.[19] *Miss Congeniality* wants to have its cake, eat it, and stay slim too.

Notes

1 For all quotations from this film, see *Miss Congeniality,* directed by Donald Petrie (2000; Burbank, CA: Warner Home Video, 2004).
2 Linda Mizejewski, *Hardboiled & High Heeled* (London: Routledge, 2004), 170.
3 Yael D Sherman, "Fashioning Femininity: Clothing the Body and the Self in *What Not to Wear,*" in *Exposing Lifestyle Television: The Big Reveal*, ed. Gareth Palmer (Aldershot and Burlington, VT: Ashgate Press, 2008), 49–63.
4 Neoliberalism is a hyper-individualistic, competitive paradigm in which each individual's greatest responsibility to society is to care for herself or himself.

5 As Carole Pateman argues, under classic liberalism, women are excluded from the public sphere. *The Sexual Contract* (Stanford, CA: Stanford University Press, 1988).

6 The meaning and location of dominant femininity has shifted tremendously over the past 50 years—not to mention the past 200. Physical appearance has been an important element in defining femininity; it is now, as Rosalind Gill argues, the central element. "Postfeminist Media Culture: Elements of a Sensibility," *European Journal of Cultural Studies* 10, no. 2 (2007): 149.

7 Sandra Bartky, *Femininity and Domination: Studies in the Phenomenology of Oppression* (New York: Routledge, 1990), 38.

8 John Berger, *Ways of Seeing* (London: British Broadcasting Corporation and Penguin Books, 1990), 46.

9 Friedrich Wilhelm Nietzsche, *On the Genealogy of Morals, Ecce Homo*, trans. Walter Kaufmann and R.J. Hollingdale, ed. Walter Kaufmann (New York: Vintage Books, 1967).

10 Joan Riviere, "Womanliness as a Masquerade," in *Formations of Fantasy*, ed. Victor Burgin, James Donald, and Cora Kaplan (New York: Methuen, 1986), 35–44.

11 Susan Brownmiller, *Femininity* (New York: Ballantine Books, 1985), 221.

12 Bartky, *Femininity and Domination*; Iris Marion Young, *Throwing Like a Girl and Other Essays in Feminist Philosophy and Social Theory* (Bloomington, IN: Indiana University Press, 1990); Brownmiller, *Femininity*; Robin Lakoff and Raquel Scherr, *Face Value: The Politics of Beauty* (Boston, MA: Routledge and Kegan Paul, 1984); Naomi Wolf, *The Beauty Myth* (New York: Harper Perennial, 2002).

13 Others have theorized this moment as "postfeminist." Indeed, Angela McRobbie's description of the "postfeminist self" is remarkably like that of the neoliberal self. As Gill argues with regard to postfeminism, both postfeminism and neoliberal femininity mandate self-scrutiny and constant improvement as a kind of "pleasurable" self-empowerment. In some ways, neoliberal femininity might be understood as a postfeminist, as well as neoliberal ideal. However, neoliberal femininity cannot simply be reduced to postfeminism. Neoliberal femininity specifically names a way of governing the self in order to succeed in the public and private spheres. As a contested term, postfeminism is too broad to be used to name a specific femininity. See: Rosalind Gill, "Postfeminist Media Culture," 147–66; Rosalind Gill, *Gender and the Media* (Cambridge: Polity Press, 2007); Angela McRobbie, "Post-feminism and Popular Culture: Bridget Jones and the New Gender Regime," in *Interrogating Postfeminism: Gender and the Politics of Popular Culture*, ed. Yvonne Tasker and Diane Negra (Durham, NC: Duke University Press, 2007), 27–39; Diane Negra, *What a Girl Wants: Fantasizing the Reclamation of Self in Postfeminism* (London and New York: Routledge, 1999); and Yvonne Tasker and Diane Negra, eds., *Interrogating Postfeminism: Gender and the Politics of Popular Culture* (Durham, NC: Duke University Press, 2007).

14 Andrew Barry, Thomas Osborne, and Nikolas S. Rose, eds., "Introduction" in *Foucault and Political Reason: Liberalism, Neo-Liberalism, and Rationalities of Government* (Chicago, IL: University of Chicago Press, 1996), 10.

15 Gill, "Postfeminist Media Culture," 165–6; Ann Gray, "Enterprising Femininity: New Modes of Work and Subjectivity," *European Journal of Cultural Studies* 6, no. 4 (2003): 489–506; Valerie Walkerdine, "Reclassifying Upward Mobility: Femininity and the Neoliberal Subject," *Gender and Education* 15, no. 3 (September 2003): 237–48.

16 Wendy Brown, "Liberalism's Family Values," in *States of Injury* (Princeton, NJ: Princeton University Press, 1995), 135–65.

17 Interestingly, "feminine" technology is used to find the best agent for the job. A male FBI agent draws on his daughter's culture, the Dress Up Sallie website, to see which

7

GIRLS' SEXUALITIES IN *THE SISTERHOOD OF THE TRAVELING PANTS* UNIVERSE

Feminist Challenges and Missed Opportunities

Sarah Projansky

In 2001, Random House's children's division, Delacorte Press, published Ann Brashares's young adult novel *Sisterhood of the Traveling Pants*, featuring the lives and friendship of four teenagers: Bridget/Bee, Carmen, Lena, and Tibby.[1] The novel hit the *New York Times* Bestsellers List and quickly became a topic of media, internet, classroom, and many adults', teens', and tweens' discussions. Three more instant bestsellers followed (2003, 2005, 2007), as well as audio books and two films, the first (Ken Kwapis, 2005) based on book one and the second (Sanaa Hamri, 2008) based on books two, three, and four.[2] As a whole, the series spent 137 weeks on the *New York Times* Bestsellers List,[3] and the two films grossed approximately $86 million worldwide (excluding DVD sales).[4] Brashares's most recent novel, *Three Willows* (2009), is not part of the traveling pants series, but it is set in the same location and provides snippets of information about Tibby's and Lena's developing lives.[5] In addition, one can follow each of the characters on myspace.com,[6] join a *Sisterhood* Yahoo! group,[7] follow blogs about both *Sisterhood* and Brashares,[8] and/or browse *Sisterhood* on YouTube. In short, *Sisterhood* is much more than four books and two films; it is arguably a media "universe," similar to although not as extensive as the Buffyverse, the *Star Trek* phenomenon, or the Potterverse.[9] Like these other worldwide phenomena, *Sisterhood* is sustained by fans, critics, marketers, and the author, all of whom continue to consume, discuss, and/or extend the lives of the characters in *Sisterhood* in its many forms.

While many people enter the *Sisterhood* universe, media and marketing generally understand it to be for girls and, furthermore, to be "good" for them. "Readers guides" at the back of each book, various online sites,[10] and some scholarship[11] not only declare that the books have educational value, but also frequently celebrate the books and films in opposition to media products that

feature "mean girls" and/or do not address "real life" issues. In contrast, authors argue that *Sisterhood* features a supportive friendship among four girls and addresses issues many actual girls face (for example, parents' divorce, death of a loved one). As a result, they define *Sisterhood* as wholesome for girls as they grapple with their own processes of growing up.[12]

Media commentaries about and the marketing of *Sisterhood*'s value for girls, however, are rarely about girls' sexuality, despite the fact that *Sisterhood* addresses this issue repeatedly, exploring three of the four characters' sexuality extensively (Bee, Lena, and Tibby). Given contemporary U.S. popular culture's anxiety about and fixation on girls' sexuality, including concern regarding skimpy fashions, oral sex, and "sexting,"[13] and given that *Sisterhood* studiously avoids the titillation media paradoxically both worry about and participate in, when reviews praise *Sisterhood* for avoiding other supposedly problematic aspects of contemporary girlhood, why do they not also praise it for addressing the complexities of sexuality in girls' lives without eroticizing girls for an adult male gaze? If reviews heap praise on Brashares and the cinematic adaptations of her novels for creating characters who interact with each other in loving ways, why do they not also praise Brashares and the filmmakers for exploring girls' sexuality beyond "belly shirts" and "micro-minis"?

The answer to these questions, I would argue, lies in the particular ways in which *Sisterhood* defines girls' relationships to sexuality. Sexuality in *Sisterhood* matches neither the protectionist tone of many of the reviews (i.e., "Innocent girls should not be associated with sex!"), nor the titillation in the sexualized images of girls in much of popular culture (think: "thong underwear for preteens").[14] Rather, in *Sisterhood*, girls desire and have consensual sex. They confront loss of virginity and the possibility of unwanted pregnancy. More obliquely, as I argue here, they also consider lesbian desire and face sexual violence. Perhaps most importantly, girls' sexuality is not just one thing in *Sisterhood*. Rather, the girls enact their own sexualities in multiple ways (sometimes contradictory ones when comparing the books and films), both different from and similar to each other. In short, perhaps the reviews do not address the topic of girls' sexuality in *Sisterhood* because its complexity makes it impossible for reviews to oppose it to (worrisome) eroticized girlhood in the way that the reviews are easily able to oppose positive "friendships" to problematic "mean girls."

I develop four interrelated arguments here about this multifaceted state of affairs. First, I argue that *Sisterhood* provides sexual options for girls that popular culture generally denies them (e.g., consensual sex). Second, I argue that—in terms of the representation of sexuality—there is a disjuncture between the public reception of these highly visible texts and the texts themselves, a disjuncture that a feminist media critic can profitably interrogate in order to produce as feminist a reading of *Sisterhood* as possible. Third, I argue that, as media critics, in order to understand a media universe such as *Sisterhood*, it is imperative that we think *across* a multiplicity of texts, examining adaptation process and serial structure in order

to highlight both the reification (through repetition) and complication (through contradiction) of various versions of girls' sexuality.

From there, fourth, I argue that—despite the diversity of sexualities available in *Sisterhood*, despite the emphasis on girls' desires for and consent to sexual interactions, and despite my ability to find some critical politics in *Sisterhood*'s representation of sexuality—the universe nevertheless privileges white monogamous heterosexuality and deflects other important dimensions of girls' sexuality, such as teen pregnancy, sexual violence, and racial and sexual diversity. Specifically, focusing first on narrative, I argue that, one, *Sisterhood* reproduces traditional romance narratives about love at first sight and one true love; and, two, it depends on the narrative trope of girls' expression of sexual desire leading to overwhelming despair (i.e., punishment).[15] Furthermore, in terms of themes, although *Sisterhood* touches on sexual violence and multiple responses to teen pregnancy, because these references are indirect and/or fleeting, they require significant work on the reader/viewer's part to notice them. Finally, sexuality in *Sisterhood* belongs almost entirely to white heterosexual girls, with Carmen's sexuality (a mixed-race character with a Puerto Rican mother and ethnically unidentified blond white father) only briefly addressed in book three and film two, and lesbianism available only through an insistently queer reading that works "against the grain." Thus, girls' sexuality in *Sisterhood* is active, multiple, and nuanced; but, nevertheless, traditional narrative forms delimit it, particularly in terms of heterosexuality and whiteness.

In sum, I argue that, as a multi-text media universe that includes both repetition and contradiction among various pieces of that universe and allows for both fan and feminist reading practices that explore the critical possibilities in those repetitions and contradictions, *Sisterhood* privileges whiteness and heterosexuality, even as it opens up sexual options for girls over and against a larger popular culture that generally denies them healthy sexuality. In the end, rather than either champion or reject *Sisterhood*, rather than privilege one of these two arguments over the other, this chapter takes seriously the value of girls' sexualities and, from that perspective, asks what the *Sisterhood* multimedia universe has to offer.

Narrative Consistency: Desire, Pursuit/Consent, Loss of Virginity, Despair (Bridget and Tibby)

In both book one and film two, Bridget or Bee (Blake Lively) pursues Eric (Mike Vogel), a coach at her soccer camp in Mexico. He is older than she, and (as her instructor) is off limits. Nevertheless, from the very first day of camp she purposefully pursues him, displaying dance and athletic skills and, in particular, using her remarkable long, thick, blonde hair first to attract his attention (she shakes her hair out as she runs past him) and then to continue to entice him. In the book, she thinks repeatedly about her hair, including details

such as: "[the] ends [of her hair] grazed his chest. She wished there were nerve endings in hair."[16] In the film, she tosses her hair for Eric in point-of-view shots; and just before she leaves her cabin in order to draw Eric out of his bed, she looks in a mirror, adjusting her hair. Through this behavior, the book and film make clear to Eric and to the readers/viewers that Bridget has strong sexual desires on which she purposefully acts. Her pursuit of Eric leads to a growing friendship and then culminates in one sexual encounter, which Bee initiates and during which they have sex off-screen (film)/during a section break (book).

Despite her previous desire, after losing her virginity Bee moves immediately into despair. In the film, we hear her voiceover as she writes a letter to Lena.

> It happened just how I always imagined it would. So why do I feel this way, Lena? How can something that's supposed to make you feel so complete end up making you feel so empty? I wish so much I could talk to my mom. I need her. And that scares me.[17]

Her narration, along with her earlier actions, makes clear that she desired and instigated the sex. Her emotional pain is not about sex, but about the awareness she achieves as a result of having had sex: No relationship with anyone, no matter how intimate, can substitute for her lost mother, who committed suicide. It is her desire to "talk to [her] mom ... that scares [her]," not her feelings about sex or Eric.[18] Nevertheless, it is the fact of having sex that moves the narratives of both the book and the film toward despair. Thus, the narrative cause is sex and the narrative effect is despair.[19]

In book four and film two, Tibby (Amber Tamblyn) experiences the same narrative as does Bee—desire/consent/loss of virginity/despair. Tibby and Brian (Leonardo Nam) have fallen in love and by this time have been dating for quite some time.[20] Thus, Tibby is happy and in a long-term and emotionally satisfying relationship. When Tibby and Brian share a bottle of wine and begin to kiss, Tibby decides to have sex with him, and *Sisterhood* emphasizes this is *her* decision. In both the film and book she asks, "Do we have ...?" (i.e., a condom),[21] and Brian even double checks with her—"Are you sure?"—before proceeding. Furthermore, the book states that Brian has been "begging" Tibby to have sex, but neither the narration nor Tibby ever use the term "pressure." In other words, Brian expresses his desire, but leaves it at that. It is Tibby who makes the decision. After having sex, Tibby is fleetingly happy. In the film she chatters away while Brian is in the bathroom, and the book reports that "she wanted to stay like this forever. She wanted to sink into his body and live there."[22] She only gets a few moments of bliss, however, before Brian reports that the condom broke. Fear of pregnancy throws Tibby into despair, during which she pushes Brian away and refuses to return her friends' phone calls. After weeks of waiting for her period, she finally has the courage to ask Lena to buy a pregnancy test. Having finally found a way to rely on her friend, the despair ends when Tibby's period arrives.

FIGURE 7.1 After sex, "Tibby" (Amber Tamblyn) is happy.

FIGURE 7.2 The condom broke: "Tibby" falls into despair.

But, what is the despair about? It is not about having had sex (after all, she was momentarily in bliss), and (we learn) it is not even really about the possibility of pregnancy. Rather, Tibby goes into a tailspin because she cannot trust that someone could love her and not leave her. Having lost Baily, a girl who befriends her in book one but then dies of leukemia, and feeling as though she has lost her parents when they decide to have two more children relatively late in Tibby's childhood, Tibby presumably fears that now that she has faced and admitted her

love for Brian, he will leave her. He understands this, saying to her in the film: "You need to have a little faith, Tib. [She smiles, as sweet non-diegetic music begins.] Not everyone you love is going to leave you." Thus, as for Bee, sex moves Tibby into an emotional relationship with herself she is initially unable to handle, but which she then works through. Again, as for Bee, while sex is not the *source* of Tibby's emotional pain, it is the narrative *cause*.[23] Furthermore, the lack of changes in the adaptation of both Bee's and Tibby's stories from book to film means that this narrative trajectory—in which despair is the effect of sex—produces a particularly steadfast version of girls' sexuality in *Sisterhood*, along with, paradoxically, an insistence on girls' self-conscious desire for and consent to sex.

Narrative Variability: Love at First Sight of One's True Soul Mate/Obstacles/Happily Ever After (Lena)

For Bee and Tibby, *consistency* between book and film fortifies their despair narratives; for Lena, *variability* does the same kind of work, reifying the one-true-soul-mate narrative when this aspect of the story survives regardless of significant changes between book one and film one. That said, as I argue in more detail below, the changes between book and film do make a difference. In both book one and film one, Lena (Alexis Bledel) goes to Greece to visit her grandparents. There, she meets Kostos (Michael Rady). They are immediately drawn to each other, but they are unable to begin a romantic relationship—for reasons that vary considerably between book (misunderstanding) and film (Romeo and Juliet-esque feuding families). Nevertheless, in both texts at the end of her visit they overcome great obstacles to find a way to be together, and the book and film both imply they have found true love that will continue regardless of physical separation.

On the one hand, this is a classic romance narrative: love at first sight, obstacle to that love, resolution in the final hour, and the promise of love everlasting beyond the story's ending.[24] Thus, from one perspective, it does not matter what obstacle delays romance: any obstacle could serve as a standard conceit for a romance narrative. Yet, in this case, the obstacles themselves set different tones for the book and film and help define Lena's relationship to herself in different ways. Given that, as I discuss above in relation to Bee and Tibby, in *Sisterhood* romance and sexuality are almost always about each girl's ability to understand and be true to herself, and the difference in Lena's story between book and film is a relevant matter.

In the book, there are two obstacles to Lena and Kostos's love. First, Lena is unwilling to accept her own erotic desires. Lena, who the book often reminds the reader is a "Greek virgin,"[25] is used to boys looking at her because she is strikingly beautiful, but Kostos seems not to care. Instead, he is the perfect romantic hero, interested in her as a person and in her artwork. Kostos's interest in her then leads to her interest in and erotic desire for—but also fear of—him. Thus, the first half

of their relationship is taken up with Lena rebuffing Kostos in order to avoid facing the fact that they have fallen in love with each other at first sight and that she is drawn to him both emotionally and physically. An unfortunate event produces the second obstacle. When Lena thinks she is alone, she decides to go for a swim, despite having forgotten her bathing suit. As she enjoys the feel of the water on her naked skin, she hears a sound and sees Kostos approaching. She thinks he is spying on her, dresses haphazardly, and runs. When she bursts into her grandmother's house and declares: "Kostos is *not* a nice boy!" her grandmother assumes the worst, despite the fact that Kostos has been like a grandson to her. Let me state that a bit more explicitly than does the book: her grandmother thinks Kostos has raped Lena. Lena's grandfather storms down to Kostos's house, accuses him of wrongdoing, and assaults Kostos's grandfather (one of his closest friends). While Lena could clear up the misunderstanding immediately, she does not. Here, the two obstacles merge: Lena is unable/unwilling to set the matter right, because to do so would require her to admit her erotic feelings for Kostos. In the end, however, Lena finds the courage and strength to accept her feelings of love and desire. She apologizes to Kostos, who (of course) accepts her apology, and they spend one evening together.

In the film, Lena again ends up in the water, but the trajectory is different. Sitting on the dock sketching, Lena notices Kostos working on his boat. Interested, she leans to the side in order to get a better look, and falls into the water. This is bad enough, but her pants get caught on a piece of metal,[26] and she is trapped under water. As she struggles, Kostos swims into frame and frees her. And, thus, they meet. Lena resists the romance initially, as in the book because of her discomfort with the intensity of the attraction. When her grandmother tells her, however—in a reversal of the book—that Lena must never see Kostos again because the grandfathers are mortal enemies, Lena finds she cannot resist. After a voiceover—during which Lena says "It makes me so sad that people like Kostos and Bridget, who have lost everything,[27] can still be open to love, while I, who have lost nothing, cannot"—she strips down to her underpants and bra and dives into the water. While this beginning parallels the book's skinny-dipping scene, when Kostos arrives and sees Lena, she—rather than running—looks back and seems to invite him into the water with her direct gaze. Romantic nondiegetic music makes clear that this time Lena has chosen to be with Kostos.

The film then provides a montage of their playful romance (they ride scooters and such), but later her grandparents find her dancing provocatively with Kostos. The film cuts quickly between a close shot of Lena's grandfather (George Touliatos) spitting in Kostos's face and a close shot of Lena's dripping wet face moving quickly through the frame as her grandmother (Maria Konstadarou) pulls her by the hair up out of a bowl of water in which the grandmother is washing Lena's face. The vitriolic nature of the grandparents' behavior matches their presumption of rape in the book, but here the grandparents oppose taboo sexuality that violates

the ethnic cultural heritage of their family feud rather than oppose the (assumed) sexual assault on their granddaughter. In the end, however, Lena convinces her grandparents to let her be with Kostos by arguing, by way of analogy to her grandparents' love for each other, that she and Kostos are soul mates. She says to her grandfather: "You had that same moment once. When you met Yia Yia. And you risked everything for it. That was your chance, Papou, and I'm asking now to have mine." When he says, "Go!", Lena runs to the boat terminal, where Kostos is about to leave for university, and they are reconciled.

The shift from false accusation of rape to stereotypical Greek family feud as the obstacle to Lena and Kostos's relationship makes a significant difference in Lena's characterization. While Lena's refusal to correct the mistake in the book is excruciating, making at least this reader really hate the character, that hatred for Lena mirrors her own hatred of herself. Lena's inability to face her desires could be understood only to hurt herself (although Kostos is clearly disappointed). But, when her unwillingness to speak up means Kostos stands accused of rape, she is forced to acknowledge that by closing off from love she not only hurts herself but also hurts others—both Kostos (accused of rape) and her grandparents (believing that their granddaughter has been raped by someone they consider to be family). Thus, the (non)rape in the book raises the stakes of the narrative about Lena's eventual move toward self-acceptance. Like Bee and Tibby, in the book Lena must fully confront herself in order to move forward in her narrative. In contrast, the film spends much less time on Lena's emotional growth, providing instead caricatured depictions of a patriarchal Greek family feud, including such old-fashioned behavior as spitting in a man's face and ritually cleansing a young woman's face.

In sum, I am making a double argument here. On the one hand, the change from false assumption of rape (book) to family feud (film) is *irrelevant*. Both narratives tell the story of love at first sight of one's soul mate,[28] with the film simply substituting the obstacle of Lena's grandparents' feud for Lena's personal emotional struggles in the book. And, like Bee's and Tibby's sex-causes-despair narrative, in both book and film Lena's is a well-established romance narrative dependent on patriarchal conceptions of monogamy and chastity. The twist, here, is that all three girls have desire and agency, and the punishment of despair lasts, but not forever. In the end, regardless of narrative context, by working through their relationships to themselves, the girls achieve happiness.[29]

On the other hand, the change in Lena's narrative between book and film is *significant*, because it alters Lena's sexuality. The book provides the one-true-soul-mate narrative so that Lena can acknowledge and take ownership of her own sexual desires. In the film, Lena's achievement is to escape the patriarchal ethnic family feud in order to run toward the conclusion of the (patriarchal) one-true-love narrative. Thus, the film is more about the one-true-soul-mate narrative, itself, de-emphasizing Lena's understanding of her own sexuality. In short, in the book, Lena's sexuality (like Bee's and Tibby's) is connected to

her understanding of herself and her ability to embrace erotic desire; whereas, in the film, Lena's sexuality goes without saying; the specificity of her desires are irrelevant.

Social and Feminist Issues: Sexual Violence and Teen Pregnancy (Lena and Tibby)

Overall, *Sisterhood* studiously produces a universe in which girls express explicit desire and initiate or clearly consent to all sexual interactions and thus in which sexual violence is virtually impossible: Lena's unspoken rape is a non-rape, after all. On the one hand, this world in which sexual violence is (virtually) impossible is a pleasurable feminist utopia. On the other hand, when reviews, readers' guides, interviews with Brashares, and online discussion sites and scholarship all position *Sisterhood* as a pedagogical text available to help readers—"real girls"—deal with complex aspects of their lives, the absence of attention to sexual violence seems more like denial. Certainly, no one media universe, no matter how big, could deal with every issue relevant to girls, but here sexual violence *does* enter Lena's narrative both in book one (false rape accusation) and more metaphorically in film one (Yia Yia's aggressive cleansing of Lena's face in response to taboo sexuality), and therefore requires attention. It's not that I want to consume yet another rape narrative. Rather, I am arguing that the momentary surfacing of sexual violence in a universe in which girls' desire and consent are crystal clear reminds me, once again, that sexual violence appears in nearly *all* popular culture narratives.[30] Reading as a feminist critic concerned with the representation of sexual violence in popular culture, then, these two brief moments of sexual violence in *Sisterhood* can be understood as symptomatic. Unlike Lena, Carmen, Tibby, and Bee, however, *Sisterhood* does not deal with its own symptoms, does not take a position on the relationship between coercion and consent, and does not present a model for facing sexual violence, as it does for facing divorce and death, for example. Put another way, as I write this paragraph I cannot get out of my mind the close-up of Lena/Alexis Bledel's dripping wet face as she gasps for breath, her head pulled violently through the frame by her hair after being caught dancing provocatively with the wrong man. This link between sex (dancing) and violence (face washing) plays over and over in my mind. Usually, when I write about sexual violence, I do not describe the actual violence as I have just done here. Rather, I purposefully take an analytical approach that refuses to repeat/extend the violence in the text. But, here, I find myself describing Lena/Alexis Bledel's face in order to insist that, despite *Sisterhood*'s commitment to girls' sexual agency, sexual violence *does* exist in *Sisterhood*. And, more importantly, I want to insist that *Sisterhood* could/should have addressed girls' experience of sexual violence, but did not.

In contrast, *Sisterhood* faces teen pregnancy head-on with Tibby and Brian's broken condom. It engages, however, in the long-standing tradition

(since Roe v. Wade [1973]), of indirectly admitting that abortion and now the morning-after pill exist, but then dodging the issue when the pregnancy scare turns out to be a scare but not an actual pregnancy.[31] In the film, Brian says: "We have options"; Tibby responds, "What if I want to take it all back, the whole night?" While the use of the word "options" refers to abortion so obliquely that many readers—like Tibby—will not even notice it, *Sisterhood* does address more fully two other aspects of teen girls' experience of unwanted pregnancy: the involvement of her partner and the morning-after pill. It is Brian, after all, who refers (indirectly) to abortion; it is Brian who finds Planned Parenthood on Bleecker Street;[32] it is Brian who "found out about the pills you can take." In short, Brian takes the problem on as his own, but simultaneously acknowledges all decisions are ultimately Tibby's to make. Thus, even as Tibby sinks into despair, losing sight of her love for Brian, he emerges as an ideal feminist boyfriend, willing to carry his load without making the false assumption that Tibby's body belongs to anyone but herself. Tibby is not so feminist.[33] She ignores all of Brian's research, imagines him as an anti-feminist boyfriend, and forgets her own explicit desire for and consent to sex. *Sisterhood*, then, provides glimpses of a feminist-informed response to potential teen pregnancy, and it creates a world in which feminist choices (abortion, morning-after pill, keeping a baby) are available as choices for a teen girl, along with her access to sexual agency. By displacing that feminist consciousness onto men (Brian), however, the narrative can focus its attention on Tibby's despair. *Sisterhood* thus makes feminist options available to its audience, but spends its own time with Tibby—ignoring those options in the pursuit of self-understanding, which, when achieved, leads her back to Brian for a romantic narrative resolution.

Diversities: Multiculturalism and Lesbianism (Carmen and Bee)

Like the utopian presence of girls' sexual desire and absence of sexual coercion, race-neutral multiculturalism pervades *Sisterhood*.[34] For example, both films employ race-neutral casting, replacing the explicitly "half Mexican" Eric of book one[35] with a blond[36] ethnically-non-specified Eric in film one, and replacing a generic "Brian McBrian" (the Mc codes him as white, of Irish descent, but the book never identifies his race or ethnicity) with an Asian American actor, Leonardo Nam, as Brian McBrian in the films. Reviews comment on this, pointing out that one of the producers is Debra Martin Chase, an African American woman known for her work in girl films, including race-neutral films such as the 1997 TV version of *Cinderella*, starring African American teen celebrity Brandy, and Disney's *Cheetah Girls*.[37] "Foreign" settings for the girls' romances include Mexico and Greece, which both the books and films represent as unbelievably beautiful: for example, through unmotivated shots/descriptions of the sun setting over the water in both locations. The "diverse" casting and settings produce a multicultural and post-racist feel, then, but without actually addressing racial

FIGURE 7.3 "Diverse" casting in *The Sisterhood of the Traveling Pants* (2005). Courtesy of Warner Bros./Photofest.

politics, such as interracial romance (Bee/Eric in the books and Tibby/Brian in film two) or the role of imperialist travel in the production of romance and eroticism.[38]

It is within this context that the Puerto Rican character, Carmen, needs to be understood. As you might have noticed, in this chapter on girls' sexuality in *Sisterhood*, I have not yet discussed Carmen. While she does have an erotic romance in book three, and a flirtation in film two, romance and sexuality are not central to her stories. Of the four girls, she is the only one who does not lose her virginity in any of the books or films. Arguably, *Sisterhood* walks a line between, on the one hand, exoticizing Carmen as a "hot" Latina and, on the other, resisting that stereotypical depiction by emphasizing aspects of her life other than sexuality. For example, the books report that Carmen is mostly comfortable with her body and the "backside ... she had inherited ... directly from the Puerto Rican half of the family"[39] and that she becomes more and more popular and attractive as high school progresses. In film one, when all four girls, with their varying body types, try on the traveling pants and find that the pants magically fit all of them perfectly, Carmen (America Ferrera) articulates her difference ("you think that a pair of

jeans that fits all three of you is going to fit aaallllll of this!?""), but in a playful way, slapping her thighs and running her hands up her body. In the DVD special features, in fact, Amber Tamblyn comments on and mimics America Ferrera's performance ("aaallllll of this!?"") with pleasure and affection. In short, Carmen/Ferrera has a stereotypical Latina body/butt, but *Sisterhood* insists that both she and seemingly everyone else appreciate it and that just because she is "hot" does not mean she is promiscuous.[40] *Sisterhood* does not, however, figure out how both to avoid stereotyping her and to develop a romance about a Latina girl's sexuality. The result of this race-neutrality, then, is that sexuality in *Sisterhood* is reserved for white girls.[41]

Furthermore, that white sexuality is (almost) exclusively heterosexual. There are no openly gay or lesbian characters in *Sisterhood*, and almost every character, including many minor ones, is in a heterosexual relationship at one point or another. This dominant heterosexuality, however, does not completely preclude queer readings.[42] For example, I read part of Bee's narrative in film two as homoerotic. This reading is not obvious, however, because it depends on knowledge of book four; and thus it would have a hard time standing on its own without an intertextual interpretive practice that requires working across multiple parts of the *Sisterhood* universe.

In book four, Bee goes on an archeological dig in Turkey. There, she meets a male professor and begins a flirtation. They find they not only have similar personalities, but they also share a passion for archeology. He shares with Bee the fact that he has a wife and daughter; Bee does not share with him the fact that she has a boyfriend, Eric.[43] Eventually, they kiss, but stop short of having sex. The next day, his family arrives, and Bee goes into despair (again), although this time she works through it more quickly, finding her way back to herself and to her love for Eric. In film two, Bee goes on the same archeological dig, but meets a *female* professor. As in book four, she connects with her professor on both emotional and intellectual levels: both Bee and Professor Nasrin Mehani (Shohreh Aghdashloo) have lost loved ones and have a deep love for archeology.

On first viewing, one might expect/hope an erotic relationship would develop between Bee and her professor in the film, since this happened in the book. And, there *are* erotic moments. For example, as Bee and Nasrin sit together talking and watching their colleagues dance after a long day's work, Bee's friends call to her, and Nasrin touches Bee on the shoulder and says, "Go," to which Bee responds, "Only if you come." Bee then pulls Nasrin up by her hands and they dance, although not strictly together. In their last interaction, Nasrin sits alone on her cot (not, for example, at her desk) reading a letter Bee has written to explain her decision to leave the program early. Bee's voiceover begins: "Dear Nasrin, You deserve more than a letter."

This homoeroticism, however, does not drive the narrative; nor is it central to Bee's process of self-discovery, as is the heteroeroticism in book four. Nevertheless, I read same-sex desire in(to) the film, because the book led me to

FIGURE 7.4 "Bee" (Blake Lively) and her professor. Homoeroticism?

expect an erotic relationship between Bee and her professor and because I want *Sisterhood*'s complex construction of girls' sexualities to include same-sex desire as part of its feminist ontology. But, this is an arduous read, one that requires a queer feminist perspective, knowledge of the larger *Sisterhood* universe beyond film two, and a political desire for media to produce narratives about girls' multiple desires. In short, while *Sisterhood* strenuously insists that girls have desire and pursue and consent to sex, it barely acknowledges lesbian desire. In fact, from another perspective, I would argue that the adaptation process that transforms the professor from a man to a woman (i.e., gender-neutral casting) is a *denial* of lesbianism, similar to *Sisterhood*'s denial of sexual violence. In both cases, it requires reading across multiple parts of the *Sisterhood* universe to find even a moment of attention to these aspects of girls' experiences of sexuality.

Conclusion

What, then, does *Sisterhood* offer regarding girls' sexualities? Having made fairly critical readings above, I turn now to as generous a feminist perspective as I can muster to argue that *Sisterhood* produces a multitextual universe in which girls desire and clearly initiate and consent to sex. It links comfort with sex, love, and romance to acceptance and knowledge of one's self. It provides information about "options" when facing unwanted teen pregnancy, including the fact that there is such a thing as the morning-after pill and that you can get it by visiting a Planned Parenthood, one of which is located in the East Village of Manhattan. Furthermore, if a reader/viewer uses insistent, creative, and queer intertextual reading practices, *Sisterhood* even furnishes the possibility of accessing abortion,

a critique of a link between sexuality and violence, and homoeroticism. It also problematizes a sexualized stereotype of Latinas, although to do so it renders girls' sexuality a white-only matter.

But, I also want to make a second argument by returning to the silence about girls' sexuality in the journalistic discussion of *Sisterhood*, not to displace my first argument but to complement it. Here, I would point out that even as *Sisterhood* acknowledges and addresses (some of) the ways girls relate to sexuality, the press and educational responses have overwhelmingly ignored the potential *Sisterhood* has to provide readers/viewers with ways of understanding girls as sexual beings. Thus, arguably, at least a version of the feminist-inflected critical reading practice I used above is necessary in order to notice lesbianism in *Sisterhood*, indeed to notice *any* girls' sexuality in *Sisterhood*. In other words, if the reviews could ignore the complexity of *Sisterhood* girls' sexualities, so might a reader/viewer. From there, if I accept the idea of *Sisterhood* as pedagogical and emphasize the idea of *Sisterhood* as an ongoing multi-text universe in part produced by its fans and critics (of which I am both), I might enter the universe by saying: if Tibby were my daughter/student I would actively suggest she consider taking the morning-after pill; if Bee were my daughter/student I would encourage her to take seriously the possibility of same-sex desire; if Lena were my daughter/student I would ask her to reflect on the relationship between sexuality and violence; if Carmen were my daughter/student I would encourage her to challenge the culture in which she is racialized in such a way as to deny her sexual desire; and if all of them were my daughters/students I would urge them to imagine their sexualities outside the confines of romance narratives that punish them with fits of despair following their choice to have sex and then solve that despair by tying them to one true soul mate *forever*. Or, to put it less fancifully, if I were to teach *Sisterhood* or talk with my actual daughter and/or son about it, I would challenge my students/children both to consider the limits *Sisterhood* places on girls' sexuality and, simultaneously, to engage the multimedia, multi-text, and multi-author aspects of the *Sisterhood* universe. Having strived to do both throughout this chapter, I nevertheless choose to conclude here with the part of my argument that emphasizes that *Sisterhood* opens up girls' sexuality in ways the vast majority of contemporary U.S. media culture, including the public discussion of *Sisterhood*, does not.

Notes

1 I would like to thank Katie Sissors for her outstanding research assistance; the editors for their careful reading; and my partner, Kent A. Ono, for attentive editing and intellectual encouragement.
2 Ann Brashares, *The Sisterhood of the Traveling Pants* (New York: Delacorte Press, 2001); *The Second Summer of the Sisterhood* (New York: Delacorte Press, 2003); *Girls in Pants: The Third Summer of the Sisterhood* (New York: Delacorte Press, 2005); *Forever in Blue: The Fourth Summer of the Sisterhood* (New York: Delacorte Press, 2007).

3 "Children's Best Sellers: Series," *New York Times*, NYtimes.com, 14 September 2008.

4 Data from Box Office Mojo, boxofficemojo.com.

5 Anne Brashares, *Three Willows: The Sisterhood Grows* (New York: Delacorte Press, 2009).

6 The characters have not "posted" since November 2008, just after the film was released. "sisterhoodcarmabelle," myspace.com; "sisterhoodbee," my space.com; "sisterhoodlenny," myspace.com; "sisterhoodtib," myspace.com. All accessed 10 August 2009.

7 http://movies/groups, yahoo.com/group/tHE-sEptEmbERS, accessed 8 January 2011.

8 See, for example, review of *The Sisterhood of the Traveling Pants*, bookslut.com, accessed 10 August 2009.

9 Of course, *Sisterhood* is also of a different genre than are the Buffyverse, the *Star Trek* phenomenon, and the Potterverse.

10 For example, see Catherine Nutter, "#4052: *The Sisterhood of the Travel Pants Test*," teacher.net, 19 November 2007.

11 See, for example: John H. Bushman and Shelley McNerny, "Moral Choices: Building a Bridge between YA Literature and Life," *Alan Review* 32, no. 1 (2004): 61–7.

12 See, for example: Jill Feiwell, "Warner Puts on *Pants*," *Variety*, 2 June 2005; Dennis Harvey, review of *The Sisterhood of the Traveling Pants*, *Variety*, 31 May 2005; Cristy Lytal, "Indigo Girls: Four Rising Stars Get Some Jean Therapy in *Sisterhood of the Traveling Pants*," *Premiere*, June 2005; Claudia Puig, "*Traveling Pants* Actresses Bond Seamlessly," *USA Today*, 31 May 2005.

13 See, for example: Diane E. Levin and Jean Kilbourne, *So Sexy So Soon: The New Sexualized Childhood and What Parents Can Do to Protect Their Kids* (New York: Ballantine, 2008); Patrice A. Oppliger, *Girls Gone Skank: The Sexualization of Girls in American Culture* (Jefferson, NC: McFarland, 2008); Mary Pipher, *Reviving Ophelia: Saving the Selves of Adolescent Girls* (New York: Ballantine, 1994). Both here and throughout the chapter I draw on Amy Hasinoff's ongoing work on the mediation of girls' sexuality in U.S. and Canadian popular culture. See Amy Hasinoff, "No Right to Sext?: A Critical Examination of Media and Legal Debates about Teenage Girls' Sexual Agency in the Digital Age" (Ph.D. dissertation, University of Illinois, 2010).

14 M. Gigi Durham, *The Lolita Effect: The Media Sexualization of Young Girls and What We Can Do About It* (New York: The Overlook Press, 2008), 83.

15 Tibby even notices this narrative requirement. In *Sisterhood of the Traveling Pants 2* she says: "The problem is, every time I try to get close to someone, there is something out there that says 'Tibby's about to be happy. Better get her.'"

16 Brashares, *The Sisterhood*, 169.

17 For all quotations from film one, see *Sisterhood of the Traveling Pants*, directed by Ken Kwapis (2005; Burbank, CA: Warner Home Video, 2008). For all quotations from film two, see *Sisterhood of the Traveling Pants 2*, directed by Sanaa Hamri (2008; Burbank, CA: Warner Home Video, 2008).

18 In fact, Bee's despair is so strong it motivates her primary storyline in book two, in which she establishes a relationship with her estranged grandmother while working through her pain over her mother.

19 In her analysis of sexuality in 11 young adult novels, Amanda MacGregor discusses *The Sisterhood of the Traveling Pants* (book one), critiquing the book for punishing Bee for having sex and for avoiding the representation of the sex act itself by displacing it with a section break.

20 When we first see Brian in *Sisterhood of the Traveling Pants 2* (film two) he presents Tibby with a flower to celebrate their 10-month anniversary; and the romantic

relationship predates *Forever in Blue* (book four), having been the primary focus of Tibby's story in *Girls in Pants* (book three).

21 Brashares, *Forever in Blue*, 52.

22 Ibid., 57.

23 This narrative is repeated again, albeit quite briefly, when Lena has sex in *Forever Blue* (book four). Having (temporarily) rejected Kostos, she chooses to have sex with Leo. Although she enjoys it and does not regret her decision, she wakes up crying and realizes that she had always assumed her first time would be with Kostos. Unlike for Bee and Tibby, however, this experience does not throw Lena into a tailspin.

24 See Hilary Radner's analysis of *Pretty Woman* (Garry Marshall, 1990) for a related argument about the persistence of traditional romance narrative structures in updated women's films attempting "to reconcile a politics of sexual parity with the conventions of the marriage plot." Hilary Radner, "Pretty Is as Pretty Does: Free Enterprise and the Marriage Plot," in *Film Theory Goes to the Movies*, ed. Jim Collins, Hilary Radner, and Ava Preacher Collins (New York: Routledge, 1992), 74.

25 "Greek virgin" seems to mean prudish in this case, despite the stereotype of the sensual Greek woman on which the film plays repeatedly.

26 These are *the* traveling pants. While space does not allow me to develop this analysis fully, one could argue that the pants function as an opinionated narrational presence, "moving" the girls where they "need" to go. In this case, Lena needed to meet Kostos, her soul mate.

27 Both of Kostos's parents are dead; Bee's mother committed suicide.

28 *Forever in Blue* (book four) emphasizes the idea of one true love through Tibby's narrative, as well. While Tibby breaks up with Brian, she cannot get over him: "'Here's one thing I know,' Lena said. ... 'There are some people who fall in love over and over. ... And there are others who can only seem to do it once.' Tibby felt tears in her eyes just like she saw in Lena's. She knew Lena was talking about her and Brian. And she was also talking about herself." Brashares, *Forever in Blue*, 312.

29 For Lena, it takes all four books for her to get to the happy endpoint.

30 For evidence and development of the claim that sexual violence appears in nearly all popular culture texts, see Sarah Projansky, *Watching Rape: Film and Television in Postfeminist Culture* (New York: New York University Press, 2001).

31 For a development of this argument, see Celeste Michelle Condit, "Prime-Time Abortion: Rhetoric and Popular Culture, 1973–1985," in *Decoding Abortion Rhetoric: Communicating Social Change* (Urbana: University of Illinois Press, 1990), 123–46.

32 This is a good example of a pedagogical *Sisterhood* moment. Not only does Brian name Planned Parenthood as a useful resource following a broken condom, but he also gives the correct location. Planned Parenthood is at 26 Bleecker Street in New York City.

33 Elsewhere, I develop an argument about the recent U.S. popular culture's representation of the more-feminist-than-women postfeminist man. Brian is a perfect example of this postfeminist man. See Sarah Projansky, *Watching Rape*.

34 Kate McInally makes a related argument about "multicultural difference" in book one. Kate McInally, "Who Wears the Pants?: The (Multi)Cultural Politics of *The Sisterhood of the Traveling Pants*," *Children's Literature in Education* 39 (2008): 187–200.

35 "He had dark straight hair and skin several shades darker than hers [Bee's]. He looked Hispanic, maybe." Brashares, *The Sisterhood*, 69.

36 Reviews even comment on his blondness. See, for example, David Noh, review of *The Sisterhood of the Traveling Pants*, *Film Journal International*, June 2005, 106–7.

37 See, for example: Neil Drumming, "Something Next," *Essence*, August 2008, 62; Michael Rechtshaffen, "DVD Review: *The Sisterhood of the Traveling Pants 2*,"

Hollywood Reporter, 18 November 2008; Jessica Shaw, "Forever in Blue Jeans: *The Sisterhood of the Traveling Pants*," *Entertainment Weekly*, 10 June 2005.

38 For a discussion of Disney's race-neutral multiculturalism, see Angharad N. Valdivia, "Mixed Race on the Disney Channel: From *Johnny Tsunami* through *Lizzie McGuire* and Ending with *The Cheetah Girls*," in *Mixed Race Hollywood*, ed. Mary Beltrán and Camilla Fojas (New York: New York University Press, 2008), 269–89. For a discussion of post-racist representations in contemporary U.S. popular culture, see Kent A. Ono, "Postracism: A Theory of the 'Post-' as Political Strategy," *Journal of Communication Inquiry* 34, no. 2 (2010): 227–33.

39 Brashares, *The Sisterhood*, 17.

40 For recent analyses of the representation of Latinas in U.S. popular culture, see: Isabel Molina Guzmán, *Dangerous Curves: Latina Bodies in the Media* (New York: New York University Press, 2010); Angharad Valdivia, "Latina Girls and Communication Studies," *Journal of Children and Media* 2, no. 1 (2008): 86–7.

41 Arguably, Lena is not white. The character is the daughter of Greek immigrants, and the actor who portrays her, Alexis Bledel, is actually Latina. Nevertheless, through Bledel's *Gilmore Girls* character and public discussions, she most often gets read as "white," and that carries over here. I discuss above the role of "Greek traditional culture" in the development of Lena's story, emphasizing that *The Sisterhood of the Traveling Pants* (film one), more than the books, depends on stereotypes of traditional ethnic behavior to develop the narrative.

42 While I could read aspects of the girls' relationships as homoerotic, it is not that satisfying (for me) to do so. But, others have. For slash related to *Sisterhood* online, see girlsinpant's Journal, http://community.livejournal.com/girlsinpants/profile, last updated 29 June 2009; Sisterhood Slash, www.fanfiction.net/community/sisterhood_slash/80247, last updated 3 May 2010.

43 Bee's boyfriend is Eric in book one and film one, with whom she reconnects in *Girls in Pants* (book three).

8

MICHAEL CLAYTON (2007)

Women Lawyers Betrayed—Again

Taunya Lovell Banks

Introduction

Women comprise approximately one-half of all law students and more than 31 percent of all American lawyers, a dramatic increase since the 1970s.[1] As the number of women lawyers increases, public perceptions about them affect their professional success and credibility in the legal arena. Americans rely on mass media, including film, for 95 percent of their information about the law.[2] The big screen gives audiences larger-than-life, long-lasting images;[3] thus, it is important to study periodically the film images of lawyers. Respect for the rule of law depends largely on public perceptions of legal actors, so it is important to dissect underlying film narratives about law and women lawyers.

As their real life numbers increased in the late 1970s and early 1980s, images of women lawyers in American film became more common. These images are both anti-lawyer and anti-woman. For the past 35 years commercial films treated women lawyers harshly, focusing on conflicts between their gender and their professional life.[4] The prevalent theme in most films is that lawyering is incompatible with the traditional role of women as mothers, daughters, and wives.[5] Women in contemporary lawyer genre films tend to fulfill two roles: the sexually aggressive woman who threatens to impair the male protagonist, or the nurturing maternal woman who provides moral stability.[6]

Women film lawyers are inextricably tied to the expectations of a traditionally masculine legal profession in which aggressiveness, sharp reasoning, and even physical intimidation are honored.[7] Typically, women lawyers' professional skills are showcased through their "destructive depositions, cutting cross-examinations, thorough preparation, and aggressive negotiation style."[8] In other words, women lawyers in film remind us continually that patriarchy and law are inseparable, and

that men continue to own the power of the law.[9] Further, this masculine behavior is in juxtaposition to the general disaster that is their personal life.

Karen Crowder, the corporate lawyer in the 2007 legal thriller *Michael Clayton* (Tony Gilroy), is perhaps the most unflattering film portrayal of a woman lawyer in recent years because she has no life outside her job. The androgynous-looking Crowder (played by Tilda Swinton) has been stripped of her sex and sexuality. Yet in many respects, harking back to Laconian philosophy, Crowder is the poster child for the notion that women, unlike men, are uncomfortable wielding power outside of the private sphere. According to this narrative, insecure women will both abuse their power and corrupt it.[10] Crowder's adversary is Michael Clayton (played by George Clooney), the big firm lawyer-fixer for whom the film is named. Unlike Clayton, who betrays the corporate client by disclosing its malfeasance, abandoning his profession to regain his integrity and self-respect, Crowder's protection of her employer-client leaves her destroyed, professionally and emotionally.

This chapter asks whether the Crowder character represents a different and more damning image of woman as lawyer. Most late twentieth- and early twenty-first-century lawyer genre films portray women lawyers, unlike their male counterparts, as torn between career and home. On the surface *Michael Clayton* suggests that gender differences no longer matter in the legal arena, but closer examination discloses a different and more troubling image of woman as lawyer.

The Film

In *Michael Clayton* the protagonist, Clayton, a former prosecutor from a working-class background, is the clean-up man, the "legal janitor," for the white-shoe law firm of Kenner, Bach and Leeden. Despite his 15 years of service, Clayton is not a partner in the largest law firm in the world. As a contract worker, he is simply a cog in the firm; he has no real job security. In other words, he is expendable, and he knows it.

The opening camera shot reminds us of the law firm's size as the camera's eye pans over a seemingly dark and empty large office building leading the viewer to a brightly lit room where over 60 lawyers are frantically sorting through mountains of documents in an attempt to speedily resolve a long-term billion dollar class action suit against the firm's big client, U-North, an agro-chemical corporation. The scene ends with Marty Bach, a named partner, yelling: "Where the **** is Karen Crowder?"[11]

Crowder, we discover in the next scene, is in the bathroom having a panic attack, the armpits of her blouse badly stained with sweat. We do not know why—yet. But almost immediately we learn that she is the general counsel of U-North, and beholden, as she reminds an interviewer, to the Corporation's male CEO for her position. Alas, immediately, Crowder's credentials are suspect.

Her comments suggest that she might not have gotten her position based on her own merits.

Upward mobility in the corporate world is usually related to whether one ties "himself" to a powerful mentor.[12] For women who follow this path to success, the gender question remains—did she sleep her way to the top? Even in the film legal world there are suggestions that some women advance because they slept their way into their jobs. Carolyn Polhemus in *Presumed Innocent* (Alan J. Pakula, 1990), for example, is characterized as "a misguided, amoral lawyer who moves up in the District Attorney's office by sleeping with two of her supervising lawyers."[13] Crowder's androgynous appearance might give one pause about whether she slept her way into the job, but you never know. Sex at that level may be more about power than physical attractiveness. On the other hand, Crowder might see her mentor as a father figure whom she does not want to disappoint. Either interpretation reinforces the notion of patriarchy among the corporate powers.

Since few women lawyers at large corporations become general counsel, Crowder is an oddity—she has broken the glass ceiling. Thus the interviewer asks: "So with all that pressure and work load, how do you keep a balance between work and life?" The question is telling because it assumes that "life" and "work" are separate. One wonders whether this is an assumption that only applies to women lawyers; whether the interviewer asks men the same question; or whether societal expectations of women are different. Crowder's answer is telling:

> Balance? (laugh) I think that's something you search for your whole life, isn't it? It is a shifting balance, really. You try to (voice drifts off) When you're really doing what you want to do who needs balance, *there is your balance*, really, enjoying what you do, there is your balance.

She has become a "corporate automaton," "a workaholic whose entire identity has become collapsed with her ability to do, and be praised for, her awful job."[14] Her words are reinforced by the interspersing of scenes of Crowder in her cold grey-blue apartment bedroom, a place almost indistinguishable from a nondescript hotel room, practicing her responses to the anticipated interviewer's question, and then parroting an improved version in response to the interviewer's actual question.[15] She and Michael Clayton are in frighteningly similar positions. Her tenure at U-North is at the pleasure of the CEO, little job security. While Clayton more fully appreciates his tenuous status, Crowder is flying blind, treading water, about to drown.

Surprisingly, film critics "virtually ignored"[16] the Karen Crowder character in reviews of *Michael Clayton* until Tilda Swinton won an Academy Award for Best Supporting Actress for the role. Crowder's androgyny prevents any sexual tension from developing between her and Clayton. Her constant state of anxiety

FIGURE 8.1 Tilda Swinton as the anxious "Karen Crowder" in *Michael Clayton* (2007). Courtesy of Warner Bros./Photofest.

prevents viewers from seeing her as a truly powerful opponent to the anti-hero Clayton. Swinton says of her character:

> I think that she has looked at a lot of photographs of [Secretary of State] Condoleezza Rice … and … at the very end of the film when she's putting together her power look … said [to the hair-stylist] "I want that one." [*sic*] You know, she's an officer, a soldier and she wears a uniform. And women in those jobs unashamedly conform to a type. They have to, because you can virtually get sacked for wearing the wrong shoes in that kind of world.[17]

On the surface Crowder, U–North's point person with Kenner, Bach and Leeden, seems to exercise a lot of power. U–North is the law firm's biggest client; thus in her dealings with the firm Crowder comes across as "imperious and demanding."[18] She is also very ambitious, a careerist. But, as Swinton's comments suggest, Crowder is simply a foot soldier. Her job is to produce the results desired by the CEO, not to guide her corporate employer to the best decision. Thus the viewer gradually comes to understand why Clayton tells her near the film's end: "For such a smart person you really are lost."

Writer and filmmaker Tony Gilroy constructs Karen Crowder as a classic example of everything that can and will go wrong when women venture into the

public sphere. She is lost professionally, immensely unhappy, prone to panic attacks, and continually filmed in shades of gray and white that echo her lackluster existence. Having defined her self-worth by the performance of her less than ideal job as U-North general counsel, Crowder desperately tries to mimic the behavioral patterns of her male counterparts. In doing so, she loses her sense of reality and quickly falls into an ethical oblivion that culminates with her ordering the murder of two members of Kenner, Bach and Leeden, the Corporation's outside counsel.

Women Lawyers in Film over the Years

In many respects the negative film treatment of Karen Crowder in *Michael Clayton* is not unusual. From the very beginning, films seldom portrayed lawyers or the legal profession in a favorable light.[19] But when women are protagonists in lawyer genre films, they are defined by their relationship with their male counterparts, and often suffer consequences when they threaten the patriarchal order.[20] In most contemporary films a woman's legal career is incidental, a plot device serving as a setting for a dramatic conflict or a romantic comedy. In *Two Weeks Notice* (Marc Lawrence, 2002), for example, lawyer-activist Lucy Kelson's (Sandra Bullock) activities are curtailed by the charming and hopelessly irresponsible playboy George Wade (Hugh Grant). In *Laws of Attraction* (Peter Howitt, 2004), Audrey Woods (Julianne Moore), a successful unmarried divorce lawyer, routinely stuffs her face with marshmallow bunnies in an attempt to calm her nerves. Both films have a conventional romantic comedy ending. Kelson and Woods couple off with their respective romantic partners and find their ultimate happiness, their neurotic tendencies curtailed by relationship bliss. Consistently portrayed as lovers, mothers, daughters, and sisters, women lawyers in film face conflicts between their traditional obligations as women and the overtly male legal world.[21]

In other films, women's emotions triumph over their logic with disastrous professional results. In the 1985 film *Jagged Edge* (Richard Marquand), the first modern lawyer film that comes close to portraying women lawyers in a favorable light,[22] Teddy Barnes, a successful litigator, leaves the District Attorney's office for a lucrative associate's position at a corporate law firm. Her fancy office and stylish clothes suggest that she is a valued and empowered member of the firm, but appearances are deceiving as she is manipulated by her male colleagues into taking a case where her gender gives the client an advantage. Then Barnes's passions overcome her logic as she enters into a sexual relationship with the client, ignoring all signs that he is guilty of murder. In a poignant scene, Barnes's trusted friend asks, "Is that your head talking or another part of your anatomy?"

In many respects the plotline in *Jagged Edge* is similar to the film classic *Body Heat* (Lawrence Kasdan, 1981) where lawyer Ned Racine is so overcome with

passion for his lover Matty Walker that he loses his reason. Walker manipulates him into killing her husband, fakes her death, and escapes with her husband's estate, leaving Racine to suffer the consequences of their torrid affair alone in his jail cell. What makes the story work in *Body Heat* is that male passion overcomes conventional lawyerly logic. The plotline operates differently when women replace men as lawyers because of the stereotype that women, unlike men, are ruled by emotion, not logic. Whereas Ned Racine's overwhelming passion in *Body Heat* is exceptional, Teddy Barnes's passion in *Jagged Edge* is stereotypical.

The distorted image of women lawyers in film is fairly widespread and is the subject of frequent commentary.[23] Most women lawyers in 1980s and 1990s films are unmarried or divorced, struggling to reconcile their professional lives with their personal lives.[24] They "are compromised by the conflation of and conflict between their two identities, since embracing the male province of law challenges their traditional feminine sides."[25] The prevalent theme of these films is that women cannot exist in the legal world without sacrificing their "female self"—their roles as mother, daughter, wife, or *girl*friend.[26]

This theme reflects older societal attitudes expressed most concretely by the United States Supreme Court in *Bradwell v. Illinois* (1872) where the Court ruled that women have no constitutional right to practice law. One justice added that women's "natural and proper timidity and delicacy ... evidently unfits [them] for many of the occupations of civil life [because]. ... The paramount destiny and mission of women are to fulfill the noble and benign offices of wife and mother."[27] Early Hollywood films conveyed a similar message.

Women appeared as lawyers in early twentieth-century films like *The People v. John Doe* (Lois Weber, 1916) (with Leah Baird), *Scarlet Pages* (Ray Enright, 1930) (Elsie Ferguson), and *Ann Carver's Profession* (Edward Buzzell, 1933) (with Faye Wray), when only a few states licensed women to practice law. But these were so-called women's films, not lawyer films. Unlike the classic legal genre that features "flawed cinematic heroes," almost always men, the main themes of women's films "are sacrifice, choice, affliction, or competition."[28] Women are portrayed as competent lawyers, who often sacrifice their careers for traditional women's roles in the private sphere like wife and mother.

In *Scarlet Pages*, for example, Mary Bancroft as a young unmarried woman leaves her child in an orphanage. She initially chooses her career, sacrificing her child. Nineteen years later Bancroft is a prominent and highly competent criminal defense lawyer destined for a judgeship who agrees to represent a young dancer accused of killing her father. In the process Bancroft learns that the girl is her biological daughter, and blames herself for her client's current plight. Over the protests of the judge and the prosecutor (her love interest), Bancroft discloses that she is the girl's biological mother, securing an acquittal for her client who no longer has to protect the man she thought was her father, a man who was trying to sell her sexual services to a wealthy admirer. In the end a disgraced Bancroft

sacrifices career advancement and possibly her legal practice for her daughter—the "proper" resolution for an early twentieth-century woman.

One original advertisement for the film read: "Which Woman Was to Blame? ... The mother who forgot her child in a mad dash for fame? Or the daughter who put honor above everything else and defended it with a blazing gun?" Another ad read: "Fate turned the tables on the country's greatest woman lawyer ... and sent her kneeling at the feet of America's most notorious gun-girl."[29] The message in this and other early women lawyer films is that women cannot cross the line into the world of men without relinquishing something of their womanhood, and suffering for it.[30]

In late twentieth-century Hollywood films attempt to reconcile the tensions arising from the influx of women into the legal world and the concomitant threat to the patriarchal system by emphasizing women lawyers' descent into immorality or their unconditional need for male support and approval.[31] Reggie Love (Susan Sarandon) in *The Client* (Joel Schumacher, 1994) represents a young male client who is a surrogate for her lost children. And in *The Verdict* (Sidney Lumet, 1982) Laura Fischer (Charlotte Rampling) literally prostitutes herself in an unsuccessful attempt to win a malpractice case against the male protagonist Francis Galvin (Paul Newman).[32]

More recent films like *Legally Blonde* (Robet Luketic, 2001) suggest young women can have it all, a career, fabulous clothes, and her man, but these films are never unequivocally feminist. Instead, they "use the words of the feminist movement—choice, equality, power—but insert them into facile spaces: the choice to wear a short or long skirt ... the power to be 'in your own face' (as long as one's face is prettily made-up)."[33] Even worse, the protagonist, Elle Woods, goes to law school only to recapture the affections of her ex-boyfriend. At its best, *Legally Blonde* is little more than a modern variation of the film classic *Adam's Rib* (George Cukor, 1949) (starring Katharine Hepburn and Spencer Tracy).

Although perhaps one of the most positive woman lawyer films, *Adam's Rib* is nonetheless problematic. Amanda Bonner (Hepburn) is a competent lawyer who challenges the very foundation of patriarchy when she defends Doris Attinger, a woman who shoots an unfaithful husband. Yet the legal principle asserted in the case is grounded in traditional notions of patriarchy—men, but not women, can shoot their unfaithful lover when "caught in the act," a distortion of the paramour statutes that excused or mitigated conduct of husbands, but not wives, who shot an unfaithful spouse's paramour.[34]

In the film, Amanda is pitted against her prosecutor husband, Adam, in a virtual battle of the sexes. The filmmaker, George Cukor, ignores the several serious ethical issues raised by pairing this lawyer couple. Specifically, there is the conflict of interest between the warring spouses and Amanda's overt solicitation of the case. Instead, he used the legal battle between Adam and Amanda in the courtroom and home front as a metaphor for post-World War II America. GIs returning from the war found "new" women at home empowered by

FIGURE 8.2 Katharine Hepburn (right) as the competent "Amanda Bonner" in *Adam's Rib* (1949). Courtesy of MGM/Photofest.

their wartime jobs, creating tensions about continuing male dominance at home and work.

Adam's Rib ends with Amanda, who, after emasculating her husband in the courtroom, makes up with him, like a "good wife," admitting, albeit coyly, that maybe there are differences between men and women. Like Elle Woods, Amanda Bonner has the legal career, fabulous clothes, and her man. Yet Amanda's notion of women's equality is superficial, based on notions of gender equality grounded in sameness discourse, ignoring the real differences, biological and otherwise, of women and men. In 1949, Amanda's arguments were revolutionary and pre-date the American feminist movement of the late 1960s and early 1970s. Nevertheless, the film is not a clear statement in favor of gender equality, and this explains why looking at *Adam's Rib* today leaves us feeling that maybe meaningful gender equality is an elusive goal. Perhaps something similar is happening in *Michael Clayton*.

Karen Crowder: Woman Lawyer Lost in a Classic Legal Genre Film

Men in the late twentieth- and early twenty-first-century America encounter postfeminist women, like Karen Crowder, in the workplace. These women

are ambitious careerists, like their male counterparts, who compete, often successfully, for top positions. Karen Crowder's loyalty is to her mentor, the corporate CEO, whose approval she desperately seeks. In this respect she is no different from earlier women film lawyers. What sets her apart from other lawyers, however, is the absence of *any* life outside her job. "Her fidelity to the job is absolute—she has nothing else, after all—and she offers a frightening specter of 'zealous advocacy' taken to its logical extreme."[35] The conflict between women lawyers' two identities, a prominent plot point in earlier films, is absent in *Michael Clayton*, yet Crowder still fails to be a good lawyer. Her passion for this job replaces sexual passion, but, like Teddy Barnes, her passion causes her downfall.

Crowder's "unexcused" incompetence raises the damning possibility that women per se may be ill-suited for the world of high-powered lawyers. This is a more troubling conclusion than other lawyer films that imply that women can be competent lawyers if they reconcile the inherent tensions between their professional and personal lives. Karen Crowder epitomizes the depravity that exists once women venture from the private sphere, where they are thought to find their ultimate satisfaction, into the public sphere of the legal world. Stripped of her femininity, she is a shell of a human being with no sense of purpose, no significant personal relationships, and no redeeming personal traits. Whereas being a workaholic may be a sign of passion and dedication in a man,[36] in a woman it is portrayed as a sign of weakness. With no sense of self, she "looks to other people for answers, for confirmation of her role and identity."[37] With her entire identity defined by her performance as general counsel of U-North, Crowder does the unthinkable; she authorizes the hit on Michael Clayton and Arthur Eden, the firm's lead lawyer on the case, to prevent disclosure of an illegally concealed memorandum indicating that the corporation knowingly manufactured a carcinogenic weed-killer. This evidence would be devastating to U-North's case.

Unsurprisingly, there is no happy ending for Karen Crowder. Moments after she emerges from the corporate boardroom victorious after persuading the board to settle the class action, she is confronted by Clayton who she thought had been killed by a car bomb. Clayton baits her into offering to pay him to walk away without disclosing either her role in the death of Arthur Eden or the incriminating memorandum signed by her mentor. Underestimating Clayton, she agrees, realizing belatedly that she has incriminated herself. Knowing that she has been undone, a defeated Crowder falls to her knees. Had a man been cast in Crowder's role these actions and reactions would not seem credible.[38] Crowder's vulnerability and believability depend on her gender. As police officers approach to arrest her, Clayton, walking away, remarks to no one in particular: "See if she needs medical attention." His comment further demeans Crowder, emphasizing her position as the weaker sex.

Michael Clayton sends several messages to the viewing audience. There is a lesson about lawyers and lawyering that applies equally to Clayton and Crowder,

namely that most lawyers, even those in top positions, have no real power. They are the foot soldiers for their clients, bending the law to achieve their client's goal. In many respects the film is a modern variation of the lawyer as shyster genre, dressed up in Brooks Brothers suits. Thus, many viewers leave believing that the increased presence of women lawyers will not automatically translate into more power for women or even the possibility that women and men can share power in the legal sphere.

Finally, as I argued throughout this chapter, *Michael Clayton* tells viewers that the powerful twenty-first-century corporate/legal world in film remains a decidedly male environment ill-suited for women, even women who give their whole lives to the job. Although more women are breaking glass ceilings in the real corporate world,[39] *Michael Clayton*'s message accurately reflects another world—a Hollywood where top directing, writing, producing, and corporate positions remain over-whelmingly male domains. One cynical possibility is that it is the desire of this male filmmaking world, not reality, that we see reflected on the large screen.

Notes

1 American Bar Association, "A Current Glance at Women in the Law 2008," abanet.org.
2 David M. Spitz, *Heroes or Villains? Moral Struggles v. Ethical Dilemmas: An Examination of Dramatic Portrayals of Lawyers and the Legal Profession in Popular Culture*, 24 Nova L. Rev. 725, 726 (2000).
3 Ralph Berets, "Lawyers in Film: 1996," *Legal Studies Forum* 22 (1998): 101.
4 Cynthia Lucia, *Framing Female Lawyers: Women on Trial in Film* (Austin, TX: University of Texas Press, 2005), 19; Heidi Slettedahl Macpherson, *Courting Failure: Women and the Law in Twentieth-Century Literature* (Akron, OH: The University of Akron Press, 2007), 189; David Ray Papke, *Cautionary Tales: The Woman as Lawyer in Contemporary Hollywood Cinema*, 25 U. Ark. Little Rock L. Rev. 485, 493–6 (2003); Carole Shapiro, *Women Lawyers in Celluloid: Rewrapped*, 23 VT. L. Rev. 303 (1998); Carole Shapiro. *Women Lawyers in Celluloid: Why Hollywood Skirts the Truth,* 25 U. Tol. L. Rev. 955 (1994).
5 Stacy Caplow, *Still in the Dark: Disappointing Images of Women Lawyers in the Movies,* 20 Women's Rts. L. Rep. 55, 60 (1999).
6 Lucia, *Framing Female Lawyers,* 164.
7 Papke, *Cautionary Tales,* 491.
8 Caplow, *Still in the Dark,* 64.
9 Lucia, *Framing Female Lawyers,* 19.
10 Ibid., 13.
11 For all quotations from this film, see *Michael Clayton,* directed by Tony Gilroy (2007; Burbank, LA: Warner Home Video, 2008).
12 See, for example: Connie R. Wanberg, Elizabeth T. Welsh and John Kammeyer-Mueller, "Protégé and Mentor Self-disclosure: Levels of Outcomes within Formal Mentoring Dyads in a Corporate Text," *Journal of Vocational Behavior* 70 (2006): 398–412 (mentoring related to positive career advancement); Christina M. Underhill, "The Effectiveness of Mentoring Programs in Corporate Settings: A Meta-analytical Review of the Literature," *Journal of Vocational Behavior* 68 (2006): 292–307 (informal mentoring more effective than formal mentoring and protégés of white male mentors earn more).

13 William G. Hyland, Jr., *Creative Malpractice: The Cinematic Lawyer*, 9 Tex. Rev. Ent. & Sports L. 231, 268 (2008).
14 Stinkylulu, "Tilda Swinton in *Michael Clayton* (2007)—Supporting Actress Sundays," stinkylulu.blogspot.com, February 2008.
15 Ibid.
16 Steven Rea, "In Suit-hairdo Uniform, Tilda Swinton Becomes Legal Evil," popmatters. com, 11 October 2007.
17 Paul Fischer, "Tilda Swinton *Michael Clayton* Interview: Tilda Swinton Takes on *Michael Clayton*," girl.com.au.
18 Brian Wright, "*Michael Clayton*: The Human Costs of Corpocracy," brianrwright. com/Coffee_Coaster, 26 October 2007.
19 For a discussion of this point see Rennard Strickland, "Bringing Bogie Out of the Courtroom Closet: Law and Lawyers in Film," *Gargoyle* 20, no. 4 (Spring 1990), 4–11; Berets, "Lawyers in Film," 99.
20 Lucia, *Framing Female Lawyers*, 19. All female lawyer films have a patriarchal figure who has genuine power over the female lawyer; Caplow, *Still in the Dark*, 57. Most female lawyers have been depicted as being dependent on a male counterpart; Papke, *Cautionary Tales*, 492.
21 Papke, *Cautionary Tales*, 493–6.
22 Law professor Stacy Caplow writes: "*Jagged Edge* was a breakthrough movie because it was the first to take seriously the possibility that a woman could function as a competent professional, respected and admired by her peers, and often brilliant in the courtroom." Caplow, *Still in the Dark*, 65.
23 See, for example: Mona Harrington, *Women Lawyers: Rewriting the Rules* (New York: Plume, 1995), 151–70 (which contains a chapter entitled "Media" on the image of women lawyers in the media); Steve Greenfield, Guy Osborn, and Peter Robson, *Film and the Law* (UK: Routledge-Cavendish, 2001), 136 (film women lawyers are weak, unethical, lack judgment, and are sexually inappropriate).
24 Lucia, *Framing Female Lawyers*, 23; Caplow, *Still in the Dark*, 64.
25 Macpherson, *Courting Failure*, 207, quoting Carolyn Lisa Miller, "What a Waste. Beautiful Sexy. Hell of a Lawyer: Film and the Female Attorney," *Columbia Journal of Gender and Law* 4, no. 2 (1994): 203–5.
26 Caplow, *Still in the Dark*, 60.
27 *Bradwell v. Illinois*, 83 U.S. 130, 142 (1872) (Bradley, J. concurring).
28 Caplow, *Still in the Dark*, 60.
29 "Taglines for Scarlet Pages (1930)," IMDb.com.
30 Papke, *Cautionary Tales*, 492, quoting Harrington, *Women Lawyers*, 154. Cynthia Lucia writes: "the female lawyer may have the power to operate within the legal arena, yet her success, it seems, is contingent upon her declaiming a stronger desire for fulfillment in the private sphere of home and family"; Lucia, *Framing Female Lawyers*, 9.
31 Caplow, *Still in the Dark*, 57. "With few exceptions, cinematic women lawyers have been depicted in patriarchal roles, dependent for their success, approval or self-protection on male colleagues, mentors, or father figures." Women lawyers were generally less independent and disappointed in their work; Papke, *Cautionary Tales*, 491.
32 Lance McMillian, *Tortured Souls: Unhappy Lawyers Viewed through the Medium of Film*, 19 Seton Hall J. Sports & Ent. L. 31, 43–4 (2008).
33 Macpherson, *Courting Failure*, 207.
34 For a discussion of the Texas paramour statute see *Anthony Price v. The State*, 18 Tex. Ct. App. 474 (1885).
35 Patrick Radden Keefe, "White Shoe, Black Hat: Michael Clayton's Devastating Critique of the Legal Profession," slate.com, 19 February 2008.

36 Whereas the female lawyer merely constructs a story, the male lawyer is "far more skilled, it appears, at mobilizing law's ostensible function of delivering justice in order to keep hidden its master purpose of maintaining existing power structures." Because the male lawyer is perceived as having a higher purpose, his time and effort is rewarded. Lucia, *Framing Women Lawyers*, 149.

37 Macpherson, *Courting Failure*, 179, 194.

38 "[O]ften situations in movies are characterized as 'problems' and 'conflicts' simply because they are happening to a woman, when, if the sexes were reversed, there would be no problem at all"; Lucia, *Framing Women Lawyers*, 63.

39 On 28 May 2009 Ursula Burns, a black woman, was named as CEO of a Fortune 500 firm, Xerox. She replaced a white woman. Today, women comprise 16 percent of the top corporate office, yet 59.6 percent of the workforce in the United States. Nanette Byrnes and Roger O. Crockett, "Ursula Burns: An Historic Succession at Xerox," businessweek.com, 28 May 2009.

9

CROSSING RACE, CROSSING SEX IN GURINDER CHADHA'S *BEND IT LIKE BECKHAM* (2002)

Managing Anxiety in Multicultural Britain

Mridula Nath Chakraborty

Gurinder Chadha's *Bend It Like Beckham* entered the global cinematic space through limited release in March 2003, achieving worldwide distribution in August 2003, remaining in release for 226 days/32.3 weeks, its widest release encompassing 1,002 theaters.[1] With a U.S. domestic box-office gross of $32,543,449 and an international gross of $44,039,884, the film was hardly a blockbuster on the order of *Casino Royale* (Martin Campbell, 2006) with its $594,239,066 worldwide gross; however, in the words of Kenneth Turan of the *Los Angeles Times*, it was

> a steamroller sensation at the British box office, becoming not only the first film by a nonwhite Briton to reach No. 1 over there, but also ending up as that country's top-grossing British-financed and -distributed film ever.[2]

Labeled by the *Guardian* as the "most commercial film director of her generation,"[3] Gurinder Chadha was awarded an Order of the British Empire in the Queen's Birthday honors list in June 2006. On being offered the OBE, Chadha was not even momentarily tempted to refuse it or give it back, as Benjamin Zephaniah and Yasmin Alibhai-Brown had done recently.[4] "Quite the opposite," she says in an interview with Geraldine Bedell in *The Observer*.

> I think my ancestors would have been thoroughly pleased. One reason I got it, I think, is that I show contemporary Britain to the outside world. I'm only able to do that—my Britain is only like it is—because of the history of the last 500 years.[5]

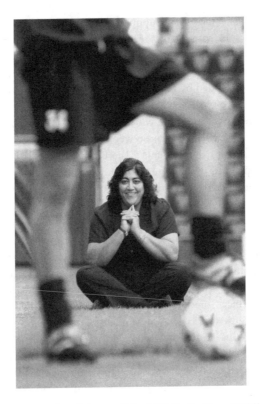

FIGURE 9.1 Gurinder Chadha, director of *Bend It Like Beckham* (2002). Courtesy of Photofest.

In the same interview, Chadha also declares that the reason that she tells stories through cinema is because her remit is "ultimately about racism. It's about the ways to diminish the impact of difference."[6] Caught between the perceived "non-Briton-ness" of the director and Chadha's claim that it is *her* Britain is the valiant attempt to "diminish the impact of difference," an attempt dear to advocates of multiculturalism and one of the reasons that the film became such a crowd-pleaser not only in the United Kingdom, but in the rest of the Anglophone world where *difference* threatens to tear apart a hegemonic social fabric.

This chapter, then, explores the film's feminist possibilities and limitations in relation to Chadha's earlier work, *Bhaji on the Beach* (1993), and argues that *Bend It Like Beckham* continues with her agenda of portraying Asian women as multidimensional figures rather than as "two-dimensional caricatures of passivity, brutalized by a backward culture and fanatical menfolk."[7] Set in Southall, London, often known as "Little India," and focusing on the dilemmas of a young woman who is a "dutiful Indian daughter and a passionate British soccer player all in

one,"[8] this "football" film draws upon a number of popular genres including female friendship and coming-of-age narratives, but, perhaps most pointedly, Shakespearean comedy, the conventions of which require the work to conclude with a restoration of order and amity. Jess (Parminder Nagra), the film's Punjabi Sikh heroine, is befriended by the Anglo Jules (Keira Knightley), the two united in their common love of soccer. Jules persuades Jess to join a local team (against her family's wishes), as a result of which she falls in love with her Irish coach, Joe (Jonathan Rhys Meyers). Torn between her desire to explore a new world (which includes a scholarship to Santa Clara University in the United States) and her love for her parents, Jess chooses both, finding a way to reconcile modernity and tradition, without denying either, in a fairytale ending.

Situating the Director: Three Genealogies

The child of migrant parents from Kenya, growing up in a Sikh Punjabi family in Southall, Gurinder Chadha began her career as a radio journalist for the BBC in 1985, during the renaissance of black British filmmaking, where black theoreticians and black practitioners exchanged ideas in highly innovative and successful workshops funded by the Greater London Council and Channel Four.[9] "Black," in this context, was a discursive category of analysis, oppositional to the racial/national essentialisms that the Empire had produced, and indicative of alliance politics between Asian and African Caribbean constituencies. But even at this time, when she was reading the influential work of Stuart Hall and Paul Gilroy, and following the cinematic practices of Isaac Julien and Hanif Kureishi, Chadha was conscious that her own specific take was "Asian," meaning that it "reflected important differences from a black African Caribbean viewpoint."[10]

Growing up in Southhall, Chadha would be familiar with that very particular site of the black British feminist movement, a site that feminist theorist Ranu Samantrai attests was "founded on conflict and was constantly troubled by the dissent of its own affiliates," which means that it needs to be differentiated from the kind of unified blackness influential male theorists were advocating as a political contingency.[11] Mark Reid analyzes "womanist cinema" of this time as a specific filmmaking practice that is "a form of resistance to raceless feminism and phallocentic pan-Africanism."[12] Chadha, thus, claims a space for the Asian within and beyond black Britishness, thereby making her work bear witness to, and record, the complex relationship between Britain and its colonized peoples from the Indian subcontinent. Her insistence not only on the plurality of her female cinematic subjects, but her investment in the very "aesthetic of conflict" arises from belonging to two worlds, two cultures, two communities, and two styles of representational politics.[13]

Chadha was also interested, right from the start, in the mainstream and the populist, so that she would be able to pack theaters in Leicester Square.[14]

She astutely confesses that her training in media meant that she knew "how to play the game—the commissioning and funding game—better,"[15] a hallmark strategy of Sikh entrepreneurship, given its protracted history of migration the world over.[16] In fact, Chadha shares with Parminder Bhachu, fellow Sikh-East-African-Indian theorist of migration, the very strong sense that diaspora is a place of enablement, a place from where fields may be played, advantageously, subversively, playfully, and always dialogically, from different positions, and where productively multiple negotiations of existing social identities may be effected.[17] Further from her home within the black British film tradition and black British feminism, Chadha is also related to feminist filmmakers of diasporic origin from the Indian subcontinent. These filmmakers, often clubbed under the umbrella term South Asian, make films that work as alternatives to mainstream cinema in their countries of domicile, and take up larger questions relating to the migration and mobility made possible by postcolonial access and the global flow of capital. South Asian diasporic cinema, in existence only since the late 1980s, seeks to address an audience familiar with, if not enamored of, what has come to be termed as Bollywood in the 1990s. In the span of the past 10 years, South Asian diasporic films have received a great fillip in the mainstream, and what is more remarkable is that some of the biggest releases have also been by feminist filmmakers: the specific examples I have in mind are by hyphenated directors of subcontinental-Indian origin from Canada and the United States, two highly successful members of what has been called the "Brown Atlantic."[18] Joining Chadha in this club are Mira Nair and Deepa Mehta, both of whom undertook serious explorations of gender and race negotiations in white-settler colonies in the early 1990s, and then went on to receive considerable worldwide box-office success in the early 2000s, by following a route that is similar to Chadha's: Nair with *Salaam Bombay* (1988), *Mississippi Masala* (1991), *Monsoon Wedding* (2001), and *The Namesake* (2006), and Mehta with *Sam and Me* (1991), the elemental trilogy: *Fire* (1996), *Earth* (1998), *Water* (2006), and *Bollywood/Hollywood* (2002). Over the past 10 years, all three have also traded their youthful trenchant politics for a more palatable cinematic fare, at the same time as the constituency that they are seen to represent, the South Asian diaspora, has also come to take its place more confidently and comfortably on the capitalist global stage.[19]

These feminist filmmakers of subcontinental Indian origin function within an oppositional framework relative to the hegemonic narrative, whether as alien/ated and marked citizens in white-settler multicultural nations who explore and expose "the dark side of the nation,"[20] or as diasporic subjects who are tied to the putative country of origin via conduits of commerce and culture, and yet challenge its hierarchical social structures. The spectacular success of their films, both as commercial and cultural artifacts, is tied to the putative ascendance of India in the global marketplace. They are playing the field at a moment when India is very much not only flavor of the month, but also threatens to own

the restaurant, so to speak, of global finance. There is an affective register in operation in their work that runs counter to any kind of overt radicalism, whether feminist or anti-racist, which is the bracket in which they are often put for cinematic discussion. In terms of circulation and reception as well, these women directors achieve widespread theatrical release for their films, instead of only a more limited release to art-house theaters, or through the film-festival circuit.

Thus my occasion here is firmly rooted in an understanding of contemporary diasporic cinema as imbricated in the transformative practices of postcoloniality and transnationality. I do not mean "transformative" in a necessarily celebratory mode, but as a practice that shifts the registers of power in order to open up modes of enquiry, and also often, perhaps, to re-inscribe them. Diasporic cinema by female directors in Anglophone multicultural nations is further haunted by that second wave question: what defines their particular feminist position—is it sexual or racialized difference that gains purchase and prominence in their practice? Despite the appeal to the "intersectionality" of race, sex, and class put forward by second wave, third world and critical race theorists, this question continues to linger interminably in the body politic of feminist studies, and is very much skin-deep in my reading practice of feminisms.

This brings me to the third lineage that I want to trace for these directors: that of feminist filmmaking. Part of the economic or educational diasporas that arrived in, and staked their claim to, white-settler multicultural nations post-1960s, this diasporic group is characterized by its access to high culture and a thorough theoretical understanding of colonial discourse and postcolonial theory, as well as world systems theory and the politics of location. Though central to the question of "race-or-sex" in Anglo-American feminist politics of the 1970s, their practice differs from the experimental filmmaking of 1970s feminists in both the United Kingdom and North America. These women directors from the Indian diaspora (which occupies a dominant hegemonic speaking position within South Asian diasporic studies) very much do the linear, content-based film and have little or no interest in the formal potential of the *avant-garde*. At this point, I heed Michelle Citron's caution that this is a false dichotomy for feminist consciousness, given that *both* forms—not only the narrative, but also the experimental—function within the idiom and ideology of patriarchal cultural production.[21] In her provocative 1988 essay, Citron explores how post-1970s feminist filmmaking went mainstream, and why the *avant-garde*, which was, for her, but "one manifestation of an almost relentless intellectual upward mobility," rendered a non-inclusive feminist language unavailable to the very constituency it was intended for, namely women.[22] Diasporic filmmakers complicate this feminist brew further by stirring in their own filmic antecedents, namely those of the Bollywood melodrama.[23] Often considered feminist, these female directors go for conventional and accepted modes of storytelling that make it possible for their productions to enter the mainstream in ways that are inaccessible for what

Citron would call a more ungraspable, nebulous, as yet unimaginable, feminist idiom.

Looking at the Film: Not Bending it Enough?

Scholarship on *Bend It Like Beckham* (hereafter, *Beckham*) has come from different quarters. It has been used to teach "cultural geography" in order to introduce students to "core concepts such as ethnicity, migration, acculturation, and assimilation," and to "explore the complex processes of social interaction that are behind both the formation of cultural identity and its interpretation by members of other groups."[24] The film has been praised, generating queer studies analyses of the ways in which it functions "as a social and cultural space where sporting bodies are made publicly in/visible";[25] it has, however, also been chastised for retreating from depicting lesbian sexuality, offering instead a comforting vision of a renovated heterosexuality.[26] The film has incited historical appraisals of how women's football or soccer pre-Independence became a site for "women's suffrage and emancipation in colonial India," and how it provided "an arena of contestation" for both anti-patriarchal and anti-colonial ideas.[27] Last, marketed in the United States as a "quirky 'chick flick,'" *Beckham* has been labeled numerous times "My Big Fat Sikh Wedding."[28] It has been compared to Mehta's box-office downer, *Bollywood/Hollywood*, and to Nair's "commercial and critical success," *Monsoon Wedding*, with all three attempting "to disrupt South Asian gender normativities of heterosexuality through challenging the dominant gendered ideologies such as female chastity and virginity, multiracial romance, and arranged marriage," while at the same time failing precisely on those counts, given that they provide "a familiar marginalization of nonheteronormative sexualities in the service of consolidating an acceptable understanding of feminist agency."[29]

In many ways, Chadha's trajectory is at one with that of the South Asian diasporic community in the global arena itself. Her portrayal of feminist agency poses necessary questions for the very state of postcolonial feminism in the contemporary neoliberal climate, and provides a space in which we might want to think of spectator pleasure in relation to women's cinema. In this context, Justine Ashby's reading of *Bend It Like Beckham* (within the frame of British postfeminism) is a useful counterpoint to the film's celebratory rhetoric: she argues that "the relationship between 'girl power,' Cool Britannia, and New Labour fostered a climate in which a coalition between postfeminist culture and Blairite politics could be tentatively sustained."[30] Tony Blair's words to Chadha, "We loved it, loved it, because this is my Britain," are an exact mirror of the filmmaker's statement that *Beckham* is a feel-good, girl-power film about *her* Britain.[31] Ashby points out that, given the film was

released in the context of racially motivated public disorders in northern English towns and cities in 2001, the election successes of the explicitly

racist British National Party in July 2002, and the widespread victimization of British Muslims following 9/11, it is difficult not to conclude that [Chadha's] choice of ending provides a highly selective, even utopian view of Blair's Britain.

Even more pointed is the departure of the two football players, Jess and Jules, to take up soccer scholarships to the United States—a development that assumes the existence of a level playing field on which postfeminist choices can take place, and be celebrated, unmediated by the extremely fraught conditions of the post-9/11 socio-political environment. Here it is worthwhile to cite Puar and Rai, who, using the film as a point of departure for a discussion of contemporary racial formations and the politics of solidarity in a post-terror era in the United States, offer reasons for its box-office success:

> The importance of a film like *Bend It Like Beckham* lies in how the too easily celebrated hybrid-diasporic-nationalist utopia produced through the film's aesthetic and soundtrack functions within the multicultural representation of diversity and intersecting histories of hegemonic struggles in Britain to produce a narrative desire for an outside space of sexual and racial freedom beyond the nation and beyond race. Through these narrative and nonnarrative processes, the movie's mode of address brings together both discourses common to hegemonic formations of race (multiculturalism, nationalist xenophobia, Punjabi "traditionalism") as well as resistance strategies (hybridity, antiracism, narrative social realism, diasporic anti-nationalism, dance, queer feminisms) of marginalized communities wanting to dismantle the supposed purity of these racial hegemonies.[32]

Beckham has enjoyed a smooth sailing since its release: it has not been surrounded by any controversy, nor has it generated any sharp divides in opinion, unlike *Bhaji on the Beach*, made 10 years ago. The story of a group of Asian women from Birmingham out for a day's frolic at Blackpool under the charge of a local feminist organization, *Bhaji* aroused anger in sections of the British-Asian community about the unflattering picture it painted of its men, and of an entrenched patriarchal structure rendered even more untenable in its diasporic existence. It also drew flak for its portrayal of a racist British society reminiscent of the Thatcher period, rather than reflecting current trends towards globalization, even though most reviews of the film were favorable. The damning portrait of masculinity in *Bhaji*, both within the minority community and the dominant majority, places the film in the same league as Steven Frears's *My Beautiful Laundrette* (1985) and Isaac Julien's *Young Soul Rebels* (1991).

Beckham is quite different in flavor: its joyous celebration of football, women's football, and, most important, the possibility of an Asian woman playing league football in Britain pushes all the right buttons: a mainstream, national sport

rendered inclusive, the feminist message of female agency and choice coexisting with the dream of love and marriage and all subversive intent from an interracial same-sex relationship safely and tamely removed from the bosom of the traditional family—all of this rendered in a manner that involves nudge-nudge, wink-wink comic relief. If *Bhaji* was an exercise in demonstrating how communities torn and transplanted from the soil of Empire could only replicate colonial racism and mutual xenophobia, then *Beckham* conducts the experiment of trying to manage the anxiety that multicultural Britain experiences vis-à-vis its ex-colonial émigrés and settlers. If *Bhaji* holds up for scrutiny the violence that patriarchy engenders in both the dominant and marginal community, then *Beckham* offers the palliative of an upbeat and optimistic resolution.

Separated by only 10 years, *Bhaji* and *Beckham* have some things in common, though: a *joie de vivre* conveyed through a great soundtrack. We want to drive coaches full of excitable, opinionated women, or kick a few footballs just from watching these films. They present an idealistic and futuristic (if still persistently heteronormative) view of interracial relationships, involving the forbidden brown and black love in *Bhaji*, and the rosier and infinitely more possible Irish–Indian romance in *Beckham*. They offer a slice of colorful, ritual-laden Asian life in Britain that contrasts with a dominant paradigm of whiteness and a community trying to contain its conflicts internally, just to come apart at the seams of femininity through female figures who function as metonyms for the nation. Last but not least, these films contain two wonderful performances by Shaheen Khan, who plays a fiery young and pushy feminist activist in *Bhaji* and a practical, conservative Indian mother, Mrs. Bhamra, in *Beckham*. But in the 10 years that have passed between *Bhaji* and *Beckham*, the nature of Asian representation in Britain has undergone a sea change. No longer able to pass off clones of television series like Vince Powell's *Mind Your Language* (1977–79, 1986), or Hanif Kureishi's *Buddha of Suburbia* (surprisingly released in 1993, too, the same year as *Bhaji*) as parodic portraits of Asians, British cinema has had to contend with the tensions of its multicultural population, as is evident in films like Udayan Prasad's serious exploration of radicalized Muslim youth in the metropolis, *My Son the Fanatic* (1998), and Damien O'Donnell's problematic and caricaturish *East is East* (1999).[33]

In *Bend it Like Beckham*, Jess Bhamra, resident of Hounslow, London wants to flout all tradition and become a football player, instead of studying to be a boring solicitor or doctor. Her mother wants her to know how to make perfect alu gobhi (you reckon it is so that Jess can feed herself in law school?), while her father mildly objects to posters of David Beckham (her hero), that "bald guy," who no doubt recalls for him punk oppressors of brown immigrants in Thatcherite England, as well as the members of the elite club who denied him membership, even though he had been the best fast bowler in Nairobi before coming to Britain. Jess's mother actually names the terms of her objection in all its historical import when she calls Beckham "that skinhead boy." Interwoven with this unlikely

sports narrative is the wedding theme, the current staple of diasporic Indian cinema, with the entire force of a resurgent middle-class heterosexual normativity behind it. In a self-reflexive moment, Jess mouths the dialogue, "I am sick of this wedding and it hasn't even started!"[34] But the audience has just begun to warm up to what it by now recognizes as "My Big Fat Punjabi wedding." Jess's older sister is getting married into a richer family in typical bourgeois social ladder-climbing mode. Jess wonders whether, in the event that she had an arranged marriage, she would be so lucky as to get someone who would let her play football. After all, "the boys never have to come home" to make full Indian dinner or get fitted for blouses that will make their mosquito-bite breasts seem like "juicy, juicy mangoes." In classic feminist mode, the mother–daughter relationship is the site of contestation about gender, ethnic, religious, and racial identity, as scenes between Parminder Nagra, who plays Jessminder Bhamra, with her mother are intercut with scenes between Keira Knightley as Juliette Paxton (Jules) and Juliet Stevenson as her mother. Mrs. Paxton's overwhelming obsession is with cleavage and the fact that all the girls she works with have bought pump-up inflatable bras for their daughters. Her own pair are most obviously the recipient of some tender loving cosmetic attention.

All through the film, Jess and Jules seem to be being marked out for the formation of a lesbian couple, from the first moment Jules watches Jess playing in the park with the boys to when they fly off together to the United States on football scholarships. Their body language, their dialogue exchange, their triangulation with the coach all suggest a familiar plot schema that points to a developing romance. The mise-en-scène of their showdown in Jules's bedroom, triggered by a drunken episode in a nightclub, is cast in stereotypical heterosexual imaginary, even though, in the theater, I am waiting for Jill Sobule's lesbian classic, "I Kissed a Girl" to light up the otherwise, and so far, inspired soundtrack. Outside of the theater, as a teaching text, *Beckham* can really be instructive as a demonstration of how to straitjacket desire to fit normative gender identity. If the film is at all about female agency mediated through desire, it lies not in Jess's determination to play football, but in Mrs. Paxton's suspicion that it is Jess who has somehow corrupted her nice English daughter. In the hilarious denouement of the film, Jules's hysterical mother orders Jess to "Get your lesbian feet out of my shoes!"

But this is a moment of postcolonial irony, not feminist emancipation or even queer triumph. Two centuries after the British codified and criminalized sex between men in India, thereby creating the strict definition of homosexuality, it is delicious to watch lesbian agency being granted to a good Indian girl. Yet, in an extremely simplistic understanding of same-sex desire, Chadha allays any fears of homosexual contamination that the filmic text may carry. Even though the only truly cringe-worthy scenes in the film are the ones between Jess and coach Joe, played by Jonathan Rhys Meyers, who has repeated the same irritating gesture in every film hence (swallowing his Adam's apple while gazing at the

heroine, be it Nagra in *Beckham* or Scarlett Johanssen in *Match Point*), I am aware that maybe 10 years back I would have swallowed it all, hook, line, and sinker. The dream of a common language between the Irish and the Indian in the jingoistic and racist British sportsfield is the flimsiest of ploys, revealing nothing of the separate and specific struggles that the nations might have respectively had in 500 years of shared history with Britain. In fact, Desai argues persuasively that the success of the contemporary diasporic Indian film lies precisely in the fact that it melds heterosexuality so seamlessly with global mobility and bourgeois consumption.[35] The United Colors of Benetton in Indian wedding hues! Throw in a great soundtrack and you have the makings of a blockbuster. Need I go on?

Feminist Visual Pleasure?

While textual analyses of films like *Beckham* are rich playgrounds for understanding what cinema does as representation and as cultural event, I have been interested foremost in something else here in this chapter—more a musing than a conclusion, something that Laleen Jayamanne identifies in her 1995 edited collection of essays titled *Kiss Me Deadly: Feminism and Cinema for the Moment* (which came out of a University of Sydney retrospective of Australian feminism in the arts as part of a Dissonance project at the Power Institute of Fine Arts held in 1991). I am very deliberately tying the moment of my chapter to a question Jayamanne asked almost 20 years ago:

> Why does a collection of essays on feminism and cinema carry the title of a famous 1950s Hollywood independent film noir by a director who had a reputation for being misogynist? ... the phrase "Kiss me deadly" encapsulates perfectly a certain local feeling of ambivalence that has been a part of the feminist project in cinema from at least the mid-80s. For those of us who came to study feminist film theory in the late 70s and early 80s in Sydney, there was, after the initial exhilaration, something like an experience of terror that the very theory that set out to explicate and transform our understanding of "Woman" in cinema was killing a certain experience of cinema. For some of us, cinema was at least as important as feminism, and there seemed to be something wrong in the way the two terms were brought together, like a kiss of death.[36]

So does cinematic pleasure run counter to feminist representation? Before I am tempted to say, in the proverbial forked tongue, "yes and no," I am also reminded of Teresa de Lauretis's 1985 essay, "Aesthetic and Feminist Theory: Rethinking Women's Cinema." De Lauretis rehearses Silvia Bovenschen's 1976 question, "Is there a feminine aesthetic?" as well as her answer: "yes and no." De Lauretis concludes that "art is what is enjoyed publicly rather than privately,

has an exchange value rather than a use-value, and that value is conferred by socially established aesthetic canons."[37] After arguing with the subject–object dialectic that posits men and women in primary binary opposition in Western epistemology, she makes the case that the "idea that a film may address the spectator as female, rather than portray women positively or negatively, seems [a] very important ... critical endeavor to characterize women's cinema as a cinema for, not only by, women."[38] We may rest our case with regard to Chadha within this tradition.

Notes

1 Data from Box Office Mojo, boxofficemojo.com.
2 Kenneth Turan, "A Soccer Film with Perfect Pitch," *Los Angeles Times*, 12 March 2003.
3 Geraldine Bedell, "Larger Than Life: Interview with Gurinder Chadha," *Guardian: The Observer*, 16 July 2006.
4 Ibid.
5 Ibid.
6 Ibid.
7 Gargi Bhattacharyya and John Gabriel, "Gurinder Chadha and the Apna Generation: Black British Film in the 1990s," *Third Text* 8, no. 27 (1994): 58.
8 Turan, "A Soccer Film."
9 These workshops were organized in response to "the uprisings and protests from the black community in the 1970s and early 1980s ... the best known of which were Black Audio Film/Video Collective, the Sankofa Film Collective, Ceddo and Retake Film and Video." Bhattacharya and Gabriel, "Gurinder Chadha," 55.
10 Bhattacharyya and Gabriel, "Gurinder Chadha," 58.
11 Ranu Samantrai, *AlterNatives: Black Feminism in the Postimperial Nation* (Palo Alto, CA: Stanford University Press, 2002), 1.
12 Mark Reid, "Dialogic Modes of Representing Africa(s): Womanist Film," *Black American Literature Forum* 25, no. 2 (1991): 375.
13 Samantrai, *AlterNatives*, 102.
14 Bhattacharyya and Gabriel, "Gurinder Chadha," 58.
15 Ibid., 57.
16 Ananya Jahanara Kabir cites theorists like Pritam Singh and Shinder Singh Thandi, Arthur Helweg, Gerald N. Barrier and A. Verne to comment upon "the 'third Punjab' of the diaspora": "From the nineteenth century onwards, the British Empire's transnational flows of labour and capital had sent Punjabis, especially Sikhs to Canada, East Africa, California, the U.K., South-East Asia and even New Zealand, making migration and entrepreneurship intrinsic aspects of Punjabi self-perception. During and after partition, this pattern of outward movement offered Punjabis of all religious backgrounds the already established 'third Punjab' as a space of rehabilitation and reconstruction alternative to the new nations of Pakistan and India." Ananya Jahanara Kabir, "Musical Recall: Postmemory and the Punjabi Diaspora," *Alif: Journal of Comparative Poetics* 24 (2004): 177.
17 Parminder Bhachu's book *Twice Migrants: East African Sikh Settlers in Britain* (London: Tavistock Publications, 1985) traces the itinerary of migration to which Gurinder Chadha belongs.
18 In her book *Beyond Bollywood*, Jigna Desai uses the term "Brown Atlantic," referring to Paul Gilroy's *The Black Atlantic* as a means of problematizing his use of the term "black" in this same volume, suggesting the controversial nature of both terms, "brown"

and "black." Jigna Desai, *Beyond Bollywood: The Politics of South Asian Diasporic Film* (New York and London: Routledge, 2004), 21; Paul Gilroy, *The Black Atlantic: Modernity and the Double Consciousness* (Cambridge, MA: Harvard University Press, 1993).

19 Jayne Caudwell traces the reception of *Bend It Like Beckham* by mainstream audiences in the United States and the United Kingdom. Jayne Caudwell, "*Girlfight* and *Bend it Like Beckham*: Screening Women, Sport, and Sexuality," *Journal of Lesbian Studies* 13, no. 3 (2009): 258, 259.

20 From Himani Bannerji's important work on multiculturalism, nationalism, and gender in her 2000 collection of essays titled *The Dark Side of the Nation*. Himani Bannerji, *The Dark Side of the Nation: Essays on Multiculturalism, Nationalism, and Gender* (Toronto: Canadian Scholars Press, 2000).

21 See Nichols's important revisionist discussion of the "false division between the avant-garde and documentary that obscures their necessary proximity." Bill Nichols, "Documentary Film and the Modernist Avant-Garde," *Critical Inquiry* 27, no. 4 (2001): 581.

22 Michelle Citron, "Women's Film Production: Going Mainstream," in *Female Spectators: Looking at Film and Television,* ed. E. Diedre Pribram (London: Verso, 1988), 48.

23 Indian film theorists have argued persuasively that the genre of Bollywood melodrama takes on the task of both delineating as well as interrogating the charge of a postcolonial nation-state. See, for example, discussions about Bollywood melodrama and the postcolonial nation-state in, *Bollywood and Globalization: Indian Popular Cinema, Nation, and Diaspora,* ed. Rini Bhattacharya Mehta and Rajeshwari Pandharipande (London, New York, Delhi: Anthem South Asian Studies, 2010).

24 Katie Algeo, "Teaching Cultural Geography with *Bend It Like Beckham*," *Journal of Geography* 106, no. 3 (2007): 133.

25 Caudwell, "*Girlfight*," 255–6.

26 Michael Giardina, "Bending It Like Beckham in the Global Popular: Stylish Hybridity, Performativity, and the Politics of Representation," *Journal of Sport and Social Issues* 27 (2003): 65–82; Mandy Treagus, "Not Bent At All: *Bend it Like Beckham*, Girls' Sport and the Spectre of the Lesbian," *M/C: A Journal of Media and Culture* 5, no. 6 (2002), retrieved from www.media-culture.org.au/0211/beckham.php.

27 Boria Majumdar, "Forwards and Backwards: Women's Soccer in Twentieth-century India," *Soccer and Society* 4, no. 2 (2003): 84, 83.

28 Justine Ashby, "Postfeminism in the British Frame," *Cinema Journal* 44, no. 2 (2005): 131.

29 Desai, *Beyond Bollywood*, 212, 213–14.

30 Ashby, "Postfeminism," 129.

31 Tony Blair, quoted in Ashby, "Postfeminism," 131.

32 Jasbir K. Puar and Amit S Rai, "The Remaking of a Model Minority: Perverse Projectiles Under the Specter of (Counter)Terrorism," *Social Text* 80, vol. 22, no. 3 (2004): 76.

33 See Jigna Desai's exhaustive work and excellent bibliography on South Asian diaspora. Desai, *Beyond Bollywood*.

34 For all quotations from this film, see *Bend It Like Beckham*, directed by Gurinder Chadha (2003; Burbank, CA: Warner Home Video, 2003).

35 Desai, *Beyond Bollywood*, 159–91.

36 Laleen Jayamanne, "Introduction," in *Kiss Me Deadly: Feminism and Cinema for the Moment,* ed. Laleen Jayamanne (Sydney: Power Publications, 1995), 3.

37 Teresa De Lauretis, "Aesthetic and Feminist Theory: Rethinking Women's Cinema," in *Female Spectators: Looking at Film and Television,* ed. E. Diedre Pribram (London: Verso, 1988), 176.

38 Ibid., 182.

10

SPEAKING THE NAME OF THE FATHER IN THE NEO-ROMANTIC COMEDY

13 Going On 30 (2004)

Hilary Radner

The film *13 Going On 30* (Gary Winick, 2004) illustrates what Joyce McDougall calls "a new or modern narcissism."[1] In particular, the film elucidates how "the absent father" in contemporary romantic comedies suggests the generation of a narcissistically fragile feminine subject for whom "the Name of the Father," in Lacanian terms, is only tenuously established. While cinema is not a direct reflection of contemporary spectators' conditions, it may suggest some of their concerns and may thus offer valuable insight into aspects of contemporary psychic conditions and their vicissitudes. In the case of *13 Going On 30*, the film articulates concerns that may illuminate the predicament of contemporary young women seeking to establish an ethical framework by which to understand their choices.

Psychoanalysis and Cinema

This chapter explores the confluence of two strands of inquiry that have marked twentieth-century thought and culture: one, the development of psychoanalytic therapeutic theory after Freud, and two, the evolution of the Hollywood romantic comedy. In one sense, this could be seen as an idiosyncratic encounter; however, both cinema and psychoanalysis, particularly as a therapeutic practice, constitute ongoing "conversations" within a social field about the problems, perambulations, and vexations of a specific, historically defined subject—most often understood as "the individual."[2] Historically, these vexations center with special regularity upon the subject as it is defined through a set of familial relations that revolve around a father, a mother, and a child, in which siblings and other members of an extended family may serve as "doubles" for any point in the triangle. Importantly, this "Oedipal" triangle, which Roland Barthes posited in the

1960s as the generative matrix for narrative itself, has become increasingly less prominent in both psychoanalytic theory and the romantic comedy in the course of the late twentieth century and early twenty-first century.[3]

Psychoanalytic theory, under the influence of analysts and researchers such as Anna Freud, Melanie Klein, D.W. Winnicott, Daniel Stern, John Bowlby, and Heinz Kohut, as well as less well-known figures like Joyce McDougall, has tended (particularly since World War Two, and with increasing intensity since the 1960s and 1970s) to focus on the relations between the child and the mother—views bolstered by the growing influence of second wave feminism in the 1960s and 1970s.[4] This chapter proposes to look at how considering the place of the mother "as the external object par excellence"[5] illuminates the articulation of the family in what I call the neo-romantic comedy, or "girly film" (those romantic comedies that accompany "chick lit" as part of the proliferating consumer culture for women generated over the past two decades). Taking the popular Hollywood film *13 Going On 30* as an exemplary instance, this analysis will demonstrate the ways in which it might be claimed that films for women are characterized by a disappearing father whose absence produces the "new or modern narcissism" identified by McDougall.[6]

While I am mindful of the fact that the gulf between cinematic representation and human experience is incommensurable, I argue that it is, nonetheless, useful to examine representations of the family within popular culture because of its ubiquity and accessibility. Though popular culture neither determines nor even necessarily reflects human experience, it does offer a vocabulary through which its viewers may come to understand and discuss their experiences—hence it would be imprudent to ignore the paradigms that popular culture offers those viewers if we wish to enter into the wider conversations of culture. I put forward here that we consider whether or not we might wish to talk about a new feminine subject—I use this term to suggest a chronology rather than a shift in perspective or philosophy (though this may be the case), which acknowledges that femininity also has a history. Indeed, I argue that there is a group of films, which I call "girly" films, that arise as part of a popular response to second wave feminism, and which are often grouped together under the rubric of post-feminism or what I have called elsewhere "neo-feminism."[7] *13 Going On 30* exemplifies certain trends that distinguish these contemporary films from other films made with a view to the woman's audience, such as those produced during the Classical Hollywood period.

The "Girly" Film

Stylistically, girly films do not offer a body of work bound by formal permutations that are associated with a specific genre or a specific narrative formula. In the girly film—films such as: *Pretty Woman* (Garry Marshall, 1990); *Sabrina* (Sydney Pollack, 1995); *Romy and Michelle's High School Reunion*

(David Mirkin, 1997); *Legally Blonde* (Robert Luketic, 2001); *Maid in Manhattan* (Wayne Wang, 2002); *Something's Gotta Give* (Nancy Meyers, 2003); *Le Divorce* (James Ivory, 2003); *13 Going On 30*[8]—the generic conventions of the romance may provide a significant narrative structure (often the defining narrative structure). Nevertheless, only a few of these films are romantic comedies in the strict sense. The aspects of these films that unite them revolve around: (1) the way in which the heroine herself is defined, in particular as a sexual subject; (2) a shift away from melodrama to romantic comedy as the primary structural vehicle for the feminine narrative, resulting in the predominance of hybridized narrative forms; (3) the creation of a set of narrative tropes that function for thematic purposes like medieval "commonplaces," being repeated from film to film, more or less obviously.[9] These "commonplaces" are tied to social developments surrounding the feminine subject and the heterosexual couple in the wake of second wave feminism, and also to the larger technological and economic environment of the late twentieth century and early twenty-first century. The commonplace that I refer to as the "disappearing" father crucially re-positions the feminine subject vis-à-vis what is referred to as "the Name of the Father" (see below). Through the manipulation of this commonplace, the maternal bond between mother and daughter is emphasized (another commonplace), while the father is, by and large, a ghostly figure.

Concomitantly, in the first half of the twentieth century, sexologists moved from a position developing out of the Doctrine of Separate Spheres, which posited women and men as having different, complementary sexual needs, to a view of human sexuality in which men and women, heterosexuals and homosexuals were equivalent in their needs and satisfactions. These paradigm shifts paved the way for radical theories of sexuality advocated during the 1960s and 1970s, in which the heterosexual male was the disadvantaged party, and the orgasm was the common coin. It was no longer possible to posit unquestioningly heterosexual coitus as the apex and norm of human sexual experience. In the case of women, if the orgasm were to be used as the measure of satisfaction, sexologists such as Masters and Johnson determined that, in fact, heterosexual intercourse was rarely the best means of gaining it. One might argue that the masculine role within the home as part of the intimate life of the family was called into question at the same time as was his role in satisfying his partner in the couple. Men, it was felt by the most vocal and more intellectual proponents of second wave feminism, had very little to do with women's happiness, as either husbands or fathers.[10] Not coincidentally, during the late 1970s and early 1980s romantic comedy made itself very scarce on the Hollywood screen.[11]

The Name of the Father

One strand of psychoanalytic theory that has continued during this period to focus on the father is that inaugurated by controversial French psychoanalyst

Jacques Lacan, through, in particular, GIFRIC—Groupe Interdisciplinaire Freudien de Recherches et d'Interventions Cliniques et Culturelles. Unlike the majority of researchers and therapists dealing with mother/child relations, who underline the embodied, phenomenological dimension of "mothering," the Lacanians stress the father as a concept, representing language itself. "[T]he father is purely a signifier," claims clinician Lucie Cantin.[12] What Cantin seeks to emphasize here is the way that the father has a fundamental symbolic function that may be considered independently of his biological role. Jean Laplanche and J.-B. Pontalis explain in *The Language of Psycho-analysis*:

> When Lacan speaks of the symbolic father, or of the Name-of-the-Father, he has an agency in mind which cannot be reduced whatever forms may be taken by the "real" or the "imaginary" father—an agency that promulgates the Law ... a Law on which the symbolic order is based.[13]

The notion of the Name of the Father in Jacques Lacan should be understood in relationship to his idea that the unconscious is structured like a language, and that the "language-ness" of the unconscious is guaranteed by the Law and its representative, whom he calls the Name of the Father. Without the Law, the unconscious runs wild—resulting in various forms of psychotic behavior in which an offending object, for example, is projected upon the "real" (what might be commonly called, for example, a hallucination). In other words, without the Law, there can be no distinction between the outside and the inside—between perception and hallucination. This can also be understood in terms of "the cut"—as suggested by Richard O'Neill Dean—the traumatic separation of mother and child, between outside and inside.[14] The father function cuts, separates, the child, the *infans*, or subject before speech, from the mother to which it was bonded through a mechanism described by Lacan as the Mirror Stage (which he locates in the Imaginary). In this early stage, Lacan assumes that the child does not distinguish between himself or herself and the mother—they are as one in a state of hallucinatory or imaginary "fullness."

Within this theoretical framework, the father is the agent of the Law and of the Symbolic and, in this sense, he is the agent of Castration. Again, Lacan's notion of castration is not about the literal loss of the sexual organ, though it may be expressed in these terms by certain subjects. Castration is fundamentally about the separation of the child from the mother, of the deflating of the child's imagined oneness with her.

Castration as separation is inherently bound to language in Lacan's thinking—to the cut. Here, Lacan borrows from the linguist Ferdinand de Saussure. Language is based on absence, in particular the absence of the thing represented. A sign cannot "be" that which it represents. For example, a chair is not the sign of a chair—it is a chair. A sign of a chair tells us that there were chairs and that there will be chairs—but it is not a chair. Similarly, a sign always represents

something beyond what it *is*, a way of ordering the world that is bound up in culture, in collective thinking, in language.

According to Lacan, we need a name for the Mother, when she is not there, or rather here, when she is absent. The absence of the mother, the child's recognition of her absence and her essential separateness, first calls forth language. Lacan relies heavily on Freud's discussion of the the *Fort/Da*, a child's game in which the child throws a spool away, and draws it back on a string, repeating the words "there" and "here." Freud observed children engaging in these kinds of games with rapt and sustained attention.[15] For Lacan, this action represents a crucial moment in which the subject assumes "lack" (and its trauma) as a foundational instance in the construction of the subject as a subject in language. The child, according to Lacan, and to Freud, is rehearsing the alternation of presence and absence. The child accepts "absence" and, as a result, can know "presence." The child, through language, comes to control or channel this initial trauma. Retrospectively, this initial assumption of lack is translated into "castration" at the Oedipal stage, leaving open the possibility alluded to by Lacan himself that the association Law/phallus/castration is culturally produced, while the initial assumption of loss, the narcissistic wound of separation and language, is not—in so far as speaking is the mark of the human.[16]

Cantin explains: "The law of the father is what represents, for the child, the law of culture—what culture imposes, allows or forbids, in establishing the conditions of everyone's satisfaction in coexistence."[17] Cantin ties the law of the father to the idea of "an irreducible lack that is inherent to language and to culture and cannot be filled."[18] At certain points, Lacan refers to this lack as generating an ethics of desire—in which the subject must desire, while realizing that this desire can never be totally fulfilled. This entails not only the recognition of limits, but also the survival of desire, necessitating a delicate balance. This desire, however, cannot be at odds with the desire of the Other for the child. In other words, if, for example, the mother wants something for the child that he or she does not want for himself or herself, the child can become paralyzed, unable to try.[19]

Cantin gives us the case of Myriam to illustrate her point. Myriam's mother dreamed of becoming a dancer—a dream that was not fulfilled. This lack of fulfillment was unbearable to Myriam's mother who thus projects her failure onto Myriam—who accepts this projection. She (Myriam) must become the failure so that her mother is relieved of this burden. Thus, at the point at which Myriam begins to enjoy success as a dancer, she becomes "ill," which arrests her progress—she is the failure her mother desires her to be. Myriam can no longer "try."

Because the mother herself cannot "assume her lack,"[20] she will not allow the father to play his role (he enjoys professional and public esteem) within the family of laying down the "law" that would require that Myriam live out her own failures and successes, rather than those of her mother. The father is unable to

perform as the agent of the Law. Cantin explains: "the position of the father is strictly linked to the place that it receives in the mother's discourse."[21] By this, Cantin does not mean the father as an individual, but his social (rather than biological) role, the "father function," in establishing and safeguarding the place that should be accorded the discourse of culture, language, the symbolic, etc., within the mother's discourse. Without the "father function," the "illusion of a self-sufficient maternal universe" is presented to the subject who is thus unable to assume her own desire, because in the eyes of the child it is the father who has failed, and not the mother.[22]

Here I propose to examine how this notion of the father illuminates the place accorded to the father in the neo-romantic comedy (those romantic comedies that accompany chick lit as part of a renaissance of feminine culture over the past 10 to 15 years). Indeed, in terms of this ongoing conversation about the family within the social field of cinema, these romantic comedies have something significant to say; though romantic comedy makes a come-back in the late 1980s and the 1990s as the neo-romantic comedy,[23] and continues to play a dominant role on today's screens, these romantic comedies tend to focus on the mother. The absence of the father has an important impact on how the narrative articulates its symbolic structure and the place that it accords the feminine subject.

In contradistinction, the screwball comedy of the 1930s often downplayed the role of the mother (as in *Philadelphia Story*, George Cukor, 1941) or dispensed with her altogether (as in *It Happened One Night*, Frank Capra, 1934). If the father does appear in the contemporary romantic comedy, he rarely holds a position of authority or influence. In other words, it is no longer possible to talk with any consistency about a "patriarchal order" expressed through the "hetero–normative couple" within the neo-romantic comedy. The 2004 romantic comedy *13 Going On 30* (*Suddenly 30* in the Australian market) offers a clear illustration of how the father is sidelined.

13 Going On 30

The film opens in 1987. Its protagonist, Jenna Rink (Jennifer Garner), persecuted by the "in-girls," rejects her nerdy best friend Matt and wishes she were "thirty, and flirty and thriving." With the help of magic wishing-dust given to her for her thirteenth birthday by Matt, she is transported to 2004, a 13-year-old trapped in the body of a 30-year-old editor of a women's magazine, *Poise*. She awakens one morning to find herself an adult, with no memory of the intervening 17 years. In an effort to get her bearings, she looks up her old childhood friend, Matt. She explains her dilemma: "I was sitting in my closet and I skipped everything. It's like a weird dream. I can't remember my life."[24] In the course of the film, she discovers that the person she has become (the person that she wanted to be) is not the person that she wants to be. Matt comes to represent her desire, an unfulfilled

wish—because, although she claims she has everything she wanted, she does not have Matt: they have lost touch.

This plot of self-discovery is complicated (and mirrored) by a crisis in Jenna's career. The magazine for which she is employed is steadily losing its readership. While planning a new format for the magazine (that parallels the new format she constructs for her "self"), Jenna breaks up with her boyfriend, a crass ice hockey player interested only in sex, studies magazine editing, and, most importantly, severs her relationship with Lucy, who had replaced Matt as her best friend during the forgotten years. With the help of Matt, now a professional but unsuccessful photographer, Jenna re-invents the magazine by returning to the values she left behind—manifested through her high school yearbook (largely shot by Matt), which represents some of the years (the best ones?—the worst ones?) that she has skipped, between the ages of 13 and 18. She, in her own words, "needs to remember what used to be good." At the heart of this project of remembering is an *aporia*, an absence, that cannot be filled through memories because these are precisely the years that Jenna never "lived." She cannot remember, she can only imagine. Fantasy, then, lies at the center of what it means to remember what used to be good in Jenna's "theater of the mind."

In the film's conclusion, Lucy steals Jenna's plans (her "re-enactment of the past that never was" and the photographs that document that re-enactment).

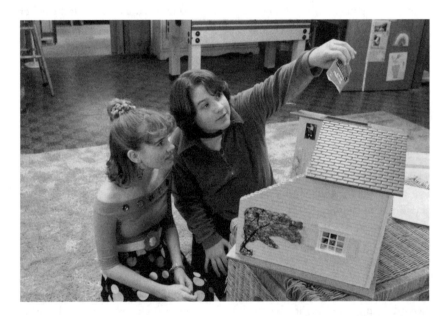

FIGURE 10.1 The young Matt and Jenna with the Dream Doll House in *13 Going On 30* (2004). Courtesy of Photofest.

She gives them to *Sparkle*, *Poises*'s competitor magazine, in exchange for a position as editor-in-chief. The viewer is given to understand that this betrayal signifies the demise of *Poise* and the end of Jenna's career. Jenna runs off to find Matt who is about to marry, and attempts to interrupt the wedding. Matt refuses, but does give her back the Jenna Dream Doll House that he made for her 17 years earlier (which she had apparently rejected).

In this first ending of the film Jenna is left alone with the Doll House. Some of the wishing-dust that originally transported her into the future lingers on the Doll House. With its help Jenna is transported back into the past into the closet where her journey began. Here, she rejoins Matt at the age of 13. This time, instead of rebuffing his advances, she plunges headlong into an embrace, lying full-length upon his body—to which he responds, when she is kissing him passionately, that she certainly knows what she is doing. She runs out of the room dragging him behind her, saying that they will be late. The film then cuts to a second ending, in which, this time, it is Jenna and Matt who marry. The film closes as Jenna moves into her dream house, a pink suburban home with a nostalgic feel.

This second magical, thus impossible, ending underlines desire as founded in loss or lack. In the first ending, Matt and Jenna come to terms with this impossibility. Matt, in particular, realizes that maturity is found in the acceptance of loss, which enables him to marry another woman, one whose attractions are not rooted in a regression into a past that never was. This acceptance of loss, in particular the loss of Jenna, representing a specific type of object for him, is articulated in terms of an ethical decision in which Matt clearly (in the film's terms) makes the right choice. Jenna, however, is not yet able to assume that ethical position equated by Lacan with the Name of the Father. Jenna begins that painful process but, in essence, refuses it by re-creating another fantasy ending that denies her irretrievable loss. She attempts to understand her mistake and retrieve what she has lost, to achieve a "do-over." While this attempt at retrieval may be considered a first step towards the construction of a different kind of ethical framework, given the subsequent "magical" solution, the status of this new ethical framework remains in doubt. Has Jenna in fact reached a point at which she can accept loss and lack?

The Missing Father

In contrast to the world that she inhabits at the film's conclusion, the initial fantasy world that Jenna creates at the age of 13 fulfills her wish—to be 30—outside patriarchy, in a world of women, or, perhaps more properly, girls. This world is not regulated by Oedipal structures and hence cannot lay the foundations for an ethical framework for its subjects within a Lacanian framework. In this world, there are no fathers, only sexually ambiguous bosses. What Jenna seems to lack in this brave new world is precisely the father. Jenna's first action (once she awakes)

is to phone her parents, who are away on a Caribbean cruise. Her father's disembodied voice greets her on the phone machine. Dad: "Hi! Sorry we missed your call. Well, we're not that sorry 'cause we're cruising in the Caribbean." Jenna responds: "You went on a cruise without me!" Jenna's distress is palpable. She experiences the inevitable loss of childhood, but all at once, as a terrible trauma. She finds herself alone and (suddenly) in the adult world.

In fact, her father appears in the film only five times (not including this phone message—his most significant statement—in which we only hear the mechanically reproduced trace of a voice that fails to recognize Jenna at all, his message being directed at an unknown caller of an unspecified identity). His appearances throughout the film serve to underline his ghostly status, as not entirely present. In the film's opening sequence, when Jenna is still 13, Jenna's mother shunts him out of Jenna's bedroom as he attempts to videotape her. When Jenna's friends arrive, she directs him upstairs, like her mother, pushing him off to the side, off the screen, out of the scene of action, in which only women and girls remain.

Later in the film, when Jenna, now 30, rushes home to the closet (where she had "wished" herself 30 at the age of 13) in a vain attempt to wish herself 13 again, her father opens the door. He has aged visibly (we see his white hair but not his face) and Jenna flings herself into his arms, just as she flung herself earlier into the arms of Matt and as she will again in the film's "magic" conclusion. When, that evening, she climbs into bed with her mother seeking comfort, her father is an indistinct figure huddled in a corner of the bed. Finally, we see both mother and father at Matt's wedding, while Jenna hides herself behind a bunch of flowers, and we catch a fleeting glimpse of him (perhaps) in a photo on the mantel of Jenna's dream house, in her dream ending.

This paltry showing on the part of Jenna's father is not perhaps the crux of the matter. The father is not the father as such; rather, he represents a function that takes the form of a prohibition:

> The prohibition configures "the impossible" per se. Its function is to serve notice to the child that there is something impossible, to support for the child the loss imposed by language until the child can face it and assume it, without being forced by a law. Only with adolescence will the subject face that which is beyond the arbitrary Oedipal and cultural prohibitions in all their forms by encountering that which is impossible to any human being. The subject's own desire as a subject will then become the way to claim a relationship to the lack of satisfaction, as it results from the human condition and not just from some seemingly arbitrary parental or cultural prohibition.[25]

In *13 Going On 30*, Jenna skips the process whereby she might "claim a relationship to the lack of satisfaction." Jenna and Lucy, Jenna's best friend, circulate

in the pre-Oedipal world of capital, a world in which the wish circulates freely in an interminable process of territorialization and re-territorialization. As Lucy departs *Poise* to take up her new job at *Sparkle*, she asks Jenna whether she is the kettle or the pot, but dismisses her own question. She recognizes that there is no difference, that they are both "black." Lucy or Jenna, *Poise* or *Sparkle*, difference is a matter of displacement. It travels. There is no symbolic order stabilized by the Law that might confer identity in this world of women, reflecting the mechanistic, polyvalent nature of pre-Oedipal desire described by Deleuze and Guattari that coincides with the logic of capital.[26] Lucy's ascent remains unimpeded as she moves from one job to another, from one office to another, from one magazine to another. In a universe without difference, satisfaction is possible, again and again and again because there are no regrets for this cynical and a-moral subject. While the film appears to unmask this "false" self, it is not entirely convincing in the alternative that it offers to the feminine subject.

The Limits of the Human Condition

Jenna must confront "the limits of the human condition" to achieve an ethical perspective: there is no "do-over" and it is not possible to "go back." Initially, Jenna goes to her mother, who typically seeks to comfort Jenna by explaining that she herself has never regretted her mistakes because otherwise she "would not have learned how to make things right." Jenna's mother does not accept the idea that fundamental to the human condition is the acceptance that it is not always possible "to make things right." At least, she does not convey this to Jenna. It is Matt who must tell Jenna, when he refuses to marry her, that "[y]ou can't always get the dream house but you can get awfully close," countering what Cantin calls "the refusal of phallic authority in the relation of the mother to the child,"[27] represented, here, by Jenna's mother who always "makes things right." But what does Jenna finally gain through her renunciation of her pre-Oedipal world? Everything that she had always "wanted," or so it seems. The magical ending relieves her of the responsibility of confronting loss and the impossibility of always "making things right."

The film is finally profoundly and irrevocably ambivalent. It appears to support the position occupied by Jenna at the film's conclusion, one in which a good life will be achieved through the recognition of loss (the idea that "you can't always get what you want"), which eventuates in the happy and desired union with Matt; however, if we read the film carefully against the grain, we might see something quite different. While the film seems to offer a happy ending, required by the conventions of the genre, the romantic comedy, the situation is not straightforward, marked by underlying contradictions that the film cannot resolve. The price that Jenna pays in her encounter with the Name of the Father, as spoken by Matt, is too great. She loses everything: job, partner, and future.

Lucy (her double) suffers no such fate, but hurtles on, whirling through the turbulent corridors of the world of capital, from success to success, from pleasure to pleasure. The "magic" that allows for the improbably happy ending, which the genre requires, does not reassure us about Jenna's fate. The viewer, acknowledging the magical happy ending as a fantasy, is left with the image of Jenna watching as the man that she loves (has always loved) marries another. Perhaps the genre cannot believe in its conventions, nor does it expect this of its viewers. Matt, nonetheless, looks forward to a "good enough" marriage, career, family, and children, whether with one woman or the other.

In 1933, Sigmund Freud wrote on "The Psychology of Women," in his *New Introductory Lectures*:

> A man of about thirty seems a youthful and, in a sense, an incompletely developed individual, of whom we expect that he will be able to make good use of the possibilities of development which analysis lays open to him. But a woman of about the same age frequently staggers us by her psychological rigidity and un-changeability. ... [As] though, in fact, the difficult development which leads to femininity had exhausted all the possibilities of the individual.[28]

One wonders if, perhaps, Lucy had the better part after all, forever shuttling between *Poise* and *Sparkle* in her world of vicious, girlish glee. Clearly Lucy has not yet been "exhausted" by "the difficult development which leads to femininity." The neo-romantic comedy may not be as new as it might initially appear, in that it re-creates that same impasse in which Freud found himself in 1933: by the time the woman is in a position to accept the Name of the Father through analysis, it will be too late for her. Rachael Bowlby, literary and cultural studies scholar, remarked that Jenna, the film's protagonist, does not, in fact, in terms of being a potential analysand, exhibit the rigidity of the feminine subject depicted by Freud. She learns and changes and, in this sense, the film offers up a more optimistic view of feminine subjectivity and its possibilities.

Bowlby also commented that her daughter had seen the film when it first came out at the age of 12 and had reported that it was a film for "younger" girls.[29] For these younger girls, the story would resonate quite differently and, indeed, more optimistically, articulating the possibility of an open, yet ethically grounded feminine symbolic order in which they are encouraged to embrace the years between 13 and 30, and perhaps to refuse the culture depicted so negatively in the film. However we read this ambivalence, the film, nonetheless, points to a certain difficulty for the feminine subject who must separate from the mother, and from the world of girls and women, if she is to enter into the world of difference and lack—that of a maturity that revolves around the Name of the Father.

I am reminded here of another passage by the New Zealand ex-patriot psychoanalyst Joyce McDougall, who resides in Paris. In *Theaters of the Mind*, McDougall remarks:

> Is there, in fact, a "new" or "modern" analysand? Or indeed a new or modern narcissism? ... The nature of the symptoms, and the way in which psychological suffering is experienced and expressed, appear to have changed over the years. This development would not have surprised Freud, who predicted that certain neuroses that were rife in his time were destined to disappear. ... His prediction would appear to have been fulfilled, particularly with regard to the dramatic hysterical symptomatology, so common in Freud's time. ... Instead, our patients complain of their incapacity to love, their feelings of profound dissatisfaction in work and social relationships, their sense of alienation from society, or their ill-defined states of emptiness, depression and anxiety.[30]

These are, in fact, the "complaints" of *13 Going On 30*, complaints that Jenna resolves only by going back in time, through the exercise of magic. McDougall emphasizes, in contrast with Gilles Deleuze and Félix Guattari, the deleterious effects of the pre-Oedipal state, in which the fragile subject is continually vulnerable to what McDougall calls "narcissistic hemorrhaging in

FIGURE 10.2 Feminine inadequacy in *13 Going On 30*. Courtesy of Columbia/ Photofest.

self-esteem," echoing the perspectives of postfeminist media scholars such as Angela McRobbie and Rosalind Gill who described contemporary young women as under siege, subject to a range of illnesses that are psychological in origin— with McRobbie going so far as to state that "[b]eing ... 'culturally intelligible' as a girl makes one ill."[31]

13 Going On 30 fails to provide a solution to the "narcissistic hemorrhaging in self-esteem" to which the contemporary feminine subject is particularly vulnerable, freed from the constraining boundaries of a repressive yet reassuring Oedipal structure supporting the Law. One might say that *13 Going On 30* represents the narcissistic fragility of a subject thrust too early into a world of sexual excess that stands in sharp contrast with the repression represented by nineteenth-century Vienna, "Freud's time," which refused to recognize the sexual drives. Paradoxically, this world of excess in the twenty-first century produces a subject for whom the existence of others remains a fraught and difficult project that cannot be resolved without the intervention of a fantasy reunion with a past that never occurred. In this sense the film can be read as offering a symbolic paradigm of this condition, generated by the neoliberal values that mark the last 30 or so years of U.S. feminine culture.[32]

Joyce McDougall explains:

> Each secret-theater self is thus engaged in repeatedly playing roles from the past, using techniques discovered in childhood and reproducing, with uncanny precision, the same tragedies and comedies, with the same outcomes and an identical quota of pain and pleasure.[33]

What is unusual in *13 Going On 30* is that the secret-theater self of 30-year-old Jenna is revealed to us: she is little Jenna, still 13 in a body that she does not recognize.

Conclusion: A Cinema of the "Moi"

The original title of *Theaters of the Mind* was *Théâtres du je*, Theaters of the "I," of the speaking subject. Philippe Porret, McDougall's biographer, considers that this paradigm of the theater as a representation of the psyche constitutes one of McDougall's most distinct contributions to psychoanalytic theory.[34] While the brevity of this intervention prevents me from fully excavating the fruitfulness of this metaphor, I hope that I have at least suggested the ways in which cinema and psychoanalysis serve to illuminate the "secret-theater self" and that cinema, like psychoanalysis, offers templates of that self as it is defined within a culturally and historically specific context. While psychoanalysis explores the speaking-subject, the "I" or "je," cinema offers us a culturally defined "me" or "moi," an ego-image that represents the culturally unstable condition of a subject that can never see himself or herself whole, but only as a series of conflicting images,

moving through constrained and repetitive patterns. Similarly, he or she is condemned to speak through a language that comes from elsewhere, and that is never her or his own. Joyce McDougall comments: "The fact that as human beings we are obliged to speak our needs and desires if we hope to have them satisfied is one of our most severe narcissistic wounds. Why are we not magically understood without words, as in infancy?"[35] Cinema seeks to represent that "magical understanding," and while we may *see*, we will never understand without putting our thoughts into words that are never fully our own.

Notes

1 Joyce McDougall, *Theaters of the Mind: Illusion and Truth on the Psychoanalytic Stage* (New York: Brunner/Mazel, 1991), 216.

2 Earlier versions of this chapter were presented orally at the University of Otago in September 2006 and at the London School of Economics in January 2007. I explored some of the issues pertaining to "the Name of the Father" in a brief oral presentation for the Ashburn Theory of Psychotherapy Seminar in 2005.

3 See Roland Barthes, *S/Z: An Essay*, trans. Richard Howard, (New York: Hill and Wang, 1974). This material was originally presented in a two-year seminar (1968–9) at the École pratique des Hautes Études as noted in the preface.

4 For a discussion of some of these issues, see Judith M. Hughes, *Reshaping the Psychoanalytic Domain: The Work of Melanie Klein, W.R.D. Fairbairn, and D.W. Winnicott* (Berkeley, CA: University of California Press, 1989).

5 Ibid., 174.

6 McDougall, *Theaters of the Mind*, 216.

7 Charlotte Brunsdon, "Career Girls," in *Soap Opera to Satellite Dishes* (London: Routledge, 1997), 47–102. I consider these films, in particular in terms of their narrative formula, stars, and industrial context, in *Neo-Feminist Cinema: Girly Films, Chick Flicks, and Consumer Culture* (New York: Routledge, 2011).

8 Some of the material about these films included in this chapter, sensibly reworked, appeared previously in H. Radner, *Neo-Feminist Cinema*, and in Hilary Radner, "*Le Divorce*: Romance, Separation and Reconciliation," in *Falling in Love Again*, ed. Stacey Abbot and Deborah Jermyn (London: I.B. Tauris, 2009), 208–21.

9 For a developed definition of this concept see Ernst Robert Curtius, *European Literature and the Latin Middle Ages* (New York and Evanston: Harper and Row, 1965).

10 See Linda Grant, *Sexing the Millennium: Women and the Sexual Revolution* (New York: Grove Press, 1994).

11 For a discussion of the evolution of the romantic comedy see Steve Neale and Frank Krutnik, *Popular Film and Television Comedy* (London: Routledge, 1990).

12 Lucie Cantin, "The Trauma of Language," in *After Lacan: Clinical Practice and the Subject of the Unconscious*, ed. Willy Apollon, Danielle Bergeon, and Lucie Cantin (Albany and New York: State University Press of New York, 2002), 41.

13 Jean LaPlanche and J.-B. Pontalis, *The Language of Psycho-analysis* (New York: Norton, 1973), 439.

14 Richard O'Neill-Dean, Oral Presentation, Ashburn Psychotherapy Seminar, 2005.

15 See McDougall, *Theaters of the Mind*, 76.

16 For a sustained explanation of the Lacanian framework see Anika Lemaire, *Jacques Lacan* (London, and Boston, MA: Routledge and Kegan Paul, 1977).

17 Cantin, "The Trauma," 41.

18 Ibid., 42.

19 Ibid., 35–48.

20 Ibid., 35–48.

21 Ibid., 45.

22 Ibid., 46.

23 For a discussion of the revitalization of the romantic comedy see Frank Krutnik, "Conforming Passions?: Contemporary Romantic Comedy," in *Genre and Contemporary Hollywood*, ed. Steve Neale (London: British Film Institute, 2002),130–47.

24 For all quotations from this film, see *13 Going On 30*, directed by Gary Winick (2004; Culver City, CA: Sony Pictures Home Entertainment, 2006).

25 Cantin, "The Trauma," 40.

26 For a full discussion of this complicated set of issues see Gilles Deleuze and Felix Guattari, *Anti-Oedipus: Capitalism and Schizophrenia* (Minneapolis, MN: University of Minnesota Press, 1983).

27 Cantin, "The Trauma," 45.

28 Sigmund Freud, "The Psychology of Women," in *New Introductory Lectures on Psycho-analysis* (London: Hogarth Press, 1949 [1933]), 173. I am indebted to Rachael Bowlby for drawing my attention to this very important passage.

29 Private conversation with Rachael Bowlby, University of Otago, Dunedin, September 2006.

30 McDougall, *Theaters of the Mind*, 216.

31 Angela McRobbie, *The Aftermath of Feminism: Gender, Culture and Social Change* (London: Sage, 2009), 97.

32 For an extended discussion of feminine culture, contemporary films for women, and neoliberalism, see Hilary Radner, *Neo-Feminist Cinema*. For a discussion of how this film illustrates the trend that Diane Negra identifies as "historical reversion," also associated with recent developments in neoliberalism, see Diane Negra, "Structural Integrity, Historical Reversion, And The Post-9/11 Chick Flick," *Feminist Media Studies*: 8, no. 1 (2008): 51–68.

33 McDougall, *Theaters of the Mind*, 7.

34 Philippe Porret, *Joyce McDougall: Une écoute lumineuse* (Paris: Éditions Campagne Première, 2005), 283.

35 McDougall, *Theaters of the Mind*, 7.

PART III
Consuming Culture(s)

11

NO COUNTRY FOR OLD WOMEN

Gendering Cinema in Conglomerate Hollywood

Rob Schaap

The global multiplex continues to yield improving returns, but it no longer plays to swelling numbers. The inflated price of tickets has been compensating for a gradual decline in cinema attendance since 2002, and the mounting evidence of feminine discontent with Hollywood's contemporary offerings affords at least one entrée into yet another episode in Hollywood's history of difficult transformations.[1]

The proposition that Hollywood's product is typically gendered has found support in a formidable array of textual analyses, yet satisfactory explanations for the phenomenon remain somewhat less numerous.[2] Hollywood's studios operate in a profoundly different organizational setting than they did 30 years ago;[3] the significance of this point for feminist scholars lies in Mosco's observation that "different ways of ... organizing cultural production have traceable consequences for the range of discourses and representations in the public domain and for audiences' access to them."[4] That famous cultural materialist Raymond Williams makes a similar point when he exhorts us to look, "not for the components of a product but for the conditions of a practice."[5] In short, the industrial organization of "new Hollywood" tends to condition the practices of production and consumption so as effectively to marginalize women, especially mature women.

No account of the conditions of Hollywood's practices—and the contingent status of its audiences—can proceed without fixing our moment in its political economic context. Whatever "globalization" is, it has demonstrably involved horizontal and vertical corporate integration across national borders, a concomitantly transformed role for the nation state, and the extension of conglomerate reach deep into our cultural experience. The very industry we call "Hollywood," while it appears to have a continuity with "Hollywood" in earlier decades, is consequently something quite new, in organization as much as context, and our

exploration shall require of us that we interrogate this global conglomerated complex, the better to understand the imperatives that drive it, and the limits of its sensitivity even to significant constituents of its multiplex audiences.

Hollywood's globalization has taken several distinct but related forms. As alliances with local producers have been forged, at once to mitigate national attempts to defend and promote local cultural production and to benefit from currency differentials, local public subsidies and exhibition "windows" (witness Warner Brothers' dealings with the New Zealand government over Peter Jackson's *The Hobbit* in 2010, or with France's StudioCanal over the projected make-over of *Escape From New York* in 2010), so has Hollywood added significantly to the stock of overseas multiplexes and video franchises. As public service broadcasters were brought to heel—whether by the intrusion of advertising into their schedules (as in New Zealand) or the advent of private enterprise competition (as in the United Kingdom), so were new markets and marketing channels for Hollywood product produced, and so was the global significance of Hollywood's structure and practice enhanced. As Toby Miller attests, the new Hollywood has now attained "command of the New International Division of Cultural Labor ... cultural labor markets, international co-production, intellectual property, marketing, distribution and exhibition."[6]

If globalization entails mergers and takeovers across borders, then woe betide the national economy whose constituent corporations were not large enough. Any economy that hosts a transnational corporation enjoys significant benefits in terms of innovation, repatriated profits, and concomitant tax receipts. The new global order would comprise only potential acquirers and the potentially acquired, and any administration too strict with its own corporations' drive to growth risked losing those corporations to more "flexible" national economies. Furthermore, should these corporations be part of the culture industry, they would contribute to the national interest in their global projection of what Joseph Nye dubbed "soft power."[7] Warner Brothers' merger with Time Incorporated in 1989 was indeed justified as "essential to the competitive survival of American enterprise in the emerging global entertainment communications marketplace."[8] Sony's acquisition of the Columbia Pictures and TriStar studios in the same year only underlined the point. By 2004, "Hollywood" effectively meant a coherently integrated system of six global mass media conglomerates, fashioned by the globalization of markets, the conglomeration of firms, and the fragmentation of audiences.[9]

For the cultural theorist Hollywood is a producer of culture; for an economist it is a producer of information. The economics of information is a special field because information is a special commodity, and one thing that makes it special is that nearly all the cost of production is invested in the original "information" produced. Thereafter, copies can be made at near zero cost. This promises dramatically increasing returns to scale for those positioned to take advantage of constant sequential resales of the one initial product.[10]

The new Hollywood has been constructed on this premise above any other. Economies of scale and scope are essential to an understanding of Hollywood, not only because they reflect the economic characteristics of its definitive product, information, and the defining imperative of its time, globalization, but because sheer size is necessary to control every point at which new competitors might challenge. The size of the conglomerates has hitherto confronted would-be competitors with insurmountable barriers to entry. Information profits those most who control most of the windows through which it attracts audiences. If information may be seen as exacting a fixed price, its utility to the buyer is a function of that buyer's capacity to benefit from it. The majors have become parts of large conglomerates precisely because only thoroughly integrated entities are in a position to maximize the continual benefits a given informational item affords. Furthermore, it is the major studios that possess the largest film libraries, enabling them to fill the most windows and affording them the rights to produce the most remakes. If pay TV, DVD, and internet are fragmenting audiences, then, "one way to adjust for that is to move the creative material across as many media outlets as possible to justify production."[11] The economics of information does, in that crucial sense, favor conglomeration. It also spreads and shifts the constitutive power of the consumer. Where "consumer power" was once concentrated at the box office, it is now diluted across multiple and proliferating outlets.

Hollywood's Big Six (or "sexopoly") are News Corporation (20th Century Fox & Fox TV), General Electric (Universal Pictures and NBC), Sony (Columbia Pictures), Time Warner (Warner Brothers), Viacom (Paramount Pictures and CBS), and Disney (Walt Disney and ABC). Six companies own and control all the United States' big studios and all the United States' big television networks. As Schatz notes, Hollywood has now effected "the strategic integration of their film and TV operations in the U.S., by far the world's richest and most robust media market, as well as their collective domination of the global movie marketplace."[12]

As early as 1991, Joseph Turow warned that Hollywood was no longer about cinema, but about large integrated mass-communication organizations. For Turow, the fragmentation of audiences, the globalization of markets, and the conglomeration of firms had produced an industrial structure that now transcended particular media. The major studios make up less than a fifth of their parent conglomerates' business and that cinematic exhibition yields ever less of those studio's revenues.[13] While the U.S. box office has languished through most of the last decade, it has been overseas and home video markets that have provided the conglomerates their growth.[14] Clearly, the cinema is no longer the goal of the films made by the major studios, a fact that helps explain why the apparently economically rational strategy of "spreading the risk" at the box office by making more and cheaper movies has given way to the "tent-pole" blockbuster and its many incarnations. As Robert Allen had already noticed by 1999, the new

Hollywood audience had become "a set of markets across which a given film and its related, but by no means identical, versions, characters and licensed paraphernalia are exploited."[15] Disney's 2006 release *Cars*, the combined box office and DVD revenues of which amounted to a healthy $700 million, shows just how significant those "licensed paraphernalia" can be. Related retail product sales currently exceed $5 billion, and Disney still has tours, theme parks, and a sequel in the works.[16]

As Schatz observes, Hollywood's theatrical releases have become little more than a "loss leader."[17] Only the first three months of a film's life are lived on cinema screens. After that, it is licensed to hotels and airlines for a few weeks, pay-per-view channels for a couple of months, sold and rented out on DVD for a few months, then cable and free-to-air television take their turns. As these "windows" continue to gain in importance relative to the box office, the projected consumers in their living rooms gain in importance relative to the audiences in the multiplexes, a development that effectively privileges youthful male audiences, deemed likely to access these "windows," mostly at the expense of mature female audiences (meaning women over 25 in Hollywood terms).

The technology taken up most rapidly in recorded history is the DVD and this is no accident. An effective but difficult alliance has developed since the mid-1990s between Hollywood's "sexopoly" (especially Sony) and the personal computer and consumer electronics sector. People tended to hire VHS, but they could be enticed to buy DVDs. In 2002, the DVD market surpassed that of VHS. In that same year, sales surpassed rentals. By 2006, "45 per cent of the studios' $42.6 billion in worldwide revenues ... came from home video."[18] Audiences for "windows" such as DVD are demonstrably paramount, and they are typically young, and disproportionately male: "studios now concentrate over eighty per cent of their cable and broadcast-network advertisements on programs watched primarily by people under 25."[19]

Films scheduled for summer release are generally required to offer action sequences sufficiently numerous and extended to satisfy the young males who are marked to buy the DVDs, console games, and merchandise a few months later. Such films are test-screened, sometimes with four endings already in the can (as in *Fatal Attraction*, Adrian Lyne, 1987), and sometimes with just the one. For example, the cast and crew of *The Bourne Identity* (Doug Liman, 2002) were recalled in 2002 to substitute an appropriately action-packed finale for the "more cerebral" denouement originally shot.[20] Computer-generated special effects offer more spectacle than any camera can capture. Seventy percent of 2004's Oscar champion, *Lord of the Rings: The Return of the King* (Peter Jackson, 2003), was computer-generated: "The new division of labor between the camera and the computer is also changing, for better or worse, the aesthetics of movies themselves."[21]

The power of the international satellite TV "window" is highlighted in Star TV's request that Fox Studios provide it with "action-based films, under two hours in length, with little dialogue and universally understood heroes

and villains."[22] Clearly, the perceived requirements of non-English-speaking audiences and young male audiences are at one. Epstein and Schatz note that every billion-dollar-earning movie released between 1999 and 2007 was based on children's literature, featured an adolescent male protagonist and sufficiently bizarre supporting characters to facilitate the licensing of games and action-figures, represented only chaste relationships, offered fantastic spectacle but never anything that might jeopardize a PG rating, ended happily, employed animation, and cast non-A-list actors (who do not command gross-revenue shares, and would remain affordable in the event of sequels).[23]

The advent of the game console has only exacerbated these trends. Activision's *Call of Duty: Modern Warfare 2* sold 4.7 million copies in North America and the United Kingdom on its first day, generating US$310 million. This is an opening-day performance beyond the reach of any tent-pole blockbuster, indeed beyond the reach of most films across all their iterations.[24] Ever since Hollywood's first steps to global domination, the capacity for action, glamor, and visual gags to appeal across linguistic boundaries has been decisive. In the early years, the context was an American public largely made up of recent immigrants and people of differential levels of education. By the 1990s, that context had come to include a global public even more differentiated in these respects. The corporate strate-gies of the mass-communications conglomerates, of which the major studios are but a small part, have ensured that most of a film's box-office and, crucially, most of its sequential window receipts, are generated outside the United States these days. Action and glamor present audiences for subtitled or dubbed films with far fewer challenges than do rich character development and complex dialogue. If the lead is male, and the need is for glamor and action, the chance of an international hit passing, for instance, the "Bechdel/Wallace Test" (two named women conversing with each other about something other than a man) is correspondingly low.[25]

Williams's exhortation not to neglect the conditions of cultural practices seems as relevant at the consumption end as it does at production. In the domestic economy of time, women remain at a significant disadvantage.[26] Women do have significant box-office power, but one thing they do not have is the demonstrably decisive "window power";[27] it is not their preferences that drive consumption of Hollywood programming and merchandising in the home. To the degree the home consumption fund underwrites and shapes Hollywood product, inequities in the division of domestic labor distort domestic consumption, which then go on to distort Hollywood production—an initial feminine disadvantage is thus entrenched and exacerbated.

Exacerbating this inequity is the demography of the box office itself. Even here, women's habits and obligations make them complicit in their own elision. At the time of writing, 2010's salient "chick flick," *Eat Pray Love* (Ryan Murphy, 2010) was doing formidable business. Yet, a Fandango poll reported that only 5 percent of that box office was male. The contemporaneous "muscle and mayhem"

release, a solid performer called *The Expendables* (Sylvester Stallone, 2010), which was designed largely for its capacity to travel well, did indeed attract the male audiences it pursued, but 42 percent of its box office was female.[28] Any executive bent on defending the masculine flavor of contemporary Hollywood has simply to point to the fact that men do not go to see ascribed "chick flicks" in nearly the numbers women go to see action movies. As Pomerantz concludes, "making movies for women actually means studios are cutting out half of the audience."[29] One recent trend in Hollywood fare, the "romaction" genre, constitutes an attempt to have the best of both worlds.[30] Angelina Jolie's ability to pout and yearn through a cacophony of stylized death and CGI-orchestrated destruction has, for worse or worst, promoted films like *Wanted* (Timur Bekmambetov, 2008) and *Salt* (Phillip Noyce, 2010) to harbinger status.

Associated with this demography-inspired mixing of genres is the *Twilight* franchise (Catherine Hardwicke, 2008; Chris Weitz, 2009; David Slade, 2010). Here, too, young protagonists inhabit a world of good and evil, of CGI-action sequences and beastly supporting players, but the accent is more on the "fangirl" than the "fanboy," 75 percent of the franchise's initial installment's audience being female.[31] Paramount Pictures had long held the rights to *Twilight*, but it took new-kid-on-the-block studio Summit Entertainment to take a punt on the "fangirl" demographic. The films' accent on eye-candy-for-all attracts audiences from both youth quadrants (males under 25 and females under 25), and merchandising windows are very much in the wind, if litigation between the studio and the designer of one *Twilight* character's jacket is any indication.[32] Demographics still rule, but perhaps a shift is afoot regardless. Female "tweenies" now matter, at the box office and in the home; their approach seemingly unobserved by the major studios.

Hollywood's insistence on a pre-identified and pre-researched demographic is entirely understandable. In 2007, a year that saw more movies released than ever, and yet more independent producers go to the wall than ever, vehicles for established stars like Ben Affleck (Miramax's *Gone Baby Gone*, directed by Ben Affleck), Reese Witherspoon (New Line's *Rendition*, directed by Gavin Hood) and Halle Berry (Dreamworks' *Things We Lost In The Fire,* directed by Susanne Bier) all flopped spectacularly. In the ensuing enquiry, Hollywood marketers concluded that these had been "movies for no-one," in that there was insufficient demographic focus to aid the films' marketers or guide its possible audiences.[33]

Marketers research potential audiences intensively, many of their techniques and findings kept tightly "commercial-in-confidence," but typically focused on "the right people": "An audience, then, has the nature of its power defined by the industry that constructs it."[34] The trouble with the over-25 quadrants is that they are rather less "the right people" than their younger counterparts. Thoughtful films are likely to be nuanced and nuanced films are likely to make for difficult marketing. The older audiences, who might be attracted, may love the film, but

even a resounding thumbs-up from such audiences is of little use to Hollywood executives, who realize that films that attract over-50s are unlikely to be attracting the quadrants every cinematic release needs. The Russell Crowe vehicle *State Of Play* (Kevin Macdonald, 2007) is a salutary example. It attracted exceptionally high approval ratings from an opening night audience, yet flopped miserably. For CinemaScore's Ed Mintz, the decisive datum was that 55 percent of that happy audience was over 50: "That tells you the movie is in trouble right away," Mintz told Patrick Goldstein.[35]

To reiterate and combine the demographic principles outlined above: females go to see films that address them as male and older audiences go to see films that address them as youngsters, but in neither case does the reverse significantly apply. Clearly, the quadrant most disadvantaged by the cruel logic of demography is the mature female, those over 25.

That films for this quadrant are made, and that some make significant money, is undeniable (witness the "older bird" romcoms of Nancy Meyers and the success of the *Sex in the City* franchise); yet the demographic remains under-represented across all major studio production schedules. The single most definitive characteristic of a major studio production is its substantial production and marketing budget, and this alone invites conservative decision-making. The weight of evidence required to inspire a departure from proven policy correlates strongly with the magnitude of the capital at risk. One or two unexpected hits per season do not constitute a weighty enough force for change, and there are rarely more than one or two hits that "subvert the paradigm" in any given year. The upshot is something of a Catch-22: major studios are not inclined to make enough risky movies to provide enough evidence to inspire enough change.

Furthermore, one characteristic Meyers' movies have in common with the *Sex in the City* franchise is the glorification of consumerism. The lead characters pursue and display their happiness and success in sumptuous surroundings and through conspicuous consumption.[36] Meyers' cashmere throws and Carrie's forays to Barneys address a feature more characteristic of mature women than their youthful counterparts: disposable income. If Hollywood does not yet address mature women in all their complexity and diversity, it does occasionally speak to their spending power. The upscale retail sector is as bent on global reach as the Hollywood conglomerates are, and product-placements and brand-promotions produce synergies that Hollywood executives understand. Rosalind Gill's claim that such films position women as "neoliberalism's ideal subjects" moves Hilary Radner to dub them "neo-feminist."[37] A wide array of scholars such as Hilary Radner, Dallas Smythe, Stuart Ewen, and Herbert Schiller stress the role of audiences as commodities to those who advertise through the windows Hollywood films are fated eventually to fill.[38] Over time, such films have the power to transmute people's material preferences, continually updating tastes for products and associated lifestyles.[39]

The chances of the major studios offering female audiences fare beyond the "romcom," the "tweenie-flick" and the neo-feminist consumption fests are hardly advanced by effectively collaborative practices between those studios. As Epstein notes, "studios may compete with each other for stars, publicity, box office receipts and Oscars, but their parent companies make most of their money from cooperation."[40] One consequence of these arrangements is that the degree to which direct competition is avoided is the degree to which studios are not obliged to take risks with alternative scripts, genres, or audiences. Antitrust provisions do not allow competing studios to "fix" their scheduling, yet releases are effectively scheduled so as not to clash with rival studios. The problem is circumvented by way of the National Research Group to which all six studios subscribe. The NRG regularly polls likely audiences and reports to its subscribers what percentage of those audiences had heard of the films set for release. Those studios with low numbers typically reschedule, thus neatly— and legally—avoiding "unproductive competition."[41] The theory of competition would have it that to avoid competition is to avoid having to differentiate one's product, ensuring calls for movies that exert "power and an emotional hold because of something inchoate churning in the engine room, a searching dissatisfaction that can't be bought off with a wedding ring or a string of suitable- for-framing orgasms" continue to fall on deaf ears.[42]

It is not only the demographic constitution of the audience that disadvantages the mature female; that of the studios plays a role as well. The "star system" remains a decisive constituent of Hollywood organization, and this has its own implications for product. If studios do not always compete for opening nights, they do for A-list directors and actors. This affords the latter a power over scripts they are typically quick to exert. The majority of auteur directors are men;[43] "no matter how appealing the script may be, without such proven directors, assembling the most desirable cast and crew may prove an insurmountable problem," so the best casts and crews are rarely directed by female directors, who rarely have the final say on scripts.[44] Hollywood's executive floors remain as masculine as they were a decade ago. Only 20 percent of studio executives are women.[45]

If the Hollywood of the past 30 years may be summarized as six conglomerates wedded to a franchise-obsessed, CG-driven "tent-pole" imperative, the primary symptom of which is a propensity for big-budget blockbusters aimed primarily at male youngsters, that does not mean the sexopoly will continue to have things its own way.[46] If the economics of information favor the behemoth, the technology of information may not. The advent of the internet, cheap editing, and special effects technologies and the prospect of digital delivery will combine profoundly, unpredictably, and rapidly over the next decade. CGI has become wallpaper;[47] as it falls within the reach of more competitors, the Hollywood blockbuster is obliged to explore more technological avenues of short-term advantage (IMAX and 3D come to mind), yet narrative suffers and audiences are faced with ever

higher ticket prices. This trend alone implies a growing field of opportunity for independents and a correspondingly louder voice for imaginative Hollywood executives.

Furthermore, perhaps the greatest challenge digital information technology poses arises out of problems of excludability. The exchange value of an item of information is decisively a function of the copyright-owner's capacity to control access to its intellectual property. Peer-to-peer technology has long plagued Hollywood in its attempts to extract continual revenues from its product. As lounge-room exhibition technologies converge with the internet, the security of a blockbuster's sojourn across its series of lucrative windows is ever more in doubt. If studios continue to treat the cinema primarily as a marketing venue for product designed to yield its profits down the line, they take a continually mounting risk. IMAX and 3D are not long-term solutions for the simple reason that technology can provide solutions for technological problems only as long as technological developments allow.

Given that the tools of film production and post-production are becoming available to ever more creative people and entities, it is mainly in distribution that truly independent productions have found themselves at the mercy of the majors. The opportunity for wholly electronic distribution, whether to silver screen or networked home theater, is becoming ever more feasible. Certainly, the majors still enjoy a decisive advantage when it comes to distributing product in the global multiplex, but the significance of that advantage is bound to diminish as technological developments threaten ever more to circumvent established channels.

Furthermore, the bourgeois lounge-room of 2010 boasts a formidable array of hi-fidelity audio-visual equipment, from plasma screen to multi-channel speaker systems. To the degree that the feminization of the domestic sphere has played a role in ensuring television wallows in the wake of cinema, it is unlikely it will continue to do so. The television system of today constitutes too sophisticated, complex and expensive an array to escape status-enhancing masculine associations. Furthermore, the improved exhibition technology demands improved production standards; much recent television fare (Home Box Office and Canal Plus productions come to mind) approximates cinema in scope, impact, and cost. Perhaps, "if the shrinking heart of the women's film has a future, it's on cable television, where so much else has been transplanted."[48]

In summary, we have traced Hollywood's latest iteration to the transformative effects of three interrelated political economic developments: the globalization of markets, the conglomeration of firms, and the fragmentation of audiences. As Peter Golding and Graham Murdock's advocacy of Critical Political Economy in the study of media and culture insists, "the economic dynamics of production structure public discourse by promoting certain cultural forms over others."[49] These "economic dynamics" have combined to produce the typically

male-oriented tent-pole blockbuster, which best takes advantage of the global audiences and proliferating modes of exhibition now available.

If the young male demographic quadrant has been its primary beneficiary, it has been the mature female quadrant that has been its main victim. The salient reasons for this are twofold. In an age of fragmented audiences, demographics rule, and the mature female quadrant pays a particularly high cost for reluctance of the male to see films aimed at the female and the young to see films aimed at the "old." Furthermore, as "windows" in the home gain in economic importance, so does the mature female quadrant suffer more from the gendered distribution of domestic labor and leisure time—if political economy is largely about who does what and who gets what, it is because women do much that they get little.

Notes

1 Data from Box Office Mojo, boxofficemojo.com; Jame Wolcott, "Carrie Bradshaw, Meet Mildred Pierce," *Vanity Fair*, August 2010; Daphne Merkin, "Can Anybody Make a Movie for Women?", *New York Times*, 15 December 2009; Sharon Waxman, "Hollywood's Shortage of Female Power," *New York Times*, 26 April 2007.
2 For an overview of feminist approaches to cinema, see Sue Thornham, *Passionate Detachments: An Introduction to Feminist Film Theory* (London: Arnold, 1997); Joseph Turow, "A Mass Communication Perspective on Entertainment Industries," in *Mass Media and Society,* ed. James Curran and Michael Gurevitch (London: E. Arnold, 1991), 160–77.
3 Thomas Schatz, "New Hollywood, New Millennium," in *Film Theory and Contemporary Hollywood Movies,* ed. Warren Buckland (New York: Routledge, 2009), 19–46; Toby Miller, Nitin Govil, John McMurria, and Richard Maxwell, *Global Hollywood* (London: British Film Institute, 2001), 17–43; Turow, "A Mass Communication Perspective."
4 Vincent Mosco, *The Political Economy of Communication* (New York: Sage, 1993), 25.
5 Raymond Williams, "Base and Superstructure in Marxist Critical Theory," in *Media and Cultural Studies: Keyworks,* ed. Meenakshi Durham and Doug Kellner (Oxford: Blackwell, 2006), 134.
6 Miller, et al. *Global Hollywood,* 18.
7 Joseph Nye, *Soft Power: The Means to Success in World Politics* (New York: Public Affairs, 2004).
8 Richard Gold, "Sony-CPE Union Reaffirms Changing Order of International Showbiz," *Variety,* 27 September 1989, 5.
9 Schatz, "New Hollywood," 20; Turow, "A Mass Communication Perspective," 161.
10 Brad DeLong and Michael Froomkin, "Speculative Microeconomics for Tomorrow's Economy," *First Monday* 5, no. 2 (2000), firstmonday.com.
11 Turow, "A Mass Communication Perspective," 172.
12 Schatz, "New Hollywood," 21.
13 Edward Jay Epstein, *The Big Picture: the New Logic of Money and Power in Hollywood* (New York: Random House, 2005), 16.
14 Schatz, "New Hollywood," 22.
15 Robert C. Allen, "Home Alone Together: Hollywood and the 'Family Film,'" in *Identifying Hollywood's Audiences: Cultural Identity and the Movies,* ed. Melvyn

Stokes and Richard Maltby (Berkeley, CA: University of California Press, 1999), 127.

16 Schatz, "New Hollywood," 31.

17 Ibid., 23.

18 Ibid., 23.

19 Epstein, *The Big Picture*, 304.

20 Ibid., 201.

21 Ibid., 21.

22 Ibid., 233.

23 Ibid., 237; Schatz, "New Hollywood," 32.

24 Jeremy Kay, "Hollywood Must Plot a New Course to Win Back Its Audience," guardian.co.uk, 7 September 2010.

25 Justine Larbalestier, "Bechdel-Wallace Test," justinelarbalestier.com, 3 September 2008.

26 John P. Robinson and Geoffrey Godbey, *Time for Life: The Surprising Ways Americans Use Their Time* (University Park, PA: Pennsylvania State University Press, 1997); Barbara Redman, "The Impact of Women's Time Allocation on Expenditure for Meals Away from Home and Prepared Foods," *American Journal of Agricultural Economics* 62, no. 2 (1980): 234–7.

27 Merkin, "Can Anybody."

28 Dorothy Pomerantz, "The Trouble With Chick Flicks," blogs.forbes.com, 12 August 2010.

29 Ibid.

30 Ann Hornaday, "Hit-hungry Hollywood Gambles on Litany of 'Romaction' Flicks," *Washington Post*, 6 June 2010.

31 Mairi Mckay, "Are Fangirls the Next 'It' Demographic?", screeningroom.blogs.cnn.com, 28 November 2008.

32 Eriq Gardner, "'Twilight' Studio Sues to Stop Sale of Bella Jacket," hollywoodreporter.com, 15 June 2010.

33 Michael Cieply, "How to Find an Audience? Try a Zoom Lens," *New York Times*, 28 October 2007.

34 Turow, "A Mass Communication Perspective," 171.

35 Ed Mintz, quoted in Patrick Goldstein, "CinemaScore's Ed Mintz: Hollywood's Secret Box-office Swami," *Los Angeles Times,* 12 October 2009.

36 Merkin, "Can Anybody"; Hilary Radner, "Nancy Meyers: Romantic Comedy and the Neglected Neo-feminist Auteur," paper presented at the annual meeting of the Society for Cinema Studies, Los Angeles, CA, 17–21 March 2010. See also Hilary Radner, "*Something's Gotta Give* (2003): Nancy Meyers, Neo-Feminist Auteur," in *Neo-Feminist Cinema: Girly Films, Chick Flicks and Consumer Culture* (New York: Routledge, 2010), 172–90.

37 Radner, "Nancy Myers: Romantic Comedy."

38 Stuart Ewen, *All Consuming Images: The Politics of Style in Contemporary Culture* (New York: Basic Books, 1988); Radner, *Neo-Feminist Cinema*; Herbert Schiller, *Mass Communication and the American Empire* (Boston, MA: Beacon Press, 1989); Dallas Smythe, "Communication: Blindspot of Western Marxism," *Canadian Journal of Political and Social Theory* 1, no. 3 (1977): 1–27.

39 Turow, "A Mass Communication Perspective," 170.

40 Epstein, *The Big Picture*, 105.

41 Ibid.

42 Wolcott, "Carrie Bradshaw."

43 Merkin, "Can Anybody"; Waxman, "Hollywood's Shortage."

44 Epstein, *The Big Picture*, 145.

45 Waxman, "Hollywood's Shortage."

46 Schatz, "New Hollywood," 30.
47 Kay, "Hollywood Must."
48 Wolcott, "Carrie Bradshaw."
49 Peter Golding and Graham Murdock, "Culture, Communications, and Political Economy," in *Mass Media and Society,* ed. James Curran and Michael Gurevitch (London: E. Arnold, 1991), 27.

12

MUSIC AND THE WOMAN'S FILM

Sex and the City: The Movie (2008)

Peter Stapleton

In the early 1980s, female pop and rock singers such as Madonna, Cyndi Lauper, and Pat Benatar developed a specifically female form of audio–visual "address."[1] These were mainstream artists, but they used some of the language of feminism in their lyrics and (especially in the case of Lauper and Madonna) adopted some of the attitude of the 1970s punk movement in their audio–visual stances and mix 'n' match fashion styles. Yet while mainly female British punk and new wave groups, for example, The Raincoats, The Slits, and The Au Pairs, emerged in opposition to, and in many cases remained outside the mainstream music industry, this attitude was co-opted and diffused in a more mainstream American context during the 1980s and 1990s.[2]

Pat Benatar subsequently became a staple of the AOR[3] genre, but Cyndi Lauper and Madonna were more "pop," appealing to an adolescent and pre-adolescent female audience which up till then had been largely taken for granted by the major music labels. In an example of a well-worn music industry practice any oppositional stance was soon reduced to just another style and, perhaps unwittingly, Madonna came to symbolize what came to be regarded as a postfeminist ethos.[4] Her song lyrics and audio–visual stance appeared to advocate freedom of choice and an assertive female individualism but above all they seemed to be a celebration of "being a material girl, living in a material world" and her media persona appeared unashamedly self-promoting.[5]

In a similar way, the "chick flicks" that emerged from the early 1990s used some of the language of feminism in their narratives and in the lyrics of songs on their popular music soundtracks, while at the same time promoting consumerism and economic individualism.[6] On the one hand, they featured female characters and female-centered narratives and also a greater percentage of female musicians on their soundtracks. On the other hand, those female characters were still

limited to a narrow range of choices within the narrative and the available choices invariably revolved around the idea of physical appearance as just another commodity. The films' use of feminist language appeared more for the purpose of encouraging audience identification, while at the same time they promoted "neo-feminist" and neoliberal ideologies and individual, economically based solutions to perceived problems in women's everyday lives.[7] While the sound-tracks featured more female musicians (almost never as instrumentalists), they were still restricted to a narrow range of prescribed gender-specific roles, to performing dance/pop tunes and stereotypical (often retro) love songs. Throughout this whole cycle of films the stylistic role of the soundtrack was gradually reduced and its promotional role increased. This trend reflected the economic imperatives of conglomerate Hollywood and highlighted the fact that soundtrack choices in all mainstream movies are likely to be made for economic rather than aesthetic reasons. In this chapter I have chosen to focus on the role of the soundtrack in *Sex and the City* (Michael Patrick King, 2008), a recent example of a "chick flick" or "woman's film," aimed specifically at a female audience, and one which has also achieved considerable success at the box office.[8] In *Sex and the City* the soundtrack functions primarily as a promotional tool, not only in the marketing of the film itself and as a unifying factor across a range of different media, but also as part of the film's relentless audio-visual promotion of consumer culture.

Soundtracks as Promotion

Following the phenomenal success of the *Saturday Night Fever* (John Badham) soundtrack in 1976, music was consistently used as a promotional tool for films and at the same time the films were used to promote the music and musicians, with single tracks often being released weeks, sometimes months, prior to the film's première.[9] From the 1980s onwards, almost every new Hollywood film was released in conjunction with promotional songs, a soundtrack album, and a music video.[10] *Pretty Woman* (Garry Marshall, 1990) was a typical example of this marketing strategy. Natalie Cole's "Wild Women Do" from the soundtrack was released over a month before the première, with the accompanying video containing footage from the film itself, and two other soundtrack songs, Roxette's "It Must Have Been Love" and Robert Palmer's "No Explanation," were also released in advance of the film.[11] In this instance, the film, individual soundtrack songs, and the soundtrack album all achieved considerable commercial success and the 1990s saw a boom in film soundtrack sales in general. Yet there were also a number of subsequent examples where films were successful at the box office and the soundtrack failed to sell and vice versa.[12] Where the music labels traditionally made their money from the sale of albums, in more recent times CD sales have plummeted and this has led to a renewed emphasis on the single track, available as a digital download or as part of an online audio-visual clip available

on YouTube. Nowadays popular musicians tend to make most of their money from touring, licensing, merchandising, endorsements, and sponsorships rather than from the sale of CDs; consequently it is in their interest to have as wide a visibility as possible over a diverse range of popular media.[13]

The huge drop in CD sales in the early 2000s led to a crisis in the recording industry, often attributed to the culture of downloading, but probably just as much a result of competition "from other newer media and consumer electronics industries."[14] In contrast to the 1990s, film soundtrack songs are now rarely big sellers but instead function more as promotion for the film and to a lesser extent for the individual artists, as evidenced by the case of *Sex and the City*. While Fergie's "Labels or Love" and Jennifer Hudson's "All Dressed Up in Love" were both released before the film itself and a clip of the latter was "leaked" online two weeks before the official release date, neither they nor India Arie's "The Heart of the Matter," which featured on the film's theatrical trailer, achieved significant chart success.[15] In fact, "Labels or Love" was only available as an extra track on Fergie's "The Dutchess Deluxe" EP. Nevertheless, their release prior to the première still served to promote the film, not only providing a foretaste of the soundtrack, but also of some of the images, and taken together they contributed to the buildup of anticipation. In addition, even in the age of the digital download, the *Sex and the City* soundtrack reached as high as No. 2 on the U.S. and No. 6 on the British charts, suggesting that audiences bought the album more as a memento of "the event."[16]

The Choice of Soundtrack Artist

New Line Records, which released the *Sex and the City* soundtrack album, is part of the Warner Music Group.[17] Along with Sony-BMG, the Universal Music Group, and the EMI Group, the Warner Music Group is one of the so-called "Big-Four" music companies.[18] While New Line Cinema (which produced *Sex and the City*) remains a division of the media conglomerate Time Warner, the Warner Music Group is now a stand-alone company.[19] In the 1980s and 1990s a film studio would generally put together a soundtrack made up of songs and artists from the rosters of affiliated labels and publishing companies. The more recent trend has, however, been towards a looser integration in the popular music industry, with the precarious economic situation of the sector "predisposing the Big-Four to collusion."[20] A majority of the *Sex and the City* soundtrack artists (e.g., Fergie, India Arie, Ciara, Al Green, Run-D.M.C., Nina Simone and the Captain and Tennille) are on labels or publishing companies affiliated to the rival Universal Music Group.[21] The fact that Universal is a subsidiary of one of the other major media conglomerates, Vivendi, suggests a package deal made by the film's producers and provides further confirmation that the choice of artist for the *Sex and the City* soundtrack was an economic rather than an aesthetic decision.

Economic rather than aesthetic considerations will also contribute to a film's "musical supervisor" (in effect a film's "musical casting director") relying largely on genre categories as a way of organizing "the right movie-music combination" for a soundtrack.[22] The *Sex and the City* soundtrack becomes part of viewer/ listener expectations of the chick flick, especially for audience members who have seen other, similar films and who understand the "codes."[23] It features a mix of contemporary and retro and of neo-classical film music, popular romantic ballads, and catchy pop and dance-oriented tunes. Almost without exception, the songs have love as their lyrical subject matter, for example, "Labels or Love," "All Dressed Up in Love," "2nite," "My First Love," "How Deep is Your Love," "The Heart of the Matter," and "How Can You Mend a Broken Heart." Unusually for a mainstream Hollywood film, the soundtrack also features a majority of female voices, yet while this certainly represents an advance towards soundtrack gender equality, it does so only in the context of a scarcity of women musicians in Hollywood and in film music generally. In addition, those female soundtrack artists are all singers in the stereotypical role of the woman musician as "face" (and body) of the music, and a closer examination of the songs only reveals the still-narrow range of roles actually available to women in popular music. As the "woman's film" has itself been reduced to a genre (as if the only films that women watch are chick flicks), it appears that female soundtrack musicians have been largely restricted to formulaic dance/pop or stereotypical love songs.

Popular music is frequently used to help broaden a film's box-office appeal and the presence of well-known musical "names" on a soundtrack can help to offset any losses a film might incur. Pop/hip-hop singer Fergie is one such name and she brings a "high-recognition" factor to *Sex and the City*, having been accorded celebrity status in the entertainment media.[24] She had previously been a member of the very successful group The Black Eyed Peas, and as a solo artist had recently achieved three number one hit singles on the U.S. charts. Her song "Labels or Love" becomes the film's title song, featured prominently over the opening credits. The song includes a short excerpt from the theme to the HBO television series, *Sex and the City* (HBO, 1998–2004), with the film to some extent relying on the audience's familiarity with, and prior knowledge of, the characters. Another artist who brings a high-recognition factor to the film is Jennifer Hudson. Her song "All Dressed Up in Love" is aurally highlighted during Carrie and Big's wedding, *Sex and the City's* narrative climax. Hudson had just received an Academy Award for Best Supporting Actress for her role in the musical *Dreamgirls* (Bill Condon, 2006), she had had chart success with her debut album, and she also earned a Grammy Award later that same year.[25] Yet even before receiving these awards, she was a well-known figure in the entertainment media, following the widespread controversy around her exit from the popular U.S. television talent quest *American Idol* in 2004.

With the main characters in *Sex and the City* all over 40, the soundtrack has clearly been regarded as a means of broadening the film's appeal to younger women and capitalizing on the success of reruns of the television series, hence the inclusion of contemporary pop and R&B singers, such as Fergie, India Arie, Joss Stone, Mutya Buena, Craig David, and Ciara, all appealing more to a younger demographic. The presence of an electronic dance music act[26] such as Kaskade on the soundtrack, along with more "alternative" pop groups such as Morningwood, The Bird and the Bee, The Weepies, and Jem, suggests an attempt to not only attract a younger audience, but also to create a slightly "hipper" aura around what is essentially a very mainstream film.[27] For the artists themselves and their labels, being on the *Sex and the City* soundtrack represents a chance for them to "cross over" to a new and potentially much larger audience. Because they are already well known in other areas of music and in other media they also represent little financial risk to the studio. A prime example is the inclusion of "I Like the Way" by Kaskade, based around DJ and producer Ryan Raddon, here with added vocals by Colette. Raddon had previously had a number of "hits" on the U.S. dance music charts, and his label Ultra Records was distributed by the Alternative Distribution Alliance, also part of the Warner Music Group.[28] The soundtrack also incorporates tracks by The Decompressors, a highly recognizable name in Hollywood film music as a result of their soundtrack contributions to a diverse range of very successful youth-oriented movies, such as *Alvin and the Chipmunks* (Tim Hill, 2007), *Ghost Rider* (Mark Steven Johnson, 2007), and *Transformers* (Michael Bay, 2007). In addition, it includes alternative pop acts such as Morningwood, The Bird and the Bee, The Weepies, and Jem, all of which had an existing presence across a range of other media. With songs by each of them having been used on TV advertisements and TV show soundtracks, and, in the case of Morningwood, featuring on a number of video games, their inclusion on the soundtrack was also indicative of the film's attempt to reach a much broader audience.[29]

Other soundtrack decisions serve to enhance the film's international appeal, taking into account the fact that overseas box-office receipts often far exceed those in the United States.[30] Several contemporary British singers are featured on the two *Sex and the City* soundtrack CDs, with Jem and Joss Stone on the original album, Duffy on the English version of the original album but not in the film, and Mutya Buena, Goldfrapp, and Amy Winehouse on the second disc of the double-CD released at the same time as the DVD of the film. Not all the artists on the second disc of the soundtrack are actually in the film, but their association with *Sex and the City* and its seemingly guaranteed female audience would be seen by their labels as a smart career move. The release of a second version of the soundtrack album, along with the prospect of a sequel to the movie, demonstrates how *Sex and the City* functions as a "franchise," an ongoing umbrella for marketing not only the films, but also a variety of ancillary products to an established audience.

The Soundtrack and the Promotion of Consumer Culture

Anihad Kassabian has emphasized the gendered nature of Classical Hollywood film music, with female characters being musically associated with passive, fixed spaces and male characters with agency and movement.[31] The main characters in *Sex and the City* are almost never shown moving through New York, a city that is supposedly synonymous with their freedom. Instead the film is largely a series of set pieces, with the only upbeat soundtrack songs used to bridge fashion show montages, implying that female agency, the ability to act, is limited to consumer choices, within a narrow area of prescribed activities for relatively wealthy women. There are three main fashion displays within the film: Carrie modeling her 1980s outfits to the sounds of "Walk this Way," modeling designer wedding dresses to the sounds of Ciara's "Click Flash," and the four women attending an actual fashion show to the sound of loud, rhythmic "beats." Along with the pop/hip-hop of "Labels or Love" which accompanies the film's opening credits and shots of clothing, accessories, and clearly visible labels, these fashion scenes offer the only upbeat soundtrack moments in the whole film. In each scene the music is highlighted and therefore demands attention from the viewer/listener. While one fan is reported to have described *Sex and the City* as "the sort of film that could be easily watched minus the soundtrack, to better appreciate the clothing,"[32] the more upbeat soundtrack songs actually assist in the film's audio-visual promotion of the fashion on display, functioning in much the same way as background music in a hip clothing store or at a contemporary catwalk show.

Such a focus on fashion is not limited to chick flicks. Hollywood films aimed primarily at a male audience also promote clothing styles and fashion accessories; for example, the dark suits in several Quentin Tarantino movies or Keanu Reeves' coat, mobile phone, and sunglasses in *The Matrix* (Andy Wachowski and Lana Wachowski, 1999),[33] but in *Sex and the City* that emphasis is more obvious and more clearly connected to the promotion of specific designers such as Vivienne Westwood.[34] With lyrics taken from the first line of the voiceover, Fergie's "Labels or Love" is effectively the theme song and, played briefly at volume, it introduces and summarizes the "high concept" of the film, fashion serving as a fundamental element in the film's "concept" or "style of filmmaking molded by economic or institutional forces."[35] While there is certainly irony in lyric lines such as "Cause I know that my credit card will help me put out the flames," it is a very knowing irony that appears to be mainly for the purpose of encouraging audience identification, entailing what Jane Arthurs has termed a "complicit critique."[36] Such a critique acknowledges potential criticism (in this case of the film's consumerism) in a humorous way yet never addresses the full implications of the phenomenon it calls into question. There is no recognition or extended analysis of structural and institutional barriers that may prevent women from doing what they want and it is taken for granted that women

have the money that they need to exercise their freedom of choice in the marketplace.

This knowing irony characterizes many of the songs on the *Sex and the City* soundtrack and has the effect of allowing for "a constant emphasis on women's appearance and sexual desirability as a source of worth" while "simultaneously subjecting this attitude to ridicule."[37] Even the Madison Park vs. Lenny B. remix of Nina Simone's version of "The Look of Love"[38] a Burt Bacharach/Hal David easy-listening tune from the 1960s, gains new meaning in the context of the film's continual association between "the look" and "love." Ultimately, the combined effect of soundtrack songs such as "Labels or Love," "All Dressed Up in Love," and "Click Flash" and the audio-visual emphasis on fashion and especially on "the new" is to promote a much older message: that a woman's worth is inextricably bound up with the way she looks. There is also irony in the film's use of "Walk this Way" by Run-D.M.C. (featuring Steven Tyler and Joe Perry of Aerosmith) to accompany Carrie's impromptu 1980s fashion show. The song is a mixture of hip-hop and hard rock, two musical genres generally regarded as appealing more to a male audience. Yet the ironic implications are countermanded by the fact that, at least initially, the song comes from a source within the film's diegesis (Samantha playing a "Best of the 80s" compilation CD). The scene depicts Carrie attempting to decide which clothes in her wardrobe to throw out, emphasizing that both the clothes and the music of the 1980s have long since become out of date and thereby reinforcing *Sex and the City*'s emphasis on "the new" and by extension its promotion of the values of consumer culture.

Soundtrack Artists and the "Look"

The film's emphasis on consumer culture and the "look" extends to its choice of soundtrack artists. Fergie has been called "one of the most glamorous girls of music," and, as with many other women musicians over the years, is as often referred to in the media in terms of her looks as for her musical ability.[39] *People* magazine has characterized her as "the (Black Eyed) Peas gyrating, belly-baring, real Bratz doll songstress."[40] Jennifer Hudson, Joss Stone, India Arie, Mutya Buena, and Ciara are not only singers but also actresses, following the template of the successful all-round artist and celebrity "brand" constructed by the likes of Jennifer Lopez.[41] Songs such as "Labels or Love," "New York Girls," "All Dressed up in Love," and "Click Flash" all directly reference fashion in their lyrics and this is further emphasized in accompanying promotional images of the female soundtrack artists showing them wearing expensive (but conservative) designer clothing. British soul singer Joss Stone, who duets with Al Green on the soundtrack's remake of "How Can You Mend a Broken Heart," also has a fashion connection. Stone was renowned for her "cover" of Nat King Cole's 1965 song L-O-V-E that accompanied the advertising campaign for Chanel's Coco Mademoiselle perfume.[42] In addition, Ciara's "Click Flash," with its "Click,

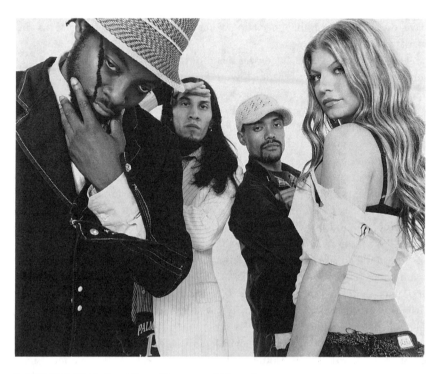

FIGURE 12.1 Black Eyed Peas. Courtesy of Photofest.

click, click, flash" hook-line, references both fashion and celebrity culture and is featured on the soundtrack as Carrie (herself a celebrity within the narrative) is portrayed modeling wedding dresses by celebrity designers. On the one hand, the fashion references signify that the film is targeting a particular female audience, one that is already "in the know"; on the other hand, they serve to emphasize *Sex and the City*'s ongoing promotion of physical appearance as a commodity.

Extra-musical Associations

The celebrity status of *Sex and the City* soundtrack artists such as Fergie and Jennifer Hudson served to promote the film and in return the film performed a cross-promotional role in helping them consolidate their own "brands." With details of their private lives so well publicized in the popular media, the presence of such artists on the soundtrack inevitably brought extra-musical associations to the audience's consumption of soundtrack songs. Fergie brought an established name and image to the film and used her celebrity status to endorse it in interviews, with comments such as "I grew up watching *Sex and the City* and I know a lot of my girlfriends did as well. We felt like these characters were our friends,

so to be part of this project is amazing."[43] Jennifer Hudson, who also plays the role of Carrie's assistant Louise in the film, had been controversially eliminated from *American Idol* and she had previously appeared in a number of supporting roles in films before winning an Academy Award for *Dreamgirls*.[44] Her story is often recounted in the entertainment media as an example that anyone can "make it" in the United States as long as they persevere, positioning her as a cross-over star who appeals to so-called "minority" audiences not represented by the "Fab Four."[45] Biographical details such as her lower socio-economic background, her large family, and the tragic murder of her mother, brother, and nephew, inevitably influence audience perception of both her soundtrack song and the character she plays in the film.

Within the fictional world of *Sex and the City*, Hudson's character Louise appears to represent traditional "core" (i.e., conservative) values, as demonstrated by her role as Carrie's assistant and "adviser" and also by the subplot that features her own romance and eventual marriage to her "hometown honey." This onscreen persona is carried over to her subsequent soundtrack song, "All Dressed Up in Love," which accompanies the final sequence when Carrie and Big marry, the music initially demanding the audience's attention. Her well-publicized biographical details and her fictional role within the film's narrative merge to bring extra-musical associations to her soundtrack song, constructing an aura of authenticity, contributing to the film's endorsement of "old-fashioned values." Significantly, one fan commented online that "this will be the song that plays at my wedding."[46]

The Use of Retro Music

In common with other contemporary chick flicks, the *Sex and the City* sound-track features a number of popular songs from past eras, mainly in the form of cover versions and remixes by contemporary artists and producers. The high proportion of "retro" tunes is likely to reflect the influence of music publishers (who are more interested in pushing their back catalog than promoting new artists) on the film's music supervisors.[47] These older songs, often already in circulation through advertisements, classic hits radio stations, and cover versions by contemporary artists, represent very little financial risk to the studio. In addition, their presence in a film can provide a springboard for their reissue and repackaging for a contemporary audience.[48] Covers and remixes allow the songs to be more accessible to the audience of today, more familiar with contemporary production sounds. They also influence audience reception for other soundtrack songs, give the contemporary musicians and producers additional legitimacy by association, and contribute to the impression of a musical continuity across generations.

The majority of chick flicks feature female characters who are successful in their working lives, but who are also portrayed as being somehow "lacking" and

needing to find something called "love" in order to achieve true happiness.[49] While the *Sex and the City* soundtrack has contemporary songs about love, for example, "All Dressed Up in Love," Craig David's "My First Love," and Jem's "It's Amazing" (with the line "Nothing can compare to deserving your dream"), the majority are from past eras. Along with the Captain and Tennille's 1970s hit "Love Will Keep Us Together" and Judy Garland's "The Trolley Song," from the musical romance *Meet Me in St. Louis* (Vincente Minnelli, 1944), there are seven covers of older songs, all pre-dating the film and all coded as romantic.[50] One of those, India Arie's version of Don Henley's 1989 hit "The Heart of the Matter," asks "How can love survive in such a graceless age," echoing a common theme in other chick flicks such as *Bridget Jones's Diary* (Sharon Maguire, 2001), a lament for the absence of "old-fashioned romance."[51] Such ideas of old-fashioned romance are also evoked by the film's neo-classical composed score which accompanies the romantic scenes between Carrie and Big. The music features lush strings and a tinkling piano and is so obviously reminiscent of Classical Hollywood codes of film music that it verges on parody. Both the romantic classical music and the retro love songs function in much the same way, contributing to audience identification and communicating through established cultural conventions.[52] They also convey an association between their vintage and "a nostalgic version of romantic certainty."[53] Significantly, here romance and nostalgia appear to have become one and the same thing, with the implication that that true romance could only exist in the imagined stability of a society characterized by traditional gender roles, one in which women were women and men were men.

Conclusion

More than any other "chick flick," *Sex and the City* reflects the economic imperatives of conglomerate Hollywood. As a result the soundtrack functions mainly as a promotional tool, in the marketing of the film, as a unifying factor across a range of media, and within the narrative as part of its audio-visual promotion of consumer culture. It plays an important promotional role in enabling the film to be seen as an event, with the soundtrack album acting as a souvenir of that event, and in the development of the successful and ongoing *Sex and the City* franchise and its carefully cultivated image of female empowerment. With the narrative featuring four 40-something characters, the soundtrack has clearly been identified as a way of broadening the film's appeal to younger women and capitalizing on the success of reruns of the HBO television series. Consequently, while it is centered around several well-known mainstream musical names, each with a "high recognition" factor, it also includes songs by more alternative artists who contribute a slightly hipper aura and connections across a range of other media.[54] Nevertheless it fulfills viewer/listener expectations of the chick flick genre, with a familiar mix of contemporary and retro, neo-classical film music, popular

romantic ballads, and catchy pop and dance-oriented tunes. While *Sex and the City* is unusual for a mainstream Hollywood film in featuring a majority of female voices on the soundtrack, a closer examination only reveals the still-narrow range of gender-specific roles actually available for women in this area of contemporary popular music and here they are once again limited to the traditional female role as vocalist and "face" (and body) of the music and to performing formulaic dance/pop and stereotypical love songs.

The *Sex and the City* soundtrack not only functions in a promotional role in the marketing of the film, but also within the narrative, as part of the film's relentless audio-visual promotion of consumer culture. The most upbeat soundtrack moments are those that accompany the film's fashion montage sequences, with the music briefly highlighted and the combination of sound and visuals evoking a sense of female agency. Yet the audio-visual associations also suggest that this agency amounts to little more than a choice between different consumer products. In this context, songs such as "Labels or Love" and "Click Flash" function as little more than advertising jingles, complementing the onscreen display of consumer culture and reinforcing the film's promotion of individual, economic solutions to perceived problems in women's everyday lives. While there is some lyrical and musical irony, it is a very knowing irony, with the overriding purpose of encouraging audience identification, a "complicit critique" that never amounts to a commentary.[55] In the end, *Sex and the City's* constant emphasis on fashion culture, and especially its emphasis on "the new," simply reinforces the concept of physical appearance as just another commodity and by extension a much older message, that a woman's worth is inextricably bound up with the way she looks.

While *Sex and the City* is a mainstream Hollywood film and all soundtrack decisions are likely to have been made for economic rather than aesthetic reasons, there are nevertheless ideological implications to the choices made. The overwhelming predominance of love songs on the soundtrack reinforces the film's narrative message that, although the main characters may be successful in their working lives, they remain emotionally unfulfilled and need to find something called love in order to achieve true happiness. At the same time, a majority of *Sex and the City's* love songs are from past eras and many of them occur during the second half of the film, thereby accentuating the narrative focus on Carrie's reconciliation with Big and Miranda's reconciliation with Steve. Not only do they fulfill genre and viewer expectations for an audience that is already "in the know," but they also promote a sense of nostalgia for a more romantic time in an imaginary past, with the distinct implication that "true romance" only existed in a pre-feminist era. The predominance of love songs in the second half of the film, the narrative trajectory towards Carrie and Big's seemingly inevitable wedding, and the aurally highlighted soundtrack climax of "All Dressed Up in Love," all combine in what amounts to an audio-visual promotion of "old-fashioned values" and heteronormativity. In the end the actual choices in love portrayed as

being available to the main characters in *Sex and the City* appear as limited and conventional as their choice of labels.

Notes

1 Lisa A. Lewis, "Being Discovered: Female Address on Music Television," *Jump Cut: A Review of Contemporary Media* 35 (1990): 7.
2 Lyrically and instrumentally early 1990s American "Riot Grrrl" groups such as Babes in Toyland, Bikini Kill, Bratmobile, and Sleater-Kinney were more directly related to the late 1970s British groups.
3 "Album-oriented rock," an American FM radio category.
4 Angela McRobbie has argued that postfeminism "positively draws on and invokes feminism." She writes that it does so "to suggest that equality is achieved, in order to install a repertoire of new meanings which emphasize it is no longer needed." See "Post-feminism and Popular Culture," *Feminist Media Studies* 4, no. 3 (2004): 255. See also Yvonne Tasker, "*Enchanted* (2007) by Postfeminism: Gender, Irony and the New Romantic Comedy," Chapter 5, this volume.
5 From her single "Material Girl" (Sire Records, 1985).
6 Such as *Pretty Woman* (Garry Marshall, 1990), *Romy and Michele's High School Reunion* (David Mirkin, 1997), *Legally Blonde* (Robert Luketic, 2001), *Maid in Manhattan* (Wayne Wang, 2002), *Bridget Jones's Diary* (Sharon Maguire, 2001), *The Devil Wears Prada* (David Frankel, 2006), and *Sex and the City* (Michael Patrick King, 2008).
7 See Hilary Radner, *Neo-Feminist Cinema: Girly Films, Chick Flicks, and Consumer Culture* (New York: Routledge, 2011).
8 Worldwide gross: $415,252,786. Data from Box Office Mojo, boxofficemojo.com.
9 Jeff Smith, *The Sounds of Commerce: Marketing Popular Film Music* (New York: Columbia University Press, 1998), 197.
10 Ibid., 189.
11 Ron Givens. "Tracking Pretty Woman," *Entertainment Weekly*, 23 March 1990.
12 R. Serge Denisoff and George Plasketes, "Synergy in 1980s Film and Music: Formula for Success or Industry Mythology," *Film History* 4, no. 3 (1999): 257.
13 Justin Bachman, "The Big Record Labels' Not-So-Big Future," *Businessweek Online*, 12 October 2007.
14 Andrew Leyshon, Peter Webb, Shawn French, Nigel Thrift, and Louise Crewe, "On the Reproduction of the Music Economy after the Internet," *Media Culture Society* 27 (2005): 183–4.
15 Data from AceShowbiz, aceshowbiz.com.
16 *Variety*, 4 June 2008.
17 WaterTower Music replaced New Line Records as "the in-house music label of Warner Brothers" in January 2010. Wrap Staff, "New Line Records Renamed WaterTower Music," TheWrap.com, 14 January 2010.
18 Bachman, "The Big Record Labels' Not-So-Big Future."
19 Reebee Garofalo, "From Music Publishing to MP3: Music and Industry in the Twentieth Century," *American Music* 17, no. 3 (1999): 347.
20 Patrick Burkart, "Loose Integration in the Popular Music Industry," *Popular Music and Society* 28, no. 4 (2005): 489–500.
21 A&M Records, onamrecords.com; and Universal Music Group, universalmusic.com.
22 Smith, *The Sounds of Commerce*, 136–7.
23 Anahid Kassabian discusses codes of film music (with reference to Classical Hollywood) in *Hearing Film: Tracking Identifications in Contemporary Hollywood Film Music* (New York: Routledge, 2001), 21–4.

24 Rebecca Coyle, "Pop Goes the Music Track: Scoring the Popular Song in the Contemporary Film Soundtrack," *Metro* 140 (2004): 96.

25 Janet Mock and Julie Wang, "Jennifer Hudson: Biography," *People Online*, updated 28 June 2010.

26 Rhythmically based electronic music often with added vocals, generally using synthesizers, sequencers, and drum-machines and performed by DJs in dance clubs.

27 "Hip" meaning "informed about the latest trends." *Webster's Online Dictionary*, websters-online-dictionary.org.

28 Warner Music Group, wmg.com.

29 The video games *Burnout Revenge, SSX on Tour*, and *Thrillsville*, Pop Culture Madness, popculturemadness.com.

30 U.S. domestic total gross $152,647,258 and foreign $262,605,528. Data from Box Office Mojo, boxofficemojo.com.

31 Kassabian, *Hearing Film*, 81.

32 Sarah Jane Rowland, "Fashion Films," mixitup.co.nz. See also Hilary Radner, "The Devil Wears Prada: The Fashion Films," in *Neo-Feminist Cinema*, 134–52.

33 "Fashion," Film Reference, filmreference.com.

34 See Hilary Radner, "*Sex and the City: The Movie* (2008): Event Movies for Femmes," in *Neo-Feminist Cinema*, 153–72.

35 "A style of filmmaking molded by economic and institutional forces." Justin Wyatt, *High Concept Movies and Marketing in Hollywood* (Austin, TX: University of Texas Press, 1994), 8, 15.

36 Jane Arthurs, "*Sex and the City* and Consumer Culture: Remediating Postfeminist Drama," *Feminist Media Studies* 3, no. 1 (2003): 87.

37 Ibid. See also Germaine Greer, *The Whole Woman* (London: Doubleday, 1999) and Imelda Whelehan, *Overloaded: Popular Culture and the Future of Feminism* (London: The Women's Press, 2000).

38 From Nina Simone, *Remixed and Reimagined* (Legacy/Sony-BMG, 2006).

39 "Fergie Talks *Sex and the City* Soundtrack," accesshollywood.com, 24 April 2008.

40 Janet Mock and Julia Wong, "Celebrity Central: Fergie Snapshot," *People Online*, updated 8 September 2010.

41 See Hilary Radner, "Neo-Feminism and the Crossover Star," in *Neo-Feminist Cinema*, 82–97.

42 "Joss Stone Chanel Coco Mademoiselle Ad 'Nat King Cole' L-O-V-E," *Style Crunch*, style.popcrunch.com, 20 September 2007.

43 Marisa Laudadio, "Listen to Fergie's *Sex and the City* Song," *People Online*, 23 April 2008.

44 "Jennifer Hudson: Biography," starpulse.com, accessed 2 February 2011; Mock and Wong, "Celebrity Central: Jennifer Hudson Snapshot."

45 The opening line of her biography at starpulse.com describes her as "a source of perpetual inspiration to millions of young hopefuls."

46 "Royaldestiny," youtube.com, accessed 15 April 2010.

47 Smith, *The Sounds of Commerce*, 209–11.

48 Ibid., 209.

49 See Diane Negra, "Structural Integrity, Historical Reversion, and The Post-9/11 Chick Flick," *Feminist Media Studies* 8, no. 1 (2008), 64.

50 The soundtrack offers "cover" versions of "The Heart of the Matter," "Walk This Way," "Auld Lang Syne," "Diamonds Are a Girl's Best Friend," "The Look of Love," "How Deep is Your Love," and "How Can You Mend a Broken Heart."

51 Steve Neale, "The Big Romance or Something Wild: Romantic Comedy Today," *Screen* 33, no. 3 (1992): 286.

52 Kassabian, *Hearing Film*, 24.

53 Ian Garwood, "Must You Remember This? Orchestrating the 'Standard' Pop Song in *Sleepless in Seattle*," in *Movie Music, the Film Reader*, ed. Kay Dickinson (London: Routledge, 2003), 116.

54 Coyle, "Pop Goes the Music Track," 96.

55 Arthurs, "*Sex and the City* and Consumer Culture," 87.

13

INDEPENDENCE AT WHAT COST?

Economics and Female Desire in Nicole Holofcener's *Friends With Money* (2006)

Michele Schreiber

In his 2005 book *American Independent Cinema*, Geoff King remarks on the connections between independent filmmaking as a mode of production that is often implicitly, if not explicitly, resistant to the standard Hollywood approach, and cites women's role in such an arena:

> To eschew plot-centric forms in the cinema is, in many cases, to choose or suffer operation on the limited resources available in the independent sphere, to be relegated to what some would consider a secondary position akin to that generally offered to women in society. The corollary should be that women are more likely to be at home in the indie sector, which may be true in some respects as far as a sensibility is concerned but is clearly not the case in terms of equal availability of opportunities or resources.[1]

While King may overstate his point by conflating independent filmmakers' deviation from traditional plot-centric conventions and women's position within society, he points to some compelling intersections between women filmmakers, the economic context in which they work, narrative structure, and ideology. The dominance of what King calls "plot-centric" narrative forms is particularly salient when looking at contemporary Hollywood-produced women's films or, as they are often derisively called, "chick flicks," which almost universally employ a narrative structure in which a single woman is depicted as being successful at everything but love and, after a few fruitless pratfall-driven attempts, finally finds the right man and is safely within the confines of a heterosexual partnership at the end of the film. Contemporary big-budget Hollywood productions, such as *The Devil Wears Prada* (David Frankel, 2006), the filmic adaptation of *Sex and the City* (Michael Patrick King, 2008), *Confessions of a Shopaholic* (P.J. Hogan, 2009), and

Bride Wars (Gary Winick, 2009), among many others, present a woman's identity as not only inextricably linked, but inseparable from, the goods, services, and experience of consumption (made possible by Hollywood's substantial production budgets). This trend is in keeping with what Diane Negra has labeled "the hyper-aestheticization of everyday life"[2] in which "identification with a level of luxury consumption far out of proportion to one's actual financial circumstances is emerging as a hallmark of contemporary existence."[3]

Whereas the average contemporary Hollywood "chick flick" presents the intermingling of the pleasure inherent in consumerism with the satisfaction to be found in romantic and platonic relationships as expected and unproblematic, independent director Nicole Holofcener's films are made outside of the Hollywood economic infrastructure which limits their resources but enables an exploration of this familiar thematic terrain in an unfamiliar way, often critiquing rather than promoting commodity culture. *Friends With Money* (Nicole Holofcener, 2006), made with a budget of $6.5 million (10 percent of *Sex and the City*'s $65 million) emphasizes, even in its title, how money, and the labor in which one engages to earn it, not only affect one's sense of personal satisfaction, independence, and autonomy, but also become especially complicated when intersecting with friendships and romantic relationships. The film's thematic focus in tandem with its streamlined visual style, and loose, episodic narrative structure creates a drastically different kind of women's film, which calls attention to the realities of its female characters' lives, which tend more toward the mundane, the neurotic, and the unresolved. *Friends With Money*, along with the rest of Holofcener's oeuvre, demonstrates that a great many complex truths— some flattering, others decidedly unflattering—can be revealed about women's everyday lives when these representations are divorced from the overproduced, excessively consumer-driven output of Hollywood. Before going into detail about the film, it is useful to give some context about the contemporary independent film "industry" in which Holofocener emerged, and the place of her brand of women's filmmaking within that mode of production.

Independence, Gender, and the Auteur

Independent cinema, which has existed in American film throughout its history in some form, saw a new phase emerge in the 1980s alongside the formation of a new "indie infrastructure" made up of The Sundance Film Festival, Independent Feature Project, and Miramax films and other specialty divisions of major studios. These organizations opened up the "in-between" space that separates Hollywood studio production and avant-garde production by expanding opportunities for filmmakers who challenge and/or deviate from Classical Hollywood conventions but still aim to attract a broader audience.[4] While scholars such as Geoff King certainly attest to the fact that the independent sphere was, and still is, far from the idyllic equal opportunity democratic collective that one would hope it would

be, its historiography tends to be dominated by the success stories of a few filmmakers, most of whom are of the same demographic—Caucasian, heterosexual, middle-class men—that has dominated the Hollywood studio system since its inception.[5] As far as women filmmakers are concerned this may very well be because, with the possible exception of Kathryn Bigelow, they have not been as successful in crossing over into the Hollywood mainstream as their male counterparts and therefore are lesser-known and easier to overlook. Scholar Christina Lane, whose book *Feminist Hollywood: Point Break to Born in Flames* is one of the few to tackle the topic of women's independent filmmaking, offers a fascinating take on this trend in her article "Just Another Girl Outside the Neo-Indie":

> a new brand of indie auteurism, grew as a result of the desire for festivals and independent studios to draw attention to their films by promoting the director as a maverick who had seized the reins of low-budget production and, in his own hip, cool way, made the system work for him. And it was nearly always a *him* because the traditional director's "mystique" of auteurism pervaded the indie festivals and studios' marketing campaigns, excluding women from increasingly commercialized imagery. As the 1990s continued, it became less likely that films would be advertised on the basis of a "woman director," meaning that women filmmakers and "female" genres became less marketable and less marketed, in a reciprocal spiral.[6]

One is reminded of the impact of this "reciprocal spiral" of women being edited out of the 1990s independent sphere's self-promotion machine when reading about the difficulty that critics had in categorizing Holofcener and her first feature *Walking and Talking* (1996). *Sight and Sound* reviewer Liese Spencer stated,

> *Walking and Talking* is a welcome example of that rare hybrid: the independent cinema chick movie. This debut feature from Nicole Holofcener is a quick-witted study of female friendship, which conveys warmth and emotion without resorting either to *Oprah*-like confessional or melodrama.[7]

And Holofcener was asked about being labeled in the "'chick flick' category" in an interview for the online magazine, *Reverse Shot*:

> RS: Does it ever bother you when people lump your films into that "chick flick" category simply because you focus on women?
> NH: You know, I don't know; I don't think they are chick flicks.
> RS: I don't either, which is why I wonder if it bothers you.

NH: You know, it would bother me if I couldn't get financing because people said, "Oh, this is a chick flick." But I get to make them, so you can call them whatever you want [laughs]. So if they need to be labeled, that's okay, as long as I can make them.[8]

Holofcener's comments shed a lot of light on how she perceives herself within the context of the industry. Her interest is in getting financing to make the films that she wants to make, and she is less concerned with how they are labeled by viewers. These varied responses to Holofcener's work bring forth many compelling issues, two of which underlie this chapter's case study. The first is, why do women's contributions to the history of the contemporary American independent cinema continue to be overlooked or, at the very least, undervalued? And, second, why is it easy for viewers to identify the differences between independent and Hollywood "men's" films, but not independent and Hollywood women's films? An examination of *Friends With Money*, with these questions in mind, will introduce some ways in which we might discuss a filmmaker as neither an independent filmmaker nor a chick flick filmmaker, but as potentially being situated in *both* of these seemingly incongruous cinematic camps and with something to offer both of them. This not only expands the ways in which we might come to define women's films, but also opens up the discussion of independent film as being a space for both male and female narratives.

"Even When It's Boring": Holofcener in Context

Nicole Holofcener's career trajectory blurs many of the same boundaries as her films, as she is one part outsider, and one part insider. She grew up in New York City and then moved with her family to Los Angeles when she was 12 years old. She later returned to New York and became a production assistant on Woody Allen's *A Midsummer Night's Sex Comedy* (1982), through the help of her stepfather Charles Joffe—a long-time executive producer of Allen's films since 1969. Holofcener also worked as an apprentice for Allen's editor Susan Morse on *Hannah and Her Sisters* (1996) and received her MFA from Columbia University, where she attracted positive attention for her short film, *Angry* (1992).[9] She scraped together $1 million in financing in order to make her first feature, *Walking and Talking*, which focuses on the complex friendship between two childhood best friends and their romantic trials and tribulations. *Walking and Talking* was distributed by Miramax, was well received by critics, and earned a respectable $1.6 million at the worldwide box office;[10] however, Holofcener struggled to get financing for her next film, *Lovely and Amazing* (2001). As Geoff King points out, she was only able to make the film, released in 2001, after she agreed to shoot it on high-definition video for the miniscule budget of $250,000.[11] *Lovely and Amazing* focuses on the Marks family and touches upon the mother and three

daughters' struggle with issues of self-acceptance revolving around weight, appearance, and professional success. It was eventually picked up for distribution by Lions Gate and saw a worldwide gross of over $4 million.[12] *Friends With Money* (2006) was Holofcener's first union film, distributed by Sony Pictures Classics, earning a worldwide gross of $15 million against a budget of $6,500,000.[13] Her most recent film *Please Give* (2010) had its world première at the Sundance Film Festival on 22 January 2009 and had its U.S. domestic release in late April 2010.[14]

As is clear from the above plot descriptions, Holofcener's films focus primarily on female characters that are both going through some process of self-discovery and working on their relationships with other women, with romantic relationships playing a less important role. The absence of a traditional romance narrative attribute is one point of distinction between her films and those made by Hollywood, causing them to be decidedly more meandering and less "plot-centric." As Brenda Blethyn, the actress who plays the Marks matriarch in *Lovely and Amazing*, has stated: "Nicole is only interested in the actual truth of things. Even when the truth is boring."[15] In other words, Holofcener has been given the label of the "female Woody Allen" for good reason. Her films have a great deal in common with his loose character-driven narratives and emphasis on dialogue instead of action. Plus, like Allen, Holofcener is not particularly interested in making her characters seem likeable or even identifiable. Manohla Dargis summarizes this perfectly in her recent review of *Please Give*:

> Few American filmmakers create female characters as realistically funny, attractively imperfect and flat-out annoying as does Ms. Holofcener…. You may not love them, but you recognize their charms and frailties, their fears and hopes…. We don't necessarily or only go to the movies to see mirror versions of ourselves: we also want (or think we do) better, kinder, nobler, prettier and thinner images, idealized types and aspirational figures we can take pleasure in or laugh at in all their plastic unreality. The female characters in Ms. Holofcener's films don't live in those movies: they watch them.[16]

Dargis's observations are most certainly applicable to *Friends With Money*, which focuses on four women: Olivia (Jennifer Aniston), an aimless pothead high school teacher-turned-maid; Christine (Catherine Keener), an unhappily married screenwriter; Jane (Frances McDormand), a depressed clothing designer going through a mid-life crisis; and Franny (Joan Cusack), a wealthy, altruistic stay-at-home mother. The film shows the intertwined lives of these friends and their significant others over a span of a time bookended by two gatherings—the first, the celebration of Jane's forty-third birthday and the last, a gathering at an ALS (Amyotrophic Lateral Sclerosis) fundraising dinner. The film is about the ways in which women support each other, but also emphasizes how, behind closed

doors, friends spend a fair amount of time expressing concern about, and passing judgment on, each other's life choices. Holofcener's presentation of this dynamic is characteristic of her subtle style, as these scenes fall short of cattiness, but feel acerbic enough to be recognizable to anyone who has walked away from a social event and had an opinion about the people with whom they interacted. The caring yet critical lens through which the friends judge each other is familiar and humorous not just because it may mirror spectators' real-life relationships but also because we might think of it as loosely mirroring the relationship between spectators and Holofcener's films. As the aforementioned critics make clear, watching the "boring truth" of women who make bad choices that lead to unsatisfying conclusions makes for a viewing experience that is often uncomfortable because of how skillfully it subverts the model of "plastic unreality" that we have come to expect from the average Hollywood women's film.

They Don't Live in These Movies

Friends With Money opens on a sequence in which a woman cleans a house, doing the kind of labor that we rarely see depicted in film, and even more rarely see depicted as our female protagonist's career choice. We see medium shots of this character—photographed only from the neck down—cleaning the toilet, pulling hair out of the bath-tub drain, opening drawers to place knick-knacks, but we don't see her face until about two minutes into the film's running time.[17] Once the viewer gets the big reveal that this maid—Olivia—is played by the best-known actress in film—Jennifer Aniston—we see her help herself to the vibrator left in the knick-knack drawer (the act of using it, not surprisingly, left off-screen). And then, after she replaces the vibrator matter-of-factly, she takes her money and leaves. Intercut with Olivia's cleaning scenes is a scene set in Christine and David's (played by Catherine Keener and Jason Isaacs) house where an architect is showing them a miniature model of a second-storey addition for their home. They are exuberant that the addition will give them a view of the ocean, and readily shrug off the architect's warning that adding a second storey in a neighborhood full of single-storey homes might upset their neighbors. When they admire the miniature couple on the balcony of the model home, David remarks, "Look honey, it's us!"[18] At the end of the scene, when Christine goes to get coffee for David and the architect, she clumsily hits her leg on the table and winces in pain. The fact that neither man seems to notice or asks her if she is okay seems insignificant at the time but becomes a recurring trope for the film's depiction of Christine and David's marriage.

I will return to, and elaborate on, these first two sets of scenes later, but first I want to briefly address what this opening sequence shows us about the two characters that I will spend less time discussing—Jane (Frances McDormand) and Franny (Joan Cusack). Jane, whose forty-third birthday celebration marks the beginning of the film, is going through a midlife crisis that consists of her

neglecting her hygiene and going off on angry tirades toward anyone whose actions displease her. One of the plot points of the film explores whether Jane's husband (Simon McBurney), whose meterosexual interest in sample sales and designer clothes strikes her friends as erring on the homosexual side, is gay. This question is introduced in their first scene when we see a gender reversal of the usual pre-party clothes deliberations, in which Aaron asks Jane whether or not his shirt looks okay and debates changing into the "new striped one" which he can "tuck in," to which Jane lovingly responds, "you're pathetic." While the film sees Aaron explore a friendship with an equally metrosexual man (humorously, also named Aaron), it is ultimately confirmed that he is not homosexual and is completely devoted to and emotionally supportive of his wife and child.

What is most compelling about the Jane/Aaron storyline in the context of this discussion is that they (and the other Aaron) own their own retail businesses. Jane is a clothing designer, Aaron a maker of organic bath and beauty products, and the other Aaron, a sock designer. However, with the exception of a quick glimpse of their products here and there and a short scene of all of the female characters trying on Jane's clothes in anticipation of the ALS fundraiser, the film does not dwell in any way on the commodity culture of which they are a part. Nor does it aestheticize the commodities themselves. When Jane's clothing is mentioned, it is for its exquisite construction but also for its astronomical price tag. Jane responds, "I know it's overpriced, but it has to be." In this line she undercuts the mythology around fashion—she knows that she has to play into it, but makes clear that she is fully aware of its superficiality. The film makes clear its distance from mainstream consumer culture seen in your average Hollywood film by having Jane's big breakdown take place in an Old Navy store. Brand placement— yes, but the depiction of the store, its employees, and its customers is far from flattering.

Franny, the wealthiest of the four characters, is introduced in a scene where, in another gender reversal, she asks her husband Matt why he had to spend $95 on a pair of shoes for their young daughter. Franny's defining characteristic is this recurring sense of guilt over spending her inherited wealth to spoil their kids (which comes up again on a Christmas shopping trip later in the film) rather than do good for people. While she is given the least amount of screen time and doesn't go through the same type of emotional journey as the other three women, the representation of her character suggests that even people with a great deal of wealth still have hang-ups and neuroses about the responsibilities that come along with money. However, Holofcener's representation of Franny and Matt's relationship as more stable and sexually satisfying than the rest of the couples in the film doesn't do much to dispel the conception that wealthy people might actually be happier. As Aaron remarks in reference to Franny and Matt: "I would have a lot of sex if I had that much money, I mean you know, nothing to worry about. No stress."

"I've Got Problems"

I will now return to the film's first two scenes depicting the characters of Olivia and Christine as it is through their stories that the film's most explicit interrogation of the complex and intertwined nature of labor, economics, commodity culture, romance and sexuality, and their ramifications for a woman's sense of autonomy and independence, can be found. Christine and Olivia are the only two primary characters who are seen working, and their narratives reveal, in quite different ways, how the type of labor that is often left off-screen (both figuratively and literally) is linked to the seemingly effortless appearance of wealth and a clean and aesthetically pleasing home environment that we have come to expect from Hollywood women's films. We might imagine that, as Dargis states, just like Holofcener's female characters are the type to watch a movie and not be in a movie, the cottage that Olivia cleans is not a house that she could live in, but might just be the type that appears in one of those movies, and Christine, being a screenwriter, might be the one to provide the script.

As a part of a screenwriting team with her husband, the blurred boundary between Christine's marriage and workplace is mirrored by the blurred boundary between the conflicts of their fictional characters, whose lines they read aloud to each other across their shared office, and the conflicts of their marriage. The first time we see their collaborative work process it is at first difficult to tell if we are witnessing a real conversation or a conversation from the script that they are writing. Since David reads the lines of the male characters and Christine reads the lines of the female characters, their performances of these roles become confused with reality. The male characters enacted, and presumably written, by David are just as abrasive and uncaring as he is. The way in which Holofcener shoots these sequences in a tight shot-reverse-shot style, isolating Christine and David in medium shots at their respective desks across the room from one another, emphasizes the distance of their relationship. The physical distance as exemplified by visual style also extends into the bedroom, as their friends continually discuss their lack of a sex life.

It is ironic that while the film emphasizes Christine's growing frustration with the emotional and physical distance she feels from a brutally honest David, their relationship is seen to cause her to disregard the feelings of others. This is most pointedly represented by the house addition, which will serve Christine and David's desire to see the ocean and allow them to showcase their "good taste," but will detrimentally affect the lives of their neighbors. They not only don't care about this, but actually seem to enjoy the act of being seen performing a particular type of commodity fetishism. This is exemplified by Christine's comment, "I swear to God as soon as we did it [went with modern decor] I feel like everyone did it." In other words, just like the happy miniature couple in the model house, being associated with their beautiful home will be enough to make it appear that they have a beautiful marriage. It is only when one of their neighbors

takes the time to show Christine that she and David's idyllic second-floor view of the ocean will effectively block the views of everyone else in the neighborhood that she begins to realize that the cost of appearing to have expensive "good taste," and of playing the role of a character in the fantasy miniature home narrative, is preventing her from having meaningful relationships with those around her. But Christine only decides to put an end to the marriage when, upon her third clumsy mishap (mirroring their aforementioned first scene together), David neglects yet again to ask her if she is okay. She comes to realize that he too is more invested in the superficial idea of their marriage than the complex emotional connection and intimacy that it should involve.

Olivia's job as a maid, and general approach to life—she is also a habitual marijuana smoker and stalks a married man with whom she had a fleeting affair— is the anchor point for most of the discourse in and around labor and economics in *Friends With Money*. We are made to understand that Olivia was once a dedicated eleventh-grade teacher who worked at a "fancy" school in Santa Monica, but was so disgusted by the fact that the wealthy students threw quarters at her old Honda that she quit and took up house cleaning instead. In one of the first group scenes, David asks Olivia "is that hip now, working as a maid?" This idea of "choice" and "hipness" associated with Olivia's career path seems to imply that because she is Caucasian and well educated there must be some other explanation for why she would stoop to the level of manual labor. (This same standard or expectation is not the case, however, with the film's ubiquitous Mexican laborers who aid and support the "lifestyle" choices of the main characters.) As David's comments (and later comments from her female friends) reveal, unlike a typical women's film protagonist who is good at her job but bad at love, Olivia is bad at both. In fact, being the only unmarried character in the film, she is the only one who is seen to pursue a sort of romantic trajectory. I say "sort of" because the representation of her quest for love and companionship is painfully awkward, far from the "meet cute" presented in your typical Hollywood chick flick.

Olivia's indifference to the boundary between the personal and professional spheres as seen in the vibrator scene at the beginning of the film suggests that not only does she feel a certain sense of ownership over the homes of her employers and their personal items, but these spaces and goods allow her to act out the sexual and commodity-driven fantasy life of a wealthier person. This carries over into her relationship with Mike, the handsome, narcissistic personal trainer with whom Franny sets her up. Olivia not only brings Mike to her cleaning jobs with her but also has sex with him in the bedrooms of her employers' homes. The boundaries are blurred even further when, after they leave each house, Mike claims half of her salary in some bizarre variant of the john/prostitute/pimp relationship. Mike even goes so far as to give Olivia a French maid's costume for her birthday so that they can fulfill one of his sexual fantasies. We see that this birthday present is more of a gift to Mike than to Olivia, as she is visibly apathetic

during the entire escapade. It is the indignity of this experience augmented by her discovery later that evening that Mike is dating another woman that brings Olivia to a realization, not unlike that which Christine comes to, that allowing her personal life to blur into professional life, and borrowing someone else's ideas of happiness, are causing her to compromise her own sense of fulfillment.

One of the film's most humorous commentaries on Olivia's investment in, and eventual disenchantment with, "buying" prepackaged fantasies is her obsession with a specific and very expensive Lancôme face cream, aptly named Resolution. Because she cannot afford the cream's $75 price tag, she goes from one department cosmetic store counter to another to strategically procure samples of it, which we see her carefully stack on her bathroom shelf and use throughout the film. However, at the same time that she becomes less and less enchanted with her job, she steals a full jar of the night cream (another dubious act left off-screen) from one of her employer's homes. As she calls each of her clients to let them know about her decision to quit, we see her liberally applying the cream to her feet, now showing a blatant disregard for its value. It is quite revealing how Olivia's suppression of her own needs and desires is linked with her obsession with the Resolution face cream and what it can do for the lines on her face. And that as soon as she becomes more in touch with herself, her investment in the culturally perpetuated ideas of the "self" promised by this commodity ceases completely.

FIGURE 13.1 "Olivia" (Jennifer Aniston) collecting free samples in *Friends With Money* (2006). Courtesy Sony Pictures Classics/of Photofest.

Olivia's dismissal of the fantasy of the face cream is also intertwined with her openness to the romantic overtures of her client Marty who, being cheap, over-weight, sloppy, unemployed, and divorced, is about as far from the prepackaged romantic leading man type as you can get. While Marty turns out not only to be a nice guy but independently wealthy, the brief glimpse that we get into their romantic relationship at the end of the film is anything but Hollywood perfect. The film's final scene shows the two in bed together with Olivia making some redecoration suggestions. She then turns to Marty and asks, "You remember when we first met, and you bargained down my price? I mean, why would you do that, when you have a lot of money?" He says, "I'm sorry, I mean, I guess I have some issues. You know how people sort of have problems? I have them." To which she replies, "That's okay. I've got problems." And, in true Holofcener fashion, it is on this line that the film fades out. There is no promise of a happy ending between Olivia and Marty. And it seems no coincidence that the thrust of this awkward closing conversation revolves around the complications and problems that are part and parcel with money and the ill-conceived perceptions that are wrapped up in it.

Certainly, this case study of *Friends With Money* only scratches the surface of the variety of interesting ways that independent female filmmakers such as Nicole Holofcener can interrogate and resist mainstream cultural fantasies targeted at women, whether it is the desire to have more money, to buy more goods, or the desire to have a cathartic happy ending. The film not only sheds light on how much an understanding of American independent cinema has to gain from giving women filmmakers their due but also makes clear, returning to Dargis's earlier quote, how much female spectators of women's films have to gain from seeing reflections of what one's life is, rather than imagining what one's life could be like if one were prettier, smarter, or richer. Olivia's journey with the coveted Resolution face cream has a lot of parallels with the female spectator's relation-ship to the "plastic reality" of your typical chick flick. Like the fantasy of the cream, these films may promise solutions to women's anxieties, and an escape into a problem-free life. But by letting go of the fantasy, it is possible to find something that's not always easy but can be decidedly more complex, interesting, and potentially more fulfilling.

Notes

1 Geoff King, *American Independent Cinema* (Bloomington, IN: Indiana University Press, 2005), 227.
2 Diane Negra, *What a Girl Wants: Fantasizing the Reclamation of Self in Postfeminism* (New York: Routledge, 2008), 152.
3 Ibid., 126
4 Certainly the industrial distinction is somewhat slippery given that since the 1990s, the independent film sector experienced an ever-increasing proclivity toward production, distribution, and marketing practices that run parallel to, and often intersect with,

Hollywood's. And, in some cases, independent has turned into "indie," reflecting a sensibility rather than a strictly economic designation.

5 Most of the leading scholarly books on American Independent Cinema tend to place women, people of color, and gay and lesbian filmmakers in their own chapter(s) with the discussion of the broader tendencies within the contemporary independent sphere largely dominated by the stories of Caucasian, heterosexual, middle-class men. See Geoff King's *American Independent Cinema*; and *Indiewood USA: Where Hollywood Independent Cinema* (London: I.B. Tauris, 2009); Emanuel Levy's *A Cinema of Outsiders* (New York: New York University Press, 1999); Greg Merritt's *Celluloid Mavericks* (New York: Thunder's Mouth Press, 2000); and Yannis Tzioumakis's *American Independent Cinema: An Introduction* (New Brunswick, NJ: Rutgers University Press, 2006).

6 Christina Lane, "Just Another Girl Outside of the Neo-Indie," in *Contemporary American Independent Film: From the Margins to the Mainstream*, ed. Chris Holmlund and Justin Wyatt (New York: Routledge, 2004), 201.

7 Liese Spencer, "*Walking and Talking*," in *American Independent Cinema: A Sight and Sound Reader*, ed. Jim Hiller (London: British Film Institute, 2008), 141.

8 Kristi Mitsuda, "Nicole Holofcener: An Interview," *Reverse Shot*, reverseshot.com, Spring 2006. This is typical of the types of questions that Holofcener is asked and the types of sentiments she expresses in interviews. A very similar interaction was had in an interview she recently did for *Please Give* in which she responds to Andrew O'Hehir's question about being a chick flick director in the following way: "I'm not trying to do anything except tell the story that interests me. It just happens that these people are women, or more characters in my movies are women, and it's the same thing when people want to call me a female director. I'm just a director. I can't deny that my audiences are definitely more female, but I think that's partly because people call them women's movies. There was one magazine that called this movie a 'bitchy chat-fest chick flick.' And it was a positive review! Like, what guy, and what intelligent woman, would ever go see that? It's frustrating." See Andrew O'Hehir, "The Art of Making 'Vagina Movies,'" *Salon*, salon.com, 29 April 2010.

9 Margy Rochlin, "FILM; Just Like Her Family: Complicated," *New York Times*, 23 June 2002.

10 Data from The Numbers, the-numbers.com.

11 Patricia Thompson, "Femme Helmers Strive for Level Playing Field," *Variety*, 28 July 2002, referenced in King, *American Independent Cinema*, 226.

12 Data from The Numbers, the-numbers.com.

13 Ibid.

14 *Please Give* website, sonyclassics.com/pleasegive.

15 Rochlin, "FILM; Just Like Her Family."

16 Manohla Dargis, "Holding Up a Mirror to Women, Thorns and All," *New York Times,* 30 April 2010.

17 The fact that this character, Olivia, is played by the best-known actress in the film—Jennifer Aniston—leads one to wonder if this is early omission is meant to emphasize the usually anonymous work of manual domestic laborers, or if it is because the audience is meant to guess whether or not the actress could possibly de-glamorize herself enough to play the role of the maid.

18 For all quotations from this film, see *Friends With Money*, directed by Nicole Holofcener (2006; Culver City, CA: Sony Pictures Home Entertainment, 2006).

14

THE FEMINIST POETICS OF SOFIA COPPOLA

Spectacle and Self-Consciousness in *Marie Antoinette* (2006)

Christina Lane and Nicole Richter

As *Marie Antoinette* (Sofia Coppola, 2006) opens, the title character (Kirsten Dunst) lies listlessly on a lavish chaise, surrounded by extravagant pink cakes set against a pastel blue background.[1] Framed in long shot, she reaches over to lightly scoop a dollop of frosting from the top of a cake as a maid slips ornate shoes on her feet. With this gesture, she turns her head toward the camera and, after the briefest of moments, looks directly at the lens with a knowing smile. This introduction puts into play a visual tension between seeing and being seen. It communicates a preoccupation with Marie's excessive consumption and the way that she co-creates herself as a material object. The opening shot's emphasis on spectacle poses a question concerning the relationship between self-representation and image production, one that is explored in all of director Sofia Coppola's films.

Coppola's first two features, *The Virgin Suicides* (2000) and *Lost in Translation* (2003), negotiate ongoing tensions between interior and exterior spaces, whether dramatic, emotional, or geographical. Yet, it is her third, *Marie Antoinette*, that most explicitly speaks to the difficulties of her own position—as a filmmaker who is both on the inside looking out and on the outside looking in. Set in the eighteenth century, this postmodern ode to girl culture captures the loneliness and alienation of the 14-year-old Dauphine—and eventual Queen—as she leaves behind her homeland of Austria and marries France's Louis XVI. It also offers an illuminating perspective on Coppola's unique approach to cinematic style while revealing her own view of her location within the American and global film industry.

Coppola has carved out a niche as an indie-boutique "arthouse" director who has a solid grasp of mainstream popular culture from within a changing studio system that relies increasingly on mega-blockbusters and remains overwhelmingly male-dominated. *Marie Antoinette* is rooted in both feminism and excess in

ways that simultaneously speak to and complicate Hollywood's trend toward big-budget, high-concept movie-making. Her films often appear to be almost (if not equally) as spectacle-driven as those produced by the place, or series of places, we know as Hollywood. However, Coppola uses codes of superficiality and visual overload differently—in order to express a subjective point of view as she struggles to assert her creative, professional, and authorial agency.

Marie Antoinette was dismissed by many critics for what they saw as a highly stylized objectification and fetishization of the female protagonist and her surroundings. The film has also been criticized because of its obvious disregard for historical accuracy. We see it, however, as a conscious effort on the part of Coppola to articulate a subjective process of feminist self-knowledge production within the confines of a highly commercial industry. The self-objectification conveyed by Marie actually becomes—over the course of her rite-of-passage into adulthood—the route by which the character deepens her self-understanding and increases her self-expression. Coppola focuses strategically on Marie's relationship to the restricted world of the film, and as a director shows that she is profoundly self-conscious about women's image-making and available modes of feminist knowledge. The charge of critics concerned with historical accuracy falters when considering *Marie Antoinette* as a fiction—a work created, in part, by Coppola which points directly to the constructed nature of representation. From the outset, Coppola positions knowledge (including historical knowledge) as unrepresentable and, making no pretense toward "truth" or "fact," she sets the stage for feminist (self-) representation.

Marie Antoinette and Coppola's entire filmography to date negotiate the perpetual tensions between sound and silence, public and private, and consumption and production. *Marie Antoinette* is a female rite-of-passage story fraught with tensions about what it means to speak or enunciate from a place of professional compromise; it centralizes women's communities and female communication within a broader set of tensions related to male looking and masculine power.

Coppola's directorial persona is often defined through traditional terms of auteurism because of the link to her status as the daughter of producer-director Francis Ford Coppola (born and bred of the 1970s auteur-generation). Her films simultaneously mobilize and resist the mystique surrounding the romantic cult of the (male) director; she inherits and challenges the logic of the "father" literally and figuratively. At the same time, *Marie Antoinette* provides insight into the contemporary status of women's mid-level budget feature filmmaking. Coppola's preoccupation with how subjective spaces of the mind connect with physical, geographical space becomes a commentary about women's film production as a national and transnational activity.

Marie Antoinette may support Coppola's position as a "Hollywood feminist auteur," but it also confirms that each term within this triumvirate (Hollywood-feminist-auteur) is outdated and problematic. After 30 years of evolving feminist

film criticism that seeks to revise existing models of auteurism (in addition to major endeavors within the film studies field to more fully encompass developments within the mediums of television, multi-media, and digital technology), Coppola's situation suggests that traditional auteurism maintains a strong hold when considering today's women directors. *Marie Antoinette* illuminates an imperative that is continually expressed by feminist critics: if contemporary debates about media authorship are to move forward, new critical paradigms are required that allow for inventive ways of thinking about the poetics—and politics—of feminism. Coppola's brand of "feminist auteurism" is therefore both a contradiction in terms and a potential formulation for articulating the process of producing gendered knowledge and representation within the confines of a conglomerate-based, mega hit-driven marketplace.

Gender and Film Production

Marie Antoinette is Coppola's only film to date financed by a major Hollywood studio—Columbia Pictures—though even this project was the result of co-distribution deals with France's Pathé and Japan's Tohokushinsha Film. The director has always shown skill in cultivating hybrid production and distribution arrangements with an eye toward the global market. She has also drawn on the resources of Francis Ford Coppola's American Zoetrope, relying on its autonomous funds as an albeit small financial base. Her debut *The Virgin Suicides* came about through merged financing from American Zoetrope and the small, Los Angeles-based Muse Productions, with eventual U.S. home video distribution by Paramount Classics. *Lost in Translation* and *Somewhere* (2010) have also benefited from an innovative model that draws support from Pathé, Tohokushinsha, and Zoetrope, while relying heavily on a home base at James Schamus's Focus Features.[2]

The advantage Coppola has enjoyed because of her father's place in Hollywood cannot be ignored; she benefits from a certain celebrity status and, simply put, a high-profile "name-brand." Yet she deserves credit for her deft ability to exploit the global contours of contemporary film production and to navigate the current American "indie" market with savvy and perseverance. Her career to date has unfolded within the context of a studio marketplace that Thomas Schatz labels "Millennial Hollywood" or "Conglomerate Hollywood," which, according to him, culminated in 2007.[3] The current American system is structured by "an epochal merger-and-acquisition wave" and the dominance of "global media superpowers," both of which have led to "blockbuster-driven franchises."[4] Taking a cue from this context, Coppola finds financing for smaller-budget, more aesthetically daring pictures through complex international co-production and distribution deals. She has engaged in a tactical, mirroring maneuver that aids her ongoing professional survival. In an environment governed by brand-based franchises, serials, and remakes, Coppola's films—which are more lyrical, poetic,

and character-driven—have succeeded not necessarily through counter-strategies of financing but rather by exploiting and aggressively co-opting reigning economic structures.

Coppola's career faces constant jeopardy given the gendered dimensions of the Hollywood marketplace. A landmark study at San Diego State University's Center for the Study of Women in Television and Film (CSWTVF) reports that, of the top 250 domestic-grossing films in 2007, only 6 percent were directed by women.[5] A follow-up study that examined 2008 revealed 9 percent of directors (of the top 250 domestic-grossing films) were women and showed "no change" from 1998, in which 9 percent of directors were women.[6] In 2000, women comprised only 11 percent of all directors working in Hollywood.[7]

The statistical portrait that emerges from 1998 to 2008 indicates that there has been relatively little improvement from 1981—a time when affirmative action initiatives were put into motion within the industry. That year, results of the formation of a Women's Steering Committee and Ethnic Steering Committee showed 3 percent of members of the Directors Guild of America were women. A collective bargaining agreement produced an article providing that studios would make "good faith efforts" toward increased employment of women and minorities.[8] Although there have been major shifts in film school admission practices and various employment initiatives, approximately 90 percent of all studio directors are male.

Manohla Dargis, reviewer for the *New York Times* and a vocal advocate for redressing lack of representation, places a good deal of blame at the feet of female executives and producers.[9] She observes that even in the 1990s when women were studio chiefs at four out of the six majors, little progress was achieved in hiring practices or developing female-driven material, especially as the decade ensued. The implication is that women have internalized the values and policies of Hollywood structures and it would take a monumental shift in corporate and ideological systems to see more women in above-the-line positions. As the conditions of Millennial Hollywood have taken hold more aggressively, the systems have become more rather than less rigid, leading to a decline in female studio heads. The precarious status of female executives may also explain their reluctance to stray from the supposedly known money-makers, such as high-concept special-effect pictures and male-driven comedies. The CSWTVF found that, although many executives espouse the notion that women's films make less at the box office and perform more poorly on opening weekend, productions that had at least one woman in a key above-the-line position (director, executive producer, producer, or writer) earned approximately the same as those with all men in top positions.[10] In other words, the industry is structured by an uninformed mythology about films that have significant female participation.

Of the original four women studio chiefs, only one remains—Amy Pascal is co-Chairperson of Sony Pictures Entertainment.[11] It is most notable then that *Marie Antoinette* (the only Coppola picture financed by a major) was green-lit by

Pascal at Sony. It is also significant that after the film performed poorly at the box office—a $40 million production that grossed $16 million—Sony did not back Coppola's next film, apparently finding the proposition too risky.

If the studio environment has provided little reassurance for women directors, these filmmakers are finding it less possible to garner support from indie divisions or boutique companies because such places are rapidly reorganizing or folding. In 2007, Time-Warner dumped New Line Cinema and shut down Warner Independent and Roadhouse Pictures. Paramount closed Paramount Vintage while Universal sold Rogue Pictures. Between 2007 and 2009, some of the most significant executives from independent companies lost economic hold.[12] The Weinstein Company has recently been treading water and in 2008, Stephen Soderbergh's long-time autonomous Section Eight returned to the Warner Bros. fold.[13]

It is clear that part of Coppola's success hinges on her mutual relationship with Focus Features, one of the few remaining specialty divisions in the current and tenuous indie market.[14] Focus's Schamus invested considerable marketing behind the push for *Lost in Translation*, which helped position Coppola to earn an Academy Award nomination for Best Direction (the third such nomination ever to go to a woman).[15] Focus also welcomed her back after the less-than-stellar box-office returns for *Marie Antoinette*. In addition to support from Focus, Coppola has succeeded by fashioning herself as a celebrity; to a certain degree she presents herself "as image," tapping into an array of industries and franchises. She co-founded the Japanese-based clothing line Milk Fed (with Stephanie Hayman) and has had an ongoing collaboration with Marc Jacobs, who has named both perfume and designer handbags after her. Francis Ford Coppola's successful winery sells a "Sofia" collection. She has also shown up numerous times as a style impresario on the pages of *Vogue* and *Vanity Fair*.[16] In the model of transnational Hollywood, Coppola synergizes an international approach to her career. In a complex configuration of consumption and production, her persona suggests that Coppola empowers herself through a logic of consumerism, achieving modes of self-representation within the realm of material objects and spectacle.

Spectacle and Self-Consciousness

To return momentarily to the opening shot, the excess that frames Marie (as she indulges in a bit of cake) signals the film's broader emphasis on seeing and being seen. As Duchesse de Polignac (Shirley Henderson) remarks at one point, "she looks like a little piece of cake."[17] Marie looks *like* cake while she looks *at* the camera. The character introduction not only acknowledges Coppola's awareness of the camera, but it also announces the director's interest in the woman's ability to look. The "look," or the gaze, exists in *Marie Antoinette* as a primary female pleasure. Coppola's films show us that the woman is a bearer of the look, but not necessarily a bearer of the voice. Coppola thus creates friction between the

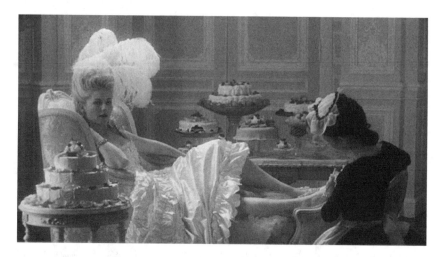

FIGURE 14.1 "Marie Antoinette" (Kirsten Dunst) as she indulges in a bit of cake. *Marie Antoinette* (2006).

visuals and sound, and brings to the foreground theoretical questions about women's looking, language, speech, and their relation to silence. Although the film has been criticized for its supposed vacuousness, its use of postmodern, "pop" imagery is quite strategic.

Coppola expresses her feminist authorship through design and spectacle. *Marie Antoinette* highlights the loneliness of the female protagonist, expressing her interior psychology through architectural space. Her heroines have difficulty speaking and finding their voice within the institutional structures that surround them. *Marie Antoinette* pushes this idea to its breaking point, by following a woman who holds absolute symbolic power but has little voice. A likeness exists between Coppola's cinematic style and the way that Marie expresses herself aesthetically in elaborately constructed costumes, hair, and make-up.

As Marie is leaving Austria for France her mother gives her the following advice: "The court of France is not like Vienna … all eyes will be on you." This line announces a new position for Marie in France—she is now an object to be looked at. Indeed, all eyes will be on her in Versailles. Indeed, the audience's eyes will be fixed on her like those of the courtiers, directed as we are by the gaze of the camera. But Marie is also able to look; in the film she is presented as both an object and subject. The theme of "looking" is most specifically exemplified in the excessive use of fans in *Marie Antoinette*—the fans often literally cover the mouths of the women using them, but leave their eyes free to see.

The "look" provides Coppola with a vocabulary for articulating the inner states of her protagonists and their relationship to the external world. For example, as Marie scans her new quarters in Versailles, she actively searches out the contours of the room and then, upon finding a box of treasures, pulls out a fan

and pauses to gaze at her face in the mirror. She places the fan over her mouth and eyes her own reflection while striking various poses. She eventually makes her way to an open window, through which she stares at the imposing view of the carefully manicured garden. The trace of Marie's look creates a series of linkages between subject and object, sound and silence, confinement and escape, all of which pivot around female desire. There is no dialogue that gives the viewer access to her inner subjective voice. Marie's voice is limited, but her eyes remain wide open.

The visual motif described above—a woman framed through a window, looking out at the world—is a distinct characteristic of all of Coppola's films. Often, these scenes include an image where the world is reflected back onto or across the woman's face. In *Marie Antoinette,* this layered reflection shot appears when Marie is riding in her carriage. We see her looking and we also see subjective point-of-view shots of what Marie sees. But Coppola never fully conveys what Marie is thinking. She allows the audience to see what Marie sees, but she grants limited access to her perspective. The story of Marie is told primarily through close-ups of Dunst's face; the audience is invited to judge her expression, and then project her interior thoughts. The ambiguity of what Marie is feeling is expressed on the surface of the image. Perhaps the character's inner world resembles Coppola's own thoughts about her films: while she maintains a high degree of self-consciousness about her style and subject, they remain essentially unknown to her viewers.

Marie's world is inundated by low murmurs, the whispers and stifled talk of those moving about Versailles. While she generally lacks a voice, she experiences the claustrophobia of sound. There exists an aural geography that reinforces how confined she is by protocol and the powers that seek to control her; it is significant that she indulges in the sounds of the opera, losing herself and escaping into the senses. At the first opera she attends, she bursts forth with an ovation after the curtain comes down, only to realize that the rest of the audience pays its respects through silence. She encourages the spectators to join in her applause and, when they do, she divines that hand-clapping offers an alternative outlet for self-expression. (Marie claps with joy in other contexts as well, while gambling or listening to a quartet.) Toward the end of the film, when she has lost favor with the French people, she again claps at the opera, only to find that no one will join her. Not only has she lost her position of power by this point, but she can barely exercise one of her few forms of self-expression.

The only character-voice that the audience is given the privilege to hear is Marie's mother, who repeatedly interrupts the life Marie pursues to remind her of her duty to bear children. The significant "voice" of the film comes from without, in the form of letters she writes to Marie. The mother's voice is the only narration in *Marie Antoinette* and continually reiterates to the young woman that she has a true purpose (however ideologically problematic) beyond the "surface play" in which she indulges. The mother is played by the iconic Marianne Faithfull

(known for her album *Broken English* [Matrix Studios, 1979]), whose voice produces its own tension within the film given her status as a rugged survivor of numerous challenges.

In the three scenes that feature the narrated letters, Marie's isolation is exaggerated through cinematography and set design. In the first, the camera tracks forward into a tight shot of Marie as she scrutinizes herself in the mirror amidst an overabundance of flowers and baubles. In the second, a slow crane shot moves from a medium shot to an extreme wide angle, depicting an overwhelmed Marie engulfed by a vast exterior wall of Versailles.

In the third and culminating voiceover scene, a downward tilt frames Marie as she slowly slides toward the floor, practically blending into the ornate wallpaper

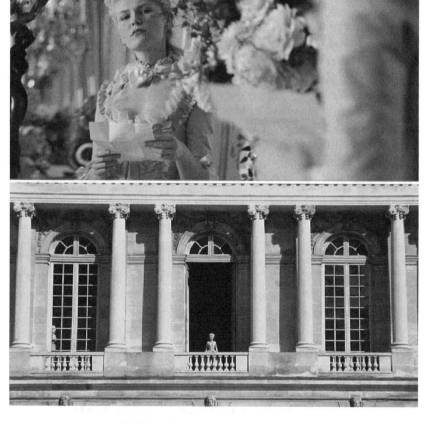

FIGURES 14.2 AND 14.3 Marie's isolation is exaggerated through cinematography and set design. *Marie Antoinette* (2006).

against which she rests. As if caught in a trap—a design partially of her own making—she looks completely lost. The slow-moving action ends as she gazes directly into the camera in what becomes a shared moment of hopelessness with the audience. Within the setting of Austria, Marie is a child who has not yet discovered her sense of self and relies on the dictates of her mother. Throughout the film the voice of the mother returns to direct her to pursue a life that is limiting. While it has been suggested by Kohei Usuda that Faithfull's voice represents "the reality of the outside world," a claim could also be made that it stands for the pressure caused by the mandates of patriarchy and sovereignty.[18] It is the symbolic world of power that confines Marie. Her mother's letters ultimately speak to the central role of Marie's body and its usefulness for bearing children. She desperately wants to become pregnant in order to please her mother and cement the nation-state friendship between Austria and France. Her body is not her own; it belongs to the people of Austria and France; it belongs to the world of politics. Like the war that France is fighting abroad, her body is contested terrain. It becomes a cultural battlefield. Her inability to bear children makes Marie so miserable that it creates a need for her to engage in excessive consumption in order to give her life meaning and joy, even if they are only temporary. Her excess functions as a symptom of the symbolic power structure—based on the logics of capital, nationhood, and patriarchy—while at the same time perpetuating these very structures.

The thematic tension between vision and voice, with its underlying implications of capitulation and resistance, helps us to better understand Coppola's situation as a filmmaker. Using her own preoccupation with women who have powerful gazes yet lack the ability to speak or communicate, Coppola becomes a speaking subject as a director and creates a unique worldview. She utilizes this place of speech to articulate the limitations of language and the depth of silence. Coppola expresses her own voice through the use of image and emphasis on aesthetics in order to comment on women's difficult relationship with the spoken word. The heroines of her films exist mostly in their inner minds, unable to connect to the world that surrounds them. Having no equals in the world with whom to share themselves, they are severed from an intellectual life that would allow them to speak themselves into existence.

There is no mention of or reference to Marie's father within the diegesis of the film. The absence of a father-voice in the film seems significant; it is as if Coppola is asserting herself as independent in her own right and responding to various cries of nepotism. This absence represents Coppola's desire to develop a clear aesthetic and a thematic break between her own work and the work of her father.

Architecture and Geography

The spaces in Coppola's films, like the remote Palace of Versailles in *Marie Antoinette*, act to domesticate the women that inhabit them and produce a system

of bodily regulation. Architecture naturalizes the repression of women and isolates them from the public realm. It is significant that Coppola does not construct the sets in which her films take place. She employs existing locations, which implies that architecture is already gendered and produces, as well as reflects, the values of the society in which it is built. By filming actual locations presumably designed and built by men, Coppola uses these structures to support her own claims about gendered space and its impact on the female characters in her films. Marie's setting makes clear that she is fundamentally lonely even as she is put on display for a prying public.

Marie's bedroom is the least private room in the house, with the entire population of Versailles taking an interest. There is no such thing as a private space in Versailles, and even the secret chamber Marie finds hidden behind her bed is actually a room for entertaining guests. Each morning, the women of the palace awaken her to see if there is any evidence of her nighttime affairs with Louis. Her lack of privacy is further exemplified in a ritual Marie must undergo as the women of the palace take turns dressing her. She is made to stand naked and uncomfortable before finally receiving her undergarments. "This is ridiculous," she says, to which Louis's mother replies, "This is Versailles." Versailles not only refers to a particular place but also to an entire way of being. Versailles collapses the distinction between individual and sovereign authority, denying the freedom of its subjects through the ritual organization of daily life.

The sharing of joy, and eroticism itself, moves out of the bedroom where it does not exist for Marie, and spreads into every other aspect of her life. She holds only symbolic power, and she finds she must express herself through aesthetic choices, primarily fashion. Coppola constructs Marie's identity and through it imagines a specifically female mode of desiring. Marie conceives of herself, and styles herself, in the image of the objects she enjoys consuming. The developing overabundance of her desire might be viewed as an indication of a superficial nature, but it can also be seen as a rejection of the repressed and joyless life at Versailles. Marie experiences an erotic relationship with the objects she consumes, which ultimately affirms her sense of living for enjoyment, a will to enjoy. This *jouissance* cannot be controlled or regulated into the daily operation of Versailles. Her desire flows in all directions and cannot be contained. This functions as a counter-representation to Louis, who even in his favorite hobby, key-making, seems to find no joy, and appears himself to have no desire for Marie. Marie's consumption can be understood as a radical act, a protest against the repression and denial of life that the protocol of Versailles demands.

The mode of desiring Coppola advances is most explicitly declared in the "I Want Candy" montage sequence. Marie embarks on her excessive consumption after a moment of breakdown, discovering that the Comtesse de Provence has born a child before her. The sequence begins with a pan from left to right of beautifully constructed shoes, and then cuts to swatches of fabrics, exquisitely

presented necklaces, and expensive jewelry pieces. Coppola couples the artistries inherent in fashion and baking with the sexual experience of touching fabrics and tasting food. The montage ends with the stylist creating an enormous, decadent and perhaps ridiculous hairstyle, and Marie asks, "It's not too much, is it?" For Versailles it is certainly too much, but for Marie nothing can be too much—it is this very excess for which she strives.

Marie shares this sensuality with other women: the young and rich of Versailles. Her activities soon pose a threat to the financial upkeep of the kingdom, and, along with the funds Louis sends to America, place her country in economic jeopardy. In this version of Antoinette's story, the sensual exploration of Marie brings about a revolution, a change in the nation-state and in the institutional structure of Versailles. It is a Versailles that Marie opposed but was a part of, and in the spirit of Coppola's films *The Virgin Suicides* and *Lick the Star* (1998), she is killed in the end, perhaps punished for her will to enjoy. Hers is consumption without production—consumption for the sake of consumption. It supplants her difficulty in having a child. In this way she finds a freedom, and even if it is not the ideal freedom to create her life, she presents herself as a spectacle and controls the way she is seen. Her voice is not validated within the world in which she lives and she finds an alternative mode of self-expression through self-fashioning and becoming self-made in aesthetic terms. Coppola's emphasis on the costuming of Marie's body reveals the labor that goes into the creation of an image and denaturalizes the process, by revealing the artistic dimension of the presentation of self. The invigorating sensuality fills a void in the short term for Marie and enables a building up of self—a stage in her development that is transitory but important. Marie rejects her suffering and chooses instead an eroticization of all aspects of life outside of her bedroom.

Freedom and Movement

Marie eventually develops a fulfilling life outside of Versailles through a community of friends and her relationship with Count Axel von Ferson. She switches to a less excessive and more natural form of life. She begins spending most of her time at Le Petit Trianon, a structure that is part of Versailles but separate from it. Versailles is never a private place, but within the world of Le Petit Trianon Marie can create her own space. She spends her days listening to music, reading, and playing in her garden, in contrast to the regimented routine of waking, praying, and eating at Versailles. She prefers more natural and less restrictive clothing during this period. Her world in this new house is also visually transformed, through saturated colors of golds and browns. She wears more muted clothing and, in counter-distinction to the splash she has made at Versailles, she announces, "I want to be forgotten."

After Marie gives birth to a daughter, the first of her four children, she spends her happiest times showing Marie-Thérèse the pleasures found in the

natural world. Le Petit Trianon allows Marie to experience the freedom of movement in the country and to actively create herself as a subject. The association between women's freedom and nature is constantly re-emphasized within Coppola's films—man-made structures are built only to limit the expression of women's souls. In breaking out of social structures and rediscovering themselves in the state of nature, Coppola's heroines feel rooted to a sense of self.

Le Petit Trianon becomes a metaphor for Coppola's position within the industry; it is a space that is connected to a large institutional structure but one that is privileged, self-sustaining, and somewhat contained within the more imposing configuration of the royal quarters. Versailles, on the other hand, is governed by a repressive protocol that is perhaps every bit as limiting to female power as Hollywood when it comes to women's filmmaking. Given the dominance of existential loneliness in Coppola's work, one might read *Marie Antoinette*'s pervasive visual codes of spatial restriction and psychological isolation as metaphors that signal the director's own position within the larger industrial system. Unlike Marie, however, Coppola's approach to style suggests that she is much more informed and knowing about her own position within broader power structures.

Coppola's complex strategies of financing and distribution have allowed her to create a vision that maintains an authenticity to herself and enabled her to actively participate in the fashioning of herself as a filmmaker. She successfully navigates the space between commercial and independent film, by creating an in-between space that facilitates a feminist poetics that can be marketed to a mass audience. Coppola creates a filmmaking version of Le Petit Trianon and becomes an author of her own beautiful and tragic world.

In a comparison between Marie and Coppola, it may seem that we can formulate an easy equation whereby Marie lives in a superficial world governed solely by consumption (and seems to find increasing power in it) while Coppola has found a way to balance consumption with production. It is certainly true that the filmmaker's perspective is rooted in "production" in the sense that she is committed to creativity and artistry. But just like Marie, Coppola exploits elements of consumption in her efforts to say something productive about her creative position within the world of commerce, and in doing so she forges a subjectivity that goes beyond a logic governed by objects, exchange, and display.

Yet Marie's character is not defined exclusively by consumption either. She puts the focus on production in the sense that she achieves creativity and artistry in the way that she consumes, through her fashioning of her body, hair, and wardrobe. For Marie, consumption plays a central role as she endeavors to produce her own image. Spectacle is the site that allows her to become a "self-made" woman. Marie finds power in materialism because she has limited access to power in the first place. Her exploitation of consumption might be seen

as similar to Coppola's in that she over-consumes—and overly stresses the image—in order to comment on the extravagance of her surroundings and her position within them. Like the self-image Marie creates, her authority in Versailles is an illusion that is staged for the sake of keeping up appearances. By becoming more and more of an image, she reveals the emptiness at the center of the "illusion of fullness" that the Versailles community strives to create.

Perhaps Coppola is able to be more radical than Marie, or say something more productive about her position, because she has access to the camera and filmmaking. This creative form allows her to be more fully liberated because it is a vehicle for her to express herself, in a way that words sometimes fail to do. It is not that she romanticizes the medium of cinema, but rather quite the opposite: she deconstructs it. Her work speaks about, on behalf of, and through the image, promoting a feminist poetics that critiques the industry, all the while revealing an intensely self-conscious perspective regarding her own relationship to authorship.

Notes

1 The authors would like to thank Rebecca Provost and Ashley Arostegui for their dedicated research assistance.
2 Tatiana Siegel, "Focus Checks into Chateau," *Daily Variety*, 17 April 2009.
3 Thomas Schatz, "New Hollywood, New Millennium," in *Film Theory and Contemporary Hollywood Movies*, ed. Warren Buckland (New York and London: Routledge, 2009), 20.
4 Ibid., 19.
5 Martha M. Lauzen, "Women @ the Box Office: A Study of the Top 100 Worldwide Grossing Films," report prepared for the Center for the Study of Women in Television and Film, womenintvfilm.sdsu.edu/research.html, 2008.
6 Martha M. Lauzen, "The Celluloid Ceiling: Behind the Scenes Employment of Women in the Top 250 Films of 2008," report prepared for the Center for the Study of Women in Television and Film, womenintvfilm.sdsu.edu/research. html, 2009.
7 Leslie Simmons, "Report: Women's Jobs Down," *Hollywood Reporter—International Edition* 403, no. 19 (2008): 103.
8 Directors Guild of America, dga.org.
9 Manohla Dargis, "Women in the Seats but Not Behind the Camera," *New York Times*, 13 December 2009.
10 Lauzen, "Women @ the Box Office."
11 Dargis, "Women in the Seats."
12 Erin Davies, "Indie-Film Shakeout: There Will Be Blood," *Time*, time.com, 7 November 2009.
13 David Segal, "Weinsteins Struggle to Regain Their Touch," *New York Times*, 15 August 2009; Martha Fischer, "Soderbergh, Clooney Break-Up Official," *Cinematical*, cinematical.com, 20 July 2006.
14 Brian Brooks, "Finally Good News! Focus Boasts a Profit and its 2010 Slate," *indieWIRE*, indiewire.com, 12 November 2009.
15 Kathryn Bigelow would be the fourth woman nominated for an Academy Award for Best Direction and the first woman to win the award.

Relationships, Identity, and Family

15

"EGGS IN MANY BASKETS"

Juno (2007), Baby Mama (2008), and the New Intimacies of Reproduction

JaneMaree Maher

Introduction

In the recently released moderately successful Hollywood comedy *Baby Mama* (Michael McCullers, 2008) starring Tina Fey, the tagline of the film read "would you put your eggs in this basket?" This query aptly captures the contemporary conundrums of reproductive decision-making most often invoked in contemporary Western cultures. It presents reproduction as a consumer option that women are called upon to consider, invoking ideas of investment. It locates individual choice as the most relevant framework for thinking about reproduction. It suggests, and this is the idea that I am interested in interrogating here, that contemporary reproduction is most often planned and evaluated as an individual project of risk and return by women. Here, I analyze two recent films, *Baby Mama* and *Juno* (Jason Reitman, 2007), considering the frameworks of reproductive consumption and certainty that are mapped in each. While acknowledging the conservative and conventional narrative threads in each film, I argue that each depicts ongoing and productive uncertainties and intimacies in reproduction that challenge the individual consumer choice and family fragmentation narratives so often mobilized in contemporary reproductive discourses.

Fantasies of Certainty and Choice

> Having a baby now goes well beyond the selection of a mate. Listen to a group of thirty-something would-be mothers and the conversation is far removed from the old notion of "falling pregnant." These women don't fall anywhere, they make informed decisions, there are supplements to take, tests to be had, results to be analyzed.[1]

Julianne Schultz, in the passage above, echoes a common view of contemporary reproduction in Western societies where social and medical assessments and evaluations are understood to determine women's decisions and experiences of conception and birth. As she notes, "falling" with its connation of accident and uncertainty is seemingly no longer applicable in women's reproductive lives. Contemporary reproductive discourses are deeply imbued with ideas of choice, control, and certainty: discussions of risk;[2] debates about rates of caesarean birth,[3] medicalization and interventions;[4] women "waiting too long" for the right conditions to reproduce and experiencing infertility as a consequence,[5] are most often framed as the outcomes of our contemporary reproductive options and opportunities. As many have pointed out, these discourses of choice and control are a double-edged sword for women; while assumptions about women's "natural" desires to reproduce have been challenged, and the conditions in which they can reproduce opened out, there are new opportunities for criticism and blame of women's reproductive choices. Lealle Ruhl suggests that "the dominant procreative ideology of advanced liberal states [is] the willed pregnancy,"[6] which seemingly authorizes women's control of their pregnancies but primarily as obligation and individual responsibility.

Ideas of choice, Angela McRobbie argues, are important in understanding how contemporary women are positioned in relationship to conventional notions of femininity and, by extension, to reproduction. McRobbie points to the "double entanglement"[7] of postfeminism which "comprises the co-existence of neo-conservative values in relation to gender, sexuality and family life ... with the processes of liberalization in regard to choice and diversity in domestic, sexual and kinship relationship."[8] This analysis suggests that while women do indeed have more choices, there are continued expectations about appropriate femininity and womanhood that shape their reproductive lives. I argue that *Baby Mama* and *Juno* draw on and reflect these entanglements of choice and constraint. In both of these films, there are clear narrative trajectories that allow for women's reproductive choices outside normative femininity (surrogacy for single women, teen pregnancy) but these intersect with conventional accounts of domesticated reproductive femininity and happy families, creating ambiguous and ambivalent accounts of reproduction.

The films emphasize issues of choice through their attention to contemporary patterns, and meanings, of consumption. As Janelle Taylor suggests, contemporary consumer culture suggests that individual mothers define and ensure optimal reproductive outcomes by their consumer choices. In each of these films, the consumption of food, goods, and reproductive services is critical to the storyline; each depicts women's decisions to undertake surrogacy, enter into adoption agreements, to purchase or exchange reproductive services for money as inherent in the landscape of contemporary reproduction and as part of women's engagement with motherhood. Taylor says that

motherhood is supposed to be a special kind of human relationship, uniquely important because uniquely free of the kind of calculating instrumentality associated with the consumption of objects.[9]

But she urges us to recognize that in contemporary societies, there are many challenges to "the illusion that mothering can somehow remain free and pure of issues of consumption and commodification."[10] These two films deal explicitly with reproduction and pathways to motherhood as forms of consumption and they clearly do not subscribe to the illusion that motherhood is free from consumer taint. In each film, there are women who can only become mothers as consumers, since they cannot conceive "naturally"; in each, class and economic resources are crucial in the reproductive choices women make and the options that they have. But while each narrative confirms ideas about contemporary reproduction as consumer choice, *Baby Mama* and *Juno* simultaneously destabilize the value and validity of such choices since chance, disappointment, and fractures are vitally important to the final resolutions.

Heather Latimer's critique of the persistence of the "language of reproductive 'freedom,' 'privacy,' and 'choice'"[11] in films such as *Juno* and *Knocked Up* (Judd Apatow, 2007) is particularly useful here. Latimer suggests that this language reveals the "entrench[ed] ... reproductive frameworks"[12] of choice and control that govern social discourses and impact on women's decisions. She contests these contemporary discourses of choice and control where "pregnancy [is] now to be imagined as a struggle between two individuals, one often imagined as needing protection from the other, who, in turn, is often imagined as concerned only with her own choices and freedoms."[13] I argue that while *Juno* and *Baby Mama* do present contemporary reproduction as a unique location where individualistic, consumerist cultures, biomedical advances, and women's changing social and familial expectations come together, they actively destabilize frameworks of conflict and choice in pregnancy and reproduction. Ideas about reproduction as a consumer project and about women's desires for conventional femininity and motherhood sit alongside stories of reproductive chance, the failure of the reproductive programs, and the creation of new intimacies between people not linked by biology, class or marriage. In the next section I offer a brief analysis of each film, arguing that while discourses of reproductive choice frame each narrative, the films suggest that reproduction never falls neatly into frameworks of choice and control.

Hollywood Reproduction: Same Old Story?

The comedic potential of reproduction has long been a staple of Hollywood narrative and the politics of women's reproductive choices have been a key focus in recent decades. In many of these films (*Baby Boom* [Charles Shyer, 1987], *Junior* [Ivan Reitman, 1994], *Nine Months* [Chris Columbus, 1995], just to name a few),

unexpected trajectories in conception, birth, or mothering (Arnold Schwarzenegger's masculine torso becoming impregnated in *Junior*, for example, or Diane Keaton's transformation from career woman to "supermum" in *Baby Boom*) move towards comfortable resolutions that reiterate the importance of mothers, fathers, and families. These stories acknowledge that journeys to reproductive fulfillment have been altered by technological advances, changing forms of family, and changes in women's lives and choices. But they also suggest continuities in women's desires since fulfillment through birth and motherhood is presented as the best outcome. Mary Desjardins argued that these films do suggest "contemporary women are being seduced"[14] into reproduction under conditions that continue to restrict women's agency and to maintain gendered burdens. It is important to situate my analysis in this critical trajectory, since both *Baby Mama* and *Juno* do close with conventional depictions of well-resourced heterosexual women happily embedded in motherhood. But I consider these films entwine these depictions with representations of other mothers, new forms of family, failed reproductive projects, and questions about consumption that challenge narrow ideas of femininity and reproduction.

The storyline of *Baby Mama* follows single career woman Kate, 37, who is yearning for a baby, even though she is clearly achieving success at work. Kate's self-introduction (offered via a voiceover that becomes the text of her conversation on a first date) makes explicit her maternal yearnings and her decision to take control, since, as she says, waiting to see if she has a baby in the general course of events would be too much of a "high-risk" strategy for her. After several unsuccessful attempts at assisted reproduction, she learns that her chances of carrying a child are "one in a million" and chooses to pursue surrogacy.[15]

Kate seeks the services of an agency that promises screening security and complete control. But immediately Kate's attempt to stay in control is undermined by her impulsive decision to enter into a surrogacy agreement with Angie, the first woman she meets from the agency. Although Kate's first impressions are not favorable, Angie positions herself as a "baby mama" in demand and Kate signs on. Angie, in the course of the film, moves in with her, flouts every one of Kate's rules for healthy pregnancy, and finally reveals that the baby she is carrying is not in fact the implanted embryo produced by Kate's egg and donor sperm. Instead the pregnancy is the result of a consoling sexual encounter with her lay-about partner, Karl, when the pregnancy test following the implantation of Kate's embryo was negative. Angie also reveals that she deliberately planned to deceive Kate, although she consistently tears up the cheques Kate gives her. Despite this deceit and disruption (which also stalls Kate's promising relationship with Rob, lawyer turned juice maker), the film moves to a positive and inclusive denouement where Kate's own accidental pregnancy combines with Angie's accidental pregnancy to produce a complex, thriving extended family that even Kate's impossible mother can enjoy.

The film invokes multiple problematic stereotypical narratives. *Baby Mama* plays on significant differences between the two women, as the educated, uptight Kate pursues her baby project and the unambitious and ditsy Angie embodies reproductive irresponsibility. Angie is presented as infantile and in need of capable Kate's "mothering" in order to grow up; in one scene, Angie cannot get out of the car because of the child lock on the door. The "feel good" outcome where each woman learns from the other cannot undercut the significance of these stratified social and economic locations. It cannot distract from seeing the ways in which reproductive services and access are linked to social and economic resources, as poorer women offer access to their reproducing gametes and bodies for wealthier women.[16] On one reading, *Baby Mama* offers a very conventional narrative closure where heteronormative and reproductive values are reinforced. In the end, each woman has successfully conceived and carried a natural child and Kate is happily settled with Rob, the father of her miracle baby. The conservative reproductive politics of *Baby Mama* are clear; after all, here are women who are simply in want of babies and ultimately husbands.

But it is the accidental reproductive outcomes that produce the happy endings and the film contests consumerist approaches to reproduction, most plainly through Sigourney Weaver's deeply unnatural surrogacy broker, Carrie Bicknell, who is ridiculed by Kate and Angie. Kate's desire to "childproof" her apartment months before the baby even arrives is responsible for Angie's urinating in her bathroom sink. We see that Kate's baby plan has gone seriously awry at her baby shower, where goods, over-the-top cakes, and questions about how they are negotiating their shared investment in Angie's pregnancy are the backdrop for revelations by Karl (Angie's no-good partner) about whose baby Angie is really carrying. As Kate shouts at Rob, she has engaged in surrogacy, in-vitro fertilization, and the commodification of pregnancy, precisely the type of selfish, reproductive "science fiction shit" that he had pointedly critiqued in contemporary societies. At this point in the film, the commodification of motherhood and reproduction is explicit and linked to failure and distress, not happy endings. Reproduction, it appears, cannot and should not be purchased or controlled and efforts to do so end in disaster. But the film's final scene shows Kate and Angie at the center of a fecund, unruly group, which includes Rob, Karl, Kate's family, Oscar, the doorman whose own reproductive history includes a "baby mama" who he feels deceived him about his son's paternity, while the soundtrack plays "what we are is still family." The film's end suggests that families and reproductive intimacies are created in failures and fractures as well as in plans and projects.

In *Juno*, as in *Baby Mama*, contested issues of pregnancy, infertility, and fracturing families underpin the film narrative. The film explores difficult questions of abortion, teen pregnancy, and commercial adoption in a landscape where conventional and conservative discourses of femininity, reproduction, and motherhood are also mobilized. Juno's pregnancy is unplanned and although she seeks a termination, she decides to continue with the pregnancy and seek out

"perfect" adoptive parents. Juno's journey is supported by her father and step-mother, her friends, and also by the father of the child, Bleeker.[17] The reproductive politics of *Juno* are animated by the conservative social ideologies that McRobbie identified as characteristic of the postfeminist era.[18] Juno's flight from the abortion clinic has been interpreted in pro-life discourses, and elsewhere, as anti-abortion.[19] Jessica L. Willis has convincingly argued that *Juno* reiterates a naturalized link between sexuality and conception even though it proffers some challenges to dominant representations of girls' passive sexuality; overall, the film draws on "traditional discourses of femininity which link sexuality to the bodily ability to procreate."[20] Vanessa, who ultimately adopts Juno's baby, lives in a sterile house in a sterile marriage; her lack of animation throughout the film suggests that women without babies are only ever partially alive. Issues of class and women's differential reproductive access and suitability for motherhood are central to the film's narrative as they were in *Baby Mama*; as Willis suggests, Juno's entry into the adoption market (and her choice of an "educated, successful couple") "distinguish Juno as a young unmarried white girl with seemingly diminished material or educational prospects."[21] Ruhl argues that particular class groups are understood to represent reproductive risk and Angie in *Baby Mama* and Juno are both marked as women who can do the bodily work of reproduction but who can't readily take reproductive responsibility.[22] Angie's early marriage and lack of education are presented as having limited her choices of employment, and Juno's pregnancy and her social location are cited as a potential "risk" to her future success.

Yet, the film's uneven resolutions and the complex range of family relationships explored do work to challenge conventional accounts of reproductive choice and responsibility. *Juno* offers representations of seemingly dysfunctional families that create happiness and provide support, even in the midst of reproductive missteps. Juno's trajectory into pregnancy is framed as accidental, but responses to the unplanned event point to the resilience of family and intimate relationships. Juno's stepmother is impatient at times, but supports and fights for Juno throughout; at one point she dismisses the ultrasound technician who passes judgment on Juno and she is Juno's support person during the birth. And while the film does seem to indicate that only well-resourced, comfortably situated women can be good mothers,[23] Vanessa's failing relationship, the critical representation of her obsessions with the right shade of yellow wall for her baby's room, and her inability to read and understand her husband's desires raise serious questions about this assumption. The final scenes where Juno plays guitar in the garden with Bleeker ensconced in the pleasure of young love have been read as indicating that the pregnancy never happened and reinforcing the anti-abortion message of the film,[24] but this co-exists with the hospital scene post relinquishment where Juno weeps inconsolably as Bleeker holds her. In my view, the film's resolution holds together reproductive fractures and intimacies rather than erasing or privileging any single narrative trajectory.

The reproductive stories in these two films are animated and framed by the complexities of reproduction under contemporary conditions of choice and consumption. And while reproduction as consumption shapes the decisions of Kate, Vanessa, Angie, and to a lesser extent Juno, these decisions don't result in the desired outcomes, or tidy narrative closures. In each film, there are unexpected connections: the scenes in *Juno* where Vanessa kneels before Juno who has offered her the opportunity to feel the baby moving and where Bren, Juno's stepmother, endorses Vanessa's motherhood, show the intermingling of difficult reproductive transfers and newly created intimacies. In these films, heterosexual relationships are refigured, accidents and chances create possibilities, and new forms of family are drawn together. I consider that these films open out new forms of reproductive intimacy that are generated inside contemporary conditions of disarticulated and commodified reproduction. While neither of these films suggests reproductive commodification and individualization can be transcended, they insist that chance, intimacy, and connection continue as central elements of women's reproductive journeys.

FIGURE 15.1 Unexpected intimacies in *Juno* (2007). Courtesy of Fox Searchlight/ Photofest.

Rethinking Personal Reproductive Lives

In the opening chapter of *Personal Lives*, Carol Smart offers a critique of current thinking about personal, emotional affective lives that is useful, in my view, for reading the reproductive dilemmas and possibilities raised in *Baby Mama* and *Juno*. She argues that contemporary accounts of family have begun to include expanded and non-nuclear groups, as new types of kin with emotional ties that are incorporated into and transformative of traditional family structures. This expansion co-exists with and contributes to the "decline of the family" thesis where nuclear family relationships are perceived to be under pressure in neoliberal individualist cultures and are understood as no longer adequate to provide necessary intimate support.[25] Smart locates the idea of family as a site of tension since inclusivity and fracture must both be included. She links these emerging and contradictory accounts of families with the individualization thesis, which suggests that continuous and active attention to one's life course is necessary in everyday life, since each person is effectively and affectively on her or his own. Previous certainties—including heterosexual couplings, women's reproduction, and nuclear family life—are no longer certain and individuals must make their own way: "decisions (large and small) are constantly being made because people can no longer rely on following old rules and models."[26] The conjunction between the refiguring of the family and the rise of the individualization narrative of personal life are central in both *Baby Mama* and *Juno*, as individual reproductive choices and complex familial intimacies coincide.

The films present the commodification and consumption of contemporary reproduction in deeply critical ways. Kate and Vanessa, though not actually carrying babies, are committed to the accumulation of information about pregnancy and babies and the relevant consumer goods that will solidify and ensure their claims as mothers. But these forms of preparation for motherhood are shown as flawed and problematic and they both enter into motherhood in ways other than those they had planned. Juno and Angie "fall" pregnant, eat inappropriate food, and engage with surveillance technologies through resistance and avoidance, thereby presenting an opportunity to challenge the norms of planning, healthy food, and pregnancy classes that shape contemporary pregnancy. These resistant engagements illuminate the widespread surveillance and management of women's reproductive consumption, and question the importance and meaning of such control. The anxieties of Kate and Vanessa about the consuming transgressions of Juno and Angie are revealed to be without foundation, as the women and the babies emerge safely and happily at the end of the films. Alternative pathways through pregnancy, not planned and not governed by the standard norms of consumption and control, are central in the film narratives and form the basis for the films' feel-good resolutions.

The sense that life courses cannot be assumed and must be actively engaged shapes the lives of all the women in these films. Kate cannot achieve motherhood

without pushing beyond boundaries of a heteronormative relationship, a nuclear family, and her own reproductive system. Angie cannot achieve adulthood or economic security without making a new form of family with Kate and commoditizing her reproductive capacity. Juno must chart a complex course to manage her early entry into reproduction and her potential happy heteronormative ending with Bleeker, one that acknowledges loss and pain. Vanessa's perfect life narrative and desire for children is diverted and potentially broken in her own inability to conceive, the failure of her previous surrogacy/adoption arrangement, and her less than suitable putative partner/father. But these ruptures are simultaneously productive and limiting and both of the films point to hopeful intimate possibilities in the midst of fragmentation and constraint.

Conclusion: Ambiguities and Possibilities

> And in the middle of this tug-of-war, they'll discover two kinds of family: the one you're born to and the one you make.
>
> (Plot summary, *Baby Mama*, Universal Pictures)

Smart suggests that the individualization thesis is connected to a sense that contemporary families are "cut off from kin and operating more as a unit of consumption" than as a source of intimate support.[27] But in *Baby Mama* and *Juno*, families are reconfigured in and through the interlocked reproductive and consumer landscapes and new intimacies and possibilities are flagged. Reproductive choices don't work out as planned, but alternative pathways to contentment or acceptance emerge. Both of these films present women's lives as constrained by reproductive desires and heteronormative assumptions; both offer conservative reiterations of women's roles as partners and mothers. But as I have suggested here, they also challenge the limits of choice and individualism, rather than confirming them as the cause of reproductive or familial dysfunction. Each film presents unruly, unexpected, and enlarged outcomes of reproduction, where losses and gains are acknowledged and encompassed, new connections are made, and new forms of family recognized. Each explores and recognizes the value of alternate and accidental reproductive pathways, and the strength that can come from newly formed family ties or existing fractured family supports. Rather than suggesting that all one's eggs can be put in one basket, each of these films suggests that reproduction will escape somehow in these contemporary disarticulated reproductive landscapes and will continue to produce accidental and unexpected reproductive intimacies.

Notes

1 Julianne Schultz, "From Conception to Perfection: Introduction," *Griffith Review: Making Perfect Bodies* (2004): 9.

2 Kerreen Reiger and Rhea Dempsey, "Performing Birth in a Culture of Fear: An Embodied Crisis of Late Modernity," *Health Sociology Review* 15 (2006): 364–73; Atul Gawande, "The Score: How Childbirth went Industrial," *New Yorker*, 9 October 2006, 59–67.

3 Katherine Beckett, "Choosing Cesarean: Feminism and the Politics of Childbirth in the United States," *Feminist Theory* 6, no. 3 (2005): 251–75; Michelle Hamer, *Delivery by Appointment: Caesarean Birth Today* (French Forest: New Holland Publishers, 2006).

4 Emily Martin, *The Woman in the Body: A Cultural Analysis of Reproduction* (Boston, MA: Beacon Press, 1989); Cath Rogers-Clark, "Birthing Experiences," in *Women's Health: A Primary Care Approach*, ed. Cath Rogers-Clark and Angie Smith (Sydney, Philadelphia, London: MacLennan and Petty, 1998), 72–81.

5 Marcia Inhorn and Daphna Birenbaum-Carmeli, "Assisted Reproductive Technologies and Culture Change," *Annual Review of Anthropology* 37 (2009): 177–96.

6 Lealle Ruhl, "Dilemmas of the Will: Uncertainty, Reproduction, and the Rhetoric of Control," *Signs: Journal of Women in Culture and Society* 27, no. 3 (2002): 642.

7 Angela McRobbie, "Post-feminism and Popular Culture," *Feminist Media Studies* 4, no. 3 (2004): 255.

8 Ibid., 256.

9 Janelle S. Taylor, "Introduction," in *Consuming Motherhood*, ed. Janelle S. Taylor, Linda L. Layne, and Danielle F. Wozniak (New Brunswick, NJ: Rutgers University Press, 2004), 3.

10 Ibid., 4.

11 Heather Latimer, "Popular Culture and Reproductive Politics: *Juno, Knocked Up* and the Enduring Legacy of *The Handmaid's Tale*," *Feminist Theory* 10, no. 2 (2009): 213.

12 Ibid.

13 Ibid., 261.

14 Mary Desjardins, "Baby Boom: The Comedy of Surrogacy in Film and Television," *The Velvet Light Trap* 29 (1992): 29.

15 For all quotations from this film, see *Baby Mama*, directed by Michael McCullers (Universal City, CA: Universal Studios, 2008).

16 Catherine Waldby and Melinda Cooper, "The Biopolitics of Reproduction," *Australian Feminist Studies* 23, no. 55 (2008): 57–73.

17 For all quotations from this film, see *Juno*, directed by Jason Reitman (2007; Century City, CA: 20th Century Fox, 2008).

18 See McRobbie, "Post-feminism."

19 For an exploration of these debates, see Latimer, "Popular Culture."

20 Jessica L. Willis, "Sexual Subjectivity: A Semiotic Analysis of Girlhood, Sex and Sexuality in the Film *Juno*," *Sexuality & Culture* 12 (2008): 242.

21 Ibid., 253.

22 See Ruhl, "Dilemmas."

23 For a sustained discussion, see Willis, "Sexual Subjectivity."

24 See Latimer, "Popular Culture."

25 Carol Smart, *Personal Life: New Directions in Sociological Thinking* (Cambridge: Polity Press, 2007), 13.

26 Ibid., 19.

27 Ibid., 10.

16

TEMPORARILY *KISSING JESSICA STEIN* (2001)

Negotiating (and Negating) Lesbian Sexuality in Popular Film

Kelly Kessler

With Ellen, Rosie, kd, Jenny Shimizu, *Bound* (Andy and Larry Wachowski, 1996), and *Showgirls* (Paul Verhoeven, 1995) in the limelight, the 1990s brought lesbianism in vogue and into the mainstream cultural consciousness at a rate until then unprecedented. Simultaneously, two struggling straight actresses taking a writing workshop in New York were dabbling in a little lesbian work of their own. Frustrated with the trials and tribulations of professional acting, Jennifer Westerfeldt and Heather Juergensen would go on to write and produce the 1997 off-off-Broadway play *Lipschtick*, a chronicle of the frustrating dating scene in New York City. A single vignette from that piece would ultimately furnish the premise for one of the top mainstream lesbian films of the millennium's turn: *Kissing Jessica Stein* (Charles Herman-Wurmfeld, 2001) *(KJS)*.

Starring the femme, straight duo—with Westerfeldt just off mainstream success in a recurring role on ABC's situation comedy *Two Guys, a Girl, and a Pizza Place* (1998–2001)—*KJS* and Fox Searchlight would bring lesbian characters, candid (and funny) discussion of lesbian sex, and romance together in one tale. It looked like lesbians had made the cinematic big time: funny, mainstream lesbians who look just like the girl next door. Assimilation complete, but was that ever the goal? This chapter examines the ramifications and possible pitfalls of the mainstream lesbian text by interrogating the technical, intertextual, and narrative nuances of this happy-go-lucky turn of the millennium girl-on-girl romance, asking how such mainstream lesbian fare may subtly work to unqueer itself or undermine its own depiction of lesbian sexuality.

Historically such quasi-mainstream lesbian films have often functioned as a sort of apologia for broaching the topic. Films sell themselves on edgy/sexy subject matter, but nonetheless often hedge their bets to stave off a possible popular (read economic) backlash. *Personal Best* (Robert Towne, 1982) and *The Fox*

(Mark Rydell, 1967) conclude with temporary femmes finding proper hetero-sexual partners (and the butches finding defeat or death). The Wachowski Brothers' *Bound* blends a traditional masculine genre (film noir) and known straight and femme stars (Jennifer Tilly and Gina Gershon) to create a film I else-where describe as "family fun for everyone."[1] More recently, *The Hours* (Stephen Daldry, 2002) and *The Kids are All Right* (Lisa Cholodenko, 2010) toy with lesbian themes to varying degrees, while using a combination of the aforemen-tioned tactics, including straight sex and hetero stars. In the end, such films couple the edginess of lesbian content with a nod to mainstream ticket buyers by provid-ing something familiar and safe (genre norms, girly and/or temporary dykes, straight stars, or an overall tongue-in-cheek style). *KJS* stands as an excellent case study of the lesbian film of the late twentieth and early twenty-first centuries. Walking a line between independent and mainstream, the film—at least on its surface—abandons the darker vision that marks many earlier lesbian texts. At the same time, *KJS* embraces similar trends as its predecessors, ones that aid in creating a lesbian-light text that devises a single *legitimate* face of lesbianism, offers the possibility of comfort (and foregone conclusions) through genre-bound storytelling, and legitimizes—narratively, visually, and aurally—straight romance over the apparent narrative focus, lesbianism.

But They're Such Pretty Girls and Such Good Friends

For decades, lesbian film scholarship has concerned itself with the visual and behavioral presentations of lesbians. In response to a slew of femme films, Christine Holmlund argues that without the butch, the femme lesbian loses her narrative legibility and simply appears as one of the girls.[2] The butch, she argues, marks the lesbian's difference and implies the sexual aspect of the relationship. As femme actresses—famous or unknown—embody the cinematic lesbian, their depictions interact with existing cultural discourse regarding lesbianism in various ways. While they may broaden the cultural conception of what a lesbian looks like, they also legitimize a specific image of lesbianism while de-legitimizing others that runs contrary to traditional notions of female gender performance. If the heroines continuously (*Chasing Amy* [Kevin Smith, 1997], *High Art* [Lisa Cholodenko, 1998], *But I'm a Cheerleader* [Jamie Babbit, 1999]) look "just like us," then what about those lesbians who look a bit more like the boy next door? *KJS* embraces a world where femmes—and really only Jessica and Helen, the film's two heroines and temporary lesbian couple—comprise the whole of the lesbian universe. In doing so, femme equals lesbian.

Within the story world of *KJS*, only one other person besides Jessica and Helen acknowledges her own lesbianism (Helen's briefly shown post-Jessica partner) and only one other assumed lesbian even merits screen-time (a smirking, pony-tailed quasi-butch who piques Helen's interest at an art show). Jessica, long blonde hair, kicky skirts, and a demure/uptight demeanor, and Helen,

FIGURE 16.1 *Kissing Jessica Stein*'s "Helen" (Heather Juergensen) and "Jessica" (Jennifer Westerfeldt) rifle through the contents of Helen's purse as the ladies awkwardly negotiate their first meeting. Courtesy of Fox Searchlight Pictures/ Photofest.

shoulder-length raven hair, femme-sexy, (initially straight) sex-aholic, define the world of lesbianism. Rather than simply expanding the image of lesbianism to include femmes or femme–femme couples, *KJS* erases the possibility of anything else. The two initially straight-identified characters meet as Helen—ready to conquer her next big quest—submits a personal ad for women-seeking-women and Jessica hastily answers it after being thrown into a Diane Keaton-esque tizzy following a slew of bad dates and an ugly run-in with an ex-boyfriend (who is incidentally her current boss, Josh). Neither woman is sure of what she wants, why she wants it, or what she will find. Ultimately, the subsequent relationship functions as a sexual test-run for both women, and the next hour of the film chronicles Jessica's attempt to overcome her own fears of a foray into lesbianism, only to find her preparing to fall back into Josh's arms at the film's end.

Complementing the film's marginalization of lesbianism through a femme-only world, *KJS* nearly erases lesbianism's sexual dimension as it transforms the relationship between Helen and Jessica into one more closely resembling a tight female friendship. Westerfeldt herself has described the writers' goals as the following: "We wanted to explore what happens when a woman decides to take the tenderness and intimacy that exists in female friendships and make it more complete."[3] But how they construct that "completeness" is at issue. Sexual or

even physical relations—that which one would assume would comprise the "completeness" of which she speaks—remain pushed to the side and receive little screen-time. Instead, the women engage in (dis)passionate girl talk, discussions of past boyfriends, compliments regarding clothes, and showings of emotional support. Such focus on the non-sexual only reinforces Jessica's initial insecurities about "what they would do" if they were in an actual lesbian relationship and allows the film to eschew the physicality or sexuality of lesbianism. What they "would do" remains left to the imagination, as the film only fleetingly depicts the Helen/Jessica physical relationship. (Notably, the most graphic sexual encounter occurs between Helen and Gregory—"her boy Friday"—on Helen's desk.) Although a few scenes broach the topic of lesbian sex—often through Jessica's inability to discuss the topic freely—the film clearly constructs the lesbian relationship as something, most often, other than sexual.

The women more powerfully emerge as "girlfriends," more reflective of *Sex and the City* (1998–2004) than *The L Word* (2004–9). While Jessica struggles continually over her sexual relationship with Helen, the two thrive in moments of nurturing, giggling, and guy talk. In doing so, focus turns from their awkward sexual relationship to a more "appropriate" female friendship. On their first date, the two share a lively discussion about Helen's lipstick (and how it would "look gorgeous on [Jessica's] complexion"), and date two begins with mutual compliments regarding their outfits and choices in footwear.[4] The ladies thrive when it comes to taking care of each other, as Helen shows relative patience in Jessica's reticence to engage in a sexual relationship and Helen finds Jessica's nurturing impulses refreshing, as she falls prey to a cold and Jessica kicks into hypochondriac Jewish mother mode, providing a hot toddy, homemade chicken soup, and a mélange of pills.

While this tight female friendship—and the caring and sharing—arguably makes for an engaging story and sympathetic characters, how does it situate lesbianism within the narrative—or culturally if film professes to reflect life? Nancy Rosenblum of the *Lesbian News* articulates her ambivalence toward the film as one that reflects a comfy/frustrated response to fun characters in a lesbian-light context. Her review states, "Is this what straight girls think it's like to be gay? If it is, we're in trouble, so why was I laughing?" She continues, "My frustration was with absence [sic] of some butch energy to bring a little lusty libido to the vanilla stars."[5] *Off Our Backs* projects a similar, perhaps more indignant critique. Sherri Whatley, like Rosenblum, acknowledges the film's strengths (good acting, smart dialogue, and so on), but questions the place for such stereotypical depictions in a cinematic environment still starving for quality lesbian love stories. She says:

> If there were a wealth of movies honoring lesbian love, and if we could be certain society would see this film as "just two straight wimmin's interpretation of a lesbian relationship," I could relax and enjoy it for the other

quality aspects that it definitely embodies. Since there is no such guarantee, if you still decide to see the movie, make sure to remind yourself not to take it too seriously.[6]

Both Rosenblum and Whatley—not surprisingly from feminist and lesbian pub-lications—highlight the continuing struggle to represent a nuanced vision of les-bianism, a struggle often obscured when apparent positive representations find their ways into the mainstream.

As Kobena Mercer argues in "Black Art and the Burden of Representation," a dearth of representation of a specific group places more pressure on each existing work to reflect the diversity of that group.[7] In the case of *KJS*, the "girlfriends" version of lesbianism may not be problematic in and of itself. The dynamic between the characters may be enjoyable to watch. The film surely presents a cohesively constructed story and found a degree of critical and economic success. What Whatley suggests, and Mercer theorizes, is a problem that arises when such hegemonically biased versions of Otherness become the domi-nant ones; they limit and tailor the type of lesbian legitimized in the cultural imagination.

I Don't Know, It Just Feels Funny: Technical Choice and (Un)Queering the Tone

KJS's mitigation of lesbian sexuality does not stop at its flirty protagonists or their less-than-sexualized relationship. Technical elements reinforce the more overt building blocks of storytelling as cinematography and editing frame salient moments, choices in setting evoke connotative power, and sound creates mood, evokes an aural history, and helps to establish a tonal undercurrent. Through such elements an attitude or bent emerges that highlights the normalcy of hetero-sexuality and the climactic bait-and-switch straight romance and helps to obscure and marginalize lesbian sexuality and the women's relationship.

On a very basic level, *KJS* belongs to a group of films that could be dubbed "the urban lesbian tale" (such as *Born in Flames* [Lizzie Borden, 1983], *All Over Me* [Alex Sichel, 1997], *High Art*, *Saving Face* [Alice Wu, 2004]). Set in New York City, such films position lesbianism—and in this case lesbian experi-mentation—as urban chic. Whereas a tale set in Louisville, Dallas, or even Chicago might raise regionally linked ideological issues associated with the Midwest or the Bible belt, New York City evokes alternative walks of life and sexual, political, and artistic experimentation. Helen's tough New York City edge and hip queer friends, however, exoticize her as *KJS* falls short of embrac-ing an "everywoman" tale. As characters hang in the chic art gallery, shop at a lower east side produce market, and fight for cabs in the chaotic streets, their surroundings mark them as urbanite Others. Jessica's roots—Westchester county/the burbs—intermittently pull her away from the urban fervor, but her

physical surroundings—and site of her relationship with Helen—repeatedly push her back.

While the New York City setting evokes a space rife for experimentation, choices in camerawork, editing, and sound create a space that makes light— tonally and temporally—of the Helen/Jessica relationship. Such elements visually and aurally define the diegetic world, and in this case one that prioritizes and respects—through visibility and musical connotation—relationships other than the primary lesbian one. Complementing the hip setting, the film's sound-track—vacillating between smooth jazz, rap, and rerecorded German cabaret— helps to establish the mood from moment to moment. Quirky jazzy numbers sprinkle throughout the film, highlighting artists like Blossom Dearie, Anita O'Day, Ella Fitzgerald, and Peggy Lee who provide an old-school charm to the contemporary tale.[8]

At Jessica and Helen's most visible moments of physical contact, the sound design shifts. Instead, hypersexual tunes create a jarring contrast to the flirty romance of classic jazz. Barry White's heavy-handed and culturally cliché "make-out" number "I'm Gonna Love You Just a Little More, Baby" under-scores their first attempt at physical intimacy. Dismantling any sense of cinematic gravity or legitimate emotion, the number—which begins as diegetic—projects a trite version of seduction. Even the women recognize the inanity of the song as Jessica says, "Is this Barry White?" and Helen responds quickly and defensively, "Uh, no." Similarly, Kurtis Mantronik's vulgarity-laced rap number "Mad" erupts during Jessica and Helen's heated grope session—and abruptly ends as Gregory interrupts for a booty call. As with the White, Mantronik's sudden R-rated lyrics—providing a range of "mf bombs," racial epithets, and "hos"—defy the classy tone set by the aforementioned jazz queens. Instead, the contrasting sound design associates a humorous break that frames lesbian sex/sexuality as something dissimilar and ludicrous, rather than natural and smooth.

Camerawork and editing further decenter—both physically and psychically— the lesbian relationship through the strategic and repeated use of off-screen space, framing, and montage. A comparison of straight intimacy and lesbian intimacy illustrates a visual bias toward the former. While major moments of the Helen/ Jessica relationship appear through fleeting and dialogue-light montage sequences or in obscured view, sexual acts and intimacy between Jessica/Josh and Helen/ random lovers repeatedly appear in full view and through developed dialogue. Three major moments of the Helen/Jessica relationship appear through montage: overcoming Jessica's fear of physical intimacy with women, this relationship is working, and this relationship is over. Largely devoid of conversation or depicted causal relations, fleeting moments define their relationship's rise and fall. Reinforcing this resistance to visually/narratively develop the relationship, both the make-out montage and the rap-accompanied grope session—the most physically graphic moments of lesbian intimacy—visually obscure one or

both women. In the former the women make out in the off-screen space below the frame and in the latter only Helen—on top of the off-screen Jessica—remains visible. Similarly, their only sex scene—in Jessica's childhood bed—occurs in complete darkness, as kissing sounds immediately give way to faux *Star Wars* theme music as the scene cross-cuts to Josh watching television. These contrast directly with scenes that depict Helen's casual sexual partners who remain in two-shot for much of their sex scenes.

Compounding the narrative/visual/aural marginalization of the Jessica/Helen relationship, the Jessica/Josh union gains narrative/visual/aural heft. Although the physicality of the lesbian relationship remains largely obscured—narratively and technically—moments between Jessica and Josh warrant uninterrupted dialogue and screen-time, making it clear just who should be kissing Jessica Stein. Immediately following Jessica's outing and public admission of her relationship with Helen, the Josh romance plotline escalates. While much of Helen and Jessica's physical and emotional intimacy is left to montage or the imagination, Josh's emotional reveal to Jessica lasts over five minutes (over four and a half of that in uninterrupted screen-time). With no underscoring, his declaration of love emerges through dialogue, shifting two-shots, one-shots, and reaction shots. This scene also includes a 20-second break in dialogue for a close-up kiss, twice as long as any close-up of physical intimacy between the two female protagonists.

In the end, the straight reveal earns as much screen-time as the entirety of Jessica and Helen's post-wedding relationship, almost wholly dismissing the Jessica/Helen union once the straight suitor makes himself known.[9] The visual depiction of their remaining relationship largely consists of a slightly less than two-minute montage of happiness (moving in together, Christmas/Hanukah, jogging, and dancing) and a three-plus-minute montage of their disintegrating level of intimacy and breakup (largely caused by Jessica's lesbian frigidity or disinterest). Not only does the Josh/Jessica pairing maintain temporal control, but its style of presentation allows for more extended character development and substance, the lesbian relationship left to wind itself down in pseudo-narrative moments of dialogue-light montage.

I've Seen This Story Somewhere Before: Safety in Genre Norms

Further sexual negotiation emerges as the film embraces genre forms historically steeped in the stabilization of social norms. *KJS* takes a multi-genre approach—using characters, conflicts, and stories familiar to the coming-of-age tale, romantic/screwball comedy, and maternal melodrama—to reinforce a sense of stasis and "normalcy" in its girl–girl (almost) love story. Whether historically used as marketing strategies, frameworks to help predict popular and economic success, or ideological tools, film genres have historically articulated and rearticulated

similar—if slightly shifting—stories and often ones most reflective of dominant mores. Judith Hess Wright argues that genre films "temporarily relieved the fears aroused by a recognition of social and political conflicts" and "serve the interests of the ruling class by assisting in the maintenance of the status quo."[10] By such retelling of stories that work though seemingly impossible conflicts, life's problems seem surmountable and narratives project a sense of satisfaction and calm.[11]

Over time genres may shift or splinter to reflect current social conflicts that refute dominant norms. For decades Hollywood has thrown kinks into the works with women's Westerns (*Bad Girls* [Jonathan Kaplan, 1994]), dyke noir (*Bound*), queer family melodrama (*Torch Song Trilogy* [Paul Bogart, 1988]), or the Native American or chick road movie (*Smoke Signals* [Chris Eyre, 1998] and *Thelma and Louise* [Ridley Scott, 1991]). *KJS*, however, embraces many of the recuperative dictates of its motivating genres and thus reflects Wright's generic construct as it unravels a comfortable and familiar tale and embraces narrative patterns that reinforce social, familial, and sexual norms—some of which run contrary to the implied lesbian narrative.

Like many gay and lesbian films, *KJS* presents a form of coming-out tale—or in the case of Jessica, coming-out and then rediscovering men. Whether wholly encompassing the narrative (*Incredibly True Adventures of Two Girls in Love* [Maria Maggenti, 1995], *Late Bloomers* [Julia Dyer, 1996]) or isolated to a small portion (*Everything Relative* [Sharon Pollack, 1996]), this trope of lesbian self-discovery often resembles the teen coming-of-age story. Much like in the teen pic, popularized by John Hughes or more serious films like *Summer of '42* (Robert Mulligan, 1971), the newly discovered lesbians must fumble through the process of discovering themselves and how they fit into their new sexually aware bodies/lives.[12] Often curious, self-conscious, and pained, cinematic adolescents suffer through the embarrassment of their own awkwardness to reach a point of self-actualization. As *KJS*, like many queer films before it, embraces this trope, it simultaneously infantilizes its adult protagonists. While technically grown women, their sexual and personal powers diminish as the film presents them as self-conscious and tongue-tied teenagers.

The characters most fully embrace awkward teen characteristics in moments of sexual expression. (This includes Helen, whose straight self proves both sexually adventurous and experienced.) The film continuously frames Jessica as shy and reticent and her attempts at physical contact as awkward. When she greets Helen after their first date, they clumsily kiss at the door, neither knowing if she should. On this same visit Jessica hopes to overcome her gross-out reflex to lesbian sex. Describing previous thoughts of such acts as "ew," she hopes to learn more through some informational lesbian-related reading material. The scene resembles teenagers hovering over a tattered edition of the *Joy of Sex*, *Playboy*, or *The Complete Kama Sutra*. Directly following and during the Barry White make-out session Helen tries the old "yawn her arm around Jessica's shoulder" routine.

(As with every television show and teen film before it, the attempt at subtlety fails.) In a later scene, Helen's friends quip "is she twelve" as she lapses into a schoolgirl tone as she chats with Jessica on the phone. As character and plot development mirror the norms of this popular teen genre, characters—and thereby lesbian representation—remain limited in their ability to link lesbian sexuality to mature adulthood. Lesbians instead emerge as childlike creatures who—at least in the case of Jessica—may stumble through many phases until they settle into the right thing: heterosexuality.

The film simultaneously embraces norms of the family or maternal melodrama. In a role written specifically for her, Tovah Feldshuh portrays Jessica's overbearing matchmaking mother. In one of the movie's most poignant moments, Mama Stein attempts to console a devastated Jessica (who is silently suffering through her breakup with Helen). In her big scene, she lays bare the pain she has experienced watching her daughter suffer at the hands of her own willfulness. As she stammers, "I think [Helen's] a lovely girl" and reveals to Jessica that she knows about the relationship, she accepts her daughter's burden and verbalizes her own pain over Jessica's choice. In this moment, the film embraces a history of tortured and sacrificing mothers as it simultaneously valorizes the selfless role of the mother and ideal womanhood.[13] Only with the approval of the matriarch can Jessica act as she rushes off to reunite with Helen. As with the coming-of-age formula, such family melodrama infantilizes the lesbian as she becomes someone in need of parental care and approval.

The most significant generic debt, however, must be paid to that which most fully implies and embraces the successful romance: the romantic or screwball comedy. Mainstream reviews highlight the film's genre-laden root. *USA Today* dubs it "a lipstick lesbian romantic comedy."[14] *Entertainment Weekly*, *Newsweek*, *Rolling Stone*, *Time*, and *People* all employ the term romantic comedy, whether as a compliment, criticism ("shallow, sitcom-style"), or invitation to intergenerational viewing ("a same-sex romantic comedy you can take your grandparents to").[15] These popular discussions of the film imply a similar knowledge base or set of generic expectations. In simplest terms, it will embrace romance and comedy.

Frank Krutnik's argument that today the term romantic comedy lacks substance or generic specificity points to a difficulty in defining generic boundaries within the broad category of the contemporary romantic comedy.[16] *KJS* fully embraces the broad designation of romantic comedy through the specific generic codes of the screwball comedy, which relies on the successful synthesis of opposites and the romantic union of two diametrically opposed character types, and projects a sense of transcendent possibility.[17] Katharine Hepburn/Spencer Tracy, Cary Grant/Irene Dunne, Hugh Grant/Sandra Bullock—they all embody characters whose outlooks, styles, classes, and energies seem wholly incompatible. In the end, however, each sinks comfortably into

the other's arms. Repetition of and familiarity with these narratives project the satisfactory ending with each new beginning. Although avoiding the butch/femme opposition, Helen and Jessica do embody more generically traditional behavioral and ideological binaries common to the screwball comedy, and they spend much of the film working toward a successful synthesis of those characteristics. Jessica's Jewish, uptight, neatnik, hypochondriac, repressed, insomniac ways directly oppose Helen's New York City WASPy-chic, sexually adventurous, yoga-induced zen. Reflective of hundreds of screwball comedies before them, their differences produce chaos as one pushes the boundaries of the other sexually and socially. In the end, such films would traditionally resolve with the two lovers synthesizing their differences and producing a new compatible whole.

About an hour and 15 minutes into the 96-minute film it looks like Helen/Jessica will go the way of Grant/Dunne and Tracy/Hepburn. As noted, however, the screenplay then escalates Josh's quest for Jessica. After his outpouring of love, the ladies sustain their coupled bliss for a total of four minutes of screen-time. Shortly thereafter the writing appears on the wall—with Jessica painting late and Helen silently suffering her sexual frustration. After a traumatic split from Helen (who wants someone more sexually attracted to her), Jessica (in an unseen passage of time) quits her job, embraces her painting, and obtains a fun new flirty haircut. Despite the dissolution of the central couple, the film ends in a style true to its roots, but with Jessica prepared to ride off into the sunset with Josh and discuss it over coffee with new best friend Helen.

As the *USA Today* reviewer says, "But because the movie adheres to the standard formula of a romantic comedy, one almost forgets that the notion of girl meeting girl and girl losing girl is hardly a traditional cinematic genre."[18] The film prepares the viewer for a lesbian love story. Its plot development and character development lead to that—for all but the final 10 minutes of the film where the screenplay inserts something akin to a hetero bait-and-switch.[19] At that point, the filmmakers' apparent promise of a lesbian love story proves disingenuous (and not so dissimilar to earlier films such as *Personal Best* and *The Fox*). As soon as the narrative allows for the public acknowledgment of the Jessica/Helen relationship, Josh slides in, supplanting Helen as the proper love object, and then almost seamlessly naturalizes the hetero romance as everyone's life suddenly seems better. (Both Jessica and Josh have quit their jobs and look and sound much more relaxed and happy, and Helen—who thankfully need not die in this contemporary tale—has found a "real" lesbian with whom she can cuddle in red satin sheets.) In the end, the title character's "sexual awakening" simply allows her to find the freedom to embrace her art and likely Josh. He ultimately slips into the film's resolution quietly though a chance meeting, and their possible future relationship becomes the topic of conversation between best platonic buds Helen

and Jess who meet to chat over coffee—in mutually flirty dresses. In these closing moments Blossom Dearie's "I Wish You Love" decries "That you and I could never be."

KJS's unexpected ending preserves the generic expectations of the screwball comedy—as Jessica and Josh have been pitted against each other as bitter ex-lovers and surly boss and uptight/fragile employee—while it simultaneously disposes of the lesbian relationship and leaves the topic of sexuality largely unexamined. Although sexual attraction is surely complicated, the film simply erases the lesbian couple in favor of the culturally preferred straight one. The romance remains, but the lesbian rendered a mere *confidant* and the Jessica/Helen relationship a mere means to self-actualization and true heterosexual bliss. Truly, the relationship set everyone "free."

Conclusion: Just Because They're Kissing Doesn't Mean It's All That Queer

As *Off Our Backs*' Whatley says in her review, "My concern is that some people who see this film will not know that many aspects of a lesbian relationship are not honored or worse, are stereotyped." All lesbian tales need not be told with a sense of gravitas. I do not mean to imply that all mainstream lesbian films have a responsibility to portray a specific vision of lesbianism: political, butch, committed, successful relationships, or sexually open. Instead, I hope this chapter has highlighted ways in which various elements of the filmmaking process—casting, shooting, sound design, storytelling—bring with them an ideological responsibility and ideological consequences. While the twenty-first century will surely bring more varied and frequent images of lesbians to television and film—already evidenced by an encouraging proliferation of primary and secondary lesbian characters in mainstream television (*Grey's Anatomy* [ABC, 2005–], *The L Word* [Showtime, 2004–9], *Wonderfalls* [Fox, 2004], *The Wire* [HBO, 2002–8]) and film (*The Kids are All Right*, *The Hours*, *Monster* [Patty Jenkins, 2003])—these articulations of sexuality will remain somewhat beholden to a history of genre norms, shooting styles, profit-driven production, and social norms. In fact, my own love–hate relationship with *KJS* reflects a complicated relationship with these industrial, technical, and narrative issues. Like Whatley and Rosenblum, I am both enchanted by the movie magic and charming characters and disturbed by the subtle undermining of a legitimized face of lesbian sexuality. As David Bordwell has argued, Classical Hollywood form (both the narrative and visual) works to—nearly unquestioningly—draw its audience into the diegetic world as the story appears to tell itself. [20] One must never forget to consider, however—as charming characters and an engaging story wash over him or her—just what those seemingly effortless tales tell.

Notes

1 Kelly Kessler, "*Bound* Together: Lesbian Film That's Family Fun for Everyone," *Film Quarterly* 56, no. 4 (Summer 2003): 13–22.
2 Christine Holmlund, "When is a Lesbian Not a Lesbian: The Lesbian Continuum and the Mainstream Femme Film," *Camera Obscura* 25–6 (1991): 145–78.
3 Stacie Stukin, "How the Other Half Laughs: What Happens When Two Straight but Spunky Girls Decide to Test Out a Lesbian Relationship? *Kissing Jessica Stein*'s Creators and Stars Heather Juergensen and Jennifer Westfeldt Smooch and Tell," *The Advocate*, 19 March 2002, 52.
4 For all quotations from this film, see *Kissing Jessica Stein*, directed by Charles Herman-Wurmfeld (2001; Los Angeles, CA: Fox Searchlight Pictures, 2001).
5 Nancy Rosenblum, "At the Movies," *Lesbian News*, March 2002, 39.
6 Sherri Whatley, "*Kissing Jessica Stein*: What Happens When Two Straight Wimmin Write a Movie Script About Lesbian Love?" *Off Our Backs*, July–August 2002, 56.
7 Kobena Mercer, "Black Art and the Burden of Representation," *Third Text* 4, no. 10 (1990): 61–78.
8 The mass-marketed soundtrack omits almost all numbers that lie outside of retro jazz, allowing the CD to solidly reflect the feel of the traditional romantic comedy.
9 Notably, when Josh makes his feelings known to Jessica, she does not say she does not "want" to go out to dinner with him. She says that she "cannot" because she is with Helen. Both dialogue and facial expressions allude to her desire to be with Josh.
10 Judith Hess Wright, "Genre Films and the Status Quo," in *Film Genre Reader II*, ed. Barry Keith Grant (Austin, TX: University of Texas Press, 1997), 41.
11 For more on the curative power of genre, see Richard Dyer, "Entertainment and Utopia," in *Hollywood Musicals: The Film Reader*, ed. Steven Cohan (London and New York: Routledge, 2002), 19–30.
12 See Timothy Shay, *Generation Multiplex: The Image of Youth in Contemporary American Cinema* (Austin, TX: University of Texas Press, 2002); David Considine, *The Cinema of Adolescence* (Jefferson, NC: McFarland, 1985).
13 Christian Viviani, "Who is Without Sin? The Maternal Melodrama in American Film, 1930–1939," *Wide Angle* 4, no. 2 (1980): 4–17.
14 Claudia Puig, "A Lipstick Lesbian Romantic Comedy," *USA Today*, 13 March 2002.
15 David Ansen, "Jessica Delivers," *Newsweek*, 18 March 2002; "Boos and Bravos," *Rolling Stone*, 28 March 2002; Richard Schickel, "The Rules of Engagement," *Time*, 25 March 2002; Lisa Schwarzbaum, review of *Kissing Jessica Stein*, *Entertainment Weekly*, 29 March 2002; Tom Gliatto and Leah Rozen, "Picks and Pans," *People*, 18 March 2002.
16 Frank Krutnik, "Conforming Passions?: Contemporary Romantic Comedy," in *Genre and Contemporary Hollywood*, ed. Steve Neale (London: BFI, 2002), 132.
17 Ibid., 130–47; Thomas Schatz, *Hollywood Genres: Formulas, Filmmaking, and the Studio System* (Philadelphia, PA: Temple University Press, 1981), 27–9.
18 Ansen, "Jessica Delivers," 60.
19 "Bait-and-switch" refers to "[a] deceptive marketing scheme resorted to by consumer good vendors when they advertise a genuine product and offer it in the store, but once the customer arrives, the merchant pretends that they are out of stock, or denigrates the product, trying to sell a higher priced alternate to the consumer." *Legal Dictionary*, duhaime.org, accessed 29 January 2011. [Editors' note.]
20 David Bordwell, "Classical Hollywood Cinema," in *Narrative, Apparatus, Ideology*, ed. Philip Rosen (New York: Columbia University Press, 1986), 24.

17

"DIE, BRIDEZILLA, DIE!"

Bride Wars (2009), Wedding Envy, and Chick Flicks

Heather Brook[1]

Introduction

There has been a long and highly productive critical association between feminism and marriage (on one hand) and between feminism and popular culture (on the other).[2] It is surprising, then, that intersection of these high traffic areas— particularly in relation to weddings—is so deserted: very little feminist research attends to weddings as they are represented in popular culture. As Chrys Ingraham says, "[c]onsidering the magnitude of wedding culture and wedding industry it is both shocking and mystifying that so few have studied weddings."[3] Several inferences might be drawn from this. First, we might surmise that weddings are simply beyond the feminist pale, that wedding culture, if we can call it that, is beneath feminist contempt. Alternatively, and more recently, we might assume that wedding culture—and perhaps marriage, too—is no longer a site needing feminist intervention: that all is well in twenty-first-century Brideland. While each of these propositions has a certain appeal, both must be rejected. More importantly, the framework that sets these "for" and "against" options up as exclusive alternatives must be challenged. It is the task of this chapter to explain why and how popular wedding culture is more complex and interesting than these alternatives allow, and to do so using the 2009 movie *Bride Wars* (directed by Gary Winick).

In *Bride Wars*, we meet two lifelong best friends: Liv Lerner (Kate Hudson) and Emma Allen (Anne Hathaway). They have dreamt, since childhood, of marrying in June, at the Plaza Hotel.[4] When they become engaged in the same week, Liv and Emma visit New York's most exclusive wedding planner, Marion St. Claire (Candice Bergen). Each is assured of the wedding of which she dreams until an administrative error results in their weddings being booked for exactly

the same time. With the next available opening years away, one bride must compromise if both weddings are to proceed with Liv and Emma as each other's maids of honor. When neither will budge, the friends fall out and begin to sabotage each other's nuptials. The narrative tracks their efforts to humiliate each other, culminating in a crisis of reconciliation. Only one wedding goes ahead, but it is Liv and Emma's friendship, not the two bride-and-groom romances, that constitutes the movie's happy ending.

The quote borrowed for the title of this chapter comes from Manohla Dargis's review of *Bride Wars* for the *New York Times*.[5] She is not the only reviewer to use the word "Bridezilla."[6] The term is a neologism used to refer to a woman dangerously obsessed with the planning and organization of her (inevitably grand) wedding.[7] Bridezillas, it seems, are universally loathed: they are self-absorbed, vain, and demanding. If they are entertaining, it is as a disastrous spectacle—and, in a way, that is what *Bride Wars* is. This spectacle is, however, thoroughly entangled with contemporary anxieties and ideas concerning gender, feminism, and sexualities. Reviewers' responses to the movie inevitably invoke these issues:

> *Bride Wars* isn't just chick-flick hell for guys, it should numb the skulls of moviegoers of all sexes and ages.[8]

> [*Bride Wars* presents] hysterical (and not in the funny sense) feminine war crimes ... [It is] everything reasonable people hate about so-called "chick flicks."[9]

> [T]his contrived, mean-spirited, unfunny farce feels like the work of someone who hates chick flicks and isn't all that fond of women in the first place.[10]

The reviewers above—and many others besides—describe *Bride Wars* as a "chick flick": that is, a mainstream movie designed to appeal to female viewers.[11] Most also pan it. UK critic Tim Robey describes *Bride Wars* as "an endurance test for straight men everywhere";[12] Kerrie Murphy, for the *Australian*, dismisses it as "anti-feminist"; and in the *Sydney Morning Herald*, Eddie Cockrell says its premise is "vaguely sexist."[13] The ease with which a lightweight film about women can be dismissed as "anti-feminist" is telling, and suggests that there is an intellectual standard applied to films targeted towards female audiences that is not invoked in the case of what we might call the "masculine froth" of action films or buddy movies. It is not entirely clear, however, that *Bride Wars* is irredeemably, obviously, or precisely anti-feminist.

In this chapter, I will explore some ways that *Bride Wars* might be understood to be sexist or anti-feminist, and assess these against competing understandings. I will argue that *Bride Wars*' reworking of fairytale motifs, its ephemerally coy homoerotics, its fetishization of clothes, and its celebration of spectacular

competition between hateful women all add weight to the charge that *Bride Wars* is decidedly anti-feminist. Against this, I will suggest that some elements of the movie can be read as subversively satirical. Some of the ideas foregrounded in *Bride Wars*—including, especially, the disarticulation of weddings from marriage—reveal that "fluffy" chick flicks about weddings are not necessarily or entirely anti-feminist. My central argument is that *Bride Wars* does subvert some of the (heavily gendered) conventions of chick flicks—including the expectation that wedding movies will be romantic comedies or weepy dramas. It does this by imperfectly repeating some of the broader gendered conventions of wedding movies, even as it presents highly conservative, even misogynistic, performances of gender on screen.

Hating Heteronormativity; Hating *Bride Wars*

In the shade of a mountain of critique interrogating marriage and its historically patriarchal weight, some feminists might dismiss *Bride Wars* as not worth watching, let alone taking seriously. It might be argued that *Bride Wars*, like mainstream movies more generally, simply rehearses an outdated and heavily heteronormative, heterogendered social script. Heteronormativity is "the view that institutionalized heterosexuality constitutes the standard for legitimate and expected social and sexual arrangements";[14] it is that system of social values and practices privileging all that is heterosexual over all that is not, continually drawing and redrawing boundaries between them. Heterogendered assumptions are both foundational to and an effect of heteronormativity, and pivot on the idea that gender differences (or naturalized hierarchical differences sustaining distinctions between the masculine and the feminine) are a necessary concomitant to heterosexuality and the policing of its heteronormative boundaries. Thus, in wedding culture in general, men must be "masculine," women must be "feminine," and these are presented as (irresistibly) mutually attractive. Wedding movies consistently retell this story. It might be argued, then, that *Bride Wars* is little more than another Hollywood fairytale disguising women's subordination as "happily ever after." This would hardly be surprising, given that fairytales are stock fodder for Hollywood wedding culture.[15]

"Cinderella with a Ball and Chain"[16]

Many wedding movies (and of course not *just* wedding movies) are variations on a number of fairytale themes, the most obvious of which, in wedding movies at least, is Cinderella.[17] The influence and appeal of fairytales is evident in an arsenal of stock devices. For example, a number of contemporary wedding movies evoke the fairytale by opening with scenes of the eventual bride-to-be in her childhood.[18] *The Wedding Planner* (Adam Shankman, 2001), *Sweet Home Alabama* (Andy Tennant, 2002), *27 Dresses* (Anne Fletcher, 2008) and *Bride Wars* all follow

this course. *Bride Wars* begins, in once-upon-a-time fashion, with Marion St. Claire narrating Emma and Liv's formative childhood experience of bearing witness to a wedding at the Plaza, and their subsequent rehearsal of pretend weddings.

What is, perhaps, unusual in the case of *Bride Wars* is that Liv and Emma play at marrying *each other* in their childhood. This is significant in that it prefigures a number of (anxiously) homoerotic moments in the movie even as it confirms a heterogendered social order. In her review of *Bride Wars*, Manohla Dargis introduces the plot as follows: "Since childhood, [Liv and Emma] have dreamed of getting married at the Plaza (alas, not to each other)."[19] Dargis's parenthetic ruefulness at the lost opportunity to showcase a lesbian wedding is extended when she goes on to hint that "there may be more to [Emma and Liv's] friendship (and the fury underlying its rupture) than either the women or the movie can admit." Tim Robey expresses similar sentiments when he says: "*Bride Wars*, in another, better, incarnation, would be an out-and-proud satire on nuptial mania, and would end with Hudson and Hathaway getting civilly partnered."[20]

Whether lesbian Bridezillas could salvage the movie is doubtful. It is not clear—given the burgeoning enthusiasm for same-sex marriage—how wedding satire would really be any more marked if the female protagonists were marrying each other. I wonder, in fact, whether a lesbian Bridezilla might not be recognizable as adhering to a newly monstrous homoconservatism in which "decent" gay and lesbian couples follow the heteroconservative example by embracing marriage and its mantle of material and sexual propriety, thus situating marriage-resisters as even more peripheral. In this sense, the possibility of a "better" *Bride Wars* featuring a more "open" acceptance of non-heterosexual sexualities is misplaced. Let me be clear about this: I am not for a second suggesting that same-sex couples should not have precisely the same relationship rights, recognition, and privileges as heterosexual couples. Nor am I suggesting that the range of sexualities represented on mainstream movie screens should not be expanded beyond its current and meagerly stereotypical limits.[21] My bigger hope is that, regardless of sexual orientation, people might reject the historically sexist, racist, and heteronormative weight of marriage, and its mystifying endorsement as the singularly "respectable" intimate relationship. As Suzanne Leonard observes, it is difficult to express this view without the critique of marriage being siphoned off as "envy."[22] Nevertheless, *Bride Wars*' homoerotics (and its potential inferences concerning same-sex marriage) have no politically progressive inflections, and in this sense the movie is an instance of "recuperation": it presents homoeroticism (or pseudo-homoeroticism) only in a very limited way, and defuses its subversive possibilities.[23]

This recuperation is accomplished in several ways, but is especially evident in one of the publicity stills from the movie. In this image, Emma and Liv are sprawled on the floor after a physical fight which Dargis describes as looking for all money like "a prelude to a kiss."[24] Lying next to each other under the rumpled

FIGURE 17.1 "Liv" (Kate Hudson) and "Emma" (Anne Hathaway) sprawled on the floor. Courtesy of 20th Century Fox/Photofest.

covers of their bridal veils, the scene is strongly reminiscent of both honeymoon bed and bubble bath. But, as the besuited legs behind them indicate, the scene remains a heteronormative spectacle: the performance (or its promise) occurs for (straight) men's visual pleasure. In *Bride Wars*, then, as in mainstream Hollywood productions featuring female friendship more generally, "connotations of same-sex desire are both invoked and repressed."[25]

It is a commonplace of feminist thinking that fairytales like Cinderella and Sleeping Beauty serve patriarchal, sexist, and/or heteronormative agendas.[26] They operate in a cinema of the collective psyche, linking psychosexual development and desire. Though her focus is the social world in general (rather than cinematic representations in particular), this is what Chrys Ingraham refers to as the "heterosexual imaginary." The "heterosexual imaginary," she says, "is that way of thinking that relies on romantic and sacred notions of heterosexuality in order to create and maintain the illusion of well-being and oneness."[27] "Imaginary" does not mean "pretended." On the contrary: the heterosexual imaginary is fully engaged with material objects and their meanings.[28]

The Perfect White Dress: Vera Wang as Fairy Godmother

Consistent with Cinderella stories and wedding movies more generally,[29] in *Bride Wars* the special dress is pivotal. Liv and Emma's bridal gowns are strongly,

differently significant. Liv, like Cinderella, is an orphan. And, just like Cinderella, Liv has a fairy godmother (Vera Wang).[30] In *Bride Wars*, the scene in which Liv and Emma find Liv's "perfect white dress" featured in trailers for the movie, and speaks to several intersecting desires: to *be* a beautiful Cinderella/bride, even if midnight comes too soon, and the sometimes frustrating, sometimes intensely pleasurable experience of shopping—or otherwise preparing with your best friend—for that fleeting opportunity to be dazzlingly attractive, and by extension, to begin the rest of one's life transformed for the better. At a bridal boutique, Emma, the less wealthy bride, spots the "perfect dress," but has already decided to wear her mother's bridal gown. This is represented as settling for something less than ideal. The scene unfolds as follows:

Emma:	Oh my god! Oh, my, god—Miss Wang! Lace bodice …
Liv:	Basque waist, ten-layer tulle. [Sighs] You should try it on.
Emma:	No! No, no, I'm wearing my mom's dress.
Liv:	Emma, are you sure? Your mom's dress is beautiful, but is it your dream or hers?
Emma:	It's mine. It's mine. I want to surprise her.
Liv:	But it's your day. Can't you just send your mom a big box of chocolates on Mother's Day and get the dress you want?
Emma:	[Touching the Wang dress] It's really pretty. And I do love strapless. I feel like I'm cheating on my mom's dress. I can't, I can't. I'm very comfortable with my decision. Put it back, put it back.

But, I mean … if *you* like it, you should try it on.[31]

Emma's settling for a dress inspired by duty rather than delight is ultimately a futile sacrifice. Unlike Marion St. Claire, whose every client is repetitively declared to be "the most beautiful bride I've ever seen," Emma's gauche maid of honor Deb (Kristen Johnston) asks:

Deb:	Hey, is the veil *supposed* to go like that?
Emma:	Yes. Why?
Deb:	Oh no, you look fine.

Not only does Emma not look "perfect," her mother does not respond in the way Emma hoped for:

Mrs Allen:	Oh my god, is that *my* dress?
Emma:	[Nods] Are you happy?
Mrs Allen:	I'm happy if you're happy. Sweetheart you could get married in a brown paper bag, I wouldn't care. This is *your* day!

The feeling we are left with is that Emma is marrying in someone else's "perfect": that in not buying her own dress, she is being somehow untrue to herself. The effect is to make even stronger the link between pleasure and consumption: the new is privileged, the only "authentic" choice. Emma's realization that, sometimes, it really should be "all about her" is, in effect, a lesson in consumption.

Female Chauvinist Brides

The women's wedding preparations reflect, in some ways, the logic of the beauty pageant, which continues to figure as a locus of feminist critique *and* as a key device in the cinematic representation of women.[32] As Yvonne Tasker observes, Hollywood's marginalization of women's friendship goes hand in hand with the availability of limited and limiting roles for women, including the display of "women set in competition with each other."[33] The prize of being awarded the title of "most beautiful" invites women to compete with each other, and presents objectification as the ultimate feminine reward.[34] In *Bride Wars*, Emma and Liv offer the spectacle of a thoroughly unreconstructed catfight. They compete against each other in fiercely manipulative ("feminine") ways. Emma tricks Liv into gaining weight, Liv switches Emma's skin-color when she goes for a pre-wedding spray-tan, and each tries to out-gyrate the other in a bizarre pole-dancing competition during Liv's hen's night. The logic of the beauty pageant extends to Emma's and Liv's representation in general. The two women are continually compared, their differences marked in the same way that different ethnicities are represented in the Miss Universe beauty pageant—as superficial variations in taste, as corporeal "flavors" to be sampled by (unmarked, but clearly white-western) appraisers. Just so that we don't confuse them, Liv is a thin, white, beautiful blonde; Emma is a thin, white, beautiful brunette. Each must "wake up," Sleeping Beauty-style, to her faults: Liv must learn to be softer, less uncompromising; while Emma needs to harden up. Each woman is differently deficient or excessive, and each represents a heterogendered "type" of femininity.

In these ways, *Bride Wars* plays a nauseatingly familiar tune. It rehearses fairytales loaded with gendered stereotypes. It normalizes outrageous consumption as it glorifies dress-shopping, and it offers the spectacle of a competition between women across a triathlon of gendered events: who is the sexier? Who has the better dress? Who is the bigger bitch? *Bride Wars* thus draws on a number of meaningfully gendered (or even misogynistic) traditions: it is part fairytale, part raunch-fest, part beauty pageant. Each lame element can be subjected to a host of by now quite familiar feminist critiques. Crudely, those critiques amount to the accusation that *Bride Wars* presents, as normal and natural, impossibly beautiful women being complete (but sexy) bitches to each other in order to get their men. These condemnatory critiques undoubtedly have some purchase, but they do not tell the whole story.

Settling for *Bride Wars*

Bride Wars is part of a thoroughly heterogendered universe, but it is not entirely anti-feminist. Consider, for example, how the centrally ironic theme of "settling" plays out. Early on, we see lawyer Liv "refusing to settle" on a client's behalf. In a boardroom full of male executives, she demonstrates her superior wits and strength. Emma, in contrast, is all about compromise. She is cunningly and ruthlessly exploited by her colleague (and stand-in maid of honor) Deb, but it is also clear that her husband-to-be, Fletch (Chris Pratt), means to exercise his conjugal authority in their marriage.

> Fletch: You know who I feel sorry for? Daniel [Liv's fiancé]. He's not even going to be able to control his own wife.
>
> Emma: What?!?

Emma's marriage, we suppose, will thus entail some "settling down": she will be required to quiet any unruly or wild behavior; she will settle for being an acceptable rather than adored spouse.

> Liv: People always make you do things you don't want to do. Emma, it's like you don't have a spine. Oh wait, that's right: you *don't* have a spine. [...]
>
> Emma: Well, no one would accuse you of being soft, Liv.
>
> Liv: At least I'm not so terrified of being alone that I people-please my way through life. Emma, you *settle.*
>
> Emma: Are you saying that I'm settling with Fletcher?
>
> Liv: I wasn't thinking of Fletcher. You came up with that one on your own.

Emma's refusal to compromise with Liv (by changing the date of her own wedding) eventually slides into a refusal to settle for a relationship in which she is not valued, and in which she cannot value herself.[35]

Accusing Emma of "settling" (for second-best) with Fletcher is clearly a terrible insult.[36] The nature of the insult, however, seems to lie in its inferences of self-deception. In the very first scene of the two friends as adults, Liv and Emma attend a third friend's wedding (where they simultaneously catch the bride's bouquet). In the time it takes for the movie to unfold, this friend's marriage has begun, stumbled, and ended. Indeed, even before all the wedding presents have been unwrapped, the new bride looks at her sleeping husband and declares, "You're irritating me." When, at the close of the movie, a friend says to this woman, "Sorry to hear about your divorce," she responds "Why? It's only my first." Similarly, prior to their engagements, Liv and Emma discuss Emma's manipulatively self-serving colleague Deb.

Emma: I think she's kind of sad. I mean, she's been divorced like three times.

Liv: She's way ahead of us. I mean, where are our divorces? I got it: get married first!

This almost nonchalant acknowledgment that having a wedding might, at some future point, also mean having a divorce bothers neither Liv nor Emma. They take their weddings—and "settling"—seriously, but marriage as such is treated less reverently. Moreover, *Bride Wars'* failure to mystify marriage is emphasized by the positioning of Emma and Liv as knowing brides. That is, each woman already lives with the man she intends to marry. This not only breaks the rule that a romantic comedy should end before the happy couple's married life begins, but also reverses it. We see, before the weddings, how Liv and Daniel, and Emma and Fletch, live as couples. There is no sense, then, in which Liv and Emma can be understood as naïve brides whose dreams of flowers and lace blind them to the (heteronormative, heterogendered) effects of marriage, because in terms of the sexual/gendered behavior they perform, Liv and Emma are as good as married already. It is impossible, in the face of Liv's and Emma's lived knowledge of conjugality, to interpret *Bride Wars* as a frothy romanticization of wifely subordination. It may be a wedding movie, but *Bride Wars* is not merely "matrimonial mystique."[37]

Not only do Liv and Emma plan their weddings principally for their own (and, initially, each other's) enjoyment, each bride also pays for her own wedding. Rather than trading herself, or being exchanged as an object of feminine value in those "bridewealth" and dowry traditions that figure marriage as a gendered marketplace, Liv and Emma settle their own wedding bills. In this way, it might be argued that the film substantiates—again, in an ironic way—Chrys Ingraham's observation that "women's increasing economic independence [is] the single most important reason for marriage's increasing irrelevance."[38] We see, in *Bride Wars*, "attributes traditionally associated with 'the feminine' [tied] with female consumer desire and increased buying power."[39] That *Bride Wars* offers no insights into the politics of the wedding industry is hardly surprising. Indeed, if anything is mystified in *Bride Wars*, it is this. Marion St. Claire and Vera Wang are presented as deserving mogul-matrons—they are fairy godmothers whose powers of transformation are truly magical. But, of course, the laborers whom their industries exploit—sequin-sewers, hotel maids, paper mill workers— remain invisible.[40] Thus, when one critic regrets the movie's "self-centered material obsessiveness, particularly in pursuit of this vaguely sexist idea that modern women remain incomplete without lavish weddings during which it's all about them" he misses the mark.[41] The tension, in my view, is not so much about gender as it is about class and consumption. This is not to say that class and consumption are not *also* gendered: Liv's and Emma's extravagance is easy to condemn partly because they are spending money—lots of money—on their

own ephemeral pleasure. Such spending remains subject to gendered double standards: men are "well-groomed," women are "vain"; men have the means to make "quality" purchases, women are recklessly extravagant.[42]

The "incorrect" gender performance constituted by women with the means to finance their own weddings risks making Emma and Liv "unlikeable"—a complaint many reviewers of *Bride Wars* raise. Jim Lane describes Liv and Emma as "unappealing" and "shrewish," while another asserts that they are "irredeemably venal and self-absorbed people."[43] Liv and Emma *are* unlikeable: their mutual spite is apparently boundless. But how should we make sense of their inability to "appeal" to viewers? If we take the characteristically second wave dictum that "so long as one woman is oppressed, all women are oppressed" seriously, and conceive of women as a relatively coherent group, we must read *Bride Wars* as a display of (all) women's bitterness. On the one hand, the movie, in this sense, reflects women as "beautiful," but corrupt and treacherous, too; ultimately, it delivers an exhortation to women to hate themselves. On the other hand, perhaps these characters' lack of appeal is a useful distancing mechanism. Why should we assume that viewers inevitably seek to identify with the characters they watch on screen?[44] From a critical distance, we can reject, or even denounce Liv's and Emma's stupid competitiveness, their thoroughly pathetic need to live out a sadly persistent childhood dream—and in the process, of course, experience satisfaction, or even smugness in ourselves.

Conclusion: Another Happy Ending?

Can we say, then, that *Bride Wars* can be read, albeit counter-intuitively, as a *feminist* movie? Well, no. Just as straightforward condemnation of *Bride Wars'* heterogendered and heteronormative elements fail to wholly encapsulate the movie, so celebration of Liv and Emma's friendship and independence misses too much. Given that Emma's and Liv's wedding obsessions do, eventually, result in (hetero) marriages for both, we might object that Marion St. Claire's "take-home" message (that postfeminist girls might find loyal friends just as comforting and fulfilling as a spouse) is mixed: the Bridezilla walk does not match the BFF talk. It remains difficult to believe that Liv and Emma's friendship could survive their mutual assaults, just as it remains hard to credit that each woman would be prepared to invest so much time, money, and attention in the one-off celebration of a not necessarily enduring marriage.

Given that feminist struggles have renovated the institutional architecture of marriage, it is timely to think again about the work that marriage does. That is, we need to consider and reconsider the social effects of marriage. Part of that endeavor must include the critical exploration of weddings and wedding culture—not just in their gendered and heteronormative elements, but also in ways that attend to relations of class and racism. To ask, as so many post- and third wave feminists do, whether any individual's wanting to be married is

somehow unfeminist, misses the point.[45] Asking feminists how they rationalize women's desire for a happy marriage is like asking critics of consumer capitalism to explain why so many people want to be rich. The desire is not so difficult to fathom—indeed, perhaps the logic of the Cinderella fairytale is a little like the logic of the lottery. People buy tickets not because they expect to win, but for the acceptably remote *fantasy* of winning. This analogy speaks to the exclusion many gay and lesbian couples continue to experience in relation to marriage: it is like a lottery whose tickets are available only to heterosexual people. Unmistakeable cruelty and injustice inhere in this; however, recognizing and even empathizing with such desires does not mean that the relevant institutions and effects should be excused from critical analysis.

If *Bride Wars* continues to glorify the fairytale white wedding, it does so in complex and sometimes anxious ways. *Bride Wars* reflects continuing anxieties over gender, sexualities, and their intersection. Its critical failure indicates, perhaps, that its performatives—or iterations of discursive/cinematic conventions—may be flawed, or at least subject to contests of interpretation.[46] Its failure has as much to do with our gendering of Hollywood and the familiar expectations it produces—namely that a movie about brides will deliver a chick flick romantic comedy, not a white girlie consumerist buddy movie—as it does our (heterogendered) expectations of weddings and marriage.

Notes

1 I would like to acknowledge staff and students at Adelaide University's Department of Gender, Work and Social Inquiry for their invitation to present this research at their 2009 seminar series, and thank them for their thoughtful and generous responses to it. Thanks also to Sandie Price, Ph.D. candidate in Women's Studies at Flinders University, for the many productive conversations and great ideas shared on this and related topics.

2 There are canonical texts in both fields: on feminism and marriage. See Mary Astell, "Reflections Upon Marriage," in *The First English Feminist: Reflections Upon Marriage and Other Writings By Mary Astell*, ed. Bridget Hill (Aldershot: Gower/Maurice Temple Smith, 1986); Jessie Bernard, *The Future of Marriage* (London: Souvenir, 1972); Christine Delphy and Diana Leonard, *Familiar Exploitation: A New Analysis of Marriage in Contemporary Western Societies* (Cambridge: Polity Press, 1992); Carole Pateman, *The Sexual Contract* (Cambridge: Polity Press, 1988); Patricia Payette, "The Feminist Wife? Notes From a Political 'Engagement,'" in *Jane Sexes It Up: True Confessions of Feminist Desire*, ed. Merri Lisa Johnson (New York/London: Four Walls Eight Windows, 2002), 139–67; Carol Smart, *The Ties That Bind: Law, Marriage and the Reproduction of Patriarchal Relations* (London: Routledge and Kegan Paul, 1984), among others; on feminism and popular culture, see Rosemary Betterton, ed., *Looking On: Images of Femininity in the Visual Arts and Media* (London; Pandora, 1987); Susan Bordo, *Twilight Zones: The Hidden Life of Cultural Images from Plato to OJ* (Berkeley, CA: University of California Press, 1996); Rosalind Gill, *Gender and the Media* (Cambridge: Polity Press, 2007); Joanne Hollows, *Feminism, Femininity and Popular Culture* (Manchester/ New York: Manchester University Press, 1999), and "Can I Go Home Yet? Feminism, Postfeminism and Domesticity," in *Feminism in Popular Culture*, ed. Joanne Hollows and Rachel Moseley (Oxford and New York: Berg, 2006), 97–118; Angela McRobbie,

Feminism and Youth Culture: From "Jackie" to "Just Seventeen" (Boston, MA: Unwin Hyman, 1991) and *The Aftermath of Feminism: Gender, Culture and Social Change* (Los Angeles, CA: Sage, 2009); Imelda Whelehan, *Overloaded: Popular Culture and the Future of Feminism* (London: Women's Press, 2000); Janice Winship, *Inside Women's Magazines* (London and New York: Pandora, 1987), among others.

3 Chrys Ingraham, *White Weddings: Romancing Heterosexuality in Popular Culture*, 2nd edn (New York: Routledge, 2008).

4 That the action occurs in New York is hardly coincidental. As Diane Negra observes, "In the chick flick genre, the association with New York is sometimes cited as explanation for unconventional or unruly female behavior." Diane Negra, "'Quality Postfeminism?' Sex and the Single Girl on HBO," *Genders OnLine Journal* 39 (2004): 15–16.

5 Manohla Dargis, "Two Weddings and a Furor" (review of *Bride Wars*), *New York Times*, 9 January 2009.

6 See Kerrie Murphy, review of *Bride Wars*, *The Australian*, 17 January 2009; Peter Canvese, review of *Bride Wars*, Groucho Reviews, grouchoreviews.com, 2009; Tim Robey, review of *Bride Wars*, *Telegraph* (UK), 9 January 2009.

7 In December 2009 a draft entry for "bridezilla" was added to the (online) *Oxford English Dictionary* (oed.com). Relevant quotations offered there include one from a review of *Bride Wars*.

8 Peter Travers, review of *Bride Wars*, *Rolling Stone*, 8 January 2009.

9 Canavese, review of *Bride Wars*.

10 Jim Lane, review of *Bride Wars*, *Sacramento News and Review*, 15 January 2009.

11 See Jo Berry and Angie Errigo, *Chick Flicks: Movies Women Love* (London: Orion Books, 2004); Suzanne Ferris and Mallory Young, "Introduction: Chick Flicks and Chick Culture," in *Chick Flicks: Contemporary Women at the Movies*, ed. Suzanne Ferris and Mallory Young (New York and London: Routledge, 2008), 2, 14.

12 Robey, review of *Bride Wars*.

13 Murphy, review of *Bride Wars*; Eddie Cockrell, review of *Bride Wars*, *Sydney Morning Herald*, 15 January 2009.

14 Ingraham, *White Weddings*, 27, emphasis deleted.

15 Tamar Jeffers McDonald, *Romantic Comedy: Boy Meets Girl Meets Genre* (London: Wallflower, 2007), 14.

16 Elvis Costello and the Attractions, vocal performance of "Black Sails in the Sunset," by Elvis Costello, recorded late 1980–early 1981, Eden Studios, London, *Out of Our Idiot*, Demon Records, Demon IMP XFIEND 67.

17 Hilary Radner, "'Pretty is As Pretty Does': Free Enterprise and the Marriage Plot," in *Film Theory Goes to the Movies,* ed. Jim Collins, Hilary Radner, and Ava Preacher Collins (London: Routledge, 1993), 56–76.

18 Writing this chapter brought me to the horrified realization that I had done exactly the same thing in my book about marriage and marriage-like relationships. See Heather Brook, *Conjugal Rites: Marriage and Marriage-like Relationships Before the Law* (New York: Palgrave, 2007). In my book, the narrative takes a different course (viz., the child playing with her bride doll is quickly, destructively bored), but I find it astonishing nonetheless that I unconsciously mimicked the generic formula.

19 Dargis, "Two Weddings and a Furor."

20 Robey, review of *Bride Wars*. Such responses indicate that *Bride Wars* offers a reasonably clear fit with the "break-up and make-up" trope of romantic comedies McDonald identifies. McDonald, *Romantic Comedy*, 118.

21 For some interesting suggestions on how this might occur in relation to heterosexuality, see Sean Griffin, ed., *Hetero: Queering Representations of Straightness* (Albany, NY: State University of New York Press, 2009).

22 Suzanne Leonard, "Marriage Envy," *Women's Studies Quarterly* 34, nos 3–4 (2006): 43–64.

23 Bruce Babington and Peter William Evans, *Affairs to Remember: The Hollywood Comedy of the Sexes* (Manchester: Manchester University Press, 1989), 273; Karen Hollinger, *In the Company of Women: Contemporary Female Friendship Films* (Minneapolis, MN: University of Minnesota Press, 1998), 4–5.

24 Dargis, "Two Weddings and a Furor."

25 Yvonne Tasker, *Working Girls: Gender and Sexuality in Popular Cinema* (New York: Routledge, 1998), 155.

26 In a nutshell, the critique is that fairytales position women as (and teach girls to be) objects whose sole worth lies in their ability to be "chosen," and whose life aim is to be married. See Donald Haase, "Feminist Fairy-tale Scholarship," in *Fairy Tales and Feminism: New Approaches*, ed. Donald Haase (Detroit, MI: Wayne State University Press, 2006), 1–36.

27 Ingraham, *White Weddings*, 26.

28 Elizabeth Freeman, *The Wedding Complex: Forms of Belonging in Modern American Culture* (Durham, NC: Duke University Press, 2002), 25–32.

29 McDonald, *Romantic Comedy*; Leda Cooks, Mark Orbe, and Carol Bruess, "The Fairy Tale Theme in Popular Culture: A Semiotic Analysis of *Pretty Woman*," *Women's Studies in Communication* 16, no. 2 (1993): 91.

30 Vera Wang is, of course, a famous designer of wedding dresses. My DVD (see below) of *Bride Wars* includes an "exclusive featurette": "The Perfect White Dress." This is little more than an extended advertisement for the Vera Wang brand.

31 For all quotations from this film, see *Bride Wars*, directed by Gary Winick (2009; Century City, Los Angeles: Fox Home Entertainment, 2009).

32 Sarah Banet-Weiser, *The Most Beautiful Girl in the World: Beauty Pageants and National Identity* (Berkeley, CA: University of California Press, 1999); Colleen Ballerino Cohen, Richard Wilk, and Beverly Stoeltje, eds., *Beauty Queens on the Global Stage: Gender, Contests, and Power* (New York; Routledge, 1996).

33 Tasker, *Working Girls*, 139.

34 Ariel Levy, *Female Chauvinist Pigs: Women and the Rise of Raunch Culture* (New York: Simon and Schuster, 2005).

35 Value," however, remains intimately connected to the acquisition of goods and services: "good" women "deserve" nice things—because, as the slogan goes, they're "worth it."

36 The same wordplay is at work in Emily Dubberley, *I'd Rather Be Single Than Settle* (London: Fusion Press, 2006).

37 Diane Negra, "Time Crisis and the New Postfeminist Heterosexual Economy," in *Hetero: Queering Representations of Straightness*, ed. Sean Griffith (Albany, NY: State University of New York Press, 2009), 176.

38 Ingraham, *White Weddings*, 20.

39 Kay Schaffer, "Scare Words: 'Feminism,' Postmodern Consumer Culture and the Media," *Continuum* 12, no. 3 (1998): 330.

40 See Ingraham, *White Weddings*; Leonard, "Marriage Envy," 48.

41 Cockrell, review of *Bride Wars*.

42 Jessica Valenti, *He's a Stud, She's a Slut and 49 Other Double Standards Every Woman Should Know* (Berkeley, CA: Seal, 2008).

43 Jim Lane, review of *Bride Wars*; Canavese, review of *Bride Wars*.

44 Judith Mayne asks similar questions. See Judith Mayne, *Cinema and Spectatorship* (London: Routledge, 1993). It is possible that in our spectatorship, we may seek to identify with characters whom we know are entirely unlike ourselves. It is also perfectly reasonable to conceive pleasure in dis-identification, or the "I'm glad I'm not as bad/ugly/mean/stupid as that" moment.

45 Payette, "The Feminist Wife?"; Hillary Frey, "Choice of a Generation," *In These Times.com* 25/23, inthesetimes.com, 15 October 2001; Merri Lisa Johnson, "Fuck You and Your Untouchable Face: Third Wave Feminism and the Problem of Romance," in *Jane Sexes It Up: True Confessions of Feminist Desire*, ed. Merri Lisa Johnson (New York/London: Four Walls Eight Windows, 2002), 13–50.

46 For more on performatives and their relevance to weddings and marriage, see Brook, *Conjugal Rites*. For more on gender performativity, see Judith Butler, *Gender Trouble: Gender and the Subversion of Identity* (New York: Routledge, 1990).

18

EXTREME PARENTING

Recuperating Fatherhood in Steven Spielberg's *War of the Worlds* (2005)

Hannah Hamad

Surrounding the release of Steven Spielberg's science-fiction blockbuster *War of the Worlds* (2005), a widely circulated publicity still featured star Tom Cruise with his arm placed protectively around the shoulders of young co-star Dakota Fanning, as they gaze heavenwards in bewildered wonder. The widespread promotional use of this image, as opposed to one showcasing its genre, spectacle, or blockbuster credentials to greater effect, manifestly indicated that fatherhood and familial relations would be thematically prominent. This thematic bent was commensurate with recent developments in Spielberg's output and, as this chapter will ultimately contend, with a current trend in depictions of screen fathers, manifested across the spectrum of Hollywood's male star-led genres.

One way of understanding the film's thematic preoccupation with fatherhood is as a continuation of Spielberg's longstanding concerns with fragmented and troubled families, through his output over time via recurring character types and scenarios like the inadequate father and child in peril. Spielberg scholars identify these as authorial concerns[1] arising from his autobiographical investment in broken families and troubled fatherhood.[2] *War of the Worlds* is thus a logical entry to his extant filmography in thematic terms, featuring a Spielbergian narrative impetus striving towards reuniting a fragmented family, in which the father no longer has a place. He shepherds his children away from danger and toward their mother amidst the crisis of an alien invasion, while transforming and rehabilitating his paternal credentials, which are initially presented as inadequate. Versions of the inadequate father populate Spielberg's films from his first cinematic outing *The Sugarland Express* (1974), in which a fugitive father abortively attempts to reunite his family. By *War of the Worlds* the irresponsible father and narratives of paternal redemption were established Spielbergian tropes.[3] Recently these figures and themes appeared in *Minority Report* (Steven Spielberg, 2002) and *Catch Me If*

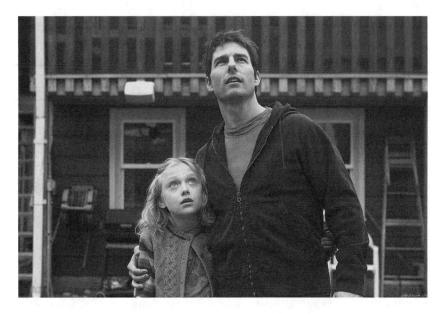

FIGURE 18.1 "Ray" (Tom Cruise) and "Rachel" (Dakota Fanning) in a publicity still that establishes the narrative and thematic significance of fatherhood in *War of the Worlds* (2005). Courtesy of Paramount Pictures/Photofest.

You Can (Steven Spielberg, 2003), which integrate the recuperation of their characters' inadequate fatherhood into their overarching narratives. Both screen fathers respectively lose their families due, it is suggested, to workaholic tendencies, but their fatherhood is redeemed upon each film's conclusion. Time has thus heralded the requirement that failing fatherhood, derogated at the outset of these narratives, be recuperated. Thus, it is in keeping with Spielberg's larger oeuvre that *War of the Worlds* is framed as a domestic crisis, that its protagonist is a failing father, and that his fatherhood is recuperated as the narrative progresses, charting what Joshua Gunn describes as his "gradual ascent" to the status of "good father."[4]

Inadequate fatherhood has thus always been thematically prominent in Spielberg films, though the recuperative imperative is a more recent development, as is the co-dependently constituted transformation of the protagonist's fatherhood within the overarching narrative: Ray needs a crisis to stage his paternal rehabilitation. This is not to say that thematizing troubled fatherhood is specific to Spielberg. Rather, narratives centered on male parenting have, as Yvonne Tasker notes, become a "prominent feature"[5] of contemporary film, and "male parents are frequently presented as *failing* their children."[6] This chapter, then, addresses how fatherhood is represented over the course of *War of the Worlds*.

After a prologue, the film begins in present-day New Jersey, where we are introduced to dockworker Ray Ferrier (Cruise) finishing a 12-hour nightshift.[7] Thereafter, he is quickly established as a divorced, estranged failing father; having sped home in his Shelby Mustang race-car, recklessly charging around corners through broken stoplights, he unexpectedly finds his pregnant ex-wife Mary Ann (Miranda Otto) with current husband Tim (David Alan Basche), waiting with his children, 16-year-old Robbie (Justin Chatwin) and 10-year-old Rachel (Dakota Fanning). During their transfer to Ray's care for the coming weekend, we learn key things about all of them, and their relationships, that establish the terms of Ray's currently derogated fatherhood, as he makes several missteps that leave his paternal credibility wanting. The first sets the tone for the tensions that follow. Ray had forgotten their eight o'clock arrangement, appearing at eight thirty to find them annoyed, though unsurprised, at his failure to appear at the pre-arranged time.

Robbie ignores Ray as he exits Tim's car, and disavows his fatherhood, calling him "Ray" to his father's chagrin.[8] The tension in this frosty exchange mounts during their awkward subsequent backyard game of catch (notable given the common deployment of this activity as a visual shorthand to signify father–son bonding),[9] which takes place over a conversation about Robbie's homework. Ray clumsily attempts to assert paternal authority, eliciting hostility, disdain, and anger from Robbie, culminating in a broken window. Ray's failure to communicate effectively in this context is particularly pointed given the gender specificity that typically accompanies sporting allegories of parenting.[10] Rachel is introduced as a visual spectacle of contemporary girlhood through brightly colored costuming and girlish accessories, greeting Ray with fonder indulgence, but it later emerges that she does not think of him as someone who can "take care" of her. Her precocious wise-beyond-her-years knowingness[11] (ordering "health" food, offering advice on how to "get through" to Robbie, confidently explaining how the body expels splinters) is articulated alongside neuroses, allergies, phobias, and physical ailments, suggesting both a degree of self-reliance, and also deep-seated vulnerability.

Inside, Mary Ann highlights Ray's domestic shortcomings, lamenting his empty fridge, another indication that he was unprepared for them. This paternal misstep is compounded, following Mary Ann and Tim's departure, when he devolves responsibility for feeding his children (a basic act of responsible parenthood) onto them, leaving them to manage while he sleeps, with a curt instruction to "You know, order." Notwithstanding his tiredness following his shift, Ray's sullen withdrawal to bed and indifferent response to Rachel's inquiry as to how they will eat in the absence of either adults or food marks his fatherhood as immature, underlined via textual motifs like his car, and costuming. He wears a hoodie, cap, and leather jacket, appropriate in his occupational context, but also notable for its similarity to Robbie's outfit, and difference from Tim's, connoting Ray's curtailed maturity, but also class difference.

Noteworthy in this introductory sequence is the juxtaposition of Ray's class position with Tim and Mary Ann's, exacerbated later in a scene at their luxury suburban residence, in contradistinction to Ray's working-class neighborhood and home. Tim's socio-economically superior status is flagged repeatedly as Ray sarcastically admires his new car, Robbie goads Ray that Tim pays for his education, and Rachel gloats about Tim's gift of bedroom TiVo, one implication being that the wealth and privilege of middle-class life with Tim and Mary Ann have instilled a sense of entitlement that his modest means and lifestyle would have precluded.

Ray's derogated working-class masculinity thus represents what Susan Faludi, considering the socio-cultural undermining of the "role of the family breadwinner,"[12] highlights as men's "loss of economic authority."[13] Meanwhile, the snappily dressed, groomed, and consumerist Tim embodies "ornamental culture"[14] that she argues strips men of gender-specific "meaningful social purpose,"[15] through emphasis on acquisition, appearance, and purchasing power, which she posits as feminine traits compared to the utilitarian "functional public role" of Ray's hardy hands-on occupation, aligned instead with devalued masculinities.[16] Tim's occupation is unspecified, but his success as the new father, relative to Ray's failures, is articulated through material trappings of middle-class family life, alongside his sensitive fathering of Rachel, indicated by their mutually affectionate parting greeting, which Ray observes resentfully.

This economic disparity communicates the devaluation of Ray's fatherhood emphasized by his dually derogated class position and masculinity; he is shown neither to fulfill the traditional role of provider, nor to evince nurturing "new man" fatherhood, that might offset this failing from a feminist viewpoint.[17] This continues a tendency of contemporary Hollywood to characterize "the white male as victim" of, among other things, feminism, represented through the suggestion that Mary Ann has discarded Ray, and through currently modish masculinities represented by Tim who fulfills requirements of fatherhood that Ray does not: he provides, is present, is emotionally effusive and tactile, and has the children's attention and affection.[18]

Ray thus exemplifies Nicola Rehling's observation that "class ... always cuts across white heterosexual masculinity ... pointing to the fact that white male power is always dependent on economic status."[19] His class is bound up with his derogated fatherhood, both in Mary Ann's eyes (she bemoans the children's shared bedroom in a dig at his small house), and the children's (as per their materialist put-downs). Sympathy for Ray is hence elicited by an "appeal to victim status," while his derogation, illustrated by the low esteem in which he is held by his upwardly mobile ex-wife and over-privileged children, is accounted for by his shortcomings as a father.[20] The film thus lays out the parameters of Ray's fatherhood with some ambivalence as to where the culpability for its inadequacy lies: with Mary Ann, and by implication with white middle-class femininities associated with feminism, or with his inability to

reorient his outmoded fathering to changing conceptualizations of ideal masculinity.

Mary Ann and Tim depart, leaving Ray with the children and an apprehensive instruction to "take care of our kids." He cockily retorts, "Mary Ann, you got *nothin'* to worry about," with misplaced confidence. This introductory sequence thus sets the terms of Ray's awkward relationship with his children, contextualizing his description in promotional materials as a "less-than-perfect father."[21] The scene communicates his good intentions, but also his inept attempts to put them into practice, and his marginal role in his children's lives. It thus primes the audience for the subsequent transformation of his fatherhood through a scenario that will mobilize and test his protective paternal instincts, moving him from self-oriented to largely selfless; in extreme circumstances, he will do whatever is necessary to protect his children, especially Rachel. This scenario, the film's overarching narrative, and principal link to its literary source (H.G. Wells's 1898 novel) and cinematic precursor (Byron Haskin's 1953 film), depicts aliens invading earth and attempting to annihilate humanity. Here, this premise is a spectacular device framing Ray's paternal rehabilitation, charting his changing relationship with his children as their level of danger escalates, and the situation intensifies.

Building up to the attack, Ray's parental ineptitude continues to manifest itself through his initial attempts to manage the situation. Upon waking, he is outraged to hear that Robbie has stolen his car, and, rushing outdoors after him, observes bizarre weather, the first indication of something amiss. Sheltering under a table after lightning strikes beside the house, Ray's nervous unease panics Rachel, and she asks, "Are we going to be okay?" Presented with this transparent plea for reassurance, a distracted Ray exacerbates Rachel's anxiety: he answers, "I don't know." He leaves her home alone to locate Robbie. Finding him, he makes sure that Robbie is safe, before reproaching him over the car and sending him to watch Rachel while he investigates. The ground trembles, and a metallic tripod emerges out of the ground, annihilating everyone in sight, although Ray makes it home safely. Washing his face in horrified realization that it is covered in human ash, he calms himself, and his protective paternal instincts are mobilized. The attack thus sets the scene that will allow his fatherhood to take center stage, as he is required to protect his children from a real and imminent threat, and shepherd them to safety.

Gripping Rachel's hand, Ray strides purposefully to the only functioning vehicle in the vicinity, and they flee. Notably, the car is a Plymouth Voyager people-carrier, reminiscent of Tim's higher-end safe-looking new vehicle. Its connotations of safety, family, and mature, responsible driving can be juxtaposed with those of Ray's Shelby Mustang, tellingly coveted by the teenage Robbie, conversely signifying speed, recklessness, youth, immaturity, and irresponsible driving. Textual motifs and mise-en-scène thus contribute to the articulation of Ray's ameliorating fatherhood. Arriving at Mary Ann and Tim's house, they find

it empty, but take shelter there. Next morning Ray finds the surrounding area destroyed, and learns from a passing news crew that the extent of the destruction is massive and the scale of the invasion global. He carries Rachel to the car, telling her not to look and uttering reassurances, in a progression from his earlier mishandling of the lightning strike. As they journey to Boston, more evidence of Ray's alienation from the daily practicalities of parenthood emerge, revealing his ignorance of Rachel's allergies and bedtime routines, with which Robbie appears familiar, and his inability to defuse her panic attacks, which, given Robbie's matter-of-fact deployment of rehearsed calming strategies, are evidently frequent.

En route to Boston, Ray and Robbie argue over his refusal to call him "Dad." Then, having stopped for a bathroom break for Rachel (taking Ray slightly aback as the practical realities of parenthood gradually begin to figure in his self-realization as a protective *paterfamilias*), Robbie attempts to join a passing military convoy in the counter-attack against the invaders. They argue, Robbie railing against Ray's inadequate fatherhood and what he perceives as his self-oriented actions, accusing him of taking them to Boston not to protect them, but to be rid of them. Back on the road, Ray attempts to make peace by allowing Robbie to drive. Encountering crowds of pedestrian refugees, Robbie wakes a sleeping Ray who tellingly does not stir until he calls him "Dad." The car is commandeered, but Ray's paternal protectiveness and desperate cries of "Where's my son!" and "All I want is my daughter!" ensure that for the moment they remain safely together.

They cross the Hudson River (surviving an attack on their ferry) and Robbie heads straight for another military unit, battling an army of tripods. Ray momentarily leaves Rachel to pursue and restrain Robbie, but faced with the threat of losing her to a well-meaning couple who think she is alone, he is presented with the dilemma of letting Robbie go, or losing Rachel. Given the film's interest in proving Ray's paternal worth, this is best achieved through Rachel, so Robbie is removed from the equation to allow for this. Robbie runs toward the battle, and Ray runs to retrieve Rachel, scooping her up with the desperate explanation "I'm her *father*." This development initially appears anomalous, and to undermine narrative cohesion, especially given that contemporary Hollywood narratives of families-in-peril, like *2012* (Roland Emmerich, 2009), which is otherwise strikingly similar in terms of its apocalyptic premise and linked narrative of paternal redemption, often prioritize staying together. Nevertheless, removing Robbie can be understood as a step toward the completion of Ray's ascent to the status of good father.[22]

Robbie is less suitable than Rachel as a vehicle for Ray's paternal rehabilitation. Ray's struggling fatherhood must compete with his manifestly more competent pseudo-fatherhood, making him his rival in terms of paternal credentials. Thus, Robbie's presence hinders the narrative and discursive centralization of Ray's fatherhood. The film emphasizes Ray's practical and interpersonal

paternal failings. Conversely, it has presented Robbie and his pseudo-parenting, as a preferable point of comparison, certainly in Rachel's eyes; following Robbie's first attempt to break from his father to join the military, she frankly and ingenuously asks, "Who's going to take care of me if you go?" Robbie's pseudo-paternal protectiveness of Rachel causes him to relent (this time). Suppressing his rebellious teenage persona, he re-assumes his pseudo-parental role and embraces her, soothing her rising panic at the prospect of his imminent departure and her abandonment to Ray's care. Meanwhile, a crestfallen Ray is positioned at the edge of the frame, physically apart from this exchange, and excluded from consideration as a suitable alternative guardian, making clear not only that Rachel does not view her father as a care-giver, but also that his attempts to fulfill the role of father-protector, since the crisis began, have not yet changed her mind-set. This moment thus communicates the state of their relationship and the valence of Ray's fatherhood, preparing the audience for Robbie's subsequent departure, which facilitates an intensification of Ray's protective paternal instincts toward Rachel, and ultimately the revalidation of Ray's fatherhood in his children's eyes.

Following his separation from Robbie and reunion with Rachel, Ray accepts shelter from Harlan Ogilvy (Tim Robbins) who has become unhinged by the crisis, having lost his own family. Ray puts Rachel to bed, recalling an earlier bedtime scene, in which he left Robbie to do this, dismissing her tersely with "No more talking." This time he sits with her, whispers gently, and tearfully sings a lullaby. Commensurate with his hitherto hands-off fatherhood he knows no lullabies, but makes do with a song he does know, in a small but significant gesture toward his changing sense of paternal responsibility and attentiveness to

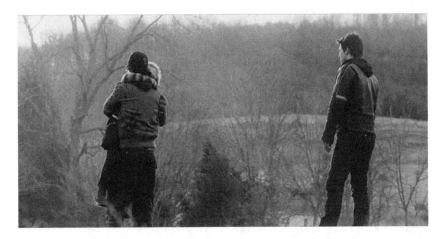

FIGURE 18.2 "Rachel" prefers the comforting arms of her brother "Robbie" (Justin Chatwin) to those of her father "Ray." *War of the Worlds* (2005).

parental obligations. Notwithstanding the trauma of losing Robbie, he suppresses his feelings to comfort Rachel, and makes her feel safe and secure under the circumstances. Her quiescent approval also marks a turning point, as she now looks to him to be fatherly in a way she previously did not.

Ogilvy takes an unnerving interest in Rachel, putting Ray on edge and his paternal protectiveness into overdrive. After narrow escapes from an alien probe and aliens themselves, which are almost bungled by Ogilvy, Ray takes a drastic step; blindfolding Rachel, encouraging her to sing to herself, he murders Ogilvy in an extreme act of paternal protectiveness. During the night they encounter another probe. Ray immobilizes it with an axe, but turning to find Rachel gone, he rushes outside to meet a tripod, which, to Ray's horror, plucks the reappeared Rachel from the ground. Using himself as bait, Ray allows himself to be taken as well in order to find and rescue his daughter. Dropped in a metal cage, he finds Rachel in a catatonic state, which he is able to bring her out of by gently repeating her name as he cradles her face in his hands. Inside the cage, he shields her with his body to prevent her from being taken once more, and then facilitates their escape by exploding a grenade in the alien's innards, risking his own life in order to get close enough to do so. Ray's worthiness as a father and credentials as a hero are thus affirmed through his successful enactment of action-oriented protectionism in this scene. Thereafter, the remainder of the journey to Boston is elided.

Arriving to find the aliens dying due to their vulnerability to bacteria, Ray performs a final act of paternal protectiveness. Shielding them both from a collapsing tripod, he holds Rachel, reassuringly repeating the words, "It's okay. It's going to be okay," again recalling an earlier scene, prior to his currently ameliorated parenting, in which he blunderingly offered no reassurance to Rachel's anxious entreaty—another gesture toward then-and-now differences in Ray's parenting before the crisis versus after. Another comes next in the final scene, as Ray delivers Rachel safely to her mother on the street outside her grandparents' home. They come to the door, trailed by Tim, relieved to see this reunion. Nobody speaks, and as Ray prepares to approach Mary Ann with the news about Robbie, he too appears on the doorstep. In contrast to his steadfast refusal to acknowledge Ray in the earlier equivalent scene, Robbie runs enthusiastically into his incredulously joyful father's arms. Ray's final moment places him in two-shot close-up, tearfully embracing Robbie with a quietly euphoric smile. Comparing the scenes that bookend their story we thus see that Robbie, as well as Ray, has developed over the course of the narrative, changing the terms of their relationship, to the benefit of Ray's paternal self-worth. This exemplifies what Tasker identifies as a representational recurrence in contemporary popular cinema, that "intensive male parenting is presented as transformative for both men and children."[23]

This scene has been compared with the ending of iconic western *The Searchers* (John Ford, 1956).[24] In this search, rescue, and protect narrative, having safely

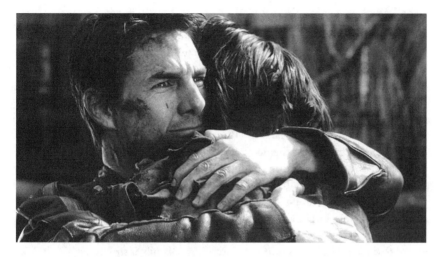

FIGURE 18.3 A moment of physical intimacy between the reunited father and son. *War of the Worlds* (2005).

delivered his abducted niece to the family homestead, a door closes on Ethan Edwards (John Wayne), shutting him out of the domestic sphere, excluding him from family life. Notwithstanding assertions that *War of the Worlds* ends with Ray similarly "alone,"[25] with "no place for him"[26] in the reconstituted family, this is not entirely the case. *War of the Worlds'* ending depicts Ray locked in his son's embrace, smilingly contentedly. The only person in the family dynamic physically removed from this reunion is Tim. This is not to suggest that *War of the Worlds* reconstitutes the broken nuclear family to include the biological father, as *2012* does, but it does ultimately emphasize the revalidation of Ray's fatherhood, with optimism for an ameliorated relationship with his children henceforth. He is powerless to reunite with Mary Ann, but has salvaged his paternal validity in his children's eyes, proving himself worthy of their hitherto withheld respect, through successfully taking on the role of paternal protector vis-à-vis Rachel. Thus, in testing the limits of Ray's fatherly devotion in extreme circumstances, the film charts his development from inadequate father and marginal figure in his children's lives, to devoted protector who will stop at nothing to keep his child safe. Ray's heroism is therefore showcased, not through spectacular action, but through single-minded determination to remove his children from danger, and to make good on his agreement with Mary Ann to "take care of our kids." It is localized, personalized, and specific to his fatherhood.

Alongside *War of the Worlds*, there has emerged a cognate cluster of thematically and structurally comparable male star-led films, including *Signs* (M. Night Shyamalan, 2002), *Road to Perdition* (Sam Mendes, 2002), *Hostage* (Florent Emilio Siri, 2005), *Live Free or Die Hard* (Len Wiseman, 2007), and *Taken* (Pierre Morel,

2008), to name only some. These films depend upon similarly contrived scenarios that recuperate failing fatherhood through enactment of paternal protectiveness in extreme circumstances, whereupon the reconstitution of a normative familial unit is not the point of the protagonist's narrative journey, so much as the revalidation of his initially derogated fatherhood. These extreme scenarios depict the redemption of inadequate fathers, deflecting feminist critiques of masculinity, by positing the male's fulfillment of the role of father-protector as compensating for domestic and interpersonal failings. *War of the Worlds* is a notable entry in this cluster, marked by tropes, themes, and motifs that recur in screen depictions of fatherhood across the spectrum of Hollywood's genre output.

This is not to suggest that these films are without precedent, in terms of thematically foregrounding fatherhood and family, which have always been structuring themes in Hollywood films. Introducing his survey of familial representations from the silent period through the mid-2000s, in which he charts the extent to which "the constitution or disruption of family is structurally central,"[27] Murray Pomerance notes that "the family... has always been, a central feature of screen depictions,"[28] while Stella Bruzzi charts and contextualizes shifts in depictions of fatherhood over time.[29] There are also precedents to the current cycle of father-oriented extreme parenting films,[30] in which the high-stakes scenarios germane to the action genre provide "the motivation for and the resolution of changing masculine heroisms," as well as staging grounds for narratives of motherhood,[31] a parenting paradigm sidelined in *War of the Worlds* and cognate films, commensurate with Tasker's observation that father-centered narratives are frequently "accompanied by the marginalization ... of mothers."[32] She also highlights the usefulness of the concept of postfeminism for understanding recurring themes in the depiction of contemporary screen fatherhood.[33] The discourse of fatherhood in *War of the Worlds* can similarly usefully be understood in postfeminist terms.

The defining features of postfeminism remain contested, debated, and fluid, and a catch-all definition articulating its nuances and complexities remains elusive.[34] However, aspects of how it has been conceptualized enable particular understandings of fatherhood in *War of the Worlds*. In relation to a major structuring debate of postfeminism, representation, and recuperation of fatherhood exemplifies what Rosalind Gill calls an "entanglement of feminist and antifeminist ideas,"[35] drawing upon Angela McRobbie's notion of the "double-entanglement"[36] of postfeminism, regarding its circuitous and ambivalent relationship to feminism.

In identifying, critiquing, and rehabilitating a bad father, *War of the Worlds*' depiction of fatherhood is one of many examples of cultural responses to "feminist calls for equity in childrearing."[37] However, through the disapproving Mary Ann we also see, as Tasker and Diane Negra contend with regard to postfeminist culture more broadly, that "feminism is constituted as an unwelcome, implicitly censorious presence," so its "concerns are silenced," as she is

removed from the narrative.[38] Thereafter it becomes a "structuring absence"[39] at once demanding the amelioration of Ray's fatherhood, but succumbing to an ideological double-bluff as Ray and his fatherhood take on "discourses of (particular versions of) feminism ... [but] do so without giving up their centrality in the narrative."[40] Thus it seems to account ideologically for the androcentric (or male-centered) depiction of parenting we are left with upon Mary Ann's departure, but with manifestly patriarchal (in terms of the social significance of fatherhood) undertones, given the discursive emphasis on the traditional role of father-protector in his rehabilitation, and Ray's ultimate fulfillment of this role.

Films like *War of the Worlds* participate in the postfeminist practice of taking feminism "into account"[41] seeming to transcend the need for a politicized feminist stance by, for example, presenting Tim as an example of the "new nurturing masculinity"[42] that circulated culturally in feminism's aftermath. The film also accords a high level of social power to the female, via the socio-economically elevated middle-class woman (Mary Ann), and what it presents as a concomitant "loss of power for men" (Ray occupies a weak position socio-economically and domestically), while gesturing toward the "tenuous assumption that all men previously occupied equally elevated positions of social and economic power"[43] via class tensions. However, socio-economic power and domestic competence are initially presented as mutually constitutive, prior to the formulation of an alternative postfeminist masculinity, for Ray, facilitated by the extreme circumstances in which he effects his paternal recuperation. Thereafter, his fatherhood is accorded a measure of ideological flexibility with regard to the imperative to reconstruct his masculinity according to Tim's model. Thus, the recuperation of Ray's fatherhood, commensurate with conceptualizations of postfeminist masculinity as an ideologically unstable or ambivalent gender discourse, can be negotiated by positioning it as "not the signifier for the re-masculinisation [*sic*] of contemporary culture—a straightforward rejection of second-wave feminism that can be easily identified as part of the backlash—but, in contrast, an unstable and troubled subject position that is doubly encoded."[44] Although tensions are unresolved and there are ideological instabilities in Ray's postfeminist fatherhood, through his enactments of protective paternalism and growth as a father in terms of maturity and competence, Ray is left sharing a much more level playing field with Tim, in terms of the ideological valence and cultural viability of their respective parenting paradigms.

In contemporary popular cinema, fatherhood is a prominent feature of screen masculinities, due in part to the relative ease with which it can be disingenuously represented as a politically innocent state, and hence negotiated as a feature of ideal masculinity. This takes place through common-sense appeals to paternal love, loyalty, and protectiveness, mobilized by crisis scenarios, and by virtue of the extreme circumstances to which genre narratives give rise. *War of the Worlds* is a notable example among many in which masculinity is articulated through

a recuperative narrative and a structuring gender discourse of postfeminist fatherhood.

Notes

1 Lester D. Friedman, *Citizen Spielberg* (Urbana and Chicago, IL: University of Illinois Press, 2006), 7–8; Andrew Gordon, *Empire of Dreams: The Science Fiction and Fantasy Films of Steven Spielberg* (Lanham, MD: Rowman & Littlefield, 2008), 260; Peter Krämer, "Steven Spielberg," in *Fifty Contemporary Film Directors Second Edition*, ed. Yvonne Tasker (London and New York: Routledge, 2010), Taylor & Francis e-Library Edition, 378; Nigel Morris, *The Cinema of Steven Spielberg: Empire of Light* (London and New York: Wallflower, 2007), 7; Frederick Wasser, *Steven Spielberg's America* (Cambridge: Polity Press, 2010), 5.
2 Joseph McBride, *Steven Spielberg: A Biography* (New York and London: Faber and Faber, 1997), 72, 219–20, 393–4.
3 Krämer, "Steven Spielberg," 378.
4 Joshua Gunn, "Father Trouble: Staging Sovereignty in Spielberg's *War of the Worlds*," *Critical Studies in Media Communication* 25, no. 1 (2008): 11.
5 Yvonne Tasker, "Practically Perfect People: Postfeminism, Masculinity and Male Parenting in Contemporary Cinema," in *A Family Affair: Cinema Calls Home*, ed. Murray Pomerance (London: Wallflower, 2008), 176.
6 Ibid., 180.
7 *War of the Worlds*, DVD, directed by Steven Spielberg (2005; London: Paramount Home Entertainments UK, 2005).
8 This motif also signifies derogated fatherhood in *Live Free Or Die Hard* (Len Wiseman, 2006) and *2012* (Roland Emmerich, 2009).
9 For example, *Field of Dreams* (Phil Alden Robinson, 1989).
10 Anna Gavanas, *Fatherhood Politics in the United States: Masculinity, Sexuality, Race, and Marriage* (Urbana and Chicago, IL: University of Illinois, 2004), 113–20.
11 This trope characterizes daughters of single fathers marked as immature, irresponsible, and/or inadequate in *Dan In Real Life* (Peter Hedges, 2007), *King of California* (Mike Cahill, 2007), and *Smart People* (Noam Murro, 2008).
12 Susan Faludi, *Stiffed: The Betrayal of Modern Man* (London: Vintage, 2000), 595.
13 Ibid.
14 Ibid., 35.
15 Ibid., 598.
16 Ibid., 35.
17 Regarding the "new man" on film see, for example, Stella Bruzzi, *Bringing Up Daddy: Fatherhood and Masculinity in Post-War Hollywood* (London: British Film Institute, 2005), 146–51.
18 Nicola Rehling, *Extra-Ordinary Men: White Heterosexual Masculinity in Contemporary Popular Cinema* (Lanham, MD: Lexington Books, 2009), 21.
19 Ibid., 5.
20 Ibid., 2.
21 "About the Film," WarOfTheWorlds.com.
22 Gunn, "Father Trouble," 11.
23 Tasker, "Practically Perfect People," 181.
24 Friedman, *Citizen Spielberg*, 155; Wasser, *Steven Spielberg's America*, 207.
25 Morris, *The Cinema of Steven Spielberg*, 354.
26 Gordon, *Empire of Dreams*, 263.
27 Murray Pomerance, "Introduction: Family Affairs," in *A Family Affair*, 2.
28 Ibid.

29 Bruzzi, *Bringing Up Daddy*.
30 See, for example, *Terminator 2* (James Cameron, 1991), *Dante's Peak* (Roger Donaldson, 1996), *Armageddon* (Michael Bay, 1998); see Karen Schneider, "With Violence if Necessary: Rearticulating the Family in the Contemporary Action-Thriller," *Journal of Popular Film and Television* 27, no. 1 (1999): 2–11; Tasker, "The Family in Action," in *Action and Adventure Cinema*, ed. Yvonne Tasker (London and New York: Routledge, 2004), 252–66.
31 For example, *Aliens* (James Cameron, 1986), *The Long Kiss Goodnight* (Renny Harlin, 1996), and *Kill Bill* (Quentin Tarantino, 2003, 2004); see Tasker, *Working Girls: Gender and Sexuality in Popular Cinema* (London and New York: Routledge, 1998), 65–88; Angela Dancey, "Killer Instincts: Motherhood and Violence in *The Long Kiss Goodnight* and *Kill Bill*," in *Mommy Angst: Motherhood in American Popular Culture*, ed. Ann C. Hall and Mardia J. Bishop (Santa Barbara, CA: ABC-CLIO, LLC, 2009), 81–92.
32 Tasker, "Practically Perfect People,"176.
33 Ibid., 175.
34 Overviews include Stephanie Genz and Benjamin A. Brabon, *Postfeminism: Cultural Texts and Theories* (Edinburgh: Edinburgh University Press, 2009), 1–50; Rosalind Gill, *Gender and the Media* (Cambridge: Polity Press, 2007), 249–71; Sarah Projansky, *Watching Rape: Film and Television in Postfeminist Culture* (New York and London: New York University Press, 2001), 66–89.
35 Gill, *Gender and the Media*, 255.
36 Angela McRobbie, "Post-feminism and Popular Culture," *Feminist Media Studies* 4, no. 3 (2004): 255.
37 Tasker, "Practically Perfect People," 176.
38 Yvonne Tasker and Diane Negra, "Introduction: Feminist Politics and Postfeminist Culture," in *Interrogating Postfeminism: Gender and the Politics of Popular Culture*, ed. Yvonne Tasker and Diane Negra (Durham, NC: Duke University Press, 2007), 3.
39 Kathleen Rowe Karlyn, "*Scream*, Popular Culture, and Feminism's Third Wave: 'I'm Not My Mother,'"*Genders* 38 (2003), http://genders.org.
40 Projansky, *Watching Rape*, 86.
41 McRobbie, "Post-feminism and Popular Culture," 255.
42 Projansky, *Watching Rape*, 85.
43 Tasker and Negra, "Introduction," 4.
44 Genz and Brabon, *Postfeminism*, 143.

PART V
Gender and Violence

kinship in terms of the "political economy of sex." By reading Lévi-Strauss in the context of Marx and Engels's writings on the family and the Freudian notion of the Oedipus complex, she argues that the heterosexual kinship structure, inter-related with the Oedipal family, is part and parcel of the political meaning of gender, based on "the traffic in women."⁵ In the Oedipal drama, let us recall, the little boy renounces his love for his mother under the threat of castration, identi-fies with his father and accepts the paternal law of the incest prohibition, and eventually finds a substitute object of love in another woman. The little girl also renounces her incestuous "lesbian" attachments to her mother when she makes a painful discovery that her mother, like the little girl herself, is castrated, and turns toward her father as a new love object who will eventually be replaced by another man. According to Rubin, the Oedipal drama initiates and socializes children into the political heterosexual kinship structure.

More recently, Judith Butler has returned to the question of kinship, debated in feminist theory in the 1970s, in the context of the current homophobic opposition to gay marriage, adoption, and parenting. In her *Antigone's Claim*, she adds three crucial interventions to the earlier feminists' debates: first of all, by questioning normative heterosexuality, she suggests that the law of incest prohibition works in tandem with the prohibition of homosexuality.⁶ More importantly, she interrogates the linguistic structural interpretation of kinship in Lévi-Strauss's anthropology and Lacan's psychoanalysis. The earlier generation of feminists found the linguistic model useful because it dissociated family from nature and biological reproduction, and placed it in the realm of other social institutions that, like language, created the symbolic meaning of gender on the basis of social relations. Yet Butler argues that the symbolic meaning of kinship is all too often based on a rigid understanding of linguistic structure that fails to account for the multiplicity of alternative kinship arrangements that do not correspond to the Oedipal and heterosexual model. On the contrary, because, in the structuralist paradigm, the Oedipal family and heterosexual kinship are synonymous with the inaugural laws of language and subject formation, these alternative arrangements, like the homosexual "buddy system" or homosexual families, are deprived, not only of political legitimacy, but also of linguistic coher-ence. In contrast with structuralism, Butler advocates an approach to kinship based on diverse social practices that are open to change and contestation.

Kinship is also one of the concepts that underlines the persistence of the color line within feminist theory. If white feminist critics approach kinship in terms of a "political economy of sex" that constitutes the social meaning of gender, Afro-American feminist theorists, such as Hortense Spillers and bell hooks, see black kinship as resistant to white supremacy, which aims to destroy not only black families but also gender as such. As Hortense J. Spillers's influential essay "Mama's Baby, Papa's Maybe: An American Grammar Book" suggests, the traumatic history of slavery attempted to strip black people of all social values, including the values of gender, and reduce them to social illegitimacy.⁷

Enslaved African persons, Spillers writes, "were culturally unmade. ... Under these conditions one is neither female nor male, as both subjects are taken into 'account' as *quantities*."[8] The "ungendered" black subjectivity suffers a double injury: not only the terror of physical violence, but also the traumatic symbolic destruction of the social significations of kinship, gender, and name. As Orlando Patterson suggests, this destruction of kinship and the value that it confers is in fact synonymous with the "social death" of the enslaved person.[9] It is precisely these unbearable "hieroglyphics" of violated black subjects that are excluded, Spillers argues, from both a "cultural seeing" that is obsessed with the visibility of color and from the white feminist theories of the body and kinship.

As bell hooks argues, in the context of the traumatic history of the systematic destruction of black kinship structures, the struggle to preserve families within black communities is an important strategy of resistance to white supremacy, even if this role is predictably relegated to black women: "historically, black women have resisted white supremacist domination" by reworking the conventional role of "home," so that it could function, not only as a safe space of care and healing, but also as a crucial place of political resistance—a "site for organizing, for forming political solidarity."[10] Speaking of the economic exploitation of working-class black women, who, like her own mother, were employed as maids in white households in the segregated South, hooks writes that these women, despite mental and physical exhaustion, created, in their homes, "spaces of care and nurturance in the face of the brutal harsh reality of racist oppression, of sexist domination," where black people could affirm themselves as subjects. [11] Although it might seem that hooks idealizes the subversive role of black family in so far as she does not take into account the negative effects of racism and sexism, nonetheless, her notion of home as a space of recovery and resistance to political domination stands in sharp contrast to a white middle-class American conception of family as a "politically neutral space."[12]

Evocative of bell hooks's idealism, Gina Prince-Bythewood's *The Secret Life of Bees*, intended for a female cross-over audience, works through the color line within kinship and citizenship practices by offering emotional/ideological resolutions to sexist and racist violence. Set in rural South Carolina in 1964, against the backdrop of the civil rights movement and racist violence, at the historical moment when the Civil Rights Act is signed into law, the film follows the story of the two female fugitives. A 14-year-old white girl, Lily (Dakota Fanning) flees the domestic violence of her abusive father, whom she refuses to call father and calls instead T. Ray (Paul Bettany), in search of the secret of her dead mother's past. She is guided in her quest by the mysterious image of a black Madonna, later referred to as the "Black Mary" in the film, that she finds among her mother's possessions.[13] The other fugitive is Rosaleen (Jennifer Hudson), Lily's black friend, who was hired by her father to be Lily's substitute mother and a housekeeper. Hudson's Rosaleen character is much younger than she is in the novel, so that she no longer fits into a traditional black "mammy" stereotype, but

FIGURE 19.1 "Lily" (Dakota Fanning) and "Rosaleen" (Jennifer Hudson). Courtesy of 20th Century Fox/Photofest.

is more like Lily's companion. Rosaleen is brutally beaten by the town's white racists when she attempts to register to vote. They head toward Tiburon, South Carolina, the place written on the picture of the Black Mary. The two fugitives find a sanctuary in the utopian household of three black sisters, May (Sophie Okonedo), June (Alicia Keys), and August (Queen Latifa). The film raises the question of the ambiguous political function of these imaginary interracial female kinship arrangements that provide "sanctuary" from political and domestic violence.

As Judith Butler reminds us, kinship mediates the relations between public and private spheres, between the family and the state. The film explores the disintegration of this mediating function of kinship and the Oedipal family under the pressure of domestic and political violence. The systematic relationship between these two kinds of violence is suggested by the initial juxtaposition of the domestic and public spaces. The film opens with a flashback of the violent separation of a young mother from her small daughter by an abusive father, followed by a gun explosion and a 14-year-old Lily's dramatic voiceover— "I killed my mother when I was 4 years old." That traumatic memory of

matricide is followed in quick succession by the metaphoric staging of the mother/daughter imaginary incestuous reunion. At night, Lily sneaks out to the peach orchard, unearths the tin box containing her mother's meager belongings, including white gloves and the picture of the "Black Mary," unbuttons her blouse, and spreads the maternal objects on her body. Metaphorically, Lily digs out her mother from her grave and imagines an incestuous intercourse with the partial maternal objects. The sexual character of her communion with her dead mother is re-emphasized by her father, who suspects that Lily has had sex with a boyfriend. In place of the symbolic separation from the maternal body, Lily both "kills" her mother and longs for an incestuous reunion with the maternal body. In so doing, she commits two archaic crimes—murder and incest—which, according to Sigmund Freud's *Totem and Taboo*, are the violent origins of the moral symbolic law.[14] It is as if the teenage girl fails to separate from her dead mother, mourn for her death, and find another substitute love object.

The film offers its viewers two divergent interpretations of Lily's sexual transgression: the more believable mother–daughter incest, veiled under the orphan's longing for her absent mother, and the improbable, but "more acceptable"—because more in line with heteronormativity—sex with the non-existing boyfriend. This scene illustrates what Butler calls a conjunction between two prohibitions: incest and homosexuality. Lily is punished for this double transgression of incest and the failure to find a heterosexual love object through her father. The infamous scene in which Lily kneels on the white grits, which like the shards of glass cut into her knees, is followed by a more cruel sadistic punishment when T. Ray tells Lily on her birthday that her mother abandoned her. Instead of being associated with the moral law, T. Ray is the source of real sadistic violence. That is why Lily refuses to call T. Ray her father and, conversely, he rejects her at the end of the film with "Good riddance." The montage of the opening scenes, juxtaposing the 4-year-old's experience of traumatic loss with the 14-year-old's failure to mourn this loss, suggests that one of the tasks of the film is to resolve the mother–daughter incest, offering the possibility of mourning the loss of the mother, while finding a reprieve from the violent father, who fails to occupy the symbolic function of the moral law, and to construct non-patriarchal representations for that law.

This domestic crisis of the white Oedipal kinship in the foreground and the unquestioned total absence of Rosaleen's black kin in the background is followed by the political crisis in the public sphere. This crisis also derives from the failure of the law to replace racist and sexist violence with order and justice. In particular, the new law fails to ensure voting rights and equality for black citizens and prevent the subsequent outbursts of racist violence. What precipitates the sequence of brutal events depicted in the film is the famous image of President Johnson, with Martin Luther King, Jr. in the background, signing the Civil Rights Act of 1964. After a two-year long congressional battle, and under the pressure of civil rights activists, especially The March on Washington for Jobs and Freedom in

Washington, D.C. on 28 August 1963, during which Martin Luther King, Jr. delivered his historic "I Have a Dream" speech, the Civil Rights Act was signed into law. This groundbreaking legislation outlawed racial segregation, provided greater legal protection to black voters, and allowed for peaceful demonstrations. When Rosaleen sees the iconic scene of the presidential signature on the television—a transmission initially barely visible and covered by "white snow" on the screen—she decides to implement that law into practice and register as a black voter. Under the pretext of buying a training bra for Lily, Rosaleen and Lily walk to the town, where Rosaleen is insulted and harassed. In response to racist intimidation, abuse, and accusations that she is illiterate, Rosaleen writes her name with the black "juice" from her spit jar on the white bullies' shoes. In so doing, Rosaleen provides a black female countersignature to the white presidential authority, which had failed to implement the law. The law, to be effective, needs not only a white presidential signature, but also a black female signature.

Rosaleen's radical political act has a double meaning. On the one hand, it expresses black rage and contempt for racist violence and enacts in the film the most explicit instance of black female resistance. Despite brutal violence and the blows of white fists, Rosaleen refuses to apologize for her act because she regards such an apology as "a different way of dying." This association of apology with death evokes the specter of what Patterson calls the symbolic death of slavery.[15] On the other hand, Rosaleen's name written in black juice constitutes a black, female, and bodily countersignature to the presidential signature. It is difficult to decide what constitutes the greater "offense"—Rosaleen's public expression of rage or her usurpation of political authority by signing, or putting into law. For Spillers, such a provocative reappropriation of black female power to name jams the reproduction of social illegitimacy and contests the white/paternal monopoly on value.[16]

Rosaleen's struggle for black voting rights is the most radical and explicit act of political resistance in the film. It is also the only moment when Rosaleen assumes the leading role in the film. Structurally and politically, her political act of disobedience links (however briefly) the political transformation of the public sphere with the rebuilding of black female kinship in the private sphere. Yet, this black female act of defiance is overshadowed or subverted, at least temporarily, by Lily's rescue of Rosaleen from the prison hospital and their joined journey to Tiburon. Thus, the initial political motif, in which Rosaleen is the main actor, is subordinated to Lily's quest for her own kinship and the secret of her mother's connection with the image of the Black Mary. In a self-reflective moment, the film places more emphasis than the novel does on Rosaleen's anger and her accusation of Lily of bad faith: by "saving" Rosaleen, Lily in fact uses her for her own purposes. The quarrel and the rift between the two characters are emphasized by the image of the two actors walking on the two opposite sides of the same road.

Although politics seems to recede to the second plane when Lily and Rosaleen find refuge from sexist and racist violence in an idealized, all-female community of three black sisters, May, June, and August, the question of kinship remains linked to politics throughout the film. The three sisters not only have different characters, but also represent three different practices within non-Oedipal kinship arrangements: domestic labor and the work of mourning for the victims of violence (May); the mediation between art and racial politics (June); spirituality, business, and the work of psychic healing (August). May, the most fragile of the three sisters, is the figure of lamentation and mourning for the cruelty in the world and especially for the victims of racist violence. Her lament is uncontainable, despite the sisters' efforts to give it a symbolic expression by constructing a black wailing wall, similar to the Wailing Wall in Jerusalem. The significant difference between these two monuments is that the Wailing Wall in Jerusalem is a public national memorial to the suffering of a people, while May's wall is a private monument to disavowed black suffering, which does not have a public monument or acknowledgment. The work of black mourning is the first discovery that Lily makes in her new location, as the camera focuses on one of the messages written by May and tucked into the wall: "Birmingham, Sept. 15, four little angels dead." May's lamentation begins with the death of her twin sister, April (who in the novel commits suicide under the burden of racism), but after April's death, the whole world becomes May's twin sister. Thus, May's sense of kinship as well as her work of mourning does not know any boundaries. Eventually the burden of lamentation for the violence in the world becomes unbearable and May relinquishes her mediation between the living and the dead by drowning herself. Nonetheless, by writing down her sorrow and losses, May teaches Lily both the affective and the symbolic dimensions of mourning.

June is the only voice of black anger and rage. That voice finds a double expression in political activism as well as in education and art. June is a cello player, a music teacher, as well as a member of NAACP,[17] working for the registration of black voters. She is the only sister who is opposed to accepting Lily into the black family and makes her feel self-conscious and ashamed of her whiteness. By contrast June is a role model for Rosaleen, who has never seen such an accomplished and politically engaged black woman. It is thanks to June that Rosaleen completes her political mission and becomes a registered black voter as well as a member of the sisterhood, renamed July, for the Fourth of July, Independence Day in the United States. The similarity between June and Rosaleen lies in their political activism in the struggle for citizenship; the contrast, reinforced by appearance and clothes, lies in class difference and poverty. June's engagement in the struggle for civil rights also resonates with Zach's (Tristan Wilds) aspirations to become a black lawyer. With its reference to two U.S. Presidents born in the South, Zachary Taylor and Abraham Lincoln,[18] Zach's full name—"Zachary Lincoln Taylor"—evokes the contradictory racist history of American democracy, in which the promise of freedom, racist terror, and white

supremacy coincide. It is this contradiction, which for an instant manifests itself as yet another outburst of racist violence when Zach and Lily go to the movies, that eventually kills his hopes for a legal career.

The main figure and the point of identification for the viewers is August, who is in charge of the beekeeping business, black female spirituality, and the emotional work of healing. However, what is problematic in the film and in the novel is that when this emotional work of healing is lavished primarily on Lily rather than on Rosaleen, it becomes depoliticized, and in danger of losing its function of resistance. As the caretaker of Lily's mother and Lily herself, the role of August is close to what bell hooks describes as "mammification" of black femininity; that is, the representation of black women as the caretakers of whites. According to hooks, the representation of blacks as the emotional supporters of whites is not a departure, but merely a refiguration of "racist stereotypes": white woman no longer "wanting a black woman to clean her house, but wanting a black woman to caretake her soul."[19] Although the film attempts to distance August's generosity extended to the white orphan from "mammification," it remains debatable whether or not it is successful in doing so. For instance, June's opposition to accepting Lily into the black household represents an implicit internal critique of "mammification." And when Lily asks August whether she loved her mother, even August expresses her resentment. "It's complicated" she says, and points to the difficulty of establishing an emotional bond between black and white women in "hateful times."

Yet, the film also makes clear that the subversive aspect of August's emotional strength and healing stems from the oral tradition of black resistance and the insurgent female spirituality. August's moral dignity and emotional recovery is intertwined with the literal figure of the "Black Mary," whose history goes back to slavery. The wooden sculpture, a figurehead from a passing ship, "Mary," represents the memory of black resistance to social death and the destruction of kinship inflicted by slavery and white supremacy. In fact, the film restructures the role of Mary in the white, patriarchal Christianity, a role that has often been criticized for its subjugation of ordinary women. By contrast, the Black Mary, a figurehead, found and retrieved from the sea by an enslaved man, Obadiah, was treated by the enslaved people as a representation of rescue and freedom sent by God. Black like them, she endured the trauma of the "Middle Passage," crossing the ocean from Africa. She is a hybrid figure of resistance and consolation, emblemized by the closed fist of her raised hand and by her heart. In the novel, August says that "our Lady filled their hearts with fearlessness and whispered to them plans of escape. The bold ones fled, … and those who didn't lived with a raised fist in their hearts."[20] Needless to say, this dualism of black militancy, symbolized by the raised black fist, and love—a dualism missed by most of the reviewers of the film—rewrites in a feminine idiom the two main political orientations of the civil rights era: the first one represented by Malcolm X, the second

by Martin Luther King. Because of this implicit analogy, the spiritual function of kinship is not opposed to politics, but rather constitutes its extension.

It is around such a double—militant as well as nurturing—maternal figure that August forms an alternative kinship system and all-female black church, called the Daughters of Mary. Black women in festive clothes gather in her house every Sunday for a service over which August presides, and in which the two other sisters, June and May, also participate. During the call-and-response performance characteristic of the black oral tradition, August retells the story of the Black Mary. Although her story focuses more on the maternal heart, reinforced by the female chanting of "touch her heart," the cinematic language of the camera revolves around Mary's closed fist. The close-ups of Mary's fist provide a counter-image to the racist violence of the white male fist hitting Rosaleen's face as well as to the helplessness of the outstretched hand of Lily's mother.

The juxtaposition of the violence in the white dysfunctional Oedipal family with the memory of resistance and healing that marks the all-female black kinship structure is at the core of the film's reversal of the contemporary racist stereotypes of black and white families in the United States. As Spillers argues, the history of white supremacy still undermines the values of black families, especially if they do not follow the white middle-class nuclear model.[21] For instance, the infamous 1965 Moynihan's "Report," prepared a year after the Civil Rights Act, blames black mothers, rather than poverty and white supremacy, for the destruction of the black families. In her commentary, Spillers argues that such a racist grammar of kinship remains "grounded in the originating metaphors of captivity and mutilation, so that it is as if neither time nor history, nor historiography ... shows [sic] movement."[22] The film rewrites this grammar first of all by reinventing the maternal function outside the Oedipal patriarchal parameters. In the absence of the biological mother, the Boatwright family safeguards the imaginary (visual representation of the maternal face, fist, and heart) and the symbolic (the storytelling) function of black motherhood. And, in contrast to the racist devaluation of black motherhood (the origins of which go back to slavery where motherhood was associated with the compulsory biological reproduction and the reproduction of social death), the sisters invent and preserve an alternative maternal genealogy that even during slavery enabled survival and resistance. In the film as it is in the book, it is the white nuclear Oedipal family, with its violent patriarch, illiteracy, economic exploitation of children and black women, and its enactment of racist violence in the public sphere, that is dysfunctional and destructive. Neither black nor white young women—Lily's mother, Lily, and Rosaleen—can survive this patriarchal kinship structure. All three of them have to flee and find a sanctuary, the space for healing of their traumas, as well as a new structure of language, kinship, and political legitimacy.

If the film offers us a parable rather than reality, the meaning of such a parable is not limited to "hope and love," as Roger Ebert suggests. Rather, through its consoling emotional appeal, the film presents to the mainstream public an

alternative, non-heterosexual vision of kinship. Haunted by the double specter of slavery and lesbianism, this kinship structure is no longer organized around the exchange of women through marriage. The three single sisters represent ambiguous and sometimes hostile attitudes toward heterosexual marriage. Even though she remembers the erotic pleasure of the heterosexual kiss, May replaces marriage with the all-consuming grief for her beloved twin sister, April, and, after her death she becomes a sister of the whole world. In her quarrel with Neil, June proclaims: "I don't want to get married, not now not ever." Although this rejection was interpreted by other characters in terms of fear or selfishness, such explanations are effectively canceled out by August's proclamation that she values her freedom more than the love of a man. And even though June in the end gives into the social imperative of heterosexuality and accepts Neil's second proposal, there is the promise that this particular union will be based on equality rather than hierarchy. Within such a non-Oedipal kinship system based on sisterhood and symbolic motherhood, other male characters, like Zach or Neil, are more like temporary, friendly visitors or lovers, rather than permanent family members.

In place of marriage as an organizing principle, the black sisterhood is formed around the cooperative distribution of diverse practices—mourning, generosity, storytelling, education, spirituality, recovery, and work—based on the principle of equality and complementarity among its members. Far from linguistic incoherence, these alternative kinship practices among women reinvent language itself, apart from the name of the father, passed from fathers to sons. In fact, the sisters' "calendar" names were given to them by their mother. And even their family name, "Boatwright," resonates with the symbolic meaning of the Black Mary figurehead, originally part of a ship. In so doing the family name conveys the symbolic maternal function, which preserves the memory of the destruction of the African names. It is among such kin that Lily can unlearn the patriarchal and racist stereotypes and learn language anew, in another idiom, both black and white, oral and written. This opportunity to learn language anew arises from June's criticism, August's storytelling, May's symbolic writing of the injuries as well as from Zach's encouragement to write and imagine what does not yet exist. At the end of the film, Lily finishes writing her story, closes her notebook, and puts it into the "Wailing Wall." It is through writing that she can imagine what does not exist—multiple symbolic mothers: "[a]ll these mothers. I have more mothers than any eight girls off the street."

To be sure, the more radical insights of the film are offset by the emotional resolutions of socio-political conflicts offered by the film, by the overarching natural imaginary, and the "bee" metaphors. It is perhaps the natural beauty, captured by the movement of the camera, and the metaphoric language of "the secret life of bees" that offers the ultimate sanctuary and the model of universal harmony. At one point August explains to Lily, "The world's really just one big bee yard," with three basic rules: "don't be afraid," "don't be an idiot," and

"no swatting." Yet as the recurrent images of "swatting" and blows of the white fists, which injure most of the characters, suggests, the world is far from being a harmonious "one big bee yard," and it takes the alternative linguistic and political practices in public and private lives to create and imagine what has never been—a non-patriarchal world without racism.

Notes

1 Ruthe Stein, review of *The Secret Life of Bees*, *San Francisco Chronicle*, 17 October 2008.
2 Bill Gibron, review of *The Secret Life of Bees*, filmcritic.com, 2008.
3 Roger Ebert, review of *The Secret Life of Bees*, *Chicago Sun-Times*, 15 October 2008.
4 Claude Lévi-Strauss, *The Elementary Structures of Kinship*, ed. Rodney Needham, trans. James Harle Bel et al. (Boston, MA: Beacon Press, 1969); Luce Irigaray, *This Sex Which is Not One*, trans. Catherine Porter (Ithaca, NY: Cornell University Press, 1985), 170–91.
5 Gayle Rubin, "The Traffic in Women: Notes on the Political Economy of Sex," in *Toward an Anthropology of Women*, ed. Rayna R. Reiter (New York: Monthly Review Press, 1975), 157–210.
6 Judith Butler, *Antigone's Claim: Kinship Between Life and Death* (New York: Columbia University Press, 2000). See also Butler, "Is Kinship Always Already Heterosexual?" in *Undoing Gender* (New York: Routledge, 2004), 102–31.
7 Hortense J. Spillers, "Mama's Baby, Papa's Maybe: An American Grammar Book," *Diacritics* 17 (1987): 65–81.
8 Ibid., 72.
9 Orlando Patterson, *Slavery and Social Death: A Comparative Study* (Cambridge, MA: Harvard University Press, 1982), 4–14, 38–46.
10 bell hooks, *Yearning: Race, Gender, and Cultural Politics* (Boston, MA: South End Press, 1990), 47.
11 Ibid., 42.
12 Ibid., 47.
13 For all quotations from this film, see *The Secret Life of Bees*, directed by Gina Prince-Bythewood (2008; Century City, Los Angeles, CA: 20th Century Fox, 2009).
14 Sigmund Freud, *Totem and Taboo*, trans. James Strachey, Standard Edition (New York: Norton, 1989), 174–200.
15 Patterson, *Slavery*, 4–14, 38–46.
16 Spillers, "Mama's Baby," 80.
17 The NAACP was an acronym for the National Organization for the Advancement of Colored People.
18 Zachary Taylor was the plantation owner who opposed the spread of slavery to the West, while Abraham Lincoln is the U.S. president associated with the abolition of slavery.
19 bell hooks, *Killing Rage, Ending Racism* (New York: An Owl Book, 1995), 221.
20 Sue Monk Kidd, *The Secret Life of Bees* (London: Penguin, 2002), 109.
21 Spillers, "Mama's Baby," 66.
22 Ibid., 68.

20

FROM VICTIM TO VIGILANTE

Gender, Violence, and Revenge in *The Brave One* (2007) and *Hard Candy* (2005)

Rebecca Stringer

> While the ethical burden to prevent rape does not lie with us but with rapists and a society which upholds them, we will be waiting a very long time if we wait for men to decide not to rape. To construct a society in which we would know no fear, we may first have to frighten rape culture to death.[1]

In this chapter I explore two recent films in which a female lead takes matters into her own hands, exacting the vigilante's revenge. As female vigilantes who turn the tables on conventional relations of gender and power, Erica Bane in *The Brave One* (Neil Jordan, 2007) and Hayley Stark in *Hard Candy* (David Slade, 2005) have both been hailed as feminist figures. Refusing to accept the status of victim and determined to avenge an attack in which her fiancé died and she barely survived, Erica Bane (played by Jodie Foster) finds a gun and uses it, tracking and killing her attackers, easily eluding police who presume New York's new vigilante killer is a man. When asked about the "feminist empowerment" evident in the role, Foster said of Bane, "Such a big part of the female psyche is that we hate inwards. What if there was a woman who said, 'I'm not going to be that kind of victim. I'm not going to hurt myself, I'm going to hurt you' … that's exhilarating to women who see this movie."[2] In *Hard Candy* the prodigiously intelligent 14-year-old Hayley Stark (played by Ellen Page) similarly decides to walk the path of the vigilante. Disrupting social expectations of age as well as gender, Stark is a girl vigilante who captures and interrogates a pedophile, exacting revenge on behalf of his victims, telling him, "I am every girl you ever watched, touched, hurt, screwed, killed."[3] As Page observed of Stark, "She sees something that's wrong about society that people are ignoring and decides to do something about it. I find that really inspiring."[4]

It is easy to see why commentators on these films have readily identified Erica Bane and Hayley Stark with feminist notions of empowerment. Patriarchal gender norms render the capacity for violence as properly masculine rather than feminine, creating for women what Connell has called a "cultural disarmament," or a social context in which men's capacity for violence is normalized, while women are typically marked as vulnerable to violence.[5] *The Brave One* and *Hard Candy* defy these gender norms, showing us strong female lead characters who actively disobey the patriarchal culture of disarmament, in an apparently feminist display of empowerment and resistance. Occupying the traditionally masculine role of the vigilante, Erica Bane and Hayley Stark appear to turn vigilantism's story of good and evil to feminist ends. Rather than bow to fear and vulnerability, they take up arms against violent men in an effort to stem their violence. Rather than supply still more spectacular cinematic examples of masculine prowess in the victimization of other persons, in these films we bear witness to the capacity of women and girls to fight back, and we meet the *bad guys* at their most vulnerable, in their downfall.

In these and other ways *The Brave One* and *Hard Candy* are clearly relevant to ongoing feminist efforts to challenge male violence and its sustaining cultures, in practice and in representation. As I explore these films, however, I shall point out the limits to a reading of them as feminist texts, highlighting the scope for feminist critique of the victim-to-vigilante narrative. While the figure of the woman vigilante speaks to contemporary feminism's emphasis on women's agency, the figure of the vigilante in general is strongly emblematic of conservative perspectives on crime, their violent vigilantism at odds with the critical ethics of collective non-violent action characterizing much of the feminist effort to challenge male violence. In view of this disjuncture, I suggest Erica Bane and Hayley Stark be read not as straightforwardly feminist, but as characters whose stories uneasily combine themes of feminism and conservatism.

Bleeding Liberals, Gendered Revenge: Reading Erica Bane

The Brave One was directed by Neil Jordan with Jodie Foster acting as executive producer as well as playing the lead role of Erica Bane. Set around the story of an urban professional in New York whose life is transformed by street crime, the film broadly retraces the plot of the 1974 classic vigilante film *Death Wish* (Michael Winner) starring Charles Bronson. In *Death Wish*, architect Paul Kersey turns to vigilantism after his wife is murdered and his daughter raped by a street gang. In *The Brave One*, Bane is a radio broadcaster about to marry her fiancé, when they are brutally, and he fatally, attacked by a street gang in Central Park. In both films New York City is itself an important character, with Kersey and Bane positioned not just as inhabitants but as lovers of New York, their intimate knowledge of the city and elevated status within it afforded by their professional endeavors—he as an architect, and Bane as an appreciative documenter of

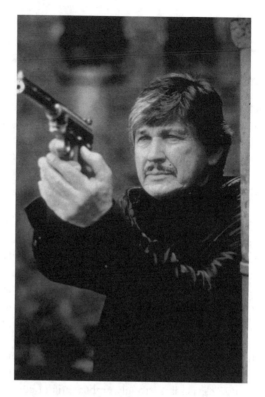

FIGURE 20.1 Charles Bronson as "Paul Kersey" in *Death Wish* (1974). Courtesy of Paramount Pictures/Photofest.

New York's history and everyday sounds, which form the subject of her successful radio show about the city, "Streetwalker." After the trauma of crime each experience New York in a completely different way. As they enter the street not as privileged professionals but as grieving armed avengers, the city they love becomes a place of paranoia, fear, and dread, a battleground on which is raging a gendered and racialized class war.

In *Death Wish* Kersey's turn to vigilantism is clearly marked as a political turn. Early in the film he confesses to being a "bleeding heart liberal," taking the side of the underprivileged and blaming crime not on its disenfranchised perpetrators but on the injustices of economic inequality and social discrimination.[6] After his traumatic loss such a political stance becomes untenable. Stripped of his liberal sympathies he becomes a vigilante, bypassing the red tape of police, law, and state, roaming the streets and putting to death a spate of criminals of the underclass, his commitment to vigilantism growing the more he is publicly lauded by fellow New Yorkers. Somewhat notoriously, Kersey's conversion to vigilantism actualizes signature themes of U.S. conservatism: strong individualism,

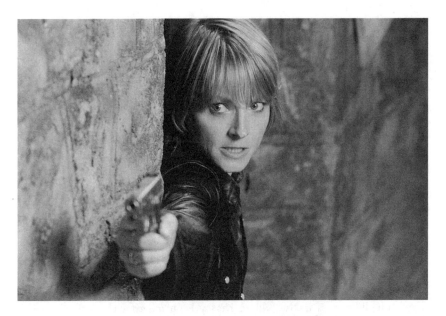

FIGURE 20.2 Jodie Foster as "Erica Bane" in *The Brave One* (2007). Courtesy of Warner Bros./Photofest.

distrust of the state, focus on the rights of crime victims, advocacy of the death penalty, and the right to bear arms. In his review of *The Brave One*, *Time* critic Richard Corliss argues that Erica Bane's turn to vigilantism is similarly implicated in conservative politics. "The movie finally buys the old right-wing argument that a conservative is just a liberal who's been mugged."[7] Some aspects of *The Brave One* strongly confirm Corliss's reading, and early in the film Bane is similarly characterized as a bleeding heart liberal—or at least as *other* to conservatism: a childless professional white woman of arty, subcultural taste in love with a British Indian doctor—with her turn to vigilantism thus also able to be read as a conservative political turn. Yet there are differences between *Death Wish* and *The Brave One*, which may mark the latter as unique in comparison with other vigilante films, complicating Corliss's reading of Erica Bane as a mere vehicle of right-wing platitudes in the wars on terror and crime. Corliss also dubs Bane a "feminist avenger," but as I unpack the similarities and differences between *Death Wish* and *The Brave One* it becomes clear that themes of gender and feminism in the character of Bane also require a more careful reading.

The Brave One is an effort to tell the story of the vigilante differently. As Foster explains, it is "a sophisticated movie living in an unsophisticated genre."[8] Unlike her male counterparts Erica Bane does not become a relentless killer. Instead we see her struggle with her conscience, encountering her vigilante self as a "stranger within," someone she does not want to be but is compelled by her trauma

to become. Where *Death Wish* and its sequels glamorize the vigilante as an action hero, *The Brave One* is oriented instead to contemplating the morality of vigilantism through Bane's inner conflict and loss of self-control. Over the course of the film Bane certainly does become an action hero. We bear witness to her steadily greater competence and confidence in the use of her gun—and Foster's steadily growing resemblance to the angular, leather-clad Bronson of the 1970s. We see her kill eight men, graphically and in slow motion: a murderous ex-Aerosmith roadie, three would-be rapists, a wife-killing crime boss, the three "perps" of Spanish Harlem who killed her fiancé. Yet, as Foster describes, "My character is wrong. She is wrong and she knows it."[9] After she kills we hear her grave doubts as voiceover: "I didn't have to kill them, I could have just shown them the gun ... why don't my hands shake? ... Inside you there is a stranger."[10] We see her face in close-up when she pulls the trigger, with Foster brilliantly articulating Bane's conflicted relation to killing, showing all at once hesitation and automation, fear and fortitude, regret and relief.

The stories of Kersey and Bane follow the same broad trajectory of trauma, removal, return, vigilantism, and escape. Yet at every turn there are subtle and significant differences in the telling. Kersey is an *indirect* victim of crime—his family is violated—whereas Bane is also a direct victim in the attack that killed her fiancé, meaning that hers is also shaped as a survivor story, a story about a woman's personal effort to survive violent victimization. Unable to work in the wake of his trauma, Kersey's boss removes him to Arizona, where he finds the gun he will use as a vigilante upon his return to New York. Bane, on the other hand, has been beaten to near death. Her removal is a coma that lasts three weeks, followed by a period of agoraphobic fear of leaving her apartment. Like a chrysalis their trauma transforms Kersey and Bane into vigilantes, with both following a trajectory of steadily greater commitment to vigilantism. Yet—and this is where it earns its status as conservative cinema—in *Death Wish* we see Kersey *converted* to vigilantism. His decision to continue killing becomes a positive choice; he embraces and owns his vigilante self. In *The Brave One* Bane is instead *condemned* to vigilantism, permanently trapped in another, post-traumatic self, engulfed by a stranger and reduced to a thing. Unlike Kersey, for Bane the depressive character of vigilantism does not abate when she is publicly lauded. When she returns to her broadcasting work she is put in the difficult position of taking talk-back calls about the vigilante. Every caller assumes the vigilante is a man. We see Bane's disgust when most callers praise him, and we see her grief when disapproving callers echo her own self-doubt. In one of the film's several references to the context of wars on terror, a disapproving caller asks, "Hasn't the Iraq war taught us anything?"

Kersey and Bane also have different relationships to vigilantism as a form of revenge. In *Death Wish* the men who attacked Kersey's family are not seen again—they are subsumed within the urban criminal underclass, against which Kersey wages a general war. In *The Brave One* Bane's vigilantism is instead

strongly cast as a woman's war on violent men, and is ultimately honed on her attackers, whose deaths she finally brings about. In this way her vigilantism bears a closer resemblance to the perpetrator-targeted revenge of women in rape-revenge narratives than to Kersey's general war on crime.[11] In the end both Kersey and Bane get away with their killings, let off by agents of the law who are seen to approve of and indeed envy their ability to instantly enact capital punishment on the street. Again, however, their escapes take place differently. At the end of *Death Wish* we see Kersey dispatched to Chicago by the New York District Attorney, where he clearly signals his intention to continue his war on crime, settling into a future of famed vigilante action that is subsequently played out across several sequel films. Meanwhile, at the end of *The Brave One*, the police investigator Detective Maloney (played by Terrence Howard) not only lets Bane off the hook, he actively assists her in the murder of the last "perp," fixing the evidence so that Bane's killings can be blamed on the men who attacked her and her fiancé. Bane exacts revenge from her attackers by killing them, and Maloney gives her a clean slate, thus opening the possibility that, unlike Kersey, Bane will recover herself and desist in vigilantism. This possibility remains open, although the final scenes put Bane as irrevocably altered, suggesting her post-traumatic struggle with vigilantism may continue. As we watch Bane escape with Maloney's blessing, we hear her voiceover: "There is no going back to that other person … this thing, this stranger, this is all you are now." Bane has exacted revenge and escaped the law, but is condemned, her unhappy fate giving no cause for celebration.

Use of a female lead character is a key point of difference between *Death Wish* and *The Brave One*, and is central to the latter's effort to deviate from genre conventions and tell the story of the vigilante differently—even though this does not guarantee that the film is feminist in its telling or intent, despite Corliss's confident anointment of Bane as a "feminist avenger." It is truer to say that *The Brave One* simultaneously subverts and redraws established gender norms, participating in both feminist and conservative representations of violent crime. Throughout *The Brave One* we are reminded that its gender role reversal is subversive. The gender norms of violence that Bane subverts are laid out in dialogue between Detective Maloney and his assistant, who refutes the idea that the killer could be a woman, saying, "Women kill their kids, husbands, boyfriends, shit they love. They don't do this." Underlining the unexpectedness of a woman vigilante, everyone assumes Bane's killings have been committed by a man; she is ignored when she tries to confess to police, a male witness describes her as "just a woman," and the men she kills underestimate the threat she poses to them, her femininity acting as cover, veiling her unfeminine status as killer. In these ways Bane is figured as a subversive agent of what Judith Butler calls "gender trouble."[12] Improperly rehearsing the norms of femininity and thereby reminding us of the instability and constructedness of those norms, Bane defies expectations and crosses gender lines, refusing feminized status as a vulnerable victim of crime, and staking a claim

on masculine prerogative power—the power to violate, the power to protect.[13] In tune with this gender trouble Bane apparently takes on feminist purpose, targeting men who are violent towards women and rescuing other women and a girl from violent men, her vigilantism rendered as all that stands between them and sexist violence. These subversive aspects of Erica Bane explain Corliss's phrase "feminist avenger."

At the same time, however, gender role reversal in *The Brave One* also redraws existing gender norms. Use of a female lead enables *The Brave One* to tell the story of the vigilante differently—by telling the story of the woman killer in a familiar way. Confirming the normative social linking of femininity with pacifism, emotionality, and moral conscience, Bane kills *as a woman*—only when suffering psychic trauma and provoked by grievous loss, and in a manner more conflicted by conscience than is socially expected of a man. As Belinda Morrissey has observed, the woman killer is rarely represented in the same way as her male counterpart.[14] That Bane's vigilantism takes place while she is possessed by a "stranger," thus in a state of diminished responsibility, would seem to confirm Morrissey's finding that women who kill are most often represented as victims rather than as fully responsible actors in the crimes they commit—a representation Morrissey traces across media, law, and feminist discourses, arguing it is problematic because it denies women fully agency and humanity. In these ways Bane's story conforms with existing norms in the representation of gender and violence, suggesting she may cause less gender trouble than first thought.

Bane's status as in some way emblematic of feminism is also questionable. In a familiar use of the figure of woman to symbolize city and nation, *The Brave One* draws an analogy between Erica's journey in the wake of her attack and America's journey in the wake of 11 September 2001. Erica is short for America, and Bane means that which causes death or destroys life. Am/Erica's trauma has altered her irrevocably, and she is engaged in a politics of revenge. In view of this analogy, if Erica is presented as a victim rather than as an agent in her crimes, then so too is America presented as a victim in the wars on terror—a contestable representation that elides, in America's case rather than Erica's, her track record of state terrorism. In the film we are reminded of the link between the names "Erica" and "America" when Bane, posing as a prostitute, rescues a Hispanic woman held captive by a man of indeterminate ethnicity. The rescued woman, her faltering speech a device to inform us of the Am/Erican analogy being drawn, asks, "Is this still Am-erica?" The woman's captor, whom Bane will shortly kill, compares himself to suicide bombers, drawing a direct link between "sexist terrorists" at home and abroad: "You know them suicide bombers ... when they die they want 12 virgins. I want them when I'm alive." Through this dialogue the film refers to a key argument used to legitimate the wars on terror—the idea that these wars will rescue women in Afghanistan, Iraq, and elsewhere from Islamic misogyny and despotism—while also positing that misogyny and despotism are alive and well on the home front, amongst the low-life of Manhattan, as

represented by this man. Just as Erica sets about rescuing the woman and killing her captor, so too America in its wars on terror has set about rescuing Islamic women. Some may read this moment as consistent with the feminist critique of male violence, which has always asked that states take violence against women just as seriously as they do terrorist violence. This moment is not consistent, however, with feminist critiques of the wars on terror, which contest the pseudo-feminist use of gender oppression to justify invasions abroad and punitive law and order policies at home, critiquing the xenophobia and historical amnesia equally at play in American wars on foreign terror and domestic crime.[15] While *The Brave One* is not crudely pro-war, its Am/Erican analogy more closely reflects the pseudo-feminism of American nationalism than it does the feminist critique of normative masculinity and male violence.

So we may be well advised to worry, with Corliss, about conservatism in *The Brave One*. Although sophisticated and willing to explore the filmic possibilities of gender trouble, *The Brave One* is after all a vigilante film: it shows us a character who enacts, by way of a series of preemptive strikes, a violently annihilating form of social cleansing. An urban professional "blows away" a spate of underclass men, all of whom are presented as fully deserving of their fate, and not at all as victims—of the vigilante, of disenfranchisement and social exile, of the city's and nation's own violent systems of class stratification and ethnic hierarchy. Morrissey's argument suggests that Bane is dehumanized in not being represented as a fully responsible actor in her crimes. Yet the manner in which Bane's victims are represented—as pseudo-victims, fully responsible for their crimes and deserving of their fate—is also dehumanizing. The back-story of street criminals disappears behind the graphic vigilante action, their histories forgotten as we see them spectacularly killed—without being asked to empathize with their suffering in the same way that we are asked to empathize with the suffering of the vigilante. Hence *The Brave One* tells the story of the vigilante differently, while leaving the conservative morality of the vigilante story largely undisturbed: the vigilante is wrong, but good; the men s/he kills are wrong, and evil.

The Grrl Avenger: Reading Hayley Stark

In comparison with *The Brave One*, *Hard Candy* makes a greater departure from vigilante films such as *Death Wish*, due in no small part to its distinctive cinematic style. Dubbed an "anti-Hollywood" style by director David Slade, *Hard Candy* is dialogue-rich, completely bereft of expensive action sequences and, most importantly, the camera is used to *infer* violence rather than graphically depict it. *Hard Candy* is distinguished by the fact that it tells a vigilante story about sexual harm, murder, and child pornography without once showing us graphic depictions of these taking place on screen. Even as this film's sustained inferences to violence are palpable and intense, absent are the spectacular scenes of rape, injury, sexual exploitation, and death that we expect to see in films in the cognate genres of

FIGURE 20.3 Ellen Page as "Hayley Stark," the Grrl Avenger in *Hard Candy* (2005). Courtesy of Lions Gate Films/Photofest.

thriller, horror, crime, and action. As though cognizant of the feminist complaint that graphic depiction of victimization objectifies the victim and can operate pornographically, the makers of *Hard Candy* refrain from visually exploiting female suffering and victimization in their film.[16] Where Bane's vigilantism takes us through a spate of night killings in the streets and subways of New York, Hayley Stark's reckoning with possible pedophile Jeff takes place in the intimate spaces of online chat, a café, and a day in his handsome suburban home. Where *The Brave One*, like *Death Wish*, makes spectacular the deaths of minority men of the criminal underclass, in *Hard Candy* the only person we see suffer is a privileged professional white man, his sufferings carefully and cleverly implied.

As in *The Brave One*, through gender role reversal *Hard Candy* makes gender trouble, telling the story of a girl vigilante of apparently feminist purpose, her vigilantism honed on pedophilic men who prey on girls and consume child pornography. Establishing its own subversiveness, *Hard Candy* underlines the unexpectedness of a girl vigilante in a dramatic twist at the beginning of the film. We meet Hayley Stark and Jeff Kohlver (played by Patrick Wilson) as "Thongrrl14" and "Lensman319," watching Stark's computer screen as their online chat becomes increasingly flirtatious and they agree to meet. Thus a familiar scene is set: a 14-year-old girl, innocently experimenting with sexuality, is preyed upon by an internet predator, agreeing to meet him face to face. When they meet a poster about a missing girl is pinned to the wall in the café, reminding us of the perils that may await Hayley. Apparently disarmed by Jeff's flattery and impressed by his status as a fashion photographer, Hayley then makes another dangerous move, insisting he take her back to his place. In what appears to be too slim an effort to guard her safety, at his place Hayley mixes her own drink, saying she is aware of the risks of the date rape drug.

We soon find it is she who has administered the drug to him. As she poses for photos, teasing him about his voyeuristic interest in photographing teenage girls, Jeff explains that it is the girls in the photos who have the power, before collapsing and losing consciousness. With vulnerability thus transferred from Hayley to Jeff, the gendered roles of captor and captive are reversed. Hayley, the at-risk would-be victim, is revealed as a highly organized vigilante whose capture of Jeff has been carefully planned and clinically executed. When he wakes tied up, Hayley's tyrannous interrogation begins. The question becomes whether Jeff is the pedophile killer Hayley believes him to be, or if he is instead a "decent guy" and mere voyeur, wrongly captured and accused by a mentally disturbed girl. As Jeff pleads with Hayley the unexpectedness of a girl vigilante is further underlined—"You need help, a teenage girl doesn't do this"—as it is when, at a gruesome point in her interrogation of Jeff, Hayley answers the door to a neighbor, who sees only innocence in her face and asks if she is available for babysitting. Just as Erica Bane's femininity acts as cover for her violence, so too do Stark's youth and femininity disguise her violent capacities and intentions.

In comparison with Erica Bane, the character of Hayley Stark is more clearly drawn as a feminist avenger—a vigilante acting directly on the basis of feminist principles. It could be argued that, as a *girl* avenger, Stark symbolizes a key trend in contemporary victim politics: the steady replacement of women with the figure of the vulnerable child as the primary focus of anti-violence efforts and public discourses of risk; the demotion and re-articulation of the issue of violence against women as issues of child abuse assume greater public prominence.[17] Stark's firm position as a defender of girls does give ground to this reading. Even so, Stark's targeting of pedophiles cannot be understood outside the context of feminist politics. As Steven Angelides reminds us, the category "pedophile" is relatively new to history, and it is only recently—in the context of the feminist movement against child sexual abuse since 1970—that children have been publicly regarded as victims in the context of child sexual abuse.[18] As Angelides describes, until 1970, "[a]t the same time as adult offenders were rendered pathetic and innocuous, children were routinely rendered sexually flirtatious, precocious and even seductive."[19] With her interrogation of Jeff unfolding as a fierce critique of patriarchal male sexuality, Stark appears to be a warrior for the feminist movement against child sexual abuse. Retracing this movement's critique of victim-blame, she rejects Jeff's claim that she had come on to him, saying "That's what they always say.... 'She was so sexy, she was asking for it, she was only technically a girl, she looked like a woman'—it's just so easy to blame a kid, isn't it?" Recasting as perverse Jeff's apparently innocuous fashion photographs of teenage girls ("underage nymphs"), and describing men's use of pornography as socially conditioned, Stark echoes long-established feminist critique of the gendered power relations that constitute the female form as object of the male gaze. That Stark targets a privileged white man, who appears to the world as a

normal, decent guy, reflects feminist challenges to normative masculinity and critiques of stereotypes of race-ethnicity and class in the social imagining of male violence.

In an obvious nod to psychoanalytic readings of gender and cinema, a long sequence in the film sees Stark pose the threat of castration. Having found Jeff's collection of illegal child pornography together with a photograph of the missing girl, Stark ties Jeff to the kitchen table, making clear her intention to perform surgical castration: "Everyone will be safer if I do a little preventive mainte-nance." We later find Stark has fooled Jeff, and us. Using a video camera Stark apparently live-screens the castration so Jeff can watch it take place, yet the camera is actually screening an educational video for surgeons. With a bag of ice, a bulldog clip, and the educational video, Stark has convincingly feigned castra-tion, creating for Jeff—and, by extension, any viewer who may identify with him—an acute experience of castration anxiety, the quintessentially masculine anxiety cinema is meant to assuage by controlling the image of woman. This simulation of castration fits with *Hard Candy*'s aesthetic of implied violence and status as a text that, by avoiding graphic representation of violence, does not risk operating pornographically. Apart from scenes of physical struggle between Hayley and Jeff (in which she unfailingly gains dominance) the castration sequence is the closest the film comes to graphic portrayal of physical violence. In keeping with the film's refusal to exploit by visually re-presenting female victimization, at its most graphic *Hard Candy* puts the male rather than the female body in peril. And at its most graphic *Hard Candy* is not very graphic—the peril cannot clearly be seen. Just as throughout the film we are denied any full and steady gaze of the photographs adorning Jeff's walls and the pornography hidden in his vault (and do not see at all his participation in the sexual exploitation and murder of the missing girl), in the castration sequence we barely glimpse the tape Hayley screens to Jeff, the action remaining squarely focused on their ever-wordy interface, the violence we think is taking place not shown but implied—a clever play on the tension between knowledge and disbelief of lack constitutive of Freudian castration anxiety.

Although Hayley Stark, more clearly than Erica Bane, reflects a feminist heritage of challenges to male violence, Stark also more closely resembles a classic vigilante: relentless and firmly committed to vigilantism as a path to justice and change. Through her combination of intelligence, ingenious cunning, and apparent anticipation of media fame, Stark also resembles a Hollywood serial killer. Where Bane kills as a woman, Stark kills as a grrl—a politicized upholder of laws that are supposed to protect girls from sexually predatory men but are failing to do so. Yet here we find a limit to a reading of Stark as a feminist figure. A committed vigilante of Bronson's ilk, we must also recognize the conservative politics of law and order given voice through her character—the respects in which Stark can also be read as a warrior for the victim's rights movement. When she finds Jeff's illegal child pornography she says, "This is what they make those

federal laws for, Jeff. This is officially sick." When Jeff offers to confess to the police, Stark is cynical about the ability of the justice system to deal justly with him, explaining with obvious nausea the various ways he will be pampered throughout an unduly brief custodial sentence with therapies and home comforts, referring to Roman Polanski's recent Oscar as proof of the pedophile's impunity. Stark's portrayal of the justice system as inefficient and soft on criminals echoes conservative calls for harsher penalties, longer jail terms and the use of capital punishment. Reflecting the conservative claim that crime victims want justice in the form of lex talionis—an eye for an eye—Stark's vigilantism does what the currently too liberal law will not do: make Jeff suffer in the same way as his victim/s suffered, through sexual violation (the simulated castration) and untimely violent death. In these moments the context of collective feminist movement against child sexual abuse disappears, or appears only to have failed the victim's right to justice. Reflecting strong individualism more so than feminist values of non-violent collective action, Stark places her faith in individual struggle as a lone vigilante, positing vigilante-activism as all that stands between girls and pedophiles.

Over the course of the film Jeff slowly sheds the mantle of "normal guy," eventually admitting, as he stabs at a girl in a photograph on the wall, "This is me, you're right. This is who I am [a killer]. Thanks for helping me see it." Stark has performed an ostensibly feminist unmasking of Jeff's normative masculinity as perniciously sexist, while ultimately turning this feminist story into a conservative one: the only just answer to Jeff's wrongdoing is capital punishment. Stark gives Jeff a choice between the civil death of legal and social marking as a convicted pedophile, or physical death by hanging. If he hangs himself in an apparent suicide, she will not tell. If he refuses, she will turn him over to the authorities and tell his loved ones who he really is. In the end justice is apparently done and Jeff hangs—although, of course, we not see this take place. We find that Stark has also previously brought about the death of another man, Jeff's partner in the murder of the missing girl, and in the closing scenes as we contemplate her playing in the woods, exhilarated and thoughtful in her escape, we wonder how long her serial vigilantism will continue. Unlike Kersey and Bane, Stark's precise personal motivations for vigilantism remain unclear, her pre-vigilante identity unknown. It is implied that she may have been a victim of sexual abuse, and she speaks of having come to the attention of psychiatrists. Yet she avoids telling her story—"Was I born a vindictive bitch or did society make me that way? I go back and forth on that"—and when at the end of the film Jeff asks that she reveals her true identity just as he has revealed his, she gives the vigilante's answer: "I am every girl you ever watched, touched, hurt, screwed, killed." In keeping with the film's progressive style in the representation of gendered violence, we only ever see Stark as vigilante and victor, never as victim. Yet it is this cinematic style itself, and not the story of Stark's victorious project of revenge, that usefully reflects the ethics of feminist movement against male violence.

From Victim to Vigilante

A key question raised by *The Brave One* and *Hard Candy* is whether the figure of the vigilante is adequate as a symbol of feminist efforts to challenge and resist male violence. The stories of Erica Bane and Hayley Stark speak to a recent turn in feminist thought toward emphasizing women's status as agents, as against supposed previous feminist emphasis on women's status as vulnerable to victimization.[20] In an influential early contribution to this turn in feminist thought, Sharon Marcus's 1992 essay "Fighting Bodies, Fighting Words" argued that feminist efforts to address male violence have focused on the aftermath of violence, instead of addressing what women can do to prevent violence from taking place. Focusing on rape, Marcus argued that rape is a highly scripted social event in which women are asked to play the role of a vulnerable victim who freezes in fear.[21] Rather than affirm women's status as vulnerable, feminists should instead emphasize women's capacity to refuse this role and fight back: "Rape [is] a process of sexist gendering which we can attempt to disrupt."[22] As we have seen, as vigilantes who target violent men, Erica Bane and Hayley Stark disrupt the sexist script of feminine victimhood, articulating instead female agency and the capacity to fight back against male violence. Yet this gender trouble comes at a price: in these characters is also figured a grievous misrepresentation of feminism as somehow finding its rightful conclusion in violent vigilantism.

Lone vigilantism is the very opposite of the actual strategies advocated in feminist anti-violence efforts, which have primarily assumed the form of collective political struggle and non-violent direct action, in the making of campaigns for public visibility, law reform, and resources for challenging a spectrum of forms of gendered violence, including rape, child sexual abuse, and spousal violence. A crucial part of these collective endeavors has been sustained critique of individualizing discourses of violence—discourses that render violence as an individual pathology rather than as a normalized socially produced pattern, discourses that evade collective responsibility and instead position women as individually responsible for combating violence. By foregrounding the lone figure of the vigilante, *The Brave One* and *Hard Candy* absent the critical ethics of collective feminist struggle from the scene. In this respect they distort the political spirit of feminist anti-violence efforts, suggesting that feminists are for the counter-violence of vigilantism when, Valerie Solanis notwithstanding, they generally are not.[23] As such these characters issue a caution to contemporary agency-oriented feminism: challenging the script of feminine victimhood may be politically significant, but we ought not assume that all images of women as agents are inherently progressive.

Notes

1 Sharon Marcus, "Fighting Bodies, Fighting Words: A Theory and Practice of Rape Prevention," in *Feminists Theorize the Political*, ed. Judith Butler and Joan Scott (New York: Routledge, 1992), 403.

2 Jodie Foster, interviewed in "I Walk the City," on *The Brave One* (Warner Bros., Los Angeles, CA: Warner Home Video, 2008).

3 For all quotations from this film, see *Hard Candy*, directed by David Slade (2005; Lions Gate, Los Angeles, CA: Fox Home Entertainment, 2006).

4 Ellen Page, quoted in "Ellen Page Interview, Part Three: *Hard Candy*," 9 June 2009, vodpod.com.

5 R.W. (aka Raewynn) Connell, *Masculinities,* 2nd edn (Cambridge, UK: Polity Press, 2005), 83.

6 For all references to this film, see *Death Wish*, directed by Michael Winner (1974; Paramount Pictures, Los Angeles, CA: Paramount Home Entertainment, 2006).

7 Richard Corliss, "Jodie Foster, Feminist Avenger," *Time Magazine*, 14 September 2007.

8 Foster, I Walk the City.

9 Ibid.

10 For all quotations from this film, see *The Brave One*, directed by Neil Jordan (2007; Warner Bros., Los Angeles, CA: Warner Home Video, 2008).

11 On the rape-revenge narrative see Jacinda Read, *The New Avengers: Feminism, Femininity and the Rape-Revenge Cycle* (Manchester: Manchester University Press, 2000) and Sarah Projansky, *Watching Rape: Film and Television in Postfeminist Culture* (New York: New York University Press, 2001).

12 Judith Butler, *Gender Trouble: Feminism and the Subversion of Identity* (New York: Routledge, 1990).

13 For an account of the masculinization of prerogative power see Wendy Brown, *States of Injury: Power and Freedom in Late Modernity* (Princeton, NJ: Princeton University Press, 1995), 166–96.

14 Belinda Morrissey, *When Women Kill: Questions of Agency and Subjectivity* (London: Routlege, 2003). See also *Killing Women: The Visual Culture of Gender and Violence*, ed. Annette Burfoot and Susan Lords (Waterloo, Ontario: Wilfred Laurier University Press, 2006).

15 See, for example, Alyson M. Cole's critique of the nationalist discourse of America as a feminized victim in the wars on terror, and Angela Y. Davis's radical critique of the American criminal justice system as slavery's historical replacement in the maintenance of white supremacy. Alyson M. Cole, *The Cult of True Victimhood: From the War on Welfare to the War on Terror* (Stanford, CA: Stanford University Press, 2006) and Eduardo Mendieta, *Abolition Democracy: Beyond Empire, Torture and Prisons*, interviews with Angela Y. Davis (New York: Seven Stories Press, 2005).

16 See Linda Alcoff and Laura Gray, "Survivor Discourse: Transgression or Recuperation?," *Signs* 18, no. 2 (1993): 260–90.

17 For a discussion of these developments and of the emergence of "child fundamentalism" see Barbara Baird, "Child Politics, Feminist Analyses," *Australian Feminist Studies* 23, no. 57 (2008): 291–305.

18 Steven Angelides, "The Emergence of the Paedophile in the Late Twentieth Century," *Australian Historical Studies* 37, no. 126 (2005): 272–95. Angelides observes at 283, "In stark contrast to Freudian notions of infantile and oedipal sexuality, and to earlier twentieth century ideas of child sexual precocity and seductiveness, children were increasingly being viewed in the 1980s as sexually innocent and vulnerable."

19 Ibid., 278.

20 For my critical reflections on this turn in feminist thought see Rebecca Stringer, "'A Nietzschean Breed': Feminism, Victimology, *Ressentiment*," in *Why Nietzsche Still? Reflections on Drama, Culture and Politics*, ed. Alan D. Schrift (Berkeley, CA: University of California Press, 2000), 247–73 and Rebecca Stringer, "Rethinking the Critique of Victim Feminism," in *Victim No More: Women's Resistance to Law, Culture and Power*, ed. Gayle MacDonald and Ellen Faulkner (Black Point, Nova Scotia: Fernwood Books, 2009), 19–27.

21 As Marcus explains, "I am defining rape as a scripted interaction which takes place in language and can be understood in terms of conventional masculinity and femininity as well as other gender inequalities inscribed before an individual instance of rape." Marcus, "Fighting Bodies," 232.

22 Ibid.

23 See Avital Ronell, "The Deviant Payback: The Aims of Valerie Solanis," in Valerie Solanis, *Scum Manifesto* (London and New York: Verso, 2004), 1–34.

21

"WHEN THE WOMAN LOOKS"

Haute Tension (2003) and the Horrors of Heteronormativity

Barry Keith Grant

Welcome to My Nightmare

Since the great achievements of the American horror film in the 1960s and 1970s, beginning with Alfred Hitchcock's *Psycho* (1960), film scholars have consistently found the genre of interest for its potential critique and subversion of dominant ideology. Considerable critical writing has shown that the undermining of bourgeois mores, chiefly through canny usages of a critical perspective grounded in radical political and psychological discourses, has been one of the genre's most notable characteristics. The notion of the Other, basic to all genres, is addressed in the horror film most directly, through the device of the "monster." The most outstanding horror films interrogate the ways by which dominant ideology is internalized by individual subjects. They challenge widely held notions of insanity, recognizing, however obliquely, Freudian notions of the pervasive nature of neurosis and psychosis, understanding that the "normal" cannot exist in a civilization based on repression and oppression, particularly with regard to the racial Other and the policing of sexuality.

Alexandre Aja's *Haute Tension* (*High Tension/Switchblade Romance*, 2003) is a particularly revealing example of contemporary horror in the wake of such theory and criticism. Its use of Freudian theory in the form of the double, one of the most common motifs of the horror genre, reveals the extent to which patriarchal culture has exerted its hegemonic power in Western culture. The film's sadistic killer is depicted visually as representing a generalized masculinity—a "non-specific male killing force," as Linda Williams describes the killers in typical slasher films[1]—and is indicative of the film's critique of masculine heterosexuality. The climactic revelation that it is actually the female protagonist, Marie, who is also the psychotic murderer who imagines herself as a male killer, is much

more than a mere plot gimmick; rather, by playing off the expectations of the conventional slasher film, it offers a profound contemplation of the crushing extent to which women are the victims of phallic masculinity, their very imaginations and desires colonized. This chapter will provide a close reading of *Haute Tension* within the context of feminist and ideological analyses of the horror film, arguing that it is a powerfully progressive text in which the plot "twist," which offers a retrospective identification with the monster, is not only consistently justifiable within the context of the film, but as well reveals a great deal about contemporary gender relations and perceptions.

For three decades now, spurred by the pioneering work of Robin Wood, film scholars have found the horror genre to be of particular critical interest. Combining aspects of Marxist, psychoanalytic, feminist, and structural analysis, Wood discusses the genre as centrally concerned with articulating the Freudian notion of "the return of the repressed." For Wood, the true subject of horror is "the struggle for recognition of all that our civilization represses or oppresses."[2] As he explains, that which is disavowed or repressed within dominant culture, as with the repressed within the individual for Freud, returns in disguised form—in the horror genre, conventionally, as that which is coded as monstrous. The source of horror, the monster, is thus the Other, that which we cannot admit exists within ourselves, and so disavow by projecting outward.

Wood proposes an elegantly simple dramatic structure as the core of the genre: "normality is threatened by the Monster." This usefully concise definition allows Wood to identify the primary thematic opposition in the genre as normality and the monstrous, and to suggest that the ideological position in any given horror film is expressed by the way it depicts the relationship between these two terms.[3] Broadly speaking, conservative films endorse the ideological status quo as normal and literally demonize deviations from the norm as monstrous; by contrast, progressive examples of the genre challenge these values, either by making the monster sympathetic or by showing normal society to be in some way monstrous in itself, problematizing any easy distinction between normal and monstrous. Wood provides a list of specific Others that have been marginalized and made monstrous in horror movies, including the proletariat, other cultures, ethnic groups, alternative ideologies or political systems, children, women, and deviations from sexual norms.[4]

All of these categories have been taken up by critics of the genre over the past two decades, although sexuality and gender have been the most frequently explored. Numerous critics, following Wood, and informed by Laura Mulvey's foundational theorizing about the gendered gaze in cinema,[5] have analyzed specific horror films and horror cycles from multiple feminist perspectives. Perhaps the most controversial of these interventions has been Carol Clover's analysis of the slasher film, particularly her notion of the "Final Girl," the female victim of the killer who ultimately appropriates both elements of phallic masculinity and the camera's gaze, finding the strength to defeat the killer in a

climactic battle.[6] As discussed below, Clover's perspective, and Linda Williams's use of gaze theory to hypothesize the relation between the woman's look in horror films and its association with the monster's freakishness, will be seen to have particular relevance to understanding the progressive thrust of *Haute Tension*.[7]

Psycho Killer, *Qu'est-ce que c'est?*

Horror films conventionally define normality as the heterosexual, monogamous couple, and the social institutions (family, police, church, military, science) that support them. Conventional horror movies tend to allow spectators the pleasure of identifying with the monster's status as outsider, but ultimately contain any potentially subversive response by having the monster defeated by characters belonging to these groups and thus representing the power of social authority. In countless monster movies the male hero must defeat the masculine monster, who may be seen to embody an uncontrollable phallic sexual aggression; then, the sexual threat of the monster destroyed (repressed), he is able to win the hand (and, implicitly, the body) of the lovely lab assistant or elder scientist's daughter, and so assume his proper place within the prevailing patriarchal order. Normative heterosexuality is thus successfully upheld in the hero's defeat of his shadow double, the monster.

Often the victorious male hero gazes at the destroyed remains of the monster and ruminates with seeming profundity that there are certain things man (!) is not meant to know. The ending of Universal Studios' classic *Dracula* (Tod Browning, 1931) is perfectly illustrative. In the film's climax, the hero, Jonathan Harker, has acted to destroy the beast of predatory sexuality, a seductive creature that slips by night into young women's boudoirs and transports them with his erotic kisses. With the help of Van Helsing, the figure of patriarchal Law who blesses their union, the creature is put to rest and phallic sexuality staked to monogamous heterosexuality. The lid is put back on the Id as well as the coffin, and with Dracula now finally able to rest in peace, the young couple ascend a long staircase to the heavenly light of day, accompanied by the promise of wedding bells on the soundtrack as the final fadeout suggests they will live happily ever after—exactly the kind of "happy" ending to which Wood refers.

Most horror films, until the 1940s, imagined the site of horror as an exoticized place, far removed from America. In *Dracula*, crossing the Borgo Pass in Transylvania represents a crossing of a distinct threshold from the rational world into one of the nightmarish, and *I Walked with a Zombie* (Jacques Tourneur, 1943) is set in the voodoo-infested jungles of the West Indies. Such exotic locales allowed for the development of expressionist atmosphere, of course, but also suggest the disavowal and projection of audiences' own desires onto the Other. In the cinema of the postwar era, however, horror began to be depicted as arising

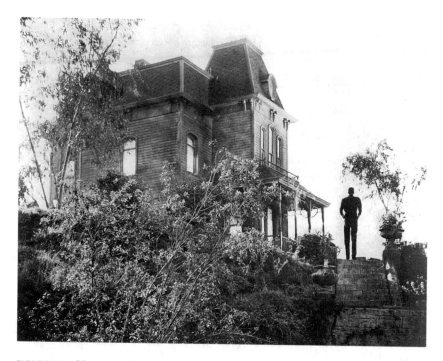

FIGURE 21.1 Horror, as the return of the repressed, emerges out of an old, dark, private house in *Psycho* (1960). Courtesy of Paramount Pictures/Photofest.

from within the American heartland, as much concerned with the ordinary and the familial as with the supernatural. The pivotal film, as mentioned above, was *Psycho*, with its wholesome boy-next-door turned schizophrenic killer. The film abides by a basic Freudian view of repression, in which Norman's repressed desire returns as the phallic aggression of Mrs. Bates, depicted as the murderous violence of distorted, repressed desire bursting forth from the old, dark, private house behind the modern, clean public motel in front of it.

The majority of serial killer horror films since *Psycho* offer a vague psycho-analytic explanation that locates the cause of the human monster's murderous madness in a traumatic, often repressed event from the past involving the charac-ter's developing sexual identity. *Halloween* (John Carpenter, 1978) stands as a paradigmatic example for the numerous slasher films to follow in its wake, with its famous opening tracking shot from young Michael Myers's point of view as he comes into the house and discovers his sister having sex with her boyfriend, a scene which seems to trigger his murderous spree. Similarly, *Haute Tension* can be read as a classic example of the return of the repressed within the horror film, but one that in the end is progressive in so far as it brings us to an awareness of the cause of that repression rather than presenting it merely as monstrous symptom. In such a reading, Marie (Cecile de France), the film's central figure, has lesbian

desire but, unable to accept this "forbidden love" within herself, projects her desire and frustration outward as an imaginary masculine aggressor.

As the narrative of *Haute Tension* begins, two college friends, Marie and Alex, or Alexia (Maiwenn Le Bosco), are driving to Alex's parents' house in the country, where they are planning to stay for the weekend to study for exams. After they arrive, are introduced, and settle in, they have a pleasant dinner with the rest of Alex's family. Later, as the two women get ready for bed, in one of the film's several pointed references to *Psycho*, Marie glimpses Alex showering, here through a window, and becomes sexually aroused. As Alex sleeps, Marie lies on her bed listening to music on her iPod and masturbating. After apparently reaching orgasm, Marie hears a doorbell ring and Alex's father responding. The man at the door (Philippe Nahon), an indistinct, grimy truck driver, brutally attacks Alex's father and then decapitates him. Marie makes her room look unoccupied and succeeds in hiding when the killer checks the rooms upstairs. Marie attempts to escape from the killer while he murders Alex's mother, slashing her throat and mutilating her while Marie watches from a bedroom closet, and shooting Alex's little brother to death in the field outside the house. The killer chains and gags Alex, taking her and locking her in the back of his truck and driving away, unknowingly also taking along Marie, who is locked in the truck while inside trying to free Alex. When the killer stops at a gas station, Marie sneaks inside before him while he fills the tank. Before she can warn Jimmy (Franck Khalfoun), the attendant, the killer murders him with an axe. Marie takes Jimmy's keys and uses his car to pursue the killer down a deserted road. Realizing that he is being followed, the killer circles behind her and rams her car with his truck, pushing it off the road. The killer pursues Marie through the woods, where she ultimately defeats him in a bloody confrontation in which she first bludgeons him with a pole wrapped with barbed wire and then suffocates him with a plastic sheet. After that, she begins to make her way back to the truck, where Alex is still imprisoned.

For the first time, the film cuts away from Marie, showing the police investigating the murder at the gas station. Along with them, we watch the station's security videotape and see Marie attacking Jimmy with an axe. Unlike the police, we suddenly realize, only 15 minutes before the film's end, that Marie is in fact a psychopathic killer with a split personality who imagines herself as a male killer. Then, when the film cuts back to Marie "rescuing" Alex from the back of the truck, morning sunlight seeming to suggest that the horrors of the night are over, we perceive the situation in a radically different fashion even as we scramble to reinterpret all that we have seen previously. Quickly we understand that Marie desires Alex, wants to possess her, but also that she has refused to acknowledge her own feelings. In the truck, Alex, once she is released, stabs Marie with the knife that Marie had given her earlier, and escapes, pursued by Marie brandishing a concrete saw, a gendered inversion of Leatherface (Gunnar Hansen) in *The Texas Chainsaw Massacre* (Tobe Hooper, 1974). Alex flags down a passing car, but

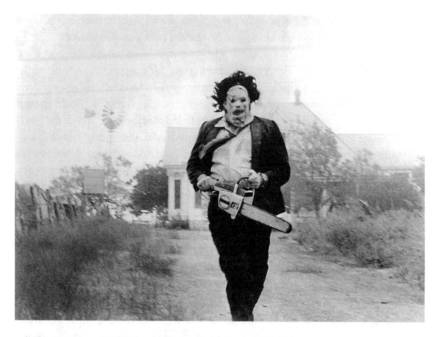

FIGURE 21.2 "Leatherface" (Gunnar Hansen) in *The Texas Chainsaw Massacre* (1974). Courtesy of Bryanston Distributing Company/Photofest.

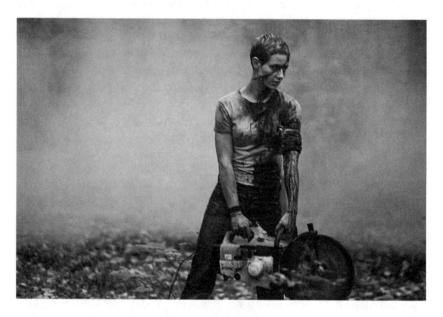

FIGURE 21.3 "Marie" (Cécile de France) brandishing a concrete saw in a gendered inversion of "Leatherface." Courtesy of Lions Gate/Photofest.

it stalls, and Marie saws through the windshield, disemboweling the male driver. Alex's Achilles tendon is sliced by a piece of the shattering glass, and she attempts to crawl away from Marie, who menaces her with the saw. As Marie declares that she will never let anyone come between them, Alex impales her through the shoulder with a crowbar she had taken from the car's toolbox. In the final scene, echoing the opening, Marie is in a psychiatric hospital room, with Alex looking at her through a one-way mirror. In the last shot, Marie turns around, facing the camera, grins, and reaches out for Alex—and the audience—as if she were aware of both.

Hit Me with Your Rhythm Stick

In retrospect, the reason for Marie's madness is attributed to the tyrannical hegemony of the heterosexual regime, a point established early in the film as the two women chat about relationships and dating after dinner. They discuss an attached guy who is hitting on Alex, and she asks Marie when she is going to take "the plunge,"[8] assuming the inevitability and universality of heterosexuality. Marie deflects her seemingly inexplicable heterosexual abstinence by saying "I'm not sex mad" (which, of course, as we find out later, is precisely what she is because her desire has been pathologized by patriarchy). Marie tells Alex that the purpose of their trip is to study, not party, indicating her repressed character. In the family home, Marie is seen at one point through a cage with two parrots, a visual symbol of her repressed, contained being. Significantly, the two women plan to begin their weekend of studying with international law, suggesting the global institutionalization of patriarchy, the Law of the Father.

But that "boiling cauldron of desire," as Freud called the Id, is nevertheless about to spill over from within Marie. Admitting that she doesn't have normal dreams ("being like everybody else is a bore"), Marie explains the opening shots of the film as her dream of someone chasing her—which she describes as feeling as if she were pursuing herself. As Williams, invoking Mulvey, notes, "In the classical narrative cinema, to see is to desire."[9] And once the erotic view of Alex's bare, wet breasts as she showers is revealed to Marie, in a shot that is clearly marked as being from Marie's point of view, her desire is triggered. Williams writes:

> [T]he power and potency of the monster body in many classic horror films … should not be interpreted as an eruption of the normally repressed animal sexuality of the civilized male (monster as double for male) but the feared power and potency of a different kind of sexuality (the monster as double for the woman).[10]

In *Haute Tension* the killer is so monstrous because as a gay woman Marie's desire is doubly threatening to dominant masculinity. Enclosed in her own sensory

290 Barry Keith Grant

world, privately listening to music (U-Roy's "Runaway Girl [Just another girl],"
a catchy reggae tune that relates to Marie in so far as both girls need to understand
their place in the world) with her iPod and earphones, Marie begins to gratify
herself sexually, and as she apparently reaches orgasm, the Monster from the Id
is released. John Carpenter says of the relationship between Laurie Strode (Jamie
Lee Curtis) and Michael Myers in *Halloween*, "She and the killer have a certain
link: sexual repression."[11] But the link has much greater narrative and visual depth
in *Haute Tension*. The film cross-cuts several times between Marie transported
in private onanistic pleasure and the killer approaching the house, suggesting
at once the fever pitch of her desire and the true relationship between the two
characters.

Repressing her "perverse" desire, Marie disavows it by recasting it in the
vilest, most aggressive masculine form she can imagine. Visually, the killer is over-
determined as representing a generalized phallic, working-class "maleness": he
wears an oily worker's cap and overalls, the company's logo lacking specificity
since it is partly obscured by wear and dirt; there is grime under his fingernails;
and his face, repulsively sweaty, is almost always obscured by his cap, by back-
lighting, or by the framing of the camera. The killer is played, significantly, by
Philippe Nahon, who was cast as the terrible masculine monster known as The
Butcher in Gaspar Noé's *Seul contre tous* (*I Stand Alone*, 1998). In representing a
general white working-class male, Marie's imaginary killer invokes the numerous
male working-class psychotic killers in earlier movies such as those in *In Cold
Blood* (Richard Brooks, 1967), *The Texas Chainsaw Massacre*, *Wolf Creek* (Greg
Mclean, 2005), and the male killer, similarly coded as a generalized white work-
ing-class figure, who bursts through the Pingots's car windshield in the shocking
climax of Catherine Breillat's *A ma soeur!* (*Fat Girl*, 2001).

With an exaggerated phallic masculinity, the killer jokes with Jimmy, the gas
station attendant, about the potential of his job for "servicing" women: "This is
the ideal place to bring girls. The old rich ladies that drive through—don't tell me
they never ask for your services." The killer's butchering of Jimmy with the axe
specifically recalls the crazed phallic aggression in classic Hollywood films from
D.W. Griffith's *Broken Blossoms* (1919) to Stanley Kubrick's *The Shining* (1980)—
not to mention Norman's fatal assault on Marion Crane (Janet Leigh) with his
knife in *Psycho*. Mulvey makes clear how the male gaze reduces women to images,
and the camera gives us a quick close-up of a *Playboy* magazine under the counter
at the gas station, as if to confirm Marie's transference of her desire to objection-
ably sexist men. The importance of photography's objectifying gaze of women is
emphasized when the killer pauses during his murder of Alex's family to look at
family photos (fingering one of Alex, he cuts out her face with a razor). Later, a
pan shot across the dashboard of the killer's truck reveals a series of photos of his
previous female victims. Significantly, the killer begins his carnage of the family
by killing the father, who typically is positioned from the patriarchal perspective
as the head of the household. The killing of the father by decapitation echoes the

first scene which includes the imagined killer using a woman's severed head for fellatio, a horrifying literalization of getting "head."

As more than one critic has observed, "One of the most conspicuous trends within contemporary French cinema is the turning to subjects and figurative territories that are usually the prerogatives of genre and exploitation films." [12] Hampus Hagman references James Quandt's use of the term "New French Extremity," represented by the films of such directors as Noé, Breillat, Francois Ozon, and Bruno Dumont, which, with their emphasis on sex and violence, he sees as a symptom of "a diminished sense of cultural identity, and, despite its self-proclaimed taboo-breaking depictions of sex and violence, a compromised concession to the visceral thrills and excessive visuals of more dominant forms of film-making." [13] Perhaps these films do pander to a wide market, but it is also the case that they are saying something serious about gender relations today that cannot be so easily dismissed.

With their focus on the relationship of masculinity to sexual violence, on one level this cycle of contemporary French cinema might be seen as a reaction to the saccharine, if not misogynist, depiction of women in earlier Nouvelle Vague films, particularly those of Jean-Luc Godard and François Truffaut, both of whom were heavily influenced by and professed a love for Hollywood cinema and its masculinist gaze, and both of whom often objectified women in their films. Breillat's *L'Anatomie de l'enfer* (*Anatomy of Hell*, 2004) contains a scene in which a woman removes a blood-soaked tampon from her vagina, steeps it in a glass of water like tea, which is then quaffed by a man (played by porn star Rocco Siffredi), who then has intercourse with her. The scene culminates with a close-up of Siffredi's erect penis dripping with the woman's menstrual blood as he withdraws from her. Certainly this scene is shocking, but there can be no more explicit image in these films of phallic masculinity as violent and predatory, if not monstrous.

A movie such as *Haute Tension* also plays off Hollywood cinema, as did Godard and Truffaut, but by recasting conventions of the horror film, a genre almost completely, and inexplicably, avoided by Nouvelle Vague filmmakers. Like such other films of the "New French Extremity" as Breillat's *A ma soeur!*, Noé's *Irreversible* (2002), and Bruno Dumont's *Twentynine Palms* (2003), *Haute Tension* is one of a number among a recent cycle of French films that depict monstrously violent masculinity. These new films of sexual violence have much in common with the most radical of horror films in their extraordinary meditation on masculine power, repression, and the fate of women in contemporary culture. Further, each of these films works, in its own way, to implicate the putatively male viewer in cinematic processes of identification and narrative surprise. Although *Haute Tension* is the only clearly recognizable horror film among this group, these other films share with it, and with the great progressive works of the genre, an apocalyptic vision as the only appropriate response to the murderous conditions of patriarchal, late capitalist civilization.

Linda Williams has discussed the horror film as one of the "body genres," that is, one of those genres that, like pornography and melodrama, works to elicit pronounced emotional and physiological excitation.[14] The sexual violence in *Baise-moi* (Virginie Despentes and Coralie Trinh Thi, 2000), one of the more infamous and extreme films of the so-called New French Extremity, makes the link between horror and pornography uncomfortably clear in seeking to undermine the masculinist, patriarchal gaze typical of both. Directed by two women, the film tells the story of two women, both workers in the sex industry and exploited by men. In a variation of *Thelma and Louise* (Ridley Scott, 1991), the pair hit the road and drive across France, dubbing themselves "the fucking condom dickhead killers"; on their journey, they have sex with both men and women and kill those they either dislike or who get in the way of their journey. In its crude construction, mise-en-scène, and explicit sexual content, *Baise-moi* appropriates the images and language of porn, a genre often condemned as expressing male fantasies that objectify women. But in *Baise-moi* these images are contextualized within the women's story; it is they who are the protagonists, who move the plot forward, countering pornography's typical privileging of the male and objectification of women. In Brechtian fashion, the two women express awareness of themselves as representations, conscious of their appropriation of masculine roles: they refer to themselves as action heroes, wonder about the absence of witty one-liners to accompany their violence, and imagine themselves dying at the end of their story like Thelma and Louise to avoid being captured by "the Man." The explicit sex scenes in *Baise-moi* may look like porn momentarily, but the film ultimately wrenches porn (and viewers along with it) into a new context, to expose its masculinist politics. *Haute Tension* does the same with the horror genre.

Until the revelation of the security videotape that Marie is also the killer, she resembles Clover's Final Girl: "She alone looks death in the face, but she alone also finds the strength either to stay the killer long enough to be rescued (ending A) or to kill him herself (ending B)."[15] In addition, Clover reminds us that "by the end, point of view is hers: we are in the closet with her, watching with her eyes the knife blade pierce the door; in the room with her as the killer breaks through the window and grabs at her; in the car with her as the killer stabs through the convertible top; and so on."[16] Indeed, in *Haute Tension*, we are encouraged to identify with Marie from the beginning. In that first narrative scene, deflecting talk in the car about dating men, she seems more sensible and mature than Alex, and she is the victim of the cruel joke Alex plays on her by pretending to leave her alone in the cornfield in the dark of night. Visually, we share Marie's point of view in her extended hide-and-seek game with the killer. We see almost (but not quite) nothing from the killer's point of view, and most of the action from Marie's perspective. And when Marie is listening to music through her earphones and then removes them, the music stops, allowing viewers to share her aural as well as visual perspective.

Typically, when the Final Girl defeats the killer, "we are triumphant" because "she is by any measure the slasher film's hero."[17] Certainly we feel this for a fleeting moment, as Marie suffocates the killer, but it is precisely at this moment of her triumph that we discover she is *also* the monster, and we fear for Alex anew rather than feel relief for her safety. When Marie returns to "rescue" Alex, the scene looks much like Clover's description: "By the time the drama has played itself out, darkness yields to light (typically as day breaks) and the close quarters of the barn (closet, elevator, attic, basement) give way to the open expanse of the yard (field, road, lakescape, cliff)."[18] In *Haute Tension*, it is indeed morning, the sunshine beaming promisingly over a lushly green rural landscape and into the back of the truck, doors flung open. But the meaning of these hopeful images is reversed, for just as Norman Bates becomes "all mother," so Marie becomes all killer. Clover writes that "When the Final Girl stands at last in the light of day with the knife in her hand, she has delivered herself into the adult world."[19] In *Haute Tension*, however, there is no positive ending, no maturation or attainment of a satisfying female sexuality for Marie. If at the beginning of the film Marie is momentarily lost in the cornfield, alone in the maize when Alex plays her prank, at the end, like Jack Torrance at the end of *The Shining*, she is lost forever within the maze of her own shattered self ("all work and no play make Jack a dull boy").

Mirror in the Bathroom

In Alexandre Aja's subsequent *Mirrors* (2008), a former New York police detective, Jack Carson (Kiefer Sutherland), discovers an evil force inside mirrors that is revealed as reflections that kill themselves, causing the people they are reflecting to kill themselves in the real world. Seeking to solve the mystery of the monsters in the mirrors, Carson follows clues that take him to a Psychiatric Detention Center, where the resident psychiatrist, Dr. Morris (Tim Ahern), explains to him that

> When one starts to perceive one's own reflection as a completely separate being, one is suddenly confronted with two separate egos, two entirely separate worlds that can surface at any given moment. A feeling of self-hatred, usually triggered by a psychological shock, can split the personality in two, hence creating two or more personalities with distinct memories and distinct behavior patterns within the same individual. The patient then has the false perception of the existence of two distinct worlds.

In *Mirrors*, this explanation is ironic (another reference to *Psycho*, this one to the psychiatrist's concluding pat analysis of Norman's pathology), since the evil force actually does exist in the world of the film, but the remark is nonetheless perfectly relevant to understanding *Haute Tension*.

It is no accident that on several occasions Marie is shown with mirror images: we see her reflection, for example, on the window glass when she looks in at Alex's father finishing up for the night on his computer. Similarly, as the killer, her image is multiplied as she moves past the beveled panes of glass in one of the house's French doors. For Williams, when the woman looks in a horror film, there is a possibility that she may see that the monster "offers a distorted reflection of her own image. The monster is thus a particularly insidious form of the many mirrors that patriarchal structures of seeing hold up to the woman."[20] In *Haute Tension*, though, the hero, who turns out to be the monster, never recognizes her kinship with the monster, never understands the monstrosity of this faceless male killer as her own guilt for being homosexual and for having internalized the values of heterosexuality and patriarchy so thoroughly. Clover writes that in the slasher film the killer is what the Final Girl "could become should she fail in her battle for sexual selfhood,"[21] and her tragic failure in *Haute Tension* shows us how monstrous Marie has been made to regard herself. As Wood notes, "The dominant images of women in our culture are entirely male created and male controlled."[22] Where Norman in *Psycho* is a man controlled by an individual woman's psyche, Marie is a woman absorbed within and molded by patriarchy itself. Thus her monstrous Other is a crude and cruel Everyman.

Crucially, while Marie may fail completely to recognize her own "monstrosity" in *Haute Tension*, the audience cannot help but see it. We need no psychiatrist to explain the monstrous case to us, as in *Psycho*, because the monster's signifiers of a generalized masculinity and the relations between him and the Final Girl that the film establishes (for example, Marie literally cowers "in the closet" after erasing her presence in the room while her masculine *alter ego* stalks the upstairs part of the house, perfectly expressing at once her sexual repression and its distorted return) make clear the film's critique of patriarchy as monstrous. Significantly, when we first discover that Marie is the murderer on the security video, her crazy eyes look directly at the camera, and us, returning our gaze; and similarly, at the end, when we look through the one-way mirror at the incarcerated Marie along with Alex, just as Alex asks "She can't see me, right?" Marie turns around, returns our gaze, and reaches out for her—and us. In both cases her look is at once threatening and accusatory. Clover writes that in the course of slasher films we come to identify with her so strongly that "we belong in the end to the Final Girl."[23] This is true in *Haute Tension* not just in terms of simple identification, but rather in so far as we are implicated in the patriarchal destruction of Marie.

Notes

Thanks to my colleague, Nick Baxter-Moore, for tracking down the U-Roy song.

1 Linda Williams, "When the Woman Looks," in *The Dread of Difference: Gender and the Horror Film*, ed. Barry Keith Grant (Austin, TX: University of Texas Press, 1996), 31.

2 Robin Wood, *Hollywood from Vietnam to Reagan* (New York: Columbia University Press, 1986), 75.
3 Ibid., 78.
4 Ibid., 73–5.
5 Laura Mulvey, "Visual Pleasure and Narrative Cinema," *Screen* 16, no. 3 (Autumn 1975): 6–18.
6 Carol Clover, *Men, Women and Chain Saws: Gender in the Horror Film* (Princeton, NJ: Princeton University Press, 1992).
7 Williams, "When the Woman Looks," 15–34.
8 For all quotations from this film, see *Haute Tension*, directed by Alexandre Aja (2003; Santa Monica, CA: Lions Gate Films Home Entertainment, 2005).
9 Williams, "When the Woman Looks," 15.
10 Ibid., 20.
11 Todd McCarthy, "Trick or Treat," *Film Comment* 16, no. 1 (January–February 1980): 24.
12 Hampus Hagman, "'Every Cannes Needs Its Scandal': Between Art and Exploitation in Contemporary French Film," *Film International* 29 (2007): 32–3.
13 James Quandt, quoted in Hagman, Ibid., 32–3.
14 Linda Williams, "Film Bodies: Gender, Genre, and Excess," in *Film Genre Reader 3*, ed. Barry Keith Grant (Austin, TX: University of Texas Press, 2003), 142.
15 Clover, *Men, Women and Chain Saws*, 35.
16 Ibid., 45.
17 Ibid.
18 Ibid., 49.
19 Ibid.
20 Williams, "When the Woman Looks," 22.
21 Clover, *Men, Women and Chain Saws*, 50.
22 Wood, *Hollywood*, 74.
23 Clover, *Men, Women and Chain Saws*, 46.

CONTRIBUTORS

Taunya Lovell Banks is Jacob A. France Professor of Equality Jurisprudence at the University of Maryland School of Law. She is a contributing co-editor of *Screening Justice—The Cinema of Law: Films of Law, Order and Social Justice* (William S. Hein, 2006). She writes about race, gender, class, and popular culture. Professor Banks is a former member of the Association of American Law Schools' Executive Committee, and a two-term Trustee of the Law School Admissions Council. She also served on the Editorial Board of the *Journal of Legal Education* and the advisory committee of the *Law & Society Review*.

Heather Brook teaches Women's Studies at Flinders University, Australia. Her key research interests center on bodies, their regulation, and resistance. She is the author of *Conjugal Rites* (Palgrave, 2007) and numerous articles reflecting her wide-ranging interest in corporeality.

Mridula Nath Chakraborty is a Postdoctoral Fellow with the Writing and Society Research Group at the University of Western Sydney. She completed her Ph.D. thesis, "Hotfooting Around Essentialism: Feminisms of Colour," at the University of Alberta in 2007. Her publications include: *A Treasury of Bangla Stories* (Srishti, 1999), co-edited and translated with Rani Ray, the exhibition catalogue *The Blue Sky Their Horizon* (University of Alberta Libraries, 2006), and a digital, oral narrative history of academic women at the University of Alberta as part of a special project on *Institutionalising Feminism*.

Michael DeAngelis is Associate Professor of Media and Cinema Studies at DePaul University. He is the author of *Gay Fandom and Crossover Stardom: James Dean, Mel Gibson, and Keanu Reeves* (Duke University Press, 2001) along with a

number of articles and book chapters on stardom, fan culture, authorship, queer studies, and popular culture.

Rosalind Gill is Professor of Social and Cultural Analysis at the Centre for Cultural, Media and Creative Industries Research at King's College London. Known for her work on gender, media, cultural industries, and new technologies as well as for longstanding interests in discourse and narrative analysis, psychosocial studies, and visual methods, she is currently writing a book about mediated intimacy and another about creatives. Her latest book (with Christina Scharff) is the edited volume *New Femininities: Postfeminism, Neoliberalism and Subjectivity* (Palgrave, 2011).

Barry Keith Grant is Professor of Film Studies and Popular Culture at Brock University in St. Catharines, Ontario. He is the author, co-author, or editor of 20 books, including *Film Genre: From Iconography to Ideology* (Wallflower Press, 2007), *Film Genre Reader* (University of Texas Press, 1986, 1995, 2003), *The Dread of Difference: Gender and the Horror Film* (University of Texas Press, 1996), and, most recently, *Invasion of the Body Snatchers* for the BFI Film Classics series (2010). Editor-in-Chief of the comprehensive four-volume *Schirmer Encyclopedia of Film* (Schirmer Reference, 2007), he also edits the Contemporary Approaches to Film and Television series for Wayne State University Press and the New Approaches to Film Genre series for Wiley Blackwell.

Hannah Hamad is Lecturer in the School of English and Media Studies at Massey University, New Zealand. She completed her Ph.D. thesis, "Postfeminist Fatherhood and Contemporary Hollywood Stardom," at the University of East Anglia in 2008. Her current research interests include postfeminist fatherhood, contemporary Hollywood film, contemporary media, and postfeminism. She is a contributor to Flow TV and has published on Hollywood stardom, masculinity, and fatherhood.

David Hansen-Miller is a London-based freelance researcher working in the non-profit sector. He completed his Ph.D. in English Literature at Queen Mary College, University of London in 2005. He has taught widely in Media and Cultural Studies, Gender Studies, and Sociology, most recently at Lancaster University. His book, *Civilized Violence: Subjectivity, Gender and Popular Cinema* is forthcoming from Ashgate.

Kelly Kessler is Assistant Professor of Media and Cinema Studies in the College of Communication at DePaul University. Her research engages primarily with the evolution of the American Hollywood musical, television genre, and the mainstreaming of lesbianism in American film and television. She is the author of *Destabilizing the Hollywood Musical: Music, Masculinity, and Mayhem* (Palgrave

Macmillan, 2010). Her works on gender, genre, and sexuality have also appeared in publications such as *Film Quarterly*, *Cinema Journal*, *Televising Queer Women*, and *The New Queer Aesthetic on Television*.

Christina Lane is Associate Professor in Film Studies at the University of Miami. She is the author of *Feminist Hollywood: From Born in Flames to Point Break* (Wayne State University Press, 2000) and *Magnolia* (Wiley-Blackwell, 2011). She has published journal articles in *Cinema Journal*, *Mississippi Quarterly*, *The Journal of Popular Film and TV*, *Australian Screen Education*, and *Film and History*, and has essays in various collections. She is Director of the Norton Herrick Motion Picture Studies Center.

JaneMaree Maher is Director of the Centre for Women's Studies and Gender Research in the School of Political and Social Inquiry at the University of Monash, Australia. Her research interests are focused on work/family balance, women's mothering and employment, and pregnancy and birth. Her publications include, as co-editor, *Globalized Motherhood: The Transformation and Fragmentation of Mothering* (Routledge, 2010) and *The Fertile Imagination: Narratives of Birth, Fertility, and Loss* (special book issue of *Meridian*, La Trobe University, 2002).

Gary Needham is Senior Lecturer in Film and Television Studies, Nottingham Trent University, UK. He has written widely on film and television and is the author of a monograph on *Brokeback Mountain* (Edinburgh University Press, 2010) and the co-editor of *Asian Cinemas: A Reader and Guide* (Edinburgh University Press, 2006) and *Queer TV: Histories, Theories, Politics* (Routledge, 2009). He is currently co-authoring *Film Studies: A Global Introduction* (Pearson) and *Warhol in Ten Takes* (British Film Institute).

Sarah Projansky is Associate Professor of Gender and Women's Studies and of Media and Cinema Studies at the University of Illinois, Urbana-Champaign. She is the author of *Watching Rape: Film and Television in Postfeminist Culture* (New York University Press, 2001) and of articles published in *Signs*, *Cinema Journal*, *The Velvet Light Trap* and various edited volumes, as well as the co-editor of *Enterprise Zones: Critical Positions on Star Trek* (Westview, 1996). She is currently completing a book on turn-of-the-twenty-first century U.S. girlhoods and the emerging field of feminist girls' media studies.

Hilary Radner is Professor of Film and Media Studies at the University of Otago. Her books include two monographs on feminine culture and subjectivity: *Shopping Around: Feminine Culture and the Pursuit of Pleasure* (Routledge, 1995) and *Neo-Feminist Cinema: Girly Films, Chick Flicks, and Consumer Culture* (Routledge, 2011). Her recent co-edited volumes include *Jane Campion: Cinema, Nation,*

Identity (Wayne State Press, 2009) and *New Zealand Cinema: Interpreting the Past* (Intellect, 2011).

Nicole Richter is Assistant Professor in the Motion Pictures Program at Wright State University. Her publications include "Ambiguous Bisexuality: The Case of *A Shot at Love with Tila Tequila*" in the *Journal of Bisexuality* and "Dressing the Body in Memories" in *Short Film Studies*. She completed her Ph.D. in Communication with an emphasis in Film Studies at the University of Miami, Florida in 2009.

Rob Schaap holds a Doctorate in International Political Economy from the Australian National University (2002). His publications include work in comparative media policy, peace studies, and political economy. He is currently teaching at the University of Canberra.

Michele Schreiber is Assistant Professor in the Department of Film Studies at Emory University. Her work has appeared in *Reclaiming the Archive: Feminism and Film History* (Wayne State University Press, 2010), the *Schirmer Encyclopedia of Film*, and *Film Quarterly*. Her current projects include: "These Fish Want a Bicycle: Romance in the Postfeminist Media" and "The Cinema of David Fincher" (under contract, Wallflower Press). She received her Ph.D. in Critical Studies from the Department of Film, Television and Digital Media at the University of California, Los Angeles in 2006.

Yael D Sherman received her Ph.D. in Women's Studies from Emory University in 2008. She is the author of "Fashioning Femininity: Clothing the Body and the Self in What Not to Wear," in *Exposing Lifestyle Television: The Big Reveal* (Ashgate, 2008) and "Tracing the Carnival Spirit in *Buffy the Vampire Slayer*: Feminist Reworkings of the Grotesque" in the journal *thirdspace*. She is completing a book on femininity, class, and power in makeover shows. She currently teaches at Spelman College.

Janet Staiger is William P. Hobby Centennial Professor of Communication in the Department of Radio-Television-Film at the University of Texas at Austin. Her books include *Media Reception Studies* (New York University Press, 2005), *Authorship and Film*, co-edited with David Gerstner (Routledge, 2003), *Perverse Spectators: The Practices of Film Reception* (New York University Press, 2000), *Blockbuster TV: Must-See Sitcoms in the Network Era* (New York University Press, 2000), *Bad Women: Regulating Sexuality in Early American Cinema* (University of Minnesota Press, 1995), *Interpreting Films: Studies in the Historical Reception of American Cinema* (Princeton University Press, 1992), and *The Classical Hollywood Cinema: Film Style and Mode of Production to 1960*, co-author with David Bordwell and Kristin Thompson (Columbia University Press, 1985).

Peter Stapleton is an independent scholar and musician located in Dunedin, New Zealand. He has played with groups such as The Pin Group, The Victor Dimisich Band, Scorched Earth Policy, Dadamah, Rain, A Handful of Dust, and Flies Inside the Sun, and currently plays with The Terminals and Eye. In 1996 he founded the Metonymic music label and since 2000 he has been a curator of the biennial Lines of Flight Festival of Experimental Music and Film.

Rebecca Stringer is Senior Lecturer in Gender Studies at the University of Otago, New Zealand. Her key research focus is victim politics, or conceptions of victimization and how these are mobilized in law and across the political spectrum. Her work has appeared in journals such as *Borderlands, The Australian Feminist Law Journal, International Journal of Drug Policy, Outskirts*, as well as in edited volumes. She is currently completing a monograph, *Knowing Victims: Feminism and Victim Politics in Neoliberal Times*.

Yvonne Tasker is Professor of Film and Television Studies at the University of East Anglia, UK. She is the author and editor of a number of books and articles exploring aspects of gender and contemporary cinema culture including *Working Girls: Gender and Sexuality in Popular Cinema* (Routledge, 1998) and (with Diane Negra) *Interrogating Postfeminism: Gender and the Politics of Popular Culture* (Duke University Press, 2007). Her most recent book is *Soldiers' Stories: Military Women in Cinema and Television since WWII* (Duke University Press, 2011).

Ewa Plonowska Ziarek is Julian Park Professor of Comparative Literature at the University at Buffalo. She is the author of: *Feminist Aesthetics: Literature, Gender, and Race in Modernity* (under review); *An Ethics of Dissensus: Feminism, Postmodernity, and the Politics of Radical Democracy* (Stanford, 2001); *The Rhetoric of Failure* (SUNY, 1995); the editor of *Gombrowicz's Grimaces: Modernism, Gender, Nationality* (SUNY, 1998); and the co-editor of *Revolt, Affect, Collectivity: The Unstable Boundaries of Kristeva's Polis* (SUNY, 2005); *Time for the Humanities: Praxis and the Limits of Autonomy* (Fordam, 2008); and *Intermedialities: Philosophy, Art, Politics* (Rowman & Littlefield, 2010).

INDEX

Page numbers in **bold** refer to figures.

female consumers 72, 135, 235–6; makeover trope 74–5, 76, 85; male consumers 38, 154–6, 158–60, 168, 244; pleasure in consuming 75, 178, 232, 233, 235–6; reproductive consumption 205–13; shopping 42, 76–8, 80, 232–3; "the new" 169, 173, 233; the promotion of consumer culture 168–9, 172–3

Coppola, Sofia 7, 30, 189–201; Coppola's feminist poetics 189–91, 193–201; gender and film production 191–3

Corliss, Richard 271, 273, 275

Cowie, Elizabeth 18–19, 21

Craig, Daniel 13, 16, **17**, 20, 21

Crewe, Ben 39

Crying Game, The (Neil Jordan, 1992) 62–3

Cukor, George 116–17

culture 81–2, 138–9, 142, 146–7; *see also* beauty pageant culture, bride culture, consuming culture(s), feminine culture, lad culture, popular culture, postfeminist culture, princess culture

Curious Case of Benjamin Button, The (David Fincher, 2008) 19, 21

Dargis, Manohla 21, 29, 30, 74, 181, 184, 187, 192, 228, 230

Davis, Angela Y. 281n15

Dean, Richard O'Neill 137

DeAngelis, Michael 2, 5, 25–35

Death Wish (Michael Winner, 1974) 269–73, 275, 276, 279

Decompressors, The 167

de Lauretis, Teresa 131–2

Dempsey, Patrick 79n7

Denby, David 70

Depp, Johnny 13, **14**

Desai, Jigna 131, 132n18, 133n33

de Saussure, Ferdinand 137–8

desire 78, 130, 147, 185–7, 195, 198, 232, 237, 257; and fantasy 3, 18, 19–20; and femininity 81, 88, 235; and repression 285–7, 289–90, 294; for romance 72, 73–4; Lacanian 138–40, 141, 142–3; narrative desire 19–20, 128; queer desire 31–2, 34, 53, 61, 94, 104–5, 106, 130, 231; reproductive desires 206–7, 208, 209, 213; sexual desire 76, 94–102, 105–6

Desjardins, Mary 208

diaspora 124–6, 127–8, 132n16, 132n17, 133n33; *see also* multiculturalism, postcoloniality

diasporic cinema 6, 124–7, 130, 131

Die Hard (John McTiernan, 1988) 17

Dika, Vera 71

Dirty Dancing (Emile Ardolino, 1987) 19, 20, 23n34

Disney 67, 68, 70, 71, 79n10, 79n11, 153, 154; Disney Princess 67, 71–3, 74, 75, 78, 79n12; Disney's race-neutral multiculturalism 102–3, 109n38

Doane, Mary Ann 59–60

Dracula (Tod Browning, 1931) 285

Dr. No (Terence Young, 1962) 21

Durgnat, Raymond 22n5

Eat Pray Love (Ryan Murphy, 2010) 155

Ebert, Roger 20, 23n36, 265

Edward Scissorhands (Tim Burton, 1990) 19, 20, 23n34

Ehrenreich, Barbara 38

empowerment (female) 68, 116–17, 172, 193, 268–9; and neoliberal femininity 82, 86, 89, 91n13; in postfeminist film 6, 68–9, 70, 73, 91n13

Enchanted (Kevin Lima, 2007) 6, 67–78, 79n10, 85; and the Disney princess 67, 71–3, 74, 75, 78, 79n12; consumption in 72, 75–8; fantasy and femininity in 67–8, 69, 70, 71–2, 73–8; irony and knowingness in 67, 68, 70, 71–3, 78; magic and romantic comedy in 67, 69–70, 73, 74–5, 76–7, 78, 79n19

Epstein, Edward Jay 155, 158

ethnicity 4, 17–18, 127, 130, 275, 284; ethnic stereotyping 6, 100, 102, 106, 108n25, 109n41, 278; *see also* postcoloniality

Expendables, The (Sylvester Stallone, 2010) 156

"fallen man" formula 16, 19, 21

Faludi, Susan 244

family 7–8, 139, 206, 208, 244, 245, 250, 258; and postfeminism 73, 206; family-in-peril narratives 241, 245–50; family relations 54, 134–5, 137–9, 241; fragmentation of 205, 209–10, 212, 213, 241–2; in black communities 258–9, 265; new family structures 4, 208, 210–12, 213, 258; nuclear families 20, 49, 82, 212, 213; Oedipal families and structures 134–5, 138, 258, 260, 265; primacy of 6, 7, 129–30; *see also* fatherhood, kinship, melodrama (family), motherhood